Basic Photography

To P. Still the first for the first . . .

Basic Photography
Seventh Edition

Michael Langford FBIPP, HonFRPS
Formerly Photography Course Director
Royal College of Art, London

ELSEVIER

AMSTERDAM • BOSTON • HEIDELBERG • LONDON • NEW YORK • OXFORD
PARIS • SAN DIEGO • SAN FRANCISCO • SINGAPORE • SYDNEY • TOKYO

Focal Press is an imprint of Elsevier

Focal Press
An imprint of Elsevier
Linacre House, Jordan Hill, Oxford OX2 8DP
200 Wheeler Road, Burlington, MA 01803

First published 1965
Second edition 1971
Third edition 1973
Fourth edition 1977
Fifth edition 1986
Sixth edition 1997
Reprinted 1998 (twice), 1999
Seventh edition 2000
Reprinted 2001, 2002, 2003, 2004

British Library Cataloguing in Publication Data
A catalogue record for this book is available from the British Library

Library of Congress Cataloguing in Publication Data
A catalogue record for this book is available from the Library of Congress

ISBN 0 240 51592 7

For information on all Focal Press titles
please visit our website at www.focalpress.com

Composition by Genesis Typesetting, Rochester, Kent
Printed and bound in Italy

Contents

Michael Langford completed this seventh edition shortly before his death in April 2000 but, sadly, never saw it in print.

The first edition of this book, in 1965, was Michael's first published title. In its seventh edition it brings his coverage of photography right up to date. This is a classic text and every photographer's bible.

Along with Michael's many other titles, this seventh edition will ensure that he lives on through his work, providing guidance to everyone who shares his great passion for photography and wants to learn more.

Picture credits

Figure 1.1 © Harold & Esther Edgerton Foundation, 1999. Courtesy of Palm Press Inc. 1.4 Brendan Corr © *Financial Times*. 1.5 Henri Cartier-Bresson/Magnum. 1.6 Lee Friedlander, New York. 1.7 Nick Ut/ Associated Press (AP). 1.8, 5.5, 7.3, 8.2, 8.5, 8.17, 8.19 Library of Congress. 1.10 © Jerry Uelsmann. 1.11, 2.1, 14.39 Royal Photographic Society, Bath. 1.12 Stephen Dalton/NHPA. 1.14, 8.8 Bill Brandt Archive Ltd at www.billbrandt.com. 1.15 © Joy Gregory. 1.16 © Hannah Starkey. 1.17, 8.24 © John Batho, courtesy Zabrieskie Gallery. 6.11 Courtesy Phase One, Denmark. 7.20 Robert Freson, *Sunday Times Magazine*. 8.1 Elliott Erwitt/Magnum. 8.7 © 2000 The Arizona Board of Regents for the Centre for Creative Photography, Tuscan, Arizona. Courtesy of Weston Gallery Inc, Carmel, Calif. 8.10 © Hunter Kennedy. 8.15 © Franco Fontana. 8.16, 8.18, 8.20 Collections/Fay Godwin. 8.26 © Ady Kerry LBIPP/AK Pictures. 8.29, 13.25 Jean Dieuzaide, Toulouse. 9.1 Courtesy Eastman Kodak Company. 9.24 © Jim Mackintosh Photography, Glasgow. 13.24 © Tansy Spinks. 14.1 © Nicky Coutts. 14.28 © Catherine McIntyre. 14.40 © Ian Coates, FBIPP. 14.41 © Paul Wenham-Clarke. 15.9 © David Hockney. 15.10 Courtesy VisualEyes Ltd. 15.11 Courtesy Martin Evening. B.5 © National Trust Photographic Library/John Bethell. (All other pictures by the author.)

Introduction

'...Technique is basic to the art of photography'
Beaumont Newhall, Museum of Modern Art (Essays, 1980)

Basic Photography is an introductory textbook, covering the varied skills which lie behind photographic practice. It is intended for students of all ages and, beginning at square one, assumes that you have no theoretical knowledge of photography, nor any scientific background. The book explains equipment and techniques, provides information on how today's 'silver halide' materials and processes work, together with new digital methods of shooting and manipulating pictures. At the same time, since technical know-how and craft skills mean little on their own, the importance of visual content and meaning in photographs is stressed throughout. In short, *Basic Photography* is planned as a primer for professionals which will interest and inform amateur photographers too.

'Photography', or 'light drawing', is essentially a combination of technique and visual observation. Developing your ability to make successful photographs must include some basic technical theory, otherwise you will not get the most out of your tools, fully explore materials, or turn out reliable results. This aspect of learning photography is like learning to write: first you have to shape the letters forming words, then spell, then string together sentences and paragraphs. But the individual who can do all this is no writer until he or she has ideas to express through words. In the same way technical theory to the photographer is a means to a visual end, something which allows better control and self-confidence in achieving what you want to say.

Basic Photography opens with a broad look at photography – putting it in context as a versatile and important contemporary medium. Then it goes on to show how photography's components, procedures and chemical processes fit together. The chapters are laid out in the same order as image production, starting with chapters on light and lenses, and proceeding through cameras, subject lighting, and composition. (These 'front end' aspects remain valid whether you use traditional photographic materials, or newer electronic methods of image capture.) The book continues with films, exposure, processing, printing, and finishing.

Many photography courses start off with students using colour (slide) film, to build up confidence in camera handling and picture

composition before progressing to more technical aspects of darkroom work. Others begin with black and white photography, which, far from being eclipsed by colour, remains an important creative medium. Reflecting both approaches, *Basic Photography* covers camera aspects of colour and black and white photography, colour film processing, and black and white processing and printing. This is also logical from the point of view of the vast majority of photographers who begin by shooting colour film and using commercial colour printing services. (Colour printing will be found in the companion volume, *Advanced Photography*; the history of technical and stylistic movements in photography is described in *Story of Photography*, also published by Focal Press.)

This seventh edition of *Basic Photography* is expanded to include new, digital forms of photography. In due course digital imagery will largely take over from traditional chemical-based procedures, especially in amateur photography. But the older processes will still be practised for their own particular qualities, just as black and white continues to be used alongside colour. Chapter 6 explains how digital cameras work, their advantages and limitations. Research and development are proceeding apace here, with industry standards still to be fully agreed. The use of computers to digitally manipulate pictures (particularly those shot on film) is however more established. It is already accepted as an important tool – a rival to the darkroom which every photographer should be able to use. This is covered in Chapter 14.

The text remains in a form that I hope is the most useful for students – either for 'dip-in' study, or sequential reading. You will find the summaries at the end of each chapter a good way of checking contents, and revising. Make use too of the Glossary and Appendices at the back of the book.

M.L.

Special thanks from Focal Press go to Sidney Ray who technically checked the page proofs of this edition.

1
What is photography?

Basically photography is a combination of visual imagination and design, craft skills, and practical organizing ability. Try not to become absorbed in the craft detail too soon. Begin by putting it into perspective with a broad look at what making photographs is all about. On the one hand there is the machinery and the techniques themselves. On the other you have the variety of approaches to picture making – aiming for results ranging from something objective, factual and precise, to work which is self-expressive and open to interpretation.

Why do you want to take photographs? What is actually involved? What roles do photographs play, relative to other ways of making pictures or expressing information and ideas? And what makes a result good or bad anyway?

Facets of photography

One of the first attractions of photography for many people is the lure of the equipment itself. All that ingenious modern technology designed to fit hand and eye – there is great appeal in pressing buttons, clicking precision components into place, and collecting and wearing cameras. Tools are vital, of course, and detailed knowledge about them absorbing and important, but don't end up shooting photographs just to test out the machinery.

Another attractive facet is the actual *process* of photography – the challenge of care and control, and the way this is rewarded by technical excellence and a final object you produced yourself. Results can be judged and enjoyed for their own intrinsic photographic 'qualities', such as superb detail, rich tones and colours. The process gives you the means of 'capturing your seeing', making pictures from things around you without having to laboriously draw. The camera is a kind of time machine, which freezes any person, place or situation you choose. It seems to give the user power and purpose.

Yet another facet is enjoyment of the visual structuring of photographs. There is real pleasure to be had from designing pictures as such – the 'geometry' of lines and shapes, balance of tone, the cropping

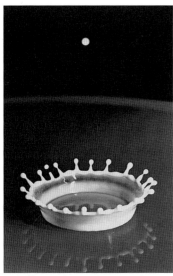

Figure 1.1 Frozen action. This high-speed flash shot of a splash of milk is a factual record. But it can also be enjoyed for its natural design. Photography has revealed something too brief for the human eye alone to see

and framing of scenes – whatever the subject content actually happens to be. So much can be done by a quick change of viewpoint, or choice of a different moment in time.

Perhaps you are drawn into photography mainly because it is a quick, convenient and seemingly truthful way of *recording* something. All the importance lies in the subject itself, and you want to show objectively what it is, or what is going on. Photography is evidence, identification, a kind of diagram of a happening. The camera is your visual notebook.

The opposite facet of photography is where it is used to manipulate or interpret reality, so that pictures push some 'angle' or attitude of your own. You set up situations (as in advertising) or choose to photograph some aspect of an event but not others (as in politically biased news reporting). Photography is a powerful medium of persuasion and propaganda. It has that ring of truth when all the time, in artful hands, it can make any statement the manipulator chooses.

Another reason for taking up photography is that you want a means of personal self-expression. It seems odd that something so apparently objective as photography can be used to express, say, issues of identity, or metaphor and mysticism – describing daydreams that may not be immediately apparent from the subject matter in front of the camera. But we have probably all seen images 'in' other things, like reading meanings into flickering flames, shadows or peeling paint. A photograph can intrigue through its posing of questions, keeping the viewer returning to read new things from the image. The way it is presented too may be just as important as the subject matter. Other photographers simply seek out beauty, which they express in their own 'picturesque' style, as a conscious work of art.

These are only some of the diverse activities and interests covered by the umbrella term 'photography'. None are 'better' or more important than others. Several will be blended together in the work of a photographer, or any one market for professional photography. Your present enjoyment in producing pictures may be mainly based on technology, art or communication. And what begins as one area of interest can easily develop into another. As a beginner it is helpful to keep an open mind. Provide yourself with a well-rounded 'foundation course' by trying to learn something of *all* these facets, preferably through practice rather than theory alone.

How photography works

Photography is to do with light forming an image, normally by means of a lens. The image is then permanently recorded either by:

(a) *chemical* means, using film, liquid chemicals and darkroom processes or
(b) *digital* means, using an electronic sensor, data storage and processing, and print-out via a computer.

Chemical forms of image recording are long established, steadily improved since the mid nineteenth century. Digital methods have only become practical within the past five years but are rapidly evolving. Photographers increasingly combine the two – shooting on film and then transferring results into digital form for manipulating and print-out.

You don't need to understand either chemistry or electronics to take good photographs of course, but it is important to have sufficient practical skills to control results and so work with confidence. The following is an outline of the key technical stages you will meet in chemical and in digital forms of photography. Each stage is discussed in detail in later chapters.

Forming and exposing an image

Most aspects of forming an optical image of your subject (in other words concerning the 'front end' of the camera) apply to both film and digital photography. Light from the subject of your picture passes through a glass lens, which bends it into a focused (normally miniaturized) image. The lens is at the front of a light-tight box or camera with a light-sensitive surface such as film facing it at the other end. Light is prevented from reaching the film by a shutter until your chosen moment of exposure. The amount of exposure to light is most often controlled by a combination of the time the shutter is open and the diameter of the light beam passing through the lens. The latter is altered by an aperture, like the iris of the eye. Both these controls have a further influence on visual results. Shutter time alters the way movement records blurred or frozen; lens aperture alters the depth of subject that is shown in focus at one time (depth of field).

You need a viewfinder, focusing screen or electronic viewing screen for aiming the camera and composing, and a light measuring device, usually built in, to meter the brightness of each subject. The meter takes into account the light sensitivity of the material on which you are recording the image and reads out or automatically sets an appropriate combination of lens aperture and shutter speed. With knowledge and skill you can override these settings to achieve chosen effects or compensate for conditions which will fool the meter.

The chemical route

Processing. If you have used a film camera the next stage will be to process your film. A correctly exposed film differs from an unexposed film only at the atomic level – minute chemical changes forming an invisible or 'latent' image. Developing chemicals must then act on your film in darkness to amplify the latent image into something much more substantial and permanent in normal light. You apply these chemicals in the form of liquids; each solution has a particular function when used on the appropriate film. With most black and white films, for example, the first chemical solution develops light-struck areas into black silver grains. You follow it with a solution which dissolves ('fixes') away the unexposed parts, leaving these areas as clear film. So the result, after washing out by-products and drying, is a black and white *negative* representing brightest parts of your subject as dark and darkest parts pale grey or transparent.

A similar routine, but with chemically more complex solutions, is used to process colour film into colour negatives. Colour slide film needs more processing stages. First a black and white negative developer is used, then the rest of the film instead of being normally

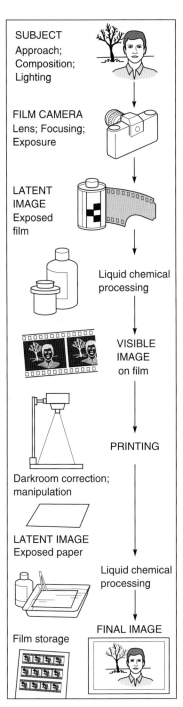

Figure 1.2 Basic route from subject to final photographic image, using film. This calls for liquid chemicals and darkroom facilities

fixed is colour developed to create a positive image in black silver and dyes. You are finally left with a positive, dye-image colour slide.

Printing negatives. The next stage of production is printing, or, more often, enlarging. Your picture on film is set up in a vertical projector called an *enlarger*. The enlarger lens forms an image, of almost any size you choose, on to light-sensitive photographic paper. During exposure the paper receives more light through clear areas of your film than through the denser parts. The latent image your paper now carries is next processed in chemical solutions broadly similar to the stages needed for film. For example, a sheet of black and white paper is exposed to the black and white film negative, then developed, fixed and washed so it shows a 'negative of the negative', which is a positive image – a black and white print. Colour paper after exposure goes through a sequence of colour developing, bleaching and fixing to form a colour negative of a colour negative. Other materials and processes give colour prints from slides.

An important feature of printing (apart from allowing change of image size and running off many copies) is that you can adjust and correct your shot. Unwanted parts near the edges can be cropped off, changing the proportions of the picture. Chosen areas can be made lighter or darker. Working in colour you can use a wide range of enlarger colour filters to 'fine-tune' the colour balance of your print, or to create effects. With experience you can even combine parts from several film images into one print, form pictures which are part-positive part-negative, and so on.

Colour and black and white. You have to choose between different types of film for photography in colour or black and white (monochrome). Visually it is much easier to shoot colour than black and white, because the result more closely resembles the way the subject looked in the viewfinder. You must allow for differences between how something looks and how it comes out in a colour photograph, of course (see Chapter 6). But this is generally less difficult than forecasting how subject colours will translate into tones of monochrome. At its best, black and white photography is considered more interpretative and subtle, less crudely lifelike than colour. For this reason it has become a minority enthusiasts' medium, still important for 'fine prints' and gallery shows. Here it readily rubs shoulders with black and white photography of the past.

Colour films, papers and chemical processes are more complex than black and white. This is why it was almost a hundred years after the invention of photography before reliable colour print processes appeared. Even then they were expensive and laborious to use, so that until the 1970s photographers mostly learnt their craft in black and white and worked up to colour. Today practically everyone takes their first pictures in colour. Most of the chemical complexity of colour photography is locked up in the manufacturers' films, papers, ready-mixed solutions and standardized processing routines. It is mainly in printing that colour remains more demanding than black and white, because of the extra requirements of judging and controlling colour balance (see *Advanced Photography*). So in the darkroom at least you will find that photography by the chemical route is still best begun in black and white.

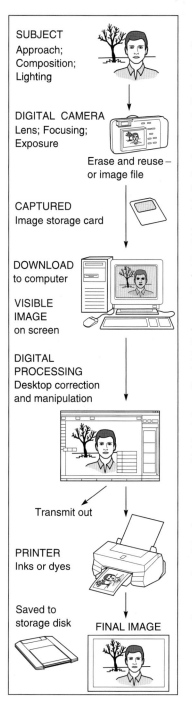

SUBJECT
Approach;
Composition;
Lighting

DIGITAL CAMERA
Lens; Focusing;
Exposure

Erase and reuse –
or image file

CAPTURED
Image storage card

DOWNLOAD
to computer

VISIBLE
IMAGE
on screen

DIGITAL
PROCESSING
Desktop correction
and manipulation

Transmit out

PRINTER
Inks or dyes

Saved to
storage disk

FINAL IMAGE

Figure 1.3 Basic digital route from subject to final image. No chemicals or darkroom are needed, and camera cards for image storage can be re-used. Images may also be digitalized from results shot on film, via a film scanner or Photo-CD

The digital route

Storing, downloading and processing. If you are using a digital camera the exposed image is recorded on a grid of millions of microscopic size light-sensitive elements. This is known as a CCD (charge-coupled device) located in a fixed but similar position to film within a film camera. Immediately following exposure the CCD reads out its captured picture as a chain of electronic signals called an image file, usually into a small digital storage card slotted into the camera body. Wanted image files are later downloaded from the card or direct from the camera into a computer, where they appear as full-colour pictures on a monitor screen. Unwanted shots are erased. After downloading or erasures you can re-use the card indefinitely for storing new camera pictures.

A software program which has also been loaded into the computer now offers you 'tools' and controls alongside the picture to crop, adjust brightness, contrast or colour and many other manipulations. Each one is selected and activated by moving and clicking the computer mouse – changes to the image appear almost immediately on the monitor display.

Printing out. When the on-screen picture looks satisfactory the revised digital file can be fed to a desktop printer – typically an ink-jet type – for full colour print-out on paper. Image files can be 'saved' (stored) within the computer's internal hard disk memory or on a removable disc.

Practical comparisons between making photographs by the chemical (film) route and the digital route appear in detail on pages 96 and 105. You will see that each offers different advantages and trade-offs, and for the time being there are good reasons for combining the best features of each.

Technical routines and creative choices

Whether you work by chemical or digital means, photography involves you in two complementary skills.

● First, there are set routines where consistency is all important, for example film processing or paper processing, especially in colour, and the disciplines of inputting and saving digital image files.
● Second, there are those stages at which creative decisions must be made, and where a great deal of choice and variation is possible. These include organization of your subject, lighting and camera handling, as well as editing and printing the work. As a photographer you will need to handle and make these decisions yourself, or at least closely direct them.

With technical knowledge plus practical experience (which comes out of shooting lots of photographs under different conditions) you gradually build up skills that become second nature. It's like learning to drive. First you have to consciously learn the mechanical handling of a car. Then this side of things becomes so familiar you concentrate more and more on what you want to *achieve* with the machinery.

Having more confidence about getting results, you find you can spend most time on picture-making problems such as composition, and capturing expressions and actions which differ with every shot and have no routine solutions. However, still keep yourself up-to-date on new processes and equipment as they come along. You need to discover what new visual opportunities they offer.

Technical routines and creative choices give a good foundation for what is perhaps the biggest challenge in photography – how to produce pictures which have interesting content and meaning. Can you communicate to other people through what you 'say' visually, be this simple humour (Figure 1.4) or some serious comment on the human condition like Figure 5.5?

Picture structuring

The way you visually compose your pictures is as important as their technical quality. But this skill is acquired with experience as much as learnt. Composition is to do with showing things in the strongest, most effective way, whatever your subject. Often this means avoiding clutter and confusion between the various elements present (unless this very confusion contributes to the mood you want to create). It involves you in the use of lines, shapes and areas of tone within your picture, irrespective of what the items actually *are*, so that they relate together effectively, with a satisfying kind of geometry (see Figure 1.5).

Composition is therefore something photography has in common with drawing, painting and the fine arts generally. The main difference is that you have to get most of it right while the subject is still in front of you, making the best use of what is present at the time. The camera works fast. Even digital methods do not offer as many opportunities to gradually build up your final image afterwards as does a pencil or brush.

'Rules' of composition have gone out of fashion, with good reason. They encourage results which slavishly follow the rules but offer nothing else besides. As Edward Weston once wrote: *'Consulting rules of composition before shooting is like consulting laws of gravity before going for a walk.'* Of course it is easy to say this when you already have an experienced eye for picture making, but guides are helpful if you are just beginning (see Chapter 8). Practise making critical comparisons between pictures that structurally 'work' and those that do not. Discuss these aspects with other people, both photographers and non-photographers.

Where a subject permits, it is always good advice to shoot several photographs – perhaps the obvious versions first, then others with small changes in the way items are juxtapositioned, etc., increasingly simplifying and strengthening what your image expresses or shows. It's your eye that counts here more than the camera (although some cameras get far less in the way between you and the subject than others).

Composition can contribute greatly to the style and originality of your pictures. Some photographers (Lee Friedlander, for example: Figure 1.6) go for offbeat constructions which add to the weirdness of picture contents. Others, like Arnold Newman and Henri Cartier-Bresson, are known for their more formal approach to picture composition.

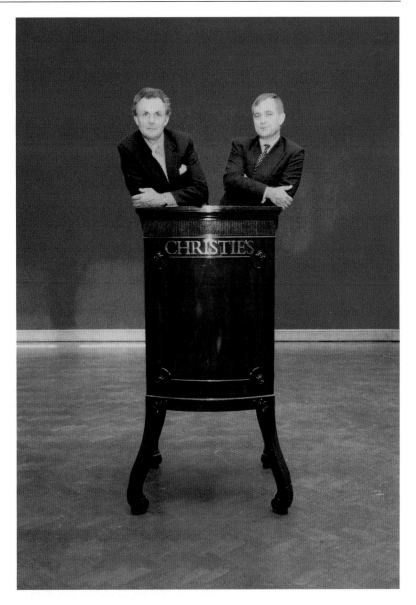

Figure 1.4 Pictures for financial newspapers don't have to be dull. The photographer recognized the visual potential of this antique auctioneer's box for his two portraits. Care over camera and figure positioning gives an eye-catching image of great simplicity. Brendan Corr for *Financial Times*

Composition in photography is almost as varied as composition in music or words – melodic or atonal, safe or daring – and can enhance subject, theme, and style. Every photograph you take involves you in some compositional decision, even if this is simply where to set up the camera or when to press the button.

The roles photographs play

There is little point in being technically confident and having an eye for composition, if you do not also understand *why* you are taking the photograph. The purpose may be simple – a clear, objective record of something or somebody for identification. It may be more

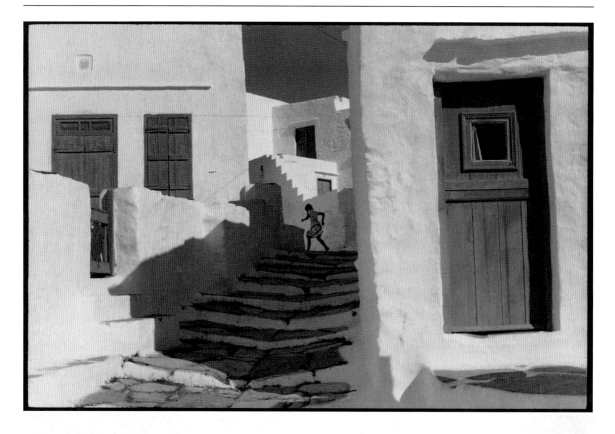

Figure 1.5 Siphnos, Greece, 1961. A Henri Cartier-Bresson picture strongly designed through choice of viewpoint to use line and tone, together with moment in time

nebulous – a subjective picture putting over the concept of security, happiness or menace, for example. No writer would pick up a pen without knowing whether the task is to produce a data sheet or a poem. Yet there is a terrible danger with photography that you set up your equipment, busy yourself with focus, exposure and composition, but think hardly at all about the meaning of your picture and why you should show the subject in that particular way.

People take photographs for all sorts of reasons of course. Most are just reminders of vacations, or family and loved ones. These fulfil one of photography's most valuable social functions, freezing moments in our own history for recall in years to come.

Sometimes photographs are taken to show tough human conditions and so appeal to the consciences of others. Here you may have to investigate the subject in a way which in other circumstances would be called prying or voyeurism. This difficult relationship with the *subject* has to be overcome if your final picture is to win a positive response from the *viewer*.

Understanding the best approach to the subject to create the right reaction from your target audience is vital too in photographs that advertise and sell. Every detail in a set-up situation must be considered with the message in mind. Is the location or background of a kind with which consumers positively identify? Are the models and the clothes they are wearing too up (or down) market? Props and accessories must suit the lifestyle and atmosphere you are trying to convey. Generally viewers must be offered an image of themselves

made more attractive by the product or service you are trying to sell. In the middle of all this fantasy you must produce a picture structured to attract attention; show the product; perhaps leave room for lettering; and suit the proportions of the showcard or magazine page on which it will finally be printed.

News pictures are different again. Here you must often encapsulate an event in what will be one final published shot. The moment of expression or action should sum up the situation, although you can colour your report by choosing what, when, and from where, you shoot. Until recently there was a long-held assumption that photographers are impartial observers, documenting events as they unfold. Reality is somewhat different, for no-one can be completely impartial. Photographers have their own beliefs and prejudices.

Photograph a demonstration from behind a police line and you may show menacing crowds; photograph from the front of the crowd and you show suppressive authorities. You have a similar power when portraying the face of, say, a politician or a sportsperson. Someone's expression can change between sadness, joy, boredom, concern, arrogance, etc., all within the space of a few minutes. By photographing just one of those moments and labelling it with a caption reporting the event, it is not difficult to tinker with the truth. The ease by which digital manipulation can now add or remove picture elements seamlessly, described in Chapter 14, has further put to rest the old adage of 'photographic truth' and 'the camera cannot lie'.

Figure 1.6 Lee Friedlander's Chicago street scene seems random in composition and timing – with every object cut into by something else. However, it purposely expresses an off-beat, depersonalized strangeness. The picture leaves the viewer asking questions

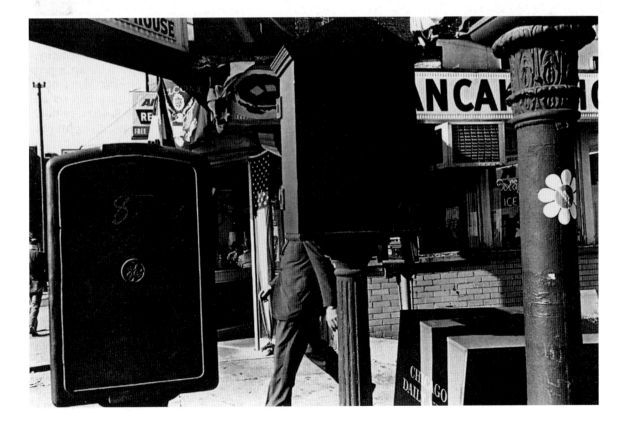

At another level, entirely decorative photographs for calendars or editorial illustration (pictures which accompany magazine articles) can communicate beauty for its own sake – beauty of landscape, human beauty, and natural form or beauty seen in ordinary everyday things (Figure 1.9). Beauty is a very subjective quality, influenced by attitudes and experience. But there is scope here for your own way of seeing and responding to be shown through a photograph which produces a similar response in others. Overdone, it easily becomes 'cute' and cloying, overmannered and self-conscious.

Photography can provide information in the kind of record pictures used for training, medicine, and various kinds of scientific evidence. Here you can really make use of the medium's superb detail and clarity, and the way pictures communicate internationally, without the language barrier of the written word. Features of a camera-formed image are not unlike an eye-formed image (Chapter 3). This seems to make it easier to identify with and read information direct from a photograph than from a sketch.

Photographs are not always intended to communicate with other people, however. You might be looking for self-fulfilment and self-expression, and it may be a matter of indifference to you whether others read information or messages into your results – or indeed see them at all. Some of the most original images in photography have been produced in this way, totally free of commercial or artistic conventions, often the result of someone's private and personal obsession. You will find

Figure 1.7 Children fleeing an American napalm strike, 1972. Nick Ut photographed these Vietnamese youngsters burnt by bombs, which produced the curtain of smoke from the village behind them. Published world-wide, it helped solidify public opposition within the US against the war

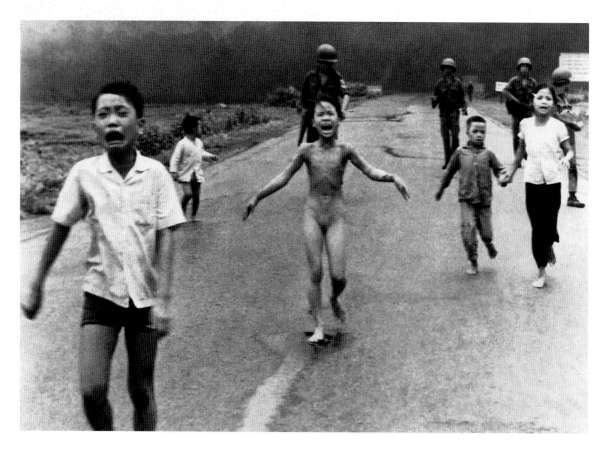

Figure 1.8 This documentary shot by Dorothea Lange was taken in San Francisco during the 1930s Depression. It relies greatly on human expressions to communicate an 'in America we trust' appeal

examples in the photography of Diane Arbus, Clarence Laughlin or Jerry Uelsmann (Figure 1.10), and photograms by Man Ray or Moholy Nagy.

There are many other roles photographs can play: mixtures of fact and fiction, art and science, communication and non-communication. Remember too that a photograph is not necessarily the last link in the chain between subject and viewer. Editors, art editors, and exhibition organizers all like to impose their own will on final presentation. Pictures are cropped, captions are written and added, layouts place one picture where it relates to others. Any of these acts can strengthen, weaken or distort what a photographer is trying to show. You are at the mercy of people 'farther down the line'. They can even sabotage you years later, by taking an old picture and making it do new tricks.

Changing attitudes towards photography

Today's awareness and acceptance of photography as a creative medium by other artists, by galleries, publishers, collectors and the general public

has not been won easily. People's views for and against photography have varied enormously in the past, according to the fashions and attitudes of the times. For a great deal of the nineteenth century (photography was invented in 1839) photographers were seen as a threat by painters who never failed to point out in public that these crass interlopers had no artistic ability or knowledge. To some extent this was true – you needed to be something of a chemist to get results at all.

Pictorialism and realism

By the beginning of the twentieth century equipment and materials had become somewhat easier to handle. Snapshot cameras, and developing and printing services for amateurs, made black and white photography an amusement for the masses. In their need to distance themselves from all this and gain acceptance as artists, 'serious' photographers tried to force the medium closer to the appearance and functions of paintings of the day. They called themselves 'pictorial' photographers, shooting picturesque subjects, often through soft-focus camera attachments, and

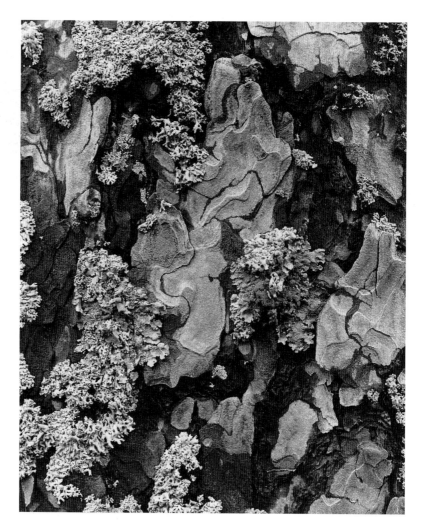

Figure 1.9 Fungus and bark on a tree trunk. The detail and tone range offered by 'straight' photography strengthen the subject's own natural qualities of pattern and form

Figure 1.10 A dream-like image constructed by Jerry Uelsmann – printed from several negatives onto one piece of paper. The apparent truthfulness of photography makes it a convincing medium for surreal pictures (see also montage by digital means, page 279)

printing on textured paper by processes which eliminated most of photography's 'horrid detail'.

Fortunately the advent of cubism and other forms of abstraction in painting, at the same time as techniques for mechanically reproducing photographs on the printed page, expanded photographers' horizons. As a reaction to pictorialism 'Straight' photography came into vogue early in the twentieth century with the work of Edward Weston (page 133), Paul Strand and Albert Renger-Patzsch. They made maximum use of the qualities of black and white photography previously condemned: pin-sharp focus throughout, rich tonal scale and the ability to shoot simple everyday subjects using natural lighting. Technical excellence was all important and strictly applied. Photography had an aesthetic of its own, but something quite separate from painting and other forms of fine art.

The advent of photographs mechanically printed into newspapers and magazines opened up the market for press and candid photography. Pictures were taken for their action and content rather than any greatly considered treatment. This and the freedom given by precision hand cameras led to a break with age-old painterly rules of composition.

Figure 1.11 'La Lettre' by Robert
Demachy. A 1905 example of
pictorial (or 'picturesque') subject
and style. Demachy made his
prints by the gum bichromate
chemical process, which gives an
appearance superficially more like
an impressionist painting than a
photograph

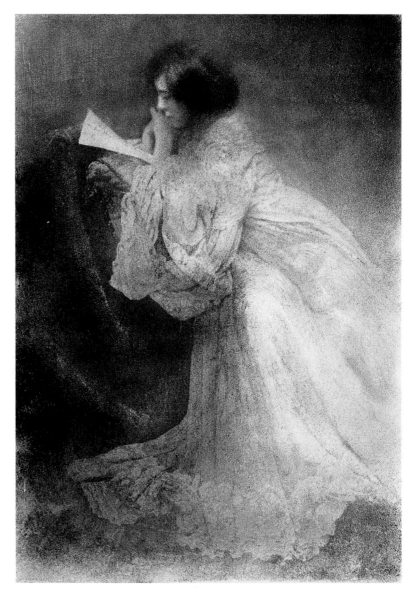

The 1930s and 40s were the great expansion period for picture
magazines and photo-reporting, before the growth of television. They
also saw a steady growth in professional aspects of photography:
advertising; commercial and industrial; portraiture; medical; scientific
and aerial applications. Most of this was still in black and white. Use of
colour gradually grew during the 1950s but it was still difficult and
expensive to reproduce well in publications.

Youthful approach of the 1960s

Rapid, far-reaching changes took place during the 1960s. From some-
thing which a previous generation had regarded as an old-fashioned,
fuddy-duddy trade and would-be artistic occupation, photography

became very much part of the youth cult of the 'swinging sixties'. New small-format precision SLR cameras, electronic flash, machines and custom laboratories to hive off boring processing routines, and an explosion of fashion photography, all had their effect. Photography captured the public imagination.

Young people suddenly wanted to own a camera, and use it to express themselves about the world around them. The new photographers were interested in contemporary artists, but neither knew nor cared about the established photographic clubs and societies with their stultifying 'rules' and narrow outlook on the kind of pictures acceptable for awards.

The fresh air this swept into photography did immeasurable good. Photographers were no longer plagued with self-conscious doubts such as 'is photography Art?' It began to become accepted as a *medium* – already the dominant form of illustration everywhere and, in the hands of an artist, a growing art form. Since photographs grew so universal in people's contemporary life-style they became integrated with modern painting, printmaking, even sculpture.

Photography began to be taught in schools and colleges, especially art colleges, where it had been previously down-graded as a technical subject. America led the way in setting up photographic university degree courses, and including it in art and design, social studies and communications. Nevertheless, few one-person portfolios of photographs had been published with high quality reproduction in books. It was also extremely rare for an established art gallery to sell or even hang photographs, let alone public galleries to be devoted to photography. As a result it was difficult for the work of individuals to be seen and become well-known. Even magazines and newspapers failed to credit the photographer alongside his or her work, whereas writers always had a published credit.

By the 1970s though all this had changed. Adventurous galleries put on photography shows which were increasingly well attended. Demand from the public and from students on courses encouraged publishers to produce a wide range of books showcasing the work of individual photographers. Creative work began to be sold as 'fine prints' in galleries to people who bought them as investments. Older photographers such as Bill Brandt, Minor White and André Kertesz were rediscovered by art curators, brought out of semi-obscurity and their work exhibited in international art centres.

The 1980s brought colour materials which gave better quality results and were cheaper than before. Colour labs began to appear offering everyone better processing and printing, plus quicker turn-around. The general public wanted to shoot in colour rather than black and white, and gradually colour was taken up by artist photographers too. Colour became cheaper to reproduce on the printed page; even newspapers started to use colour photography.

Today the availability of less daunting, user-friendly camera equipment combined with a much bigger public audience for photography (and more willing to receive original ideas) encourages a broad flow of pictures. Galleries, books and education have brought greater critical discussion of photographs – how they communicate meanings through a visual language of their own. There are now so many ways photography is used by different individuals it is becoming almost as varied and profound as literature or music.

Personal styles and approaches

The 'style' of your photography will develop out of your own interests and attitudes, and the opportunities that come your way. For example, are you mostly interested in people or in objects and things you can work on without concern for human relationships? Do you enjoy the split-second timing needed for action photography, or prefer the slower more soul-searching approach possible with landscape or still-life subjects?

If you aim to be a professional photographer you may see yourself as a generalist, handling most photographic needs in your locality. Or you might work in some more specialized area, such as natural history, scientific research or medical photography, combining photography with other skills and knowledge. Some of these applications give very little scope for personal interpretation, especially when you must present information clearly and accurately to fulfil certain needs. There is greatest freedom in pictures taken by and for yourself. Here you can best develop your own visual style, provided you are able to motivate and drive yourself without the pressures and clear-cut aims present in most professional assignments.

Style is difficult to define, but recognizable when you see it. Pictures have some characteristic mix of subject matter, mood (humour, drama, romance, etc.), treatment (factual or abstract), use of tone or colour, composition . . . even the picture proportions. Technique is important too, from choice of lens to form of print presentation. But more than anything else style is to do with a particular way of *seeing*.

Figure 1.12 Tree frog jumping. A rapid sequence of three ultra-fast flash exposures made on one frame of film and shot in a specially devised laboratory set-up, by Stephen Dalton. Time-and-action record photography provides unique subject information for natural history research and education

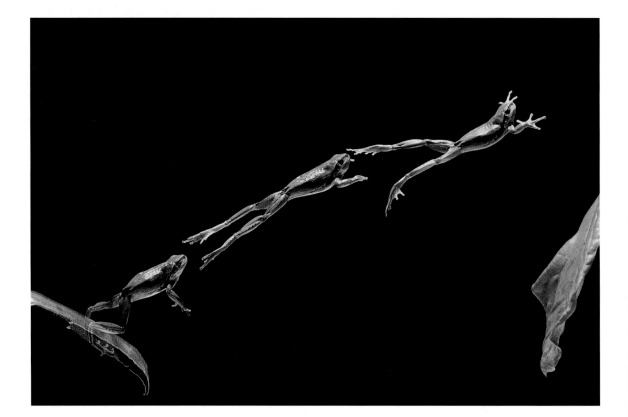

Figure 1.13 Colour photography was for a long time considered more life-like, and so less expressive than black and white. But a hand-coloured black and white print, like this portrait by Sue Wilks, allows you to emphasize chosen areas with total freedom

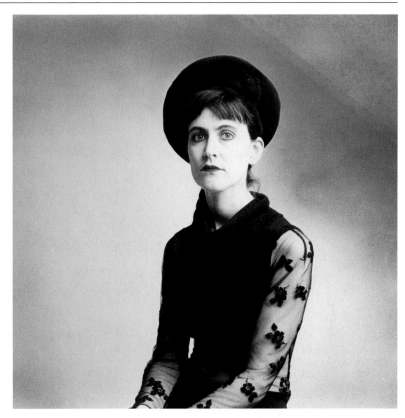

Content and meaning

You can't force style. It comes out of doing, rather than of analysing too much, refined down over a long period to ways of working which best support the things *you* see as important and want to show others. It must not become a formula, a mould which makes everything you photograph turn out looking the same. The secret is to coax out the essence of each and every subject, without repeating yourself. People should be able to recognize your touch in a photograph but still discover things unique to each particular subject or situation by the way you show them.

In personal work the content and meaning of photographs can be enormously varied. A major project 'Memory & Skin' by Joy Gregory explores identity and how people in one part of the world view people in another. Her quiet observation explores connections between the Caribbean and Europe by tracing fragments of history. The picture Figure 1.15 is a cluttered mix of vague and specific detail but within the context of the series theme you can return to it several times and see new things. (Compare with Figure 1.14 which is instantly direct and graphic but contains less depth and meaning.)

Hannah Starkey's work is also about memory, real and imagined, forming a series on women's lives in the inner city. Detailed and strongly narrative, her individually untitled pictures represent little moments of familiarity – the kind of undramatic, ordinary observations and experiences of life. In Figure 1.16 an ageing woman contemplates

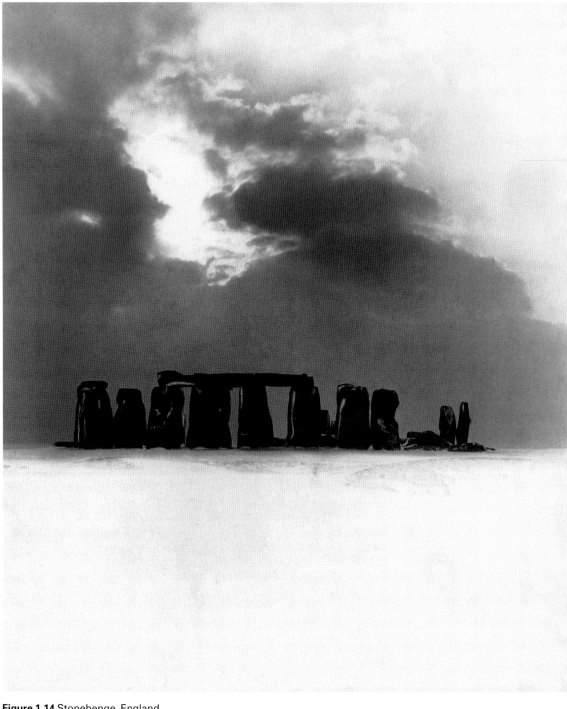

Figure 1.14 Stonehenge, England, under snow, by Bill Brandt. A dramatic black and white interpretative image of great simplicity. It was seen and photographed straight but printed with very careful control of tonal values

her reflection with both anxiety and pleasure. Other elements contained in the room say something about earlier times. And yet the whole series of Hannah's pictures are not documentary but *tableaux*. Her people are posed by actresses and every item specially picked and positioned. Content and meaning rule here over authenticity, but are based on acute observation and meticulous planning. Bear in mind here that tableaux (pictures of constructed events) have a long history in photography. Victorians like Julia Margaret Cameron and H.P. Robinson produced many photographs narrating stories. This 'staged' approach has always of course been present in movies, and in most fashion and advertising still photography.

Sometimes the content of personal work is based on semi-abstract images in which elements such as colour, line and tone are more important than what the subject actually *is*. Meaning gives way to design and the photographer picks subjects for their basic graphic content which he or she can mould into interesting compositions. Figure 1.17 is one such example.

Look at collections of work by acknowledged masters of photography (single pictures, shown in this book, cannot do them justice): Henri Cartier-Bresson's love of humanity, gentle humour and brilliant use of composition, Jerry Uelsmann's surreal, viewer-challenging presentation of landscape, or Robert Demachy's romantic pictorialism. Cindy Sherman, John Pfahl, Martin Parr and Mari Mahr are photographers who each have dramatically different approaches to content and meaning. Their work is distinctive, original, often obsessional.

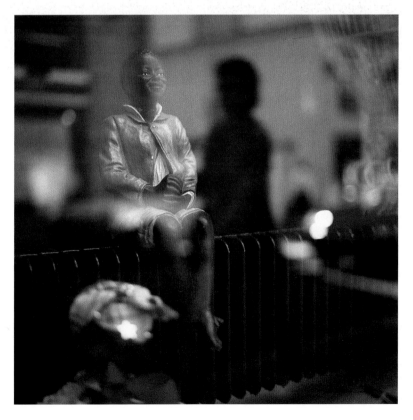

Figure 1.15 Shop window, Nantes, France. A straight, thought provoking documentary shot from a project by Joy Gregory, 'Memory & Skin'. Her pictures explore how people view others from a different part of the world

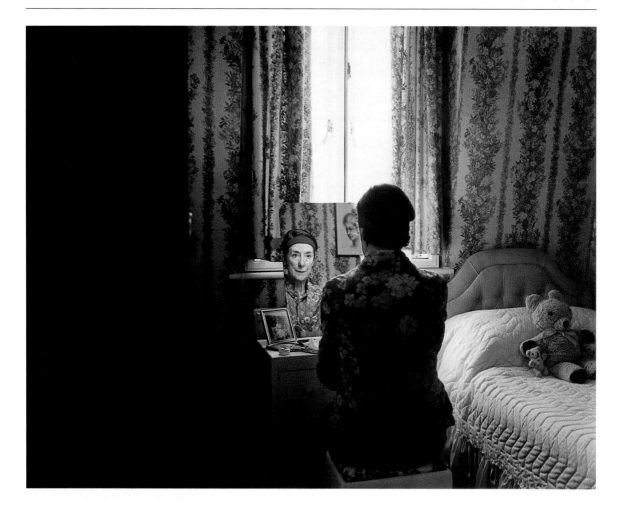

Figure 1.16 Untitled – February 1991. This picture by Hannah Starkey is one of her series entitled 'Women Watching Women'. The content and meaning of each shot relate to little moments familiar to experiences in everyday life. The real and the fictional are combined here, see text

In the fields of scientific and technical illustration the factual requirements of photography make it less simple to detect individuals' work. But even here high-speed photography by Dr Harold Edgerton and medical photography by Lennart Nilsson stand out, thanks to these experts' concern for basic visual qualities too.

Measuring success

There is no formula way to judge the success of a photograph. We are all in danger of 'wishful seeing' in our own work, reading into pictures the things we *want* to discover, and recalling the difficulties overcome when shooting rather than assessing the result as it stands. Perhaps the easiest thing to judge is technical quality, although even here 'good' or 'bad' may depend on what best serves the mood and atmosphere of your picture.

Most commercial photographs can be judged against how well they fulfil their purpose, since they are in the communications business. A poster or magazine cover image, for example, must be striking and give its message fast. But many such pictures, although clever, are shallow

Figure 1.17 The subject is the inside of a circus tent – but content is mostly irrelevant in John Batho's creative graphic composition concerned with colour and line. You might read it as landscape, or as flat, two-dimensional abstract design – a piece of artwork complete in itself

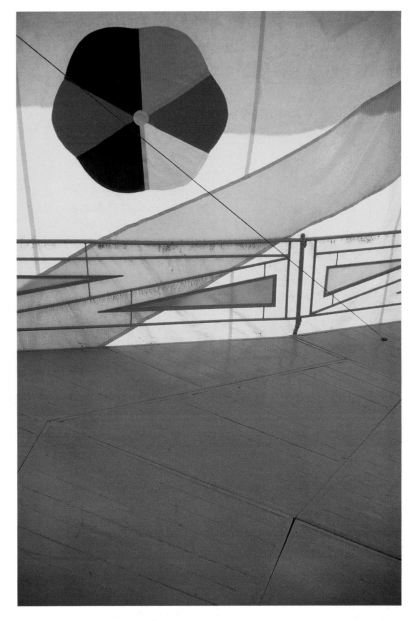

and soon forgotten. There is much to be said for other kinds of photography in which ambiguity and strangeness challenge you, allowing you to keep discovering something new. This does not mean you have to like everything which is offbeat and obscure; there are as many boring, pretentious and charlatan workers in photography as in any other medium.

Reactions to photographs change with time too. Live with your picture for a while (have a pinboard wall display at home) otherwise you will keep thinking your latest work is always the best. Similarly it is a mistake to surrender to today's popular trend; it is better to develop

the strength of your *own* outlook and skills until they gain attention for what they are. Just remember that although people say they want to see new ideas and approaches, they still tend to judge them in terms of yesterday's accepted standards.

A great deal of professional photography is sponsored, commercialized art in which success can be measured financially. Personal projects allow most adventurous, avant-garde picture making – typically to express preoccupations and concerns. Artistic success is then measured in terms of the enjoyment and stimulus of making the picture, and satisfaction with the result. Rewards come as work published in its own right or exhibited on a gallery wall. Extending yourself in this way often feeds commercial assignments too. So the measure of true success could be said to be when you do your own self-expressive thing, but also find that people flock to your door to commission and buy this very photography.

Summary. What is photography?

- Photography is a *medium* – a vehicle for communicating facts or fictions, and for expressing ideas. It requires craftsmanship and artistic ability in varying proportions.
- Technical knowledge is necessary if you want to make full use of your tools and so work with confidence. Knowing 'how' frees you to concentrate on 'what' and 'why' (the photograph's content and meaning).
- Always explore new processes and equipment as they come along. Discover what kind of images they allow you to make.
- Traditionally in photography the image of your subject formed by the camera lens is recorded on silver halide coated film. Processing is by liquid chemicals, working in darkness.
- New technology now allows us the option of capturing the lens image by electronic digital means. Results can also be manipulated digitally, using a computer. You don't need chemicals or a darkroom.
- Visually, camera work in colour is easier than black and white. Colour is more complex in the darkroom.
- Photography records with immense detail, and in the past had a reputation for being essentially objective and truthful. But you can use it in all sorts of other ways, from propaganda to 'fine art' self-expression.
- Taking photographs calls for a mixture of (a) carefully followed routines and craft skills, to control results, and (b) creative decisions about subject matter and the intention of your picture.
- Photographs can be enjoyed/criticized for their *subject content*, or their *structure*, or their *technical qualities*, or their *meaning*, individually or together.
- The public once viewed photography as a stuffy, narrow pseudo-art, but it has since broadened into both a lively occupation and a creative medium, exhibited everywhere.
- Developing an eye for composition helps to simplify and strengthen the point of your picture. Learn from other photographers' pictures but don't let their ways of seeing get in the way of your own response to subjects. Avoid slavishly copying their style.

• Success might be gauged from how well your picture fulfils its intended purpose. It might be measured in technical, financial or purely artistic terms, or in how effectively it communicates to other people. In an ideal world all these aspects come together.

Projects

When you are working on projects it is helpful to maintain your own visual notebook. This might be a mixture of scrapbook and diary containing written or sketched ideas for future pictures, plus quotes and work by other photographers, writers or artists which you want to remember (add notes of your own). It can also log technical data, lighting diagrams and contact prints relating to shots planned or already taken.

The projects below can be completed in either written or verbal (discursive) form, but they must include visual material such as prints, photocopies or slides.

1 Find and compare examples of *people photographs* which differ greatly in their function and approach. Some suggested photographers: Cecil Beaton, Diane Arbus, Yousuf Karsh, Dorothea Lange, Elliott Erwitt, Julia Margaret Cameron, August Sander, Martin Parr, Cindy Sherman, Arnold Newman.
2 Compare the landscape work of three of the following photographers, in terms of their content and style: Ansel Adams, Franco Fontana, Bill Brandt, Alexander Keighley, Joel Meyerowitz, Fay Godwin, John Blakemore.
3 Looking through newspapers, magazines, books, etc., find examples of photographs (a) which provide objective, strictly factual information; and (b) others which strongly express a particular point of view, either for sales promotion or social or political purposes. Comment on their effectiveness.
4 Shoot four examples of photographs in which picture *structure* is more important than actual subject content. In preparation for this project look at work by some of the following photographers: Ralph Gibson, André Kertesz, Lee Friedlander, Paul Strand, Laszlo Moholy Nagy, Barbara Kasten, Karl Blossfeldt.
5 Find published photographs which are *either* (a) changed in meaning because of adjacent text or caption, or by juxtaposition with other illustrations; *or* (b) changed in significance by the passing of time.

2
Light: how images form

It was said earlier that you don't have to understand physics to take good photographs. But understanding the practical principles behind photography and photographic equipment gives you a broader, more flexible approach to problem solving. It is also interesting. For example, the way light is manipulated to form images is not really very complicated – did you know it can be done with a hole in a card?

We start with the very foundation stone of photography, which is light. What precisely is light, and which of its basic features are helpful to know when you are illuminating a subject, using lenses and learning about colour? From light and colour we go on to discuss how surfaces and subjects look the way they do, and why light has to be bent with glass to create a usable image.

The lens is without doubt the most important part of any camera or enlarger. Starting with a simple magnifying-glass lens you can begin to see how photographic lenses form images. Later this will lead us on to other key components of camera equipment.

Light itself

Light is fundamental to photography; it is even in its very name ('photo'). And yet you are so familiar with light you almost take it for granted. Light is something your eyes are sensitive to, just as your ears relate to sound and your tongue to taste. It is the raw material of sight, communicating information about objects which are out of range of other senses. Using light you can show up some chosen aspects of a subject in front of the camera and suppress others. Light channels visual information via the camera lens onto photographic material, and enables you to enjoy the final result. At this very moment light reflected off this page carries the shape of words to your eyes, just as sound would form the link if we were talking. But what exactly *is* light?

Visible light is a stream of energy radiating away from the sun or similar radiant source. Its four important characteristics, all present at the same time, are:

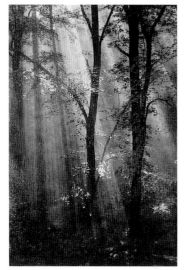

Figure 2.1 Light travels in straight lines, shown clearly in this wooded landscape by pictorialist Alexander Keighley (1917)

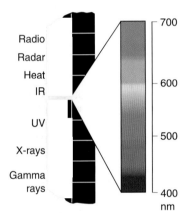

Figure 2.2 Light travels on a straight line path but as if in waves, like the outward movement of ripples when a smooth water surface is disturbed

1 Light behaves as if it moves in waves, like ripples crossing the surface of water, Figure 2.2. Different wavelengths give our eyes the sensation of different colours.
2 Light travels in a straight line (within a uniform substance). You can see this in light 'beams' and 'shafts' of sunlight, Figure 2.1, and the way that shadows fall.
3 Light moves at great speed (300,000 kilometres or 186,000 miles per second through space). It moves less fast in air, and slightly slower still in denser substances such as water or glass.
4 Light also behaves as if it consists of energy particles or 'photons'. These bleach dyes, cause chemical changes in films and electronic response in digital camera sensors, etc. The more intense the light, the more photons it contains.

Wavelengths and colours

What you recognize as light is just part of an enormous range of 'electromagnetic radiations'. As shown left, this includes radio waves with wavelengths of hundreds of metres through to gamma and cosmic rays with wavelengths of less than ten thousand-millionths of a millimetre. Each band of electromagnetic radiation merges into the next, but has its own special characteristics. Some, such as radio, can be transmitted over vast distances. Others, such as X-rays, will penetrate thick steel, or destroy human tissue. Most of this radiation cannot be 'seen' directly by the human eye, however. Your eyes are only sensitive to a narrow band between wavelengths 400 nm and 700 nm approximately. (A nanometre or nm is one millionth of a millimetre.) This limited span of wavelengths is therefore known as the *visible spectrum*.

When a relatively even mixture of all the visible wavelengths is produced by a light source the illumination looks 'white' and colourless. But if only some wavelengths are present the light appears coloured. For example, in Figure 2.3, wavelengths between about 400 nm and 450 nm are seen as dark purpley violet. This alters to blue if wavelengths are changed to 450–500 nm. Between 500 nm and 580 nm the light looks more blue-green, and from about 580 nm to 600 nm you see yellow. The yellow grows more orange if the light wavelengths become longer; at 650 nm it looks red, becoming darker as

Figure 2.3 Some of the electromagnetic spectrum (left), and the small part of it forming the visible spectrum of light (enlarged, right). Mixed in roughly the proportions shown in colour here, the light appears 'white'

Figure 2.4 Most sources of light produce a mixture of wavelengths, differing in colour and expressed here in greatly simplified form

the limit of response is reached at 700 nm. So the colours of the spectrum – violet, blue, green, yellow and red – are really all present in different kinds of white light (sunlight, flash or studio lamps for example).

The human eye seems to contain three kinds of light receptors, responding to broad overlapping bands of blue, green and red wavelengths. When all three receptors are stimulated equally by something you see, you tend to experience it as white, or neutral grey. If there is a great imbalance of wavelengths – perhaps the light contains far more red (long) waves than blue (short) waves – stimulus is uneven. Light in this case may look orange tinted, just as happens every day around sunrise or sunset.

Try to remember the sequence of colours of the visible spectrum. It's useful when you need to understand the response to colours of black and white films, or choose colour filters and darkroom safelights (see Chapter 12). Later you will see how the concept of three human visual receptors together responding to the full colour spectrum is adapted to make photographic colour films work too.

It seems odd that humans can biologically sense only a relatively tiny part of the vast electromagnetic spectrum. However, with most naturally occurring infra-red, ultra-violet, X-ray and gamma-ray wavelengths from space shielded from us by the Earth's atmosphere, we have evolved without need of detection devices (or defences) for these kinds of radiation. Beings on another planet, with a totally different environment, might well have evolved with organs capable of sensing, say, radio waves but completely 'blind' to visible light as we know it.

Shadows

Light travels in straight lines and in all directions from a light source. This means that if you have *direct* light from a comparatively 'compact' source such as the sun in a clear sky, a candle, bare light bulb or a small flash unit, this light is harsh. Objects throw contrasty, sharp-edged shadows. Figure 2.5 shows how having all the light issuing from one spot must give a sudden and complete shut-off of illumination at the

Figure 2.5 A compact, distant light source used direct makes objects cast a sharply defined shadow. A larger source – simply formed here by inserting a large sheet of tracing paper – gives a soft, graduated shadow. See also Figure 7.1

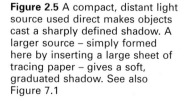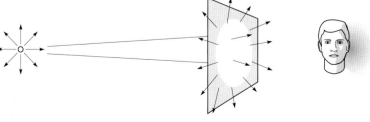

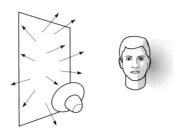

Figure 2.6 A lamp, sunlight or flashgun directed entirely onto a matt white surface such as a wall or large card will reflect to also give soft, diffused shadows

shadow edge. But look what happens when you place tracing paper in the light beam (or block the direct light and reflect the remainder off a matt white wall, Figure 2.6). Tracing paper passes light but also *diffuses* it. The light passed through the paper scatters into new straight lines proceeding in all directions from every part of its large area surface. The object you were illuminating now casts a softer-edged, graduated shadow, and the larger and closer your diffusing material the less harsh and contrasty the shadow becomes. This is because light from a large area cannot be completely blocked out by the subject; most of the parts previously in shadow now receive at least some illumination. The same would happen with sunlight on an overcast day.

It's very important in practical photography to recognize the difference between direct, harsh lighting and soft, diffused lighting. Shadow qualities greatly influence the way subjects and scenes look. Bear in mind this is not something you can alter in a photograph by some change of camera setting or later manipulation. Understanding and controlling lighting is discussed in detail in Chapter 7.

When light reaches a surface

When light strikes a surface – maybe a building, or a landscape or face – what happens next depends upon the texture, tone and colour of the material, and the angle and colour content of the light itself.

Materials opaque to light

If the material is completely opaque to light – metal or brick for example – some light is reflected and some absorbed (turned into heat). The darker the material the smaller the proportion of light reflected. This is why a dark camera case left out in the sun gets warmer than a shiny metal one.

If the material is also coloured it reflects wavelengths of this colour and absorbs most of the other wavelengths present in the light. For example blue paint reflects blue, and absorbs red and green from white light. But if your light is already lacking some wavelengths this will alter subject appearance. To take an extreme case, when lit by deep red illumination, a rich blue will look and photograph black, see Figure 2.7. You need to know about such effects in order to use colour filters (Chapter 9).

Surface finish also greatly affects the way light is reflected. A matt surface such as an eggshell, drawing paper or dry skin scatters the light evenly. The angle from which light strikes it makes very little difference. However, if the surface is smooth and reflective it acts more like a mirror, and reflects almost all the light back in one direction. This is called *specular reflection*.

If your light strikes the shiny surface at right angles it is reflected backward along its original path. You get a patch of glare, for example, when flash-on-camera shots are taken flat on towards a polished glass window or gloss-painted wall. But if the light is angled it reflects off such surfaces at the same angle from which it arrived, Figure 2.7. So try to arrange your lighting direction or camera viewpoint to bounce glare light away when photographing a highly reflective surface. (If you are using built-in flash angle your camera viewpoint.)

Figure 2.7 Light reflection. Top: Light reflected from a matt surface scatters relatively evenly. Centre: From a shiny surface light at 90º is returned direct. Oblique light directly reflects off at the same angle as it arrived (incident). Bottom: Coloured materials selectively reflect and absorb different wavelengths from white light. However, appearance changes when the viewing light is coloured

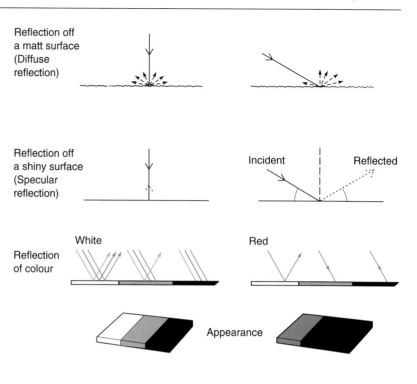

Materials transparent or translucent to light

Not every material is opaque to light, of course. Clear glass, plastic and water for example are *transparent* and transmit light directly, while tracing paper, cloud and ground glass diffuse the light they transmit and are called *translucent*. In both cases if the material is coloured it will pass more light of these wavelengths than other kinds. Deep red stained glass transmits red wavelengths but may be almost opaque to blue light, see Figure 2.8.

Since translucent materials scatter illumination they seem milky when held up to the light and look much more evenly illuminated than clearer materials, even when the light source is not lined up directly behind. Slide viewers work on this principle. The quality of the light is similar to that reflected from a white diffused surface.

Refraction

Interesting things happen when direct light passes obliquely from air into some other transparent material. As was said earlier, light travels slightly slower when passing through a denser medium. When light passes at an angle from air into glass, for example, its wavefront (remember the ripples on the water, Figure 2.2) becomes slowed unevenly. This is because one part reaches the denser material first and skews the light direction, like drawing a car at an angle into sand, Figure 2.9. A new straight-line path forms, slightly steeper into the glass (more perpendicular to its surface). The change of light path when light travels obliquely from one transparent medium into another is known as *refraction*.

Figure 2.8 Light transmission:
Top: Diffusely transmitting
materials (milky plastic, ground
glass) scatter light fairly evenly.
Centre: Clear materials pass most
of the light directly. Angled light
is part reflected, mostly refracted.
Bottom: Coloured materials pass
only selected wavelengths from
white light. When the viewing
light is a colour different to the
material, no light may get through

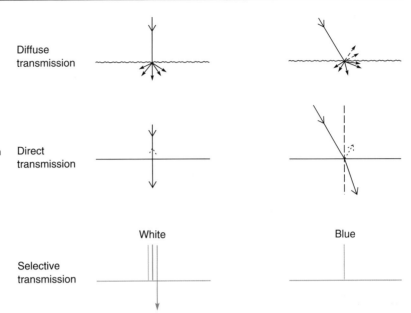

You can see refraction at work when you poke a straight stick into clear water; it looks bent at the water surface. Again, looking obliquely through a thick, half-closed window, parts of the view through the glass look offset relative to what can be seen direct. But most importantly because of refraction, lenses bend light and so form images, as we will come to shortly.

Remember that refraction only bends *oblique* light. Light which strikes the boundary of two transparent materials at right angles slows minutely but does not change direction. And most light reaching the boundary at a very low angle (very oblique) is reflected off the surface.

The whole picture

In practice then the range of objects around us appear the way they do because of the mixture of effects they have on light – diffuse and

Figure 2.9 Refraction. Light slows
when passing from air into glass.
Wavefronts slow unevenly if light
reaches the denser medium
obliquely (left). The effect is like
driving at an angle from the
highway onto sand (right).
Uneven drag causes change of
direction. Light striking the
boundary at right angles (centre)
slows but does not alter direction

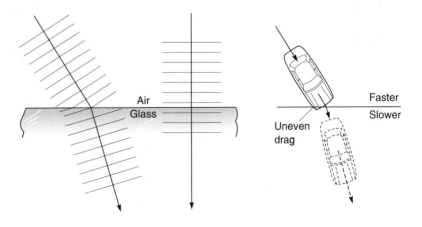

specular reflection, some absorption, often transmission and refraction too. An apple side-lit by direct sunlight for example reflects coloured wavelengths strongly from its illuminated half. Most of this is diffusely reflected, but part of its smooth skin reflects a bright specular highlight, just where the angle of the sun to the surface matches the angle from this point to your eye. The shape and relative darkness of the shadow to one side of the apple gives you further clues to its form. From experience your eyes and brain recognize all these subtle light 'signals' to signify solidity and roundness, without your actually having to touch the apple to find out. This is essentially what optical aspects of seeing and photographing objects are all about.

Light intensity and distance

The closer your light source is to your subject the brighter it will be illuminated. Figure 2.11 shows that because light travels in straight lines a surface receives *four times* as much illumination (four times as many photons) from a compact light source as it would if the same-size surface were twice as far away. For example, if you are using a small flashgun or studio lamp to light a portrait, halving its distance from the subject gives you four times the light, so exposure can be quartered. The same applies to printing exposures when you alter enlarger height (Chapter 13, and in close-up situations, page 191).

In practice this 'inverse square law' (twice the light source distance one quarter the illumination) means that you must be especially careful

Figure 2.10 Imagine you are looking at this scene direct. Light would be communicating information about its different parts to you in a mixture of ways. The water jets *transmit* and *refract* light, glittering parts of the lake surface *specularly reflect*, while the grey stone *diffusely reflects* light. What little light from the sky alone reaches shadowed areas beneath the fountain is mostly absorbed by blackened stone

when lighting a number of items at different distances in a small studio, using a harsh compact light source such as a spotlight. It may then be impossible to correctly expose items nearest and farthest from the light at any one exposure setting. A solution is to move the light source much further away, so the ratio of nearest to farthest distance becomes less (page 113), or change to a larger, diffused light source which will give you much less illumination 'fall-off' effect.

The same problem does not arise with direct sunlight outdoors. The sun is so vastly far away that any two places on earth – be they seashore or mountain peak – are almost equal in distance from the sun. Brightness variations in landscape photography may be created by local atmospheric conditions but not by the sun's distance. If you are photographing indoors, however, using the sun's light entering through a small window, the window itself acts like a compact light source. Intensity will then alter with distance in the same way as if you had a lamp this size in the same position.

Making light form images

Suppose you set up and illuminate a subject, and just face a piece of tracing paper (or film) towards it. You will not of course see any image on the sheet. The trouble is that every part of your subject is reflecting some light towards every part of the paper surface. This jumble of light simply illuminates it generally.

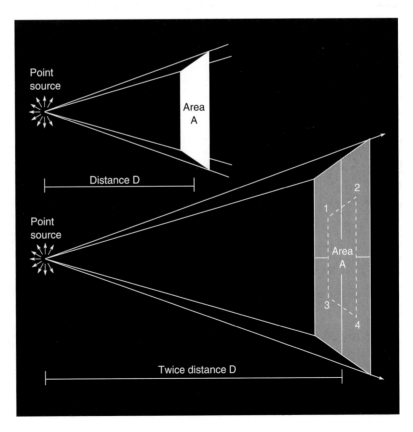

Figure 2.11 Direct light from a compact source (such as a small flash unit or studio lamp) illuminates your subject at quarter intensity when you double the lamp-to-subject distance. The same light spreads over four times the area. Known as 'inverse square law'

One way to create order out of chaos is by restricting the light, adding between subject and paper a sheet of opaque material such as kitchen foil containing a pinhole. Since light travels in straight lines, those light rays from the top of the subject able to pass through the hole can only reach the *bottom* part of the paper. And light from lower parts of the subject only reaches the *top* of the paper (Figure 2.12). As a result your paper sheet shows a dim, rather fuzzy *upside-down* representation of the subject on the other side of the pinhole.

The best way to see a pinhole image is to be in a totally darkened room, with foil or black paper over the window facing a sunlit scene outside. Make a drawing-pin size hole in the foil and hold up tracing paper about 30 cm (12 in) in front of it to receive the image.

You can easily take colour photographs using a pinhole if your camera has a removable lens. See Project 1 at the end of the chapter. So the business of actually forming an image is not particularly complicated or technical.

Practical limitations to pinhole images

The trouble with a pinhole-formed image is that results are not good enough for most photography (see Figure 2.13). None of the image detail is ever quite sharp and clear, no matter where you position the

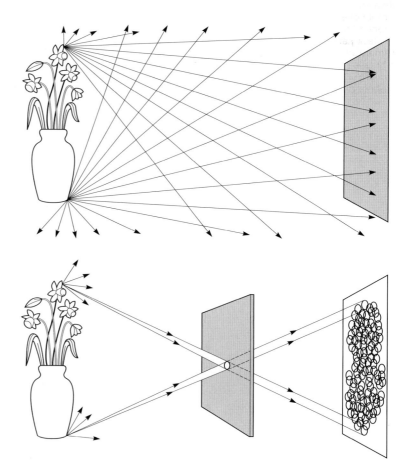

Figure 2.12 Top: A sheet of paper just held up towards an illuminated subject receives a jumble of uncontrolled light rays, reflected from all its parts. Bottom: A pinhole in an opaque screen restricts rays from each part of the subject to a different area of the paper; a crude upside-down image is formed

Figure 2.13 Pinhole versus lens.
Pictures taken using a 35 mm SLR
camera body fitted with (left)
kitchen foil having a 0.25 mm
diameter pinhole; (centre) a
simple plastic magnifying glass
'stopped down' to f/8 with a hole
in black paper; and (right) the
camera's standard 50 mm lens at
f/11 (see Figure 3.6). Based on the
camera's TTL light readings, the
pinhole needed 20 seconds, the
magnifier 1/60 s and the lens
1/30 s exposure. When focused for
the centre, the magnifier gives the
poorest definition of all near
picture edges. The pinhole gives
slightly unsharp detail
everywhere

tracing paper. This is because the narrow 'bundle' of light rays reflected
from any one part of the subject through the pinhole forms a beam that
is *diverging* (gradually getting wider). As Figure 2.12 showed, the best
representation you can get of any one highlight or point of detail in the
subject is a patch or *disc* of light. What should be details become many
overlapping discs of light which give the image its fuzzy appearance.

Then again a pinhole-formed image is so *dim*. You can brighten it by
enlarging the hole, but this makes image detail even less sharp and
clear. (And if you make *two* holes you get two overlapping images,
because light from any one part of the subject can then reach the paper
in two places.)

Even if you accept a dimmer image and try to sharpen detail by using
a still smaller hole, those discs of light can obviously never be smaller
than the hole itself. And you quickly get to a point where further
reduction actually makes results worse because of an optical effect
known as *diffraction*, page 326. The smaller and rougher the hole the
greater the percentage of light rays displaced by this effect, relative to
others passing cleanly through the centre.

Using a lens instead

The best way to form a better image is to make the hole bigger rather
than smaller, then *bend* the broad beam of light you produce so that it
narrows (*converges*) instead of continuing to expand. This is done by
using refraction through a piece of clear glass. Figure 2.9 showed how
light passing obliquely from air into glass bends at the point of entry to
become slightly more perpendicular to the surface. The opposite
happens when light travels from glass into air, as air is less dense. So
if you use a block of glass with sides which are non-parallel (Figure
2.14) the total effect of passing light through it is an overall change in
direction.

In practice, a shaped piece of glass that is thicker in the centre than
at its edges will accept quite a wide beam of diverging light and convert
it into a converging beam. Mechanically it is easiest to create this

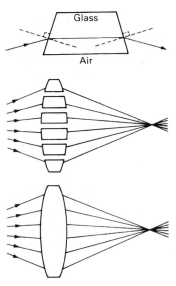

Figure 2.14 Lens evolution. Top: Using a non-parallel sided glass block, refraction at each air/glass surface (compare with centre of Figure 2.8) causes an overall change of direction. Think of a lens shape as a series of blocks which bend many light rays to a common point of focus

Figure 2.15 A converging lens bends diverging beams of light to a point of focus. However, if the lens-to-screen distance is incorrect, either too near or too far as shown right, images again consist of fuzzy 'circles of confusion'. (This is why out-of-focus highlights become discs – Figure 2.16)

required shape by grinding and polishing a circular disc of glass. So you have a circular glass *converging* lens.

When you make images using a lens instead of just a hole the upside-down picture on your tracing-paper screen appears much brighter, but details are only sharply resolved when the paper is at one 'best' distance from the lens. If you position it too close or too far away, the light rapidly broadens out (Figure 2.15) and points of detail turn into discs even larger than given by a pinhole. The result is a very unclear 'out-of-focus' effect. So a lens has to be focused precisely; the correct image position will depend on the light-bending power of the lens, and the distance between lens and subject.

Focal length and image size

The light-bending power of a lens is shown by its *focal length*. As shown in Figure 2.17, the focal length of a simple lens is the distance between the lens and a sharply focused image of an object at infinity. (In practice this means something on the horizon.) Focal length takes into account the type of glass (its *refractive index*) and its shape.

A lens with a long focal length has relatively weak bending power – it needs a long distance to bend light rays to a point of focus. The *stronger* the power of the lens, the *shorter* its focal length. The picture detail is also smaller in size than the same subject imaged by a longer focal length lens.

Imaging closer subjects

The lens-to-image distance you need for sharp focus changes when your subject is nearer than infinity. The rule is: the closer your subject, the greater distance required between lens and image, see Figure 2.19. This is why you often see camera lenses move *forwards* when set for close distances, and for really close work you may have to fit an extension tube between body and lens (see page 90). Clearly there are problems when the scene you are photographing has a mixture of both distant and close detail, all of which you want in focus.

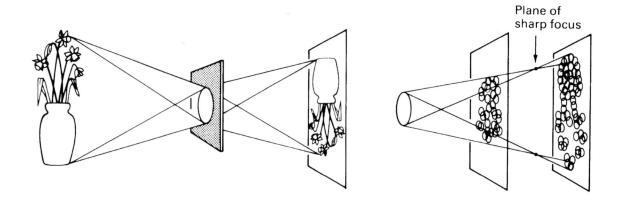

Plane of sharp focus

Figure 2.16 This image was made with a wide-diameter lens focused for one droplet on the barbed wire. Droplets closer (left) and further away (right) become unsharp patches of light at this focus setting. Notice how each patch takes on the shape of the lens diaphragm

Figure 2.17 Focal length. In the case of a simple lens, focal length is the distance between the lens and the position of a sharp image of an object at infinity

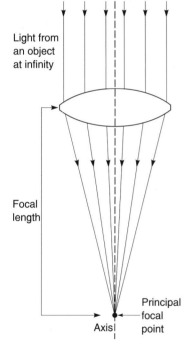

Light from an object at infinity

Focal length

Axis

Principal focal point

Conjugate distances. Figure 2.20 shows the basic relationship between subject distances and image distances, in terms of lens focal length. These are known as linked or 'conjugate' distances. For example, light from a subject located somewhere between infinity and two focal lengths from your converging lens will come into focus somewhere in a zone between one and two focal lengths on the imaging side of the lens. It's the kind of situation you meet in most general photography. Where the subject is precisely two focal lengths distant the sharp image is formed two focal lengths behind the lens, as well as being exactly the *same size* as the subject. Magnification (height of subject divided into the height of its image) is then said to be 1. This is a typical situation for close-up and 'actual size' photography.

When your subject is closer than two focal lengths, the image is formed beyond two focal lengths behind the lens, and magnification is more than 1. In other words, the image shows the subject enlarged. This is the situation when a lens is used for projecting slides or making enlargements.

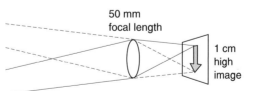

50 mm focal length

1 cm high image

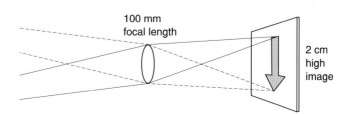

100 mm focal length

2 cm high image

Figure 2.18 Focal length and image size. The longer the focal length the larger the image. This is why cameras taking large format pictures need longer focal length lenses to include the same amount of your subject

Figure 2.19 The closer the subject to a lens, the greater the distance it needs to bring the light into sharp focus. Light rays from a distant subject point are more parallel, so the same lens bending power brings them to focus nearer to the lens

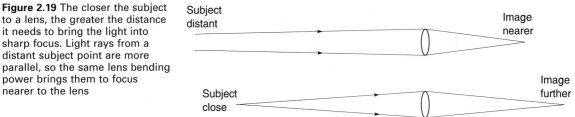

The nearer your subject comes to being one focal length from the lens, the bigger and further away its sharp image becomes. When it is exactly one focal length away no image forms at all; light passes out of the lens as parallel rays. (This is the reverse of imaging a subject located at infinity, Figure 2.17.)

Check out all these imaging zones for yourself, using a converging-lens reading glass and piece of tracing paper. It is always helpful to know (at least roughly) where and what size to expect a sharp image, especially when you are shooting close-ups, or printing unusual size enlargements. Ways of calculating detailed sizes and distances are shown on page 305.

Summary. Light: how images form

- Light travels in straight lines, as if in wave motion. Wavelengths are measured in nanometers. Light forms a tiny part of a much wider range of electromagnetic radiation. It transmits energy in the form of 'photons'.

- Your eyes recognize wavelengths between 400 nm and 700 nm as progressively violet, blue, green, yellow, red – the visible spectrum. All colours if present together are seen as 'white' light.

Figure 2.20 Conjugate distances. The positions where subjects at different distances from a lens are sharply imaged

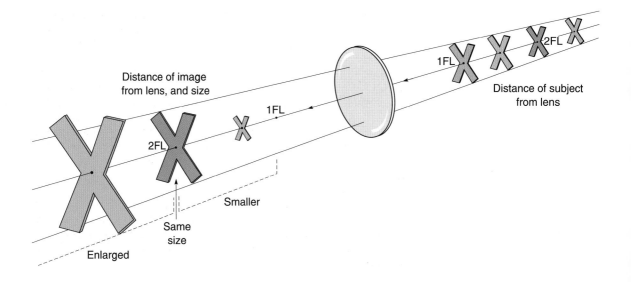

- Subjects illuminated by a relatively compact direct light source cast harsh, hard-edged shadows. Light from a large-area source (including hard light *diffused*) gives softer, graduated shadows.
- Light striking an opaque material is absorbed and/or reflected.
- Smooth, shiny surfaces give you specular reflection – direct light is mostly reflected all one way. Oblique illumination bounces off such a surface at an angle matching the light received. Matt surfaces scatter reflected light and are much less directional.
- Transparent materials directly transmit light; translucent materials diffuse light. Light passing obliquely from one transparent material to another of different density is refracted (bent) more perpendicular to the surface in the denser medium.
- Coloured materials absorb and reflect or transmit light *selectively* according to wavelength. Appearance varies with the colour of the light source illuminating them.
- The amount of illumination (photons) received by a surface area from a direct, compact light source is quartered each time its distance from the light source is doubled.
- Because light travels in straight lines a pinhole in an opaque material forms a crude upside-down image of an illuminated subject.
- A converging lens gives you a brighter, sharper image than a pinhole, by bending a wide beam of diverging light from your subject so that it converges to a point of focus. The position of sharp focus depends on the refracting power of the lens, and subject distance.
- Lens power is shown by focal length, in simple optics the distance between the lens and a sharp image of an object at infinity. The longer the focal length the larger the image.
- Close subjects come to focus farther from the lens than distant subjects. A subject two focal lengths in front of the lens is imaged same-size two focal lengths behind the lens. Magnification is image height divided by subject height.

Projects

1 Take pinhole colour slides. Remove the lens from a single-lens-reflex 35 mm camera and tape kitchen foil in its place (it is easiest to tape it across an extension ring which you then simply attach or detach from the body). Pierce the foil with a needle to give a hole about 0.3 mm diameter, free of bent or ragged edges. You should just be able to make out the image of a bright scene through your camera viewfinder. Set your internal exposure meter to manual mode. If the image is too dim to get readings, set the camera's ISO scale to its highest rating or the exposure-compensation dial to the most extreme minus setting. Then multiply the exposure time shown either by the set ISO divided by the actual ISO, or the equivalent effect of the compensation setting.
2 Take pictures using a magnifying (reading) glass in place of your regular SLR camera lens. Fit a collar of black paper around the rim of the glass to prevent direct light entering the camera. Try some shots adding black paper with a hole in it over the lens to reduce its diameter by half. Compare the results, and also against results of Project 1.

3 Practise forming images on tracing paper with a magnifying glass, or the lens detached from your camera. Work in a darkened room and use a lit hand torch as your subject. Check out image size as well as position when the subject is in the various distance zones shown in Figure 2.20.

3

Lenses: controlling the image

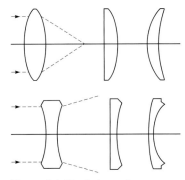

Figure 3.1 Single lens elements can be made in a great range of shapes and glass types. The top row here converge light. The bottom row, which are all thinnest in the centre, cause light to diverge. Diverging lens elements are combined with (stronger) converging elements in photographic lenses to help counteract optical defects

Figure 3.2 One type of 50 mm lens made as the normal focal length lens for a 35 mm camera. It combines seven lens elements, five converging and two diverging light

The next step in understanding lenses is to see how the controls on your camera's lens allow you to alter the image. This introduces focusing scales and lens aperture (including *f*-numbers). The aperture adjusts image brightness and the range of subject distances you can focus sharply at one setting. It is very important in image-making to know when and how to create total sharpness, or to localize image detail. Some differences between cameras of different format (picture size) start to appear here too.

Photographic lenses

A simple glass lens gives you a much better image than a pinhole. However, its quality is still a long way short of the standard needed for photography. When you look closely at Figure 2.13, image sharpness is poor and not maintained equally over the whole picture, even when the subject is all at one distance. Simple single lenses often distort shapes, create odd colour fringes or give a general 'misty' appearance. Occasionally such results work well as interpretative romantic images, but it is better to have a lens capable of producing utmost image clarity and detail. Then you can add a diffuser to the camera or later manipulate results digitally (Chapter 14) when you want pictures of the other kind.

The main object of *photographic* lens design and manufacture is to produce lenses which minimize optical defects (known as 'aberrations') while increasing resolution of detail and image brightness. To achieve this a range of special optical glasses is used, each type having different refraction and dispersion properties. So a photographic lens has a 'compound' construction, containing a series of elements of different shapes and made from different glass types to help neutralize aberrations. In fact, a camera lens of normal focal length typically has 5–8 elements (Figure 3.2). Their centring and spacing within the metal lens barrel is critical, and can be upset if the lens is dropped or roughly knocked. But even the number of elements causes problems, as the tiny percentage of light reflected off every glass surface at the point of refraction multiplies as scattered light. If uncorrected, the result would

Figure 3.3 Engraving around lenses here shows (top) name of lens; maximum aperture f/5.6 and focal length 180 mm and (bottom) name, f/1.7 maximum aperture, 50 mm focal length

Figure 3.4 Angle of view. All four lenses here give a similar angle of view. They each differ in focal length but are used on different format cameras, maintaining a close ratio of focal length to picture format diagonal. Each combination will therefore include about the same amount of your subject in the picture. See also Figure 2.18

be images that lack contrast and sparkle – like looking through a window with multiple double-glazing. Modern lenses therefore have their elements surface-coated with one or more extremely thin layers of a transparent material which practically eliminates internal reflections under most conditions. However, light may still flare if you shoot towards a bright light source just outside the picture area and fail to use a lenshood, see page 92.

Your camera or enlarging lens is therefore a relatively thick barrel of lens elements, all of them refracting light but together having an overall *converging* effect. Every photographic lens has its focal length (usually in millimetres) clearly engraved around the lens barrel or front-element retaining ring.

Focal length and angle of view

The focal length photographers and manufacturers regard as 'normal' for a camera is approximately equal to the diagonal of the camera's picture format. In other words:

For a 6 × 7in rollfilm camera, a lens of about 80–105 mm would be considered normal.

For a 35 mm (24 × 36 mm) camera, between 35 mm and 50 mm focal length is normal.

For APS (17 × 30) picture size cameras, the normal lens is 25 mm.

And for a digital camera with a tiny 4.8 × 6.4 mm sensor, the lens would only be 6–10 mm focal length.

As Figure 2.18 showed, the shorter the focal length the smaller the *image* the lens produces. But a lens of short focal length used with a small-format camera gives the same *angle of view* as a lens of longer focal length used in a bigger camera. You are just scaling everything up or down. All your combinations above therefore give an angle of view of about 45°, and so each camera set up to photograph the same

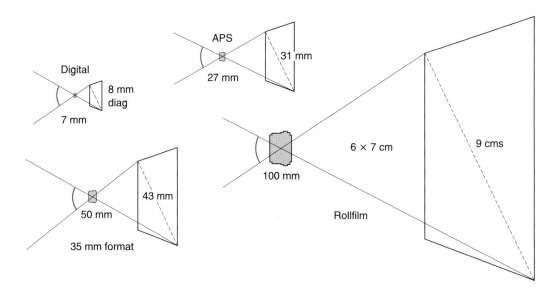

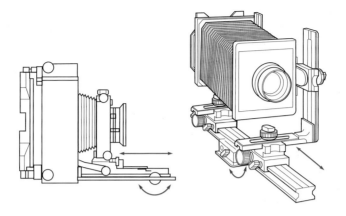

Figure 3.5 Lens focusing movement. Top left: Typical focusing ring on a manually focusing 35 mm single-lens reflex camera. Bottom left: Focusing ring on an autofocus SLR, rotated by hand when switched to Manual. Right: Two kinds of larger format sheet film cameras. Having longer focal length lenses which need greater physical focusing movement a focusing knob on the camera body shifts the whole lens-carrying front panel

(distant) subject will include about the same amount of the scene, see Figure 3.4. The use of lenses giving a wider or narrower angle of view is discussed on page 79.

Focusing movement

Cheap simple cameras have lenses which are so-called 'focus-free'. In practice this means the lens is fixed in position to sharply image subjects about 2.5 m from the camera. The assumption is that this is a typical situation for snapshots, and items slightly nearer or further away will appear reasonably sharp due to depth of field, page 44.

Most lens units include some means of adjusting its position forwards or backwards for focusing subjects closer or more distant respectively. Typically the whole lens shifts smoothly by a centimetre or so within a sleeve (or internal elements alter position). Focus is manually adjusted by rotating the lens barrel, or via a motor under the control of a sensor which detects when the image is sharp. See *autofocusing*, page 67. Often point-and-shoot autofocus compact cameras show no distance settings on the lens. Lenses on cameras offering greater control (all single-lens reflexes for example) show a scale of subject distance which moves against a setting mark, see Figure 3.5.

All lenses can be set to focus for infinity (∞ symbol). The closest subject distance offered depends on a number of factors. For example, the lens may not maintain the same high image optical resolution at close distances (see macro lenses, page 90) and mechanically it may be difficult to shift the lens further forward. The longer the focal length the greater the physical movement needed for adjusting focus settings. Again, close-up focusing may be purposely prevented because the lens is part of a camera with separate direct viewfinder, page 54. This grows increasingly inaccurate in framing up your picture the closer you work.

Normal lenses for large-format sheet film cameras need more focusing movement to cover a similar range of subject distances, owing to their longer focal length. The whole front unit of the camera moves independently of the back, the two being joined together by bellows. There is seldom any scale of distances on lens or camera body; you focus by checking the actual image on a ground glass screen at the back of the camera, see page 63.

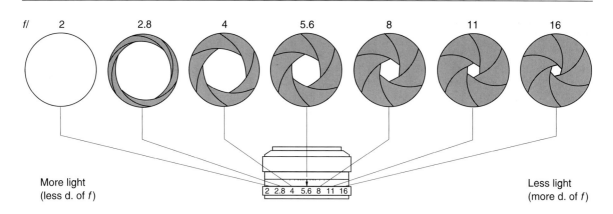

More light
(less d. of f)

Less light
(more d. of f)

Figure 3.6 Typical f-number sequence (some lenses may open up beyond f/2, and stop down beyond f/16)

Aperture and *f*-numbers

Inside most photographic lenses you will see a circular hole or aperture located about midway between front and back elements. Usually a series of overlapping black metal blades called an iris diaphragm allows the size of this aperture to be narrowed continuously from full lens diameter to just the centre part of the lens. It is adjusted with a setting ring or lever outside the lens barrel. Most smaller-format cameras control the aperture size automatically, at the moment of exposure. (On single-lens reflex cameras you may not see the aperture actually alter when you turn the ring, unless you first detach the lens from the camera; see page 58.)

A series of relative aperture settings can be felt by 'click' and are shown on a scale of figures known as *f-numbers*. Notice that the *smaller* the relative aperture the *higher* the *f*-number. They typically run:

$$f/2; \quad 2.8; \quad 4; \quad 5.6; \quad 8; \quad 11; \quad 16; \quad etc.$$

The *f*-numbers follow what is an internationally agreed sequence relating to the brightness of the image. It is like operating a 'light tap'; each change to the next highest number halves the amount of light passing through your lens. And because the aperture is positioned in the lens centre it dims or brightens the entire image evenly.

The *f*-number system means that every lens set to the same number and focused on the same (distant) subject gives matching image brightness, irrespective of its focal length or the camera size. You can change lenses or cameras, but as long as you set the same *f*-number the image brightness remains constant.

Figure 3.7 The basis of f-numbers. Each time the diameter (D) of a circle is doubled its area (A) increases four times

How f-numbers work

The actual *f*-numbers themselves denote the number of times the effective diameter of the aperture divides into the lens focal length. So *f*/2 means setting an aperture diameter one-half the focal length; *f*/4 is one-quarter, and so on. The system works because each *f*-number takes into account two main factors which control how bright an image is formed:

1 *Distance between lens and image*. As you saw in Figure 2.11, doubling the distance of a surface from a light-source quarters the light it receives. And since distant subjects are focused one focal

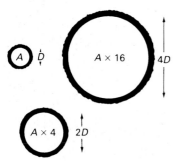

Figure 3.8 Image brightness. These lenses differ in focal length and therefore give different-size images of the same distant subject. But by having diaphragm diameter effectively one-eighth of focal length in each case, the images match in brightness. Both are working at *f*/8

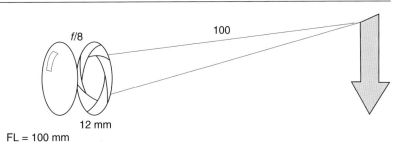

FL = 100 mm

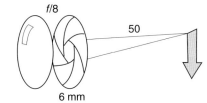

FL = 50 mm

length from the lens, a lens of (say) 100 mm focal length basically forms an image only one-quarter as bright as a lens of 50 mm.

2 *Diameter of the light beam.* Doubling the diameter of a circle increases its area four times, Figure 3.7. So if the diaphragm of the first lens passes a beam of light 12 mm wide and the second only 6 mm wide, the first image is four times as bright as the second.

Now if you express (2) as a fraction of (1), you find that both lenses are working at near-enough relative apertures of *f*/8 (100 ÷ 12, and 50 ÷ 6), which is correct since their images match in brightness. So:

f-number = lens focal length ÷ effective aperture diameter

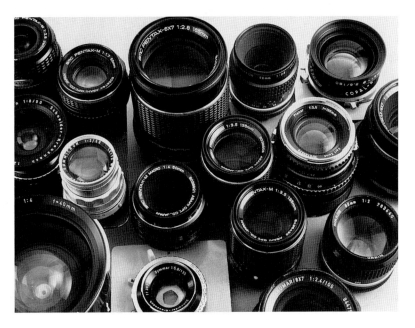

Figure 3.9 This collection of lenses – for large, medium and small format cameras – shows the variety of ways in which information on aperture, focal length, maker, and reference number appear

In practice the *f*-number relationship to brightness breaks down when working very close up, because the lens-to-image distance will then differ greatly from one focal length, see page 89.

The *f*-number settings are also occasionally referred to as 'stops'. In early photography, long before iris diaphragms, each stop was a thin piece of metal punched with a hole the required size which you slipped into a slot in the lens barrel. Hence photographers speak of 'stopping down' (changing to a smaller opening, higher *f*-number). The opposite action is 'opening up'.

You will find in practice that upper and lower limits of the *f*-number scale vary with different lenses. Most small-format camera lenses stop down to *f*/16 or *f*/22. Larger, sheet-film camera lenses are designed to continue down to *f*/32 or *f*/45. Smaller apertures are useful for extra depth of field, see below, but if taken to extremes diffraction (page 326) starts to destroy image detail. This is why no lens will stop down literally to pinhole size.

At the other end of the *f*-number scale, limits are set by price and the current state of technology. The wider the maximum relative aperture setting the more difficult it is for the manufacturer to suppress aberrations. The lens must also be bigger, and costs more. But then a wide-aperture lens passes more light (it is 'fast') and this is handy in dim conditions – for photo-journalism for example. Apertures of *f*/1.4 are quite common on standard non-zoom lenses for small-format cameras. Often a lens design may produce acceptable image quality up to a relative aperture wider than, say, *f*/2 but not as wide as the next *f*-number, *f*/1.4. A maximum setting of *f*/1.8 or some other irregular *f*-number will then appear as the limiting factor on its scale. Most large-format camera lenses only open to about *f*/4 at the most. In fact, the 'best' aperture with most lenses is around *f*/8, being a compromise between the opposite influences of lens aberrations and diffraction.

The *f*-number of your lens' maximum aperture, together with its focal length, name and individual reference number, are engraved on the lens rim. You may find that, of two lenses identical in make and focal length, one is almost twice the cost of the other because it has a maximum aperture one stop wider. This can be a high price to pay for the ability to shoot in poorer light or use faster shutter speeds, particularly when you can buy excellent ultra-fast film.

Depth of field

Your lens aperture is an important control for dimming or brightening images – helping to compensate for bright or dim subject conditions (see Exposure measurement, Chapter 10). But it has an even more important effect on visual results whenever you photograph scenes containing a number of items at various distances from the lens. Imagine for example that the shot consists of a head-and-shoulders portrait with a street background behind and some railings in front. If you focus the lens to give a sharp image of the face and take a photograph at widest aperture, both the street and railings will appear unsharp. But if you stop down to, say, *f*/16 (giving more exposure time to compensate for the dimmer image) you are likely to

Figure 3.10 Why aperture diameter alters depth of field. Right: When you focus a lens for a close subject it images each detail of a more distant item as an unsharp disc of light. Left: Stopping down to a smaller lens aperture narrows all cones of light. Although still not in critical focus other items begin to look sharp too

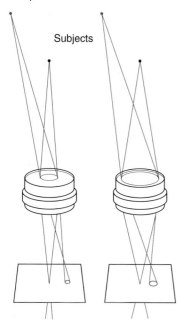

Subjects

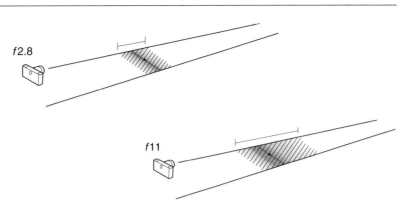

Figure 3.11 The practical effect of changing depth of field. The focus setting of the lens remained the same for both shots. (A slower shutter speed was needed for the right hand version to maintain correct exposure)

find that everything appears in focus from foreground through to background. This changing 'zone' of sharp focus, nearer and further than the object distance on which you actually focused, is known as *depth of field*.

Depth of field is the distance between the nearest and furthest parts of a subject that can be imaged with acceptably sharp detail at one focus setting of the lens.

Widest aperture (smallest *f*-number) gives least depth of field, while smallest aperture (highest *f*-number) gives most. There are two other significant effects: (1) depth of field becomes less when you are shooting close-ups and greater when all your subject matter is further away; (2) the longer the focal length of your lens the less depth of field it gives, even with the same aperture and subject distance (Figures 3.13 and 5.2).

Practical significance

It is very important to be able to control depth of field and make it work *for* your pictures, not *against* them. By choosing shallow depth of field you can isolate one item from others at different distances. You can create emphasis, and 'suggest' surroundings without also showing them in such detail that they clutter and confuse. Such pictures are said to be 'differentially focused', Figure 3.12. But remember that minimizing depth of field with a wide aperture also means you must be really accurate with your focusing – there is much less latitude for error. You may also have exposure problems if you choose to shoot at wide aperture in bright lighting, or with fast film, or want to create blur effects by means of a slow shutter speed.

On the other hand, by choosing greatest possible depth of field your picture will contain maximum information. It can be argued that this is more like seeing the actual subject, because the *viewer* can decide what to concentrate on, rather than being dictated to by you. For most commercial and record photography, people expect photographs to show detail throughout. Just be careful that you notice (and avoid) any unwanted clutter in the foreground or background. Where possible, check the actual focused picture with the diaphragm aperture at the same diameter to be used for photography.

Sometimes you cannot produce sufficient depth of field by stopping down (perhaps lighting conditions are so dim or film so

Figure 3.12 Shallow depth of field. Using a wide aperture (*f*/2) limits detail, concentrates interest on an element at one chosen distance – the pollen-covered flower tip

slow that an unacceptably long exposure is needed). In such cases take any step which makes the image *smaller*. Either move back, or use a shorter focal length lens or smaller-format camera. Later you will have to enlarge the image in printing, but you still gain on depth of field. See top left picture, Figure 5.2.

How depth of field works

Figure 3.13 Depth of field at different apertures when a 50 mm lens is focused for 7 metres (left) and for 1.5 metres (right). The symbol ∞ denotes infinity. Depth of field is greatly reduced with close subjects

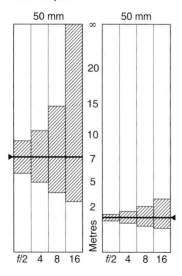

To understand why depth of field changes you need to remember how a lens critically focuses an image point at one distance only, depending on how far the lens is from the subject. In this position light from other parts of the subject nearer or farther from the lens comes to focus farther away or nearer, forming discs instead of points of light. They are known as *circles of confusion*. Large circles of confusion, overlapping (Figure 2.15) give the image an extremely unsharp appearance.

Since your eyes have limited resolving power, when viewing a final print or slide you rate an image acceptably sharp even when tiny discs are present instead of dots. The upper limit to what most people accept as sharp is taken to be 0.25 mm diameter on the final print. (The same applies to the dot pitch on a computer screen.) Lens manufacturers for 35 mm format cameras assume that if 25 × 20 cm (10 × 8 in) enlargements are made (film image magnified × 8) to this standard then the largest acceptable circle of confusion *on film* is 0.25 ÷ 8 = 0.03 mm.

By accepting discs up to this size as sharp, subjects slightly nearer and farther away than the subject actually in focus start to look in focus too. And if the lens aperture is made smaller all the cones of light become narrower, so that images of subjects even nearer and farther are brought into the zone of acceptable sharp focus. Depth of field has increased.

Again if you move farther back from the subject or change to a shorter focal length lens, the positions of sharp focus for images of

Figure 3.14 Maximum depth of field. This scene has important elements at several different distances and was shot at *f*/16 to produce sharp detail throughout

Figure 3.15 Depth of field when standard focal length lenses for different formats are used at an identical aperture (*f*/4 here). All were focused for 7 metres. Larger format cameras produce less depth of field because they use longer focal length lenses

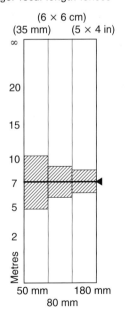

nearest and farthest subject parts bunch closer together. Their circles of confusion become smaller, again improving depth of field.

So remember that you produce greatest depth of field when:

- *f*-number is high (the lens is stopped down);
- subject is distant;
- focal length is short;
- you can accept relatively large circles of confusion (big enlargements won't be needed).

With subjects beyond about ten focal lengths from the lens, depth of field extends farther behind the subject than towards the lens. Hence the photographer's maxim 'focus one-third in', meaning focus on part of the scene one-third inside the depth of field required. With close-up work, however, depth of field extends more equally before and behind the focused subject distance.

Using depth of field scales on lenses

You may find that your camera lens carries a depth of field scale, next to its scale of subject distances (Figure 3.16). The scale gives you a rough guide to the limits of depth of field and is useful if you are 'zone focusing' – presetting distance when there is no time to judge focus and depth of field visually. Scales also show how you can gain bonus depth of field in shooting distant scenes. For example, if it is focused on infinity (losing half your depth of field 'over the horizon'), read off the nearest subject distance sharp. This is called the 'hyperfocal distance' for the *f*-number you are using. Change your focus to this setting and depth of field will extend from half the distance through to the horizon; see Figure 3.17.

Depth of field is also exploited in some cheap cameras with simple symbols for setting lens focus. Typically a silhouette of mountains sets the lens to its hyperfocal distance; a 'group of people' symbol means 3.5 metres; while a 'single head' is 2 metres. Provided the lens has a

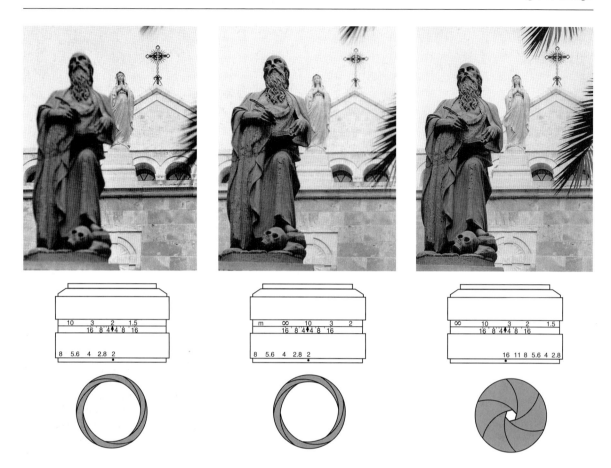

Figure 3.16 Using zone focusing. The lens above has a depth of field scale located between focusing and *f*-number scales. To zone focus, first visually focus the nearest object you want sharp (left) noting the marked distance. Then do the same for the most distant part (centre). Using the depth of field scale, set the lens for a distance which places both near and far parts within the zone of sharp focus at a small aperture. Here *f*/16 is needed (far right). Remember to set a slower shutter speed to maintain the same exposure

Figure 3.17 Using hyperfocal distance. For maximum depth of field with distant scenes, first set the lens to infinity. Note the nearest distance still within depth of field for the *f*-number you are using, here 10 metres (left). Then refocus the lens for this 'hyperfocal' distance (right). Depth of field will extend from half this distance to infinity

small working aperture, these zones overlap in depth of field. So users stand a good chance of getting in-focus pictures as long as they make the correct choice of symbol.

Remember that depth of field limits don't occur as abruptly as the figures suggest – sharpness deteriorates gradually. Much depends too on what *you* regard as a permissible 'circle of confusion'. If you intend to make big enlargements, your standard of sharpness on film must be higher, and this automatically means less depth of field. Even if your camera allows you to observe depth of field effects on a focusing screen

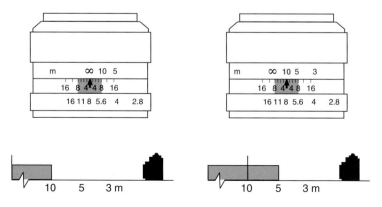

Figure 3.18 Depth of focus. Unlike depth of field this is concerned with focus accuracy between lens and image, e.g. in the camera or enlarger. The smaller the lens aperture and larger the maximun permissible circle of confusion (C), the greater the depth of focus. (Think of this focusing latitude as the distance you could freely move a ring along two cones positioned apex to apex)

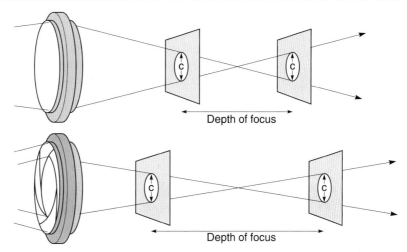

Depth of focus

Depth of focus

(page 54) you should work well within the limits of what *looks* sharp, or you may be disappointed with the final print.

When using a camera giving a large-format image you can anticipate less enlargement than, say, with a 35 mm camera. But although this makes a larger circle of confusion permissible, the long focal length lens needed by the large camera to include the same angle of view has a much stronger and opposite influence. In practice the smaller your camera the greater your depth of field. However you also have to bear in mind the effect of the grain pattern of the chemically recorded image when a smaller film is enlarged. The same applies to the number of pixels used by a digital camera. Since final sharpness in your photograph is influenced by these factors as well as depth of field, the small camera is deprived of some of its advantages. You will find more on camera comparisons in Chapter 4.

Depth of focus

Depth of focus often gets confused with depth of field. But whereas depth of field is concerned with making light from different subject distances all come to focus at one lens setting, depth of focus refers to how much you can change the lens-to-image distance without the focused image of any one subject growing noticeably unsharp. It is therefore concerned with tolerance in the lens-to-sensitive material distance in your camera or enlarger, and accuracy in focusing.

As Figure 3.18 shows, the two 'depths' have certain features in common. Depth of focus increases with small aperture and large permissible circle of confusion. However, depth of focus becomes greater the *closer* your subject and the *longer* the focal length of the lens. (Both changes cause light to come to focus further from the lens, making the cones of light narrow.)

These reversed features mean that in practice:

● A small-format camera needs its lens more precisely positioned relative to the film than a large camera. This is due to its shorter focal length normal lens, as well as smaller acceptable maximum circle of confusion. A large-format camera does not therefore need

engineering with quite the same precision as a 35 mm camera, and its greater depth of focus also allows more use of 'camera movements'; see Appendix B.

● When you visually focus the image given by a camera or enlarging lens, always have the lens at widest aperture. This minimizes depth of focus, making it easier to see the true position of accurate focus. The picture is brighter too.

● Using your camera to photograph very close subjects (photo-macrography) it is easiest to alter lens focus to get the image roughly correct size – then *move the whole camera* backwards or forwards to get the picture pin-sharp. You will be focusing by exploiting the shallow depth of field under these conditions, rather than struggling with deep depth of focus which could keep you finely adjusting lens focusing for a long time.

Lens care

Your lens is the most important part of the camera or enlarger. It is important to prevent damage to its glass surfaces. On a camera you can help to do this with some form of lens cap, or a clear glass UV filter (page 172). Avoid carrying a camera over your shoulder or in a bag containing other loose items without some lens protection. A small speck on the glass is relatively unimportant – it just minutely reduces illumination, but a greasy finger mark, scratches, or a layer of dust will scatter and diffuse light, so your images have less contrast and detail.

Loose dust and debris is best puffed away with a blower brush or gently guided to the rim of the lens. Grease or marks left by spots of rain may have to be removed with a soft tissue moistened in lens cleaning fluid. A scratched lens will probably have to be sent for repolishing.

Don't become too obsessive about polishing lenses. You will do far more harm than good if you start to mark permanently the surface of the glass or top coating. Prevention is much better than cure.

Summary. Lenses: controlling the image

● Photographic lenses are assembled from multi-elements to help correct optical aberrations produced by single-elements. Glass surfaces are coated throughout to minimize reflections. Smallest and largest aperture settings are also restricted to help reduce aberration effects.

● A typical 'normal' focal length lens for a camera has its focal length approximately the same as the diagonal of the picture format. It must also be designed to give an image of satisfactory quality over the whole of this area. The smaller the camera the shorter the focal length lens it uses.

● The longer the lens focal length the greater the physical focusing movement needed to cover a range of subject distances.

● An out-of-focus image of a point on the subject broadens into a 'circle of confusion'. Provided this is relatively small (typically 0.25 mm or smaller on the final result) it will still look acceptably sharp.

● Focusing (manual or by autofocusing mechanism) ranges from infinity setting down to a closest subject distance determined by whether the lens still maintains satisfactory image quality; and the accuracy of the camera's viewfinder.

- Relative apertures are given *f*-numbers. Each number is focal length divided by diameter of effective aperture, so the *lowest f-number* denotes *widest* aperture setting. Each *f*-number change either doubles or halves image brightness. Typically the scale runs *f*/2, 2.8, 4, 5.6, 8, 11, 16.
- Depth of field is the zone between nearest and furthest subjects which are all acceptably in focus at one distance setting.
- Depth of field is increased by 'stopping down'. It is also greater when you focus distance subjects, use a lens of shorter focal length, or accept lower standards of what passes as sharpness.
- When shooting three-dimensional scenes, control over depth of field allows you to either isolate and emphasize, or to give maximum information by resolving detail throughout. Preview the effect visually by checking the image itself, or use a depth of field scale if you are zone focusing.
- As a guide, focus on an item one-third inside the total depth of field you need. For distant shots, focusing for the hyperfocal distance will give you depth of field from half this distance to infinity.
- Small-format cameras give greater depth of field than large-format cameras, assuming normal lenses are used under the same conditions of distance and *f*-number.
- Depth of focus is the amount that lens–image distance can vary before an originally sharply imaged part of the subject appears unsharp. It is greatest with close subjects and long focal length lenses.
- Take care of your lenses by protecting them from scratches, finger marks and dust. Clean only when necessary. Learn to remove dust and slight marks safely, and leave the rest to experts.

Projects

1 Visually check depth of field. Use a single-lens reflex camera fitted with a preview button (or work with a large format camera). Arrange a scene containing well-lit objects at, say, 1 m, 2 m and beyond 3 m. Focus for 2 m and view the result at widest aperture. Next set the lens to *f*/8, press the preview button if using an SLR, and *ignoring the dimmer image* see how nearest and farthest objects have improved in sharpness. Test again at *f*/16. Also compare the effects of focusing on closer or more distant groups of objects.

2 Bright out-of-focus highlights spread into approximately *circular* discs of light because lens and diaphragm are nearly circular. Cut out a star or cross shape from black paper and hold it against the front of your SLR camera lens, set to widest aperture. View a subject full of sparkling highlights (such as crumpled foil) rendered out of focus, and see the change of appearance your shape gives.

3 Using your camera on a tripod, compose a picture containing detailed objects over a wide range of distances, from about 0.5 m to the far horizon. Take a series of shots at (1) widest aperture and (2) smallest aperture, with the lens set for (a) infinity, (b) the hyperfocal distance for your aperture (read this off the depth of field scale), (c) a foreground object, (d) the same object as (c) but with the camera twice as far away and refocused. Compare results for depth of field changes. Remember to adjust exposure time for each change of aperture.

4
Cameras using film

Figure 4.1 The main types and formats of current cameras using film. Back row: Large format monorail and baseboard view cameras. Middle row: medium format rollfilm single lens reflex and direct viewfinder cameras. Front row: Small format 35 mm single lens reflexes (manual and advanced), also APS compact camera

This chapter takes you from the lens alone to the camera as a whole. It explains the main camera components, and shows how – put together in different combinations – they make up today's mainstream camera designs. It also compares the advantages and disadvantages of various camera types. Although this chapter and Chapter 5 concentrate on *film* cameras, much of the information here is valid even if you are considering using a *digital* camera.

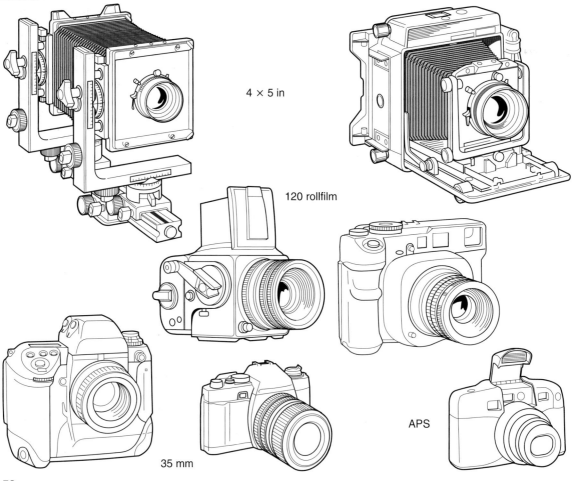

4 × 5 in

120 rollfilm

APS

35 mm

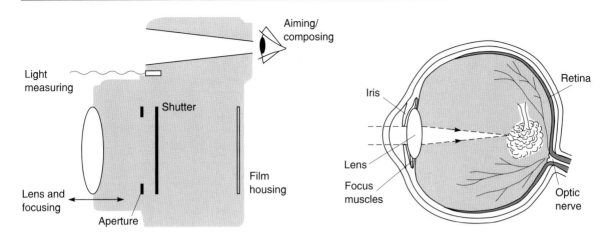

Figure 4.2 Left: the key components necessary in a photographic film camera, whatever its actual design or size. Right: components with similar functions in our human camera, the eye. Muscles alter lens shape to focus. The iris varies its diameter like a camera aperture. The retina forms the (curved) light-sensitive surface, and the optic nerve communicates image information signals to the brain. Clear fluid fills the eyeball, maintaining the lens-to-retina distance

Plenty of 'front end' components such as viewfinder, auto-focusing, zoom lens and built-in flash are common to both kinds of camera. (Chapter 6 discusses features unique to cameras recording by digital means.)

When you look at modern sophisticated equipment it's hard to believe that a camera is basically a box with a lens at the front and some form of light-sensitive surface at the back. Yet the first cameras were just that – wooden boxes put together by the local carpenter. A telescope objective was mounted over a hole at the front, and a holder for chemically coated material arranged to fit into the other end.

During 160 years' evolution many different camera designs have been invented, improved or discarded. And yet today's camera equipment can be divided into just four types: view cameras, compacts, twin-lens reflexes and single-lens reflexes. At the same time, camera picture sizes fall into three different groups: *large format* (sheet film, typically 5×4 in), *medium format* (rollfilm sizes giving 6×6 cm, etc.) and *small format* (principally 35 mm but also APS size film).

The essential components

Whatever its picture size or type of design, a camera should offer the following controls and adjustments, either manual or automated:

1 A means of accurately aiming the camera and composing the picture.
2 Ability to focus precisely.
3 A shutter to control the moment of exposure and how long light acts on the sensitive surface.
4 An aperture to control depth of field and image light intensity.
5 A method of loading and removing film, without allowing unwanted light to affect it. And preferably:
6 A meter to measure the light and indicate or set the exposure needed for each shot.

Figure 4.3 Direct viewfinding accuracy. The separate positioning of viewfinding (V) and taking lens (T) causes framing variations between what you see and what is photographed. This parallax error increases greatly at close subject distances (exaggerated here)

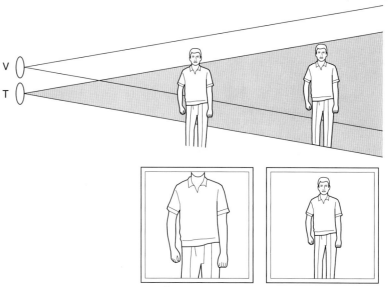

Close up result Distant result

Composing and focusing

The oldest, and most awkward, way to accurately compose and focus your picture is still used in large format view cameras for professional photography. A ground glass screen at the back of the camera allows you to see and focus the actual image formed by the lens, Figure 4.16. You then exchange this for film before shooting.

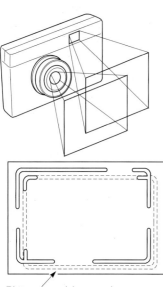

Picture area (close-ups)

Figure 4.4 Correction lines for parallax. The viewfinder in this compact camera suffers both horizontal and vertical parallax error, due to its location relative to the lens. Extra lines in the viewfinder display show the top and sides of the picture limits (broken lines) at closest focusing distance

Another arrangement, dating from early amateur cameras, is to have a line-of-sight viewfinder built into the body as found in today's compact cameras. It gives a separate direct view of the subject, and is masked to have the same angle of view and height-to-width proportions as the picture given by the camera lens. The trouble with this *direct vision viewfinder* is that although it exactly frames up distant subjects, as you photograph closer up what you see through the finder becomes increasingly displaced and inaccurate, see Figure 4.3. Since this fault is due to the separate, parallel viewpoints of camera lens and viewfinder it is known as 'parallax error'. Within the viewfinder window a correction line has to show the true top of your picture when shooting at your closest focusing distance.

To focus the lens on a direct viewfinder camera, simple types may just have a lens positioning control you set to one of a series of subject symbols (views; groups; portraits). A few high quality 35 mm or medium format direct viewfinder cameras have a precision, manual rangefinder system. As Figure 4.5 shows, you see your subject twice: once straight through the viewfinder, the other ducted (via a mirror and window) from a viewpoint further along the camera body. This second view is superimposed over the central area of the first, and moves sideways as you alter camera lens focusing. When you see both versions coincide in their detail of items at a particular distance the lens is correctly focused for this part of your subject. Optics in the viewfinder may also tilt to help compensate parallax error according to the lens focus setting.

Figure 4.5 A manual rangefinder focusing system. This uses an optical rangefinder containing glass (S) with a semi-silvered spot, and a pivoting mirror (M) controlled by the camera lens focusing mechanism. In the viewfinder you see a second image centre-frame. The two coincide and merge when rangefinder (and lens) are set for the distance of this subject; see broken line at M

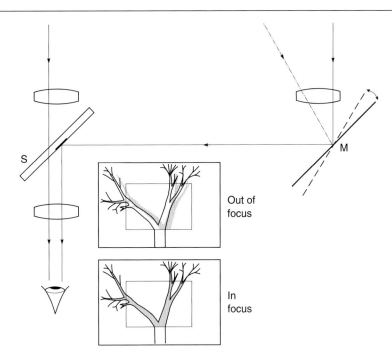

The majority of direct viewfinder compact cameras now have an automated rangefinding system which gives full *autofocus* (AF). As you begin to press the shutter release, the distance to that part of your subject composed centre-frame is measured by a form of electronic rangefinder, Figure 4.21, and lens focusing is automatically adjusted to the appropriate setting.

The above systems of composing and focusing your picture work reasonably satisfactorily for most general subjects. For real accuracy however you need to work viewing the image given by the camera lens (without the slowness and inconvenience of a view camera). Single lens reflex cameras allow this by having a mirror behind the lens to reflect the image up to a viewable focusing screen near the top of the camera body. This mirror shifts out of the way of the film just before exposure, Figure 4.31.

A focusing screen is the only film camera system offering 'what you see is what you get'. It accurately displays the visual effects of depth of field on your picture at different aperture settings and lens focal lengths. Single lens reflex cameras are designed to hold the lens at widest aperture (brightest image, least depth of field) while you are composing and checking focus. So you really need some way of snapping the aperture down to the setting which will come into use when the shutter fires, to preview exactly how much of your picture will be sharp, see page 59. Most 35 mm single lens reflexes have autofocusing but allow you to select manual focus setting too.

Figure 4.6 Bladed, between-lens shutter. The lower drawing shows how the blades (simplified here to three) rapidly open or close when the ring is part-rotated

Shutter

The camera shutter is a mechanical unit set in one of two positions, either (a) built into the middle of the lens, next to the aperture, or (b) at the back of the camera just in front of the film surface.

(Resetting)

Figure 4.7 Metal bladed focal plane shutter opening sequence, as shown from the film side. Two spring blades pass downwards in turn, forming a moving slot through which the image reaches the film

A front or 'between-lens' shutter has several thin opaque blades which rapidly swing out of, and back into, the light beam to make the exposure when the release is pressed. In this central position the shutter has an even effect on the whole image, and only a small movement is needed to open and close the light path. It is also easy to synchronize this action with flash: contact is made to the (electronic) firing circuit the instant the blades are fully open. Often compact cameras combine the action of shutter and aperture, see page 58.

A rear or focal-plane (FP) shutter is more practical in cameras with interchangeable lenses. (Since it covers the film you can change lenses at any time.) Focal plane shutters in modern small format cameras often have sliding metal blades, Figure 4.7. Alternatively there are two roll-up fabric blinds. One blade or blind opens to start the exposure, the other follows to block out the light again. For short exposures the two follow each other across the film so closely they form a slit which actually exposes the picture. After each shot the blades or blinds are wound back, this time overlapped to avoid further exposure, ready for the next picture.

Having a focal-plane shutter also means that light can be allowed to pass through the lens and provide an image for viewfinding and focusing via a reflex system (Figure 4.27). And since one shutter will serve a range of lenses of different focal lengths you don't have to have a between-lens shutter in each.

The usual range of shutter speeds, on both types of shutter, is:

1, 1/2, 1/4, 1/8, 1/15, 1/30, 1/60, 1/125, 1/250, 1/500 sec

Advanced cameras with FP shutters may continue this series down to 1/8000 sec. Most modern single-lens reflex cameras use electronically timed FP shutters offering settings up to 30 secs, or B (see below). Large diameter between-lens shutters for view cameras have big cumbersome blades to move and may not operate faster than 1/250 sec.

The doubling/halving progression of shutter settings (figures rounded up or down in some instances) complements the aperture *f*-number scale in terms of exposure given to the film. In other words, 1/30 at *f*/8 is the same exposure as 1/60 at *f*/5.6 or 1/15 at *f*/11. Actual

Figure 4.8 A fabric blind focal plane shutter. One blind follows the other horizontally. The sequence also shows how flash is usually triggered when the first blind has fully opened – at this point the film frame receives the full image

$\frac{1}{60}$ sec (Resetting)

choice depends on the depth of field you want and whether movement should record frozen or blurred (see pages 136 and 145). And if you combine fastest shutter speed with smallest aperture – or slowest speed with widest aperture – you can give correct exposure over a very wide range of subject brightness conditions.

If you want an exposure longer than offered by the scale of shutter speeds you may find that your camera has the setting 'B'. (B stands for 'Brief', or 'Bulb' after early photographers' use of an air bulb and tube system to hold the shutter open.) On B setting the shutter opens when you press the release button and remains open as long as you keep it pressed down, normally using a cable release.

Figure 4.9 The effect of shutter speed on a moving image. Left: 1/500 sec at *f*/2.8. Right: 1/8 sec at *f*/22. One shows detail but no sense of action, the other exaggerates movement (including camera shake). See also Figures 8.12 and 14.24

Flash can be fired by a between-lens shutter at all marked speeds. FP shutters are slightly more difficult here because the flash must only fire when the entire film frame is uncovered (Figure 4.8). Otherwise only part of your picture will appear. Contact to fire the flash is made when the edge of the opening blind gets to the far end of the frame. Provided you use the speed marked on the camera for flash, *or any speed slower,* the second blind will not yet have started to travel and the full frame is uncovered for exposure. (In general don't exceed speeds of 1/250 with most 35 mm metal blade FP shutters; or 1/60 with large 6 × 7 cm blind FP shutters.)

Between-lens and FP shutters that are electronically timed integrate easily with the metering, autofocus and film wind-on circuits of small-format cameras. They give 'stepless' settings – speeds between the marked times – when exposure is under the automatic control of the meter. Operating power is drawn from the camera's main battery supply. (An electronic between-lens shutter for view camera use has a battery compartment attached.) However, if the battery fails or your camera meter circuit is not switched on, many electronic shutters default to 1/60 second. Some shutters cease functioning altogether.

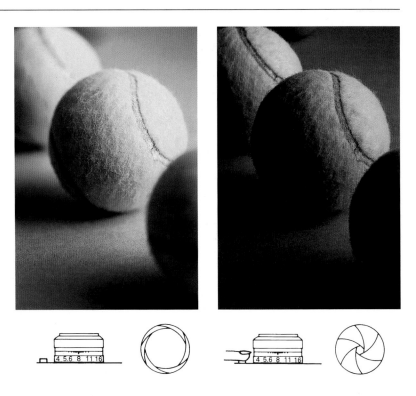

Figure 4.10 Depth of field preview. Lenses on single-lens reflex cameras have apertures you pre-set but remain fully open for easiest focusing and viewfinding (near right). If the camera offers a preview button this will stop down the lens to the taking aperture. The image on the focusing screen now becomes darker (far right) but shows you the actual depth of field you will record on film

After a shot is taken, all focal-plane and most between-lens shutters, mechanical or electronic, have to be re-tensioned before they can be fired to take the next picture. Often the cocking mechanism is set by winding on the film and so is hardly noticed. View cameras usually have a tensioning lever beside the shutter, and this must be activated before you fire the shutter with another lever or a cable release, Figure 4.15.

Aperture

Physically, the diaphragm system used for lens aperture control differs little from camera to camera. As shown in Chapter 3, a series of overlapping sliding blades forms a hole of continuously variable diameter. Sometimes, however, when the camera has a between-lens shutter, shutter and diaphragm are combined. The shutter then has five or six suitably shaped blades designed to open only part way, temporarily forming a hexagonal aperture of the correct size according to the f-number preset. This reduces the mechanism needed and is very suitable for linkage to the exposure setting in fully automated compact cameras.

In cameras that allow you to compose and focus the actual lens image, the aperture can be preset. This means that you (or the camera's auto-exposure system) set the required f-number but the lens still stays fully open for brightest image viewing until just before the shutter is fired. On single-lens reflex cameras this last-minute stopping down is triggered automatically from the shutter release mechanism. On most view cameras you can stop down directly to a preset aperture by manually releasing a 'press focus' lever.

In all cases you will probably want to check depth of field effects at different shooting apertures. On some 35 mm and most rollfilm SLR cameras there is a special aperture-preview button on the camera body or lens; so long as you keep this pressed the diaphragm responds to any setting made on the *f*-number scale; see Figure 4.10. Regard an aperture-preview button as a desirable feature in any SLR camera intended for serious photography.

Light measurement

Practically all modern small- and medium-format cameras have some form of built-in circuit to measure the brightness of light from the subject and so assess correct exposure. The system signals when you have manually set a suitable combination of *f*-number and shutter speed, or else it automatically sets (a) the correct shutter speed for an aperture you have set (known as aperture priority or Av mode), (b) or the correct aperture for a shutter speed you have set (shutter priority or Tv mode), or (c) a suitable combination of shutter and aperture settings chosen by the system from a built-in programme. The practical advantages and disadvantages of each are compared on page 188.

A tiny light-sensitive measuring cell may be located on the front of the camera body pointing direct at the subject from close to the lens, or cells can be suitably positioned inside the camera, sampling light which has come through the camera lens itself. In both positions the cell should measure through any filter you may use over the lens. An internal cell system works equally well with any change of lens.

All modern exposure-measuring systems need to be powered by a battery. This is usually tapped off the same power circuit for autofocus, shutter timing and film drive. You may have to set the sensitivity of the film you are using (its ISO speed) although most 35 mm cameras do this automatically, reading a bar code on the cassette via electrical contacts in the film feed compartment. Large-format cameras seldom have light-measuring arrangements built in, and you have to add a metering attachment or use a hand meter instead; see Chapter 10. (Alternatively, if you are working with a medium or large camera without a meter, take readings with a small-format internal-meter camera and then transfer the settings it shows.)

Figure 4.11 The four main forms in which light-sensitive film is loaded into cameras of differing sizes. Left to right: 120 rollfilm; 4 × 5 in sheet film, part-inserted into a double-sided film holder; cassette of 35 mm film; cartridge for APS (Advanced Photographic System) film. The film notch tells you which way up the sensitive surface is facing (see Figure 9.8). The cassette auto-sensing code sets the camera's exposure system for the speed of the film

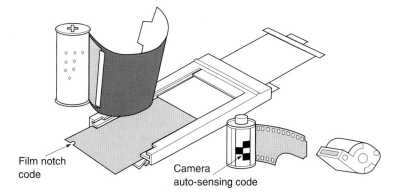

Film notch code

Camera auto-sensing code

Film housing

Unlike digital cameras, a film camera must allow you to repeatedly load and remove light-sensitive material without having it fogged by light. The oldest way to achieve this is to have separate sheets of film in a light-tight holder – a system still used for view cameras. The double-sided holder, Figure 4.16, slips into the back of the camera, displacing a focusing screen, and one side is then opened to face the (shuttered) lens. Most cameras, however, use film in lengths (35 mm wide, or 6.2 cm wide rollfilm) to allow many exposures at one loading. The film passes from feed to take-up compartments behind a picture-size aperture, flattened against it by a spring-loaded pressure plate. It is protected from light during loading and unloading because the film is contained in a cartridge, or a cassette having a velvet 'light-trapped' feed slot. Rollfilm is just tightly rolled up on a spool together with opaque backing paper.

Between exposures regular 35 mm cassette film is wound through the camera onto a permanently fitted open take-up spool. It must be rewound back into its light-proof cassette before you open the camera to remove the film for processing. Rollfilm does not need rewinding; it winds completely on to an identical, removable, take-up spool protected by the last few inches of backing paper. (You can also buy 35 mm bulk film for 250- or 500-exposure accessory backs, page 153.) Small, APS size cartridge film units are designed for easy drop-in loading of APS amateur cameras, see Figure 4.13. Once inside the camera the cartridge is automatically opened and film advanced; after the last exposure (or whenever you want to change film type) film is returned into the cartridge which recloses ready for removal.

Sheet film holders also allow you to change what is in your camera from one film type to another at any time. If you want to do the same with a 35 mm or rollfilm camera without wasting frames it is quickest to either have two bodies, changing the lens from one to the other, or use a camera designed with interchangeable film magazines. Most cameras with magazine backs also accept pack holders for instant picture film.

Lengths of film are shifted through the camera either by an electric motor triggered immediately the shutter closes after each exposure, or by hand using a wind-on lever. The wind-on, shutter cocking and exposure release are normally interlocked, so that you cannot take another picture until the previous shot has been wound on, and vice versa. Some cameras offer a button to over-ride the system for special superimposition effects. Cameras with built-in motor drive normally power-rewind the film back into its cassette after the end of the film has been reached.

Camera types – which is best?

Having reviewed the basic components present in some form in *every* camera system – for aiming; focusing; controlling depth of field and exposure; and housing the film – how do they go together to make up today's range of camera types? No one camera is *ideal*. Some are extremely versatile but something of a compromise, not matched to any one kind of photography. Some are specialist tools which enable you to tackle a narrow range of tasks in ways impossible with any other gear.

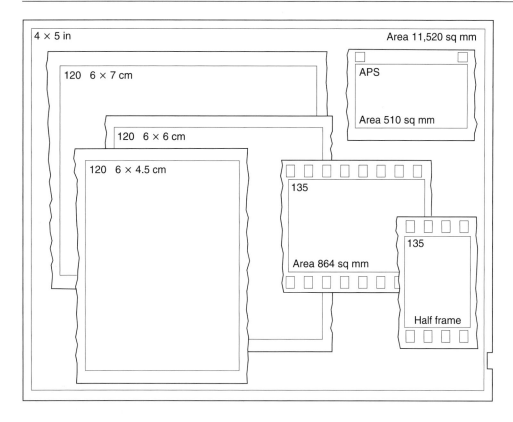

Figure 4.12 Picture formats.
The picture areas given by large
(4 × 5 in), medium (120) and small
(35 mm and APS) format cameras,
drawn here life-size. 120 rollfilm
and 35 mm provide different
formats according to the camera
design. All APS cameras allow
you to preset a choice of three
formats, see page 68

Then again, modern small format (35 mm and APS) film cameras are internally very sophisticated, requiring least knowledge of photographic technicalities to get acceptable snap-shots. Medium and large format cameras often lack sophistication. So you must understand photographic principles more thoroughly to operate these cameras successfully. Another facet to consider is the rapidly improving performance of digital cameras (Chapter 6). However, since they retain most of the optics and mechanisms needed in film cameras, arguments for and against different camera designs raised here are largely common ground.

If possible try to get 'hands on' experience of all four main camera types (view cameras; compacts; twin and single lens reflexes). Compare convenience, toughness and reliability as well as all-important image quality. Decide what sort of camera controls feel right for you, and consider whether the size and proportions of the picture a particular camera gives are best suited to your work.

Large, medium or small format?

Figure 4.12 shows the most common picture formats given by today's cameras using film. At first you might imagine that using an enlarger makes film size rather irrelevant, because all results can be blown up to make a given size print. However, consider the following:

1 The larger the format the finer the quality your final image is likely to have – better definition, less grainy pattern, subtler tone and colour

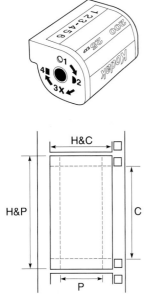

Figure 4.13 APS film. Top: Cartridge is smaller than a 35 mm cassette. Light-proof apertures in the base signal (1) contains unexposed film; (2) is partly exposed; (3) exposed but unprocessed, or (4) contains processed film (see page 155). Bottom: The whole 30 × 17 mm picture area is exposed in the camera, but can be cropped in enlarging to give three alternative ratios. C ('classic') dimensions give 2:3 ratio proportions, like 35 mm, H (HDTV) dimensions give 9:16, and P ('panorama') give 1:3. Your choice when shooting is recorded magnetically on the film edge and later programmes the mini-lab enlarger

gradation. The 4 × 5 in format, for example, has 13 times the area of the regular 35 mm format; you can make enlargements to 16 × 20 in before image quality becomes worse than an enlargement to only 4 × 6 in from 35 mm. When you make large exhibition prints these differences become very noticeable.

2 Pictures shot on small-format cameras have greater depth of field than pictures on large- and medium-format cameras (standard lenses, and same f-number) even when enlarged to the same size. Put another way, you can shoot at a much wider aperture and still get the same depth of field.

3 The larger the camera the more it physically intrudes between you and your subject. A small camera gives you greater freedom of viewpoint, is more mobile and much faster to set up and use, and allows you to shoot pictures in quicker succession.

4 Small format cameras are often fitted with lenses that are 'faster', i.e. have larger maximum apertures. Among other advantages, the brighter image makes it possible to shoot at hand-held shutter speeds under dim lighting. 35 mm camera systems have a vastly greater range of lenses and accessories available too; see Chapter 5. Where equivalent items exist at all for medium- or large-format kits they are much more expensive.

5 Some specialized light-sensitive film materials are made only for large-format cameras. Having sheet film holders allows you to change from one film to another with ease, and you can process pictures individually. However, a small-format camera kit makes it easier to shoot and process a large *quantity* of pictures. Also 35 mm is ideal for slides.

6 Large format cameras offer you a wide range of 'camera movements' (Figure B1 and Appendix B) for image control.

7 Enlargers, and digital film scanners (Chapter 14) are more costly the larger the film format they accommodate.

The other important consideration is format *shape*. Height-to-width proportions have a strong influence on picture composition. Most formats are rectangular, 35 mm regular frame having a ratio of 2:3. At first sight a square format would seem the easiest to work with. You don't have to choose between vertical and horizontal shapes when framing up a shot. But then you don't have the up/down or sideways thrust they can add to your picture either. Most pictures finally seem to be used in some rectangular format anyway.

Of course, during enlarging you can crop off unwanted image parts, but you will find that the original camera format still influences your picture making. Similarly some shapes are definitely more 'comfortable' to compose subjects within than others. A few panorama wide-angle rollfilm cameras (Figure 4.25) offer ratios of 1:2 or even 1:3. These long thin negatives, up to 6 × 17 cm, must be enlarged using a large format enlarger.

One final point concerns professional photography and client relations. Small-format cameras are still seen as *amateur* cameras, however excellent their performance. When you are commissioned for a commercial shot and turn up with a 35 mm outfit not dissimilar to the client's own, the effect is less impressive than medium or large specialist-looking equipment. This is a valid aspect of business psychology.

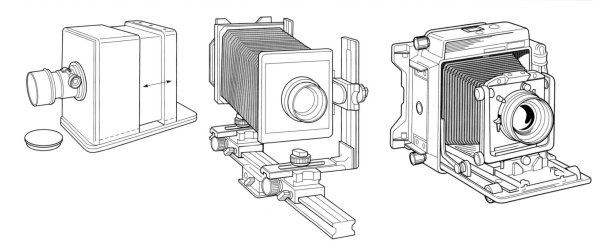

Figure 4.14 View cameras. Both monorail (centre), and baseboard (right) designs are derived from wooden sliding-box plate cameras (left) used by pioneer photographers in the 1840s

The review of how different camera types work which follows begins with view cameras. Although now less used because of improved medium- and small-format equipment, they are deceptively simple. Little is hidden away inside, and it is easy to see how the basic components work together.

How view cameras work

This type of camera design relates back directly to the earliest form of photographic plate camera, as used by pioneers such as Louis Daguerre. Equipment then consisted of two boxes, one sliding inside the other for focusing, and having a lens at the front and a ground glass screen at the back. Today's view cameras are still large format, but designed for sheet film. The most usual size is 4×5 in; others include 7×5 in and 9×6.5 cm, even 8×10 in. You can adapt *down* from any of these sizes by fitting an appropriate back or adaptor for smaller sheet film, rollfilm, instant-picture material, or digital recording (Chapter 6).

The camera lens with its between-lens shutter is mounted on a clip-on panel which fits over the camera front. You can quickly change to lenses of different focal lengths, also ready-mounted on panels. The front of the camera is connected to the back by opaque concertina bellows to keep out non-image-forming light, yet allow a wide range of lens-to-film focusing distances. A finely etched glass screen at the back shows you the (upside-down) image for focusing and composition. This back can be rotated from horizontal to vertical format. As the screen is spring-loaded, when you push in a film-holder between glass and bellows your film surface becomes located in exactly the position previously occupied by the etched surface of the glass, Figure 4.16.

The lens-carrying front of the camera can be tilted, or offset sideways up or down independently from the back. These 'camera movements' are important for professional architectural and still-life photography. They allow you extra control over depth of field and shape distortion, explained in detail in Appendix B.

There are two main types of view-camera design, monorail and baseboard. Monorail types are unit-constructed on a bar, and are always used on a stand. To focus you move either the front (lens) standard or

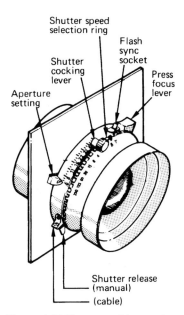

Shutter speed selection ring

Flash sync socket

Shutter cocking lever

Press focus lever

Aperture setting

Shutter release (manual)

(cable)

Figure 4.15 Shutter and lens unit. Typical view camera lens unit with mechanical bladed shutter. The panel it is mounted on makes it interchangeable with other lens units

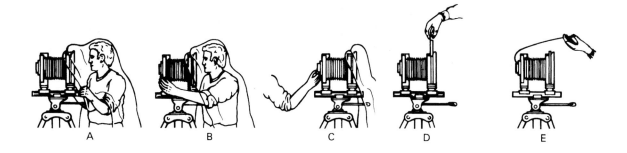

A B C D E

Figure 4.16 Photographing procedure with a view camera. A: Composing and focusing on the ground glass screen. B: stopping down while visually checking depth of field. C: closing and setting the shutter. D: after inserting a filmholder, withdrawing the darkslide covering the film. E: firing the shutter

Figure 4.17 Below left: Monorail view cameras are unit constructed, allowing different lengths of bellows, rail, and size of back, as well as independent movements of lens and film. Some cameras have U-shaped standards, others L-shaped (Figure 4.14). Below right: Baseboard type view camera folded, and open for use on a tripod. The lens pulls forward onto a focusing track; flaps which fold out at the back shade the ground glass focusing screen

rear (focusing screen) standard along the rail. Having such an open unit structure, a monorail offers the same camera movements front and back, allowing an enormous amount of offsetting.

The baseboard type of view camera, also called a 'technical camera', is a box-like unit with a hinged front. Opening this flap you find you can pull the lens standard out onto it, on runners. Then by turning a milled knob at the edge of the board you move the runners, focusing the lens backwards or forwards while you check the image on the focusing screen. A baseboard camera is quicker to set up on its stand and use than a monorail type. However, it offers less comprehensive movements, especially back movements.

With all view cameras you need a fold-out hood or an old-fashioned focusing cloth over your head and camera back to block out ambient light, so you can clearly see the image. Figure 4.16 shows the typical prolonged sequence needed to take a picture. Exposure is most often measured with a separate hand meter (Chapter 10).

View camera advantages

1 Cameras offer large format image quality (very apparent in really big exhibition prints) and an unrivalled range of camera movements.
2 You can take and process single exposures. When working in the studio this allows a check on each result as you go along.
3 Relatively simple construction. There's little to go wrong.

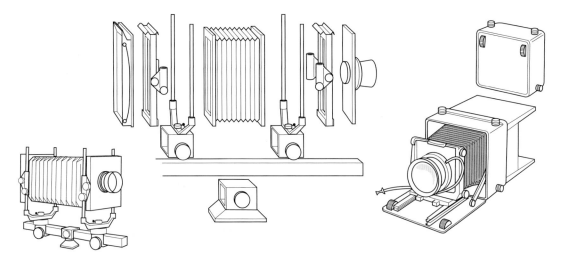

Figure 4.18 Rising front. A view camera offering this camera movement is still often used for architectural subjects where most elements are well above the lens centre. Tilting a normal camera upwards would make vertical lines converge. Instead, the camera back here was kept upright and the front lens standard raised to include more arch top, less road. (See also digital manipulation of perspective, page 287)

4 The large format and static nature of the camera encourage you to build up carefully considered compositions, almost like drawing or painting.
5 Still often chosen for architectural, landscape and still-life photography; also for close-ups and copying because even the normal-length bellows allows considerable lens–film extension.

View camera disadvantages

1 Camera kit, film holders and tripod are bulky to carry and slow to set up and use. The dim, upside-down image is awkward to view.
2 It takes time to measure exposure, and with a hand meter there are exposure calculations needed when working close, see page 191.
3 Impractical camera for many subjects, e.g. sports, candids, etc.
4 Continuous improvements in the resolution of films and lenses for medium- and small-format cameras have undermined the image quality advantage of large equipment.

How direct viewfinder cameras work

This term covers cameras using direct vision (also known as *real image*) viewfinders, notably small-format 'compacts'. Unlike view cameras or reflex cameras which allow you to see the actual image

Figure 4.19 Direct viewfinder compact cameras. Left: Designed for APS film. Right: Uses 35 mm film. A: shutter release and power wind-on. B: LCD panel, displaying frame counter, battery state, etc. C: Front window of viewfinder. D: Windows for IR autofocus system. E: light sensor for auto-exposure setting programme. F: Flip up or pull out flash. G: Lens zooming control

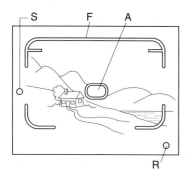

Figure 4.20 Information shown in a typical compact camera viewfinder. F: Suspended frameline, with parallax-correcting top lines for closest focusing distance. A: Autofocusing area. S: Shake warning diode (for when a slow speed is in use). R: 'Flash ready' indicator

formed by the lens, they have a separate window set into the camera body through which you look at your subject directly; see Figures 4.3 and 4.4. Based on early user-friendly cameras invented to overcome the prolonged practical procedures that large-format view cameras demand, they are typically pocketable, and fully self-contained. Everything, including flash, is built-in. Technical settings are automated by sophisticated technology, making cameras instantly ready for shooting pictures hand-held.

Direct viewfinder cameras come in a huge range of compact point-and-shoot designs – some for 35 mm, others for APS size film. There are also some more expensive versions having manually set exposure controls and rangefinders, which are designed more for professional work. These use either 35 mm or rollfilm.

Compact, point-and-shoot designs (35 mm and APS)

The aim of these cameras is to make photography of 'typical' subjects simple. They achieve a high technical success rate, even under quite a wide range of shooting conditions. Photographers with little interest or skill in controlling results can expect to get clearly recorded images, provided they work within limitations such as not too close; holding the camera steady; and not trying to light a huge landscape with flash. The 'auto-almost-everything' features put compact cameras well ahead when you make a quick decision to take actuality pictures of an event. There's no delay over settings – you can even hold the camera up over your head in a crowd and get sharp, well exposed results. Also you are more likely to always carry a camera with you when it is smaller and more pocketable than a reflex type.

Features common to both 35 mm and APS compact cameras include:

Viewfinder. The direct vision viewfinder always shows your subject looking sharply focused. Picture limits often shown by a white outline 'suspended' on a slightly larger viewing area (Figure 4.20). Short extra lines near the top show the true upper limit of your framing when shooting close-up (parallax correction, page 54). Also a central zone is marked where autofocusing will take place. Information such as 'flash

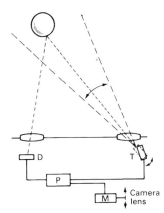

Figure 4.21 Infra-red AF system. When the shutter release is half depressed transmitter (T) scans centre of subject area. Detector (D) senses when the reflected signal is strongest. Processing circuit (P) relates this to the position of (T) halting the camera lens focusing motor at the step giving correct setting for the distance

Figure 4.22 Using AF lock. Top: When the main subject is not positioned centre frame the background becomes autofocused instead. Centre: briefly re-compose the picture, autofocus and apply AF lock, then return to your chosen picture composition (bottom) before exposing

ready' or warning of 'too close for focusing range' may appear as light signals alongside the frame lines or beside the eyepiece of the viewfinder. It is important that your viewfinder has an eyepiece large enough to give you clear sight of all four corners of your picture at the same time – particularly if you wear glasses.

Autofocus (AF). Most autofocusing systems are 'active', meaning that they use diodes transmitting and receiving infra-red wavelengths (like those used for TV remote control). These operate through two windows in the camera body, Figure 4.19. The system works on the rangefinder principle, page 54, but it sends out a beam of invisible IR rays from one window and has a narrow-angle detector cell behind the other. First pressure on the shutter release button causes a motor to adjust the camera lens focusing and scan the beam across your subject, Figure 4.21, within the mid-frame target area. Both stop when a strong return signal is detected. In practice the lens is 'stepped' through a series of settings between infinity and closest focusing distance. Low-cost cameras may work using only seven setting stages. Others have 100 or more stages, which allows the autofocusing to be much more precise.

An IR system will even focus in darkness, but it can be fooled sometimes if you are photographing through glass windows at 90°, or shooting against a bright light source. Watch out too for situations when you compose a picture containing two people and the AF measuring area falls entirely on background or foreground between the pair; see Figure 4.22. Cameras have an 'AF lock' button to deal with this – you first coincide the measuring area with one of the figures, autofocus with a half pressure on the shutter release, then apply the lock and recompose your picture as you want it with main subjects off-centre but now remaining sharply focused. However, the procedure takes time and it is tempting to shoot subjects centre-frame.

Zoom lens. Compact cameras don't have interchangeable lenses like SLRs or view cameras. Apart from the cheapest models it is usual to have a zoom (variable focal length) lens. Control buttons then provide you with a smooth optical adjustment which enlarges or reduces how much of your subject fills the frame – in other words narrowing or widening angle of view. Optics within the direct viewfinder must also alter position to keep pace with what the camera lens includes.

Auto-exposure (AE). Shutter speeds and aperture settings are determined and set internally by a programme. This takes into account the light-sensitivity of the film you have loaded (read direct off the cassette or cartridge by modern cameras, page 155) and the brightness of the subject you are photographing as measured by a light sensor facing it from the front of the camera, Figure 4.19. A good compact camera may make settings ranging from 1/8 sec @ f/2.8 to 1/500 @ f/16, but not actually show you what these are. If conditions demand speeds of 1/30 sec or slower a signal warns you to use a tripod or change to flash; some cameras automatically switch the flash on.

Built-in flash. Flash built into a compact camera body is typically powerful enough to give correct exposure at subject distances up to about 3 m. The closer and more reflective the subject the shorter the

flash duration, see page 206. The flash is triggered by the shutter and is followed by a recharging delay of up to 10 sec after each flash. You have to wait for a 'flash ready' signal in or beside the viewfinder before taking the next shot.

An inherent problem with compacts is 'red-eye' caused by the closely positioned flash illuminating the back of people's eyes, page 53. To minimize red-eye, the flash is housed as far to one side of the camera lens as possible. Some designs use a fold-up or pull-out arrangement (Figure 7.13) to achieve this.

Compacts using 35 mm film. The widest range of compact cameras is still of this type. A great variety of film types is available in 35 mm. Films can be user-processed if you so wish; and the image is big enough to enlarge to exhibition sizes without much deterioration. The standard lens focal length is 34 mm but most have zoom lenses, typically 38–70 mm (×2 zoom range) or 38–105 mm (×3). However, the greater the zoom lens range the more bulky the camera becomes, which is self-defeating. With such a wide range of 35 mm compacts and prices, comparisons are difficult to make, but the best quality 35 mm types remain ahead of the best APS compacts.

Figure 4.23 The three picture formats offered by APS. In every case the full 30 × 17 mm frame is exposed, but you also record a magnetic signal on the film which later programmes lab equipment to make either a 6 × 4 in, 7 × 4 in, or 10 × 4 in print

APS compacts. Advanced Photographic System cameras are, as the name implies, intimately linked with modern processing and printing equipment used by photofinishing labs. Introduced in 1996, cameras are smaller than 35 mm compacts and only accept 23 mm wide APS film housed in a cartridge different in shape to 35 mm cassettes, Figure 4.13. The cartridge simply drops in, is opened when you shut the film compartment, and the film loaded, wound-on and rewound by motor. All APS negatives are 17 mm × 30 mm but three sizes of print are possible, nominated when you take each picture. By setting 'panoramic' for example the viewfinder re-masks to 3:1 format ratio. It also records signals on transparent magnetic coating on the film itself which programme the photofinisher's equipment to enlarge only a long narrow part of the negative and make a print 10 in × 4 in. Other settings you can make for all or any pictures on the film are 2:3 ratio (prints 6 in × 4 in) or 9:16 (prints 7 in × 4 in); see Figure 4.23.

Other kinds of PQI (Print Quality Improvement) data may be recorded invisibly on their respective film frame – date and time of shooting, whether flash was used, etc. – to get the best quality out of automatic machine printing. Processed film is returned inside its cartridge, which is not intended for owner opening. Large-scale photofinishing machinery apart, little darkroom equipment is made for APS (although films can be digitally scanned like 35 mm, see page 270. Because APS format is smaller than 35 mm, cameras have 24 mm or 27 mm focal length lenses as standard. Almost all in fact have zoom lenses, e.g. 24–52 mm or 32–65 mm ×2 zooms, or 30–90 mm or 25–100 mm ×3 and ×4 zoom range.

APS compact cameras (in conjunction with APS photofinishing centres) allow photographers with no technical knowledge to get good results up to 10 × 4 in. But you may quite soon want to graduate to 35 mm with its greater range of equipment (particularly advanced equipment) and possibilities of do-it-yourself processing and printing.

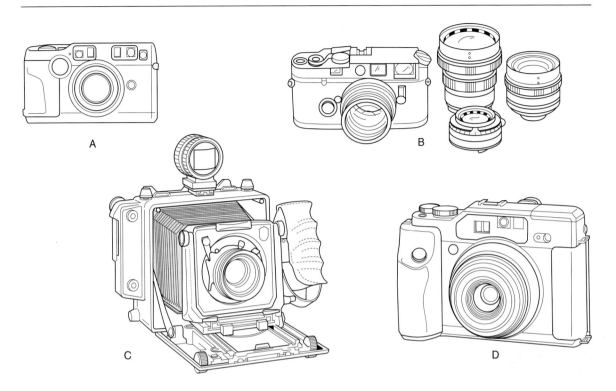

Figure 4.24 Direct viewfinder cameras for mainly professional usage. A: Contax 35 mm compact, with manual/auto rangefinder. B: Leica manual rangefinder 35 mm with some of its interchangeable lenses. C: Baseboard 4 × 5 in camera with coupled rangefinder. D: Rollfilm 6 × 4 cm format camera with an auto-focus, zoom lens

Professional type direct viewfinder cameras

What are often referred to as rangefinder cameras are intended mostly for the professional market and priced accordingly. They include some 35 mm format cameras such as the Leica and Contax, several for medium format rollfilm, and a few large-format hand-held cameras; see Figure 4.24. Viewfinders are mostly 'parallax corrected', meaning that optics slightly shift the frame lines downwards the closer you focus.

An attraction of these cameras is their quiet shutters, and reduced weight relative to single-lens reflexes offering the same picture format, Figure 4.29. They are also rugged and have high precision optics. In the case of the Leica it has an almost soundless focal-plane shutter (good for photo-journalism) and a modest range of interchangeable lenses. The viewfinder automatically changes its frame lines according to the lens you fit. Exposure reading is made through the taking lens, by a hinged light-sensor just in front of the shutter blind which moves out of the way immediately before you shoot.

Rollfilm direct viewfinder cameras may also feature interchangeable lenses and manual rangefinding focusing, or have a zoom lens and autofocusing. Everything of course is scaled up in size – if the format is 6 × 7 cm the standard lens is likely to be 80 mm, or a 55–90 mm zoom on a 6 × 4.5 cm camera. They are popular with some professionals for wedding and social portrait work where both formal groups and actuality pictures will be needed.

Specials. A few direct viewfinder rollfilm cameras are designed for more limited, special applications. They include wide angle cameras giving a panoramic-type format such as 6 × 17 cm, and highly portable

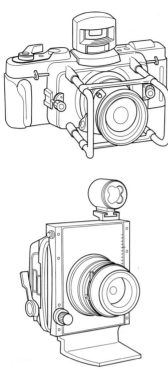

Figure 4.25 Specialist purpose direct viewfinder cameras. Top: A wide-angle 6 × 17 cm rollfilm camera (focus by distance scale only). Bottom: architectural 'shift' camera accepting a roll or sheet film back.

Figure 4.26 Given time and a static subject you can correct both framing and viewpoint parallax error. Compose the picture, then finally raise the camera by the distance between lens and viewfinder

'shift' and cameras for architectural photography which allow you to raise the lens to control perspective (see page 306). Some baseboard view cameras also accept a direct vision finder matching the lens in use, and have an optical rangefinder linked to the focusing track mechanism. You can then take hand held pictures on 4 × 5 in sheet film or change to medium format pictures by attaching a rollfilm back.

Direct viewfinder camera advantages

1 An all-in-one unit, mostly quick to bring into use and record things as they happen – getting a picture you would otherwise miss. Press photographers often carry an automatic compact as a back-up camera.
2 The viewfinder gives a sharp, bright image. You may also see part of your subject in the viewfinder before it enters the marked frame, good for sport and action.
3 Modern compacts pack in a wide range of practical features – motordrive, autofocus, auto-exposure setting programme, zoom lens, flash – yet remain small.
4 Rollfilm DV cameras may be designed for specialist roles, hand-held architectural photography, panoramas; or more general work where portability plus medium format results are required.

Direct viewfinder camera disadvantages

1 Parallax error between viewfinder and lens is a real problem when working close. Even though 'parallax corrected' cameras give accurate *framing*, the *viewpoint* difference still gives you a slightly different alignment of elements one behind another – sufficient to upset critical compositions.
2 There is no convenient way of visually checking depth of field.
3 It is easy to have a finger, or strap, accidentally blocking the lens, exposure sensor, or autofocus rangefinding window. You will not see this looking through the separate viewfinder.
4 PS film cameras are quick and conveniently automatic to use, but not geared to user-processing or large prints. They offer little scope to extend your photography through knowledgeable use of technical controls when shooting (although, like 35 mm, pictures can be digitally manipulated later; see Chapter 14).
5 Inexpensive autofocus compacts take a perceptible time to focus (typically 1/10 second). Delay between pressing and firing can mean you lose the key instant of a fast action shot.
6 The small flash built into compact cameras is not very powerful and gives only 'flat on' light. It cannot be bounced unless the camera has a shoe accepting an add-on flashgun.
7 Most small format compacts are totally reliant on battery power to function.

How reflex cameras work

Reflex cameras can be traced back to one of the earliest forms of camera obscura used for sketching views. With a mirror fixed at 45° behind the lens the image is reflected up to a horizontal surface and becomes *right way up*. Soon after the invention of photography this reflex arrangement was mounted on top of a basic plate camera to act

Figure 4.27 For centuries before photography artists used the reflex 'camera obscura' to form a right-way-up image on glass, convenient for tracing

as a full-size focusing viewfinder. The combination was called a twin lens reflex. A few rollfilm versions of twin-lens reflexes (TLR) are still made, but further development resulted in single-lens reflex (SLR) cameras. These offer a much more accurate and informative image checking system.

Twin-lens reflexes

As shown in Figure 4.28, a TLR camera has two lenses of identical focal length mounted one above the other on a common panel. The distance from the top lens (via the mirror) to the focusing screen must be the same as the distance between the bottom lens and the film. The focusing screen is also the same size as the picture format. You can therefore focus and compose the image on the top screen, where it is shaded from light by a hood, then fire the between-lens shutter in the lower lens knowing that the picture will be correctly focused on film. Differences in viewpoint between the two lenses give parallax error though, especially with close subjects.

The top lens has a fixed aperture, the same or wider than the maximum given by the diaphragm of the lower lens. This produces a bright image and minimal depth of field for easier visual focusing. The image on the screen is right way up, but *reversed left to right*, a feature which makes it almost impossible to follow moving subject matter. There is therefore a simple fold-in direct viewfinder in the metal hood. However, since this viewpoint is 75 mm (3 in) or more from the taking lens, parallax error is even more extreme.

TLR cameras are designed to give square format pictures. This is because the camera is awkward to use on its side – the image on screen goes upside-down. Some models have a built-in exposure meter, located behind a semi-silvered area of the mirror.

TLR advantages

1 A mechanically simple design, with a very quiet shutter.
2 You see the visual effect of focusing, on the full-size screen, even during the exposure itself.
3 The camera is easy to use over a wide range of viewpoints from floor level to high above your head (holding the camera upside-down).
4 A TLR costs less than a rollfilm SLR camera with similar lens quality. It is a cheap way into medium-format photography, practical for weddings and portraits.

TLR disadvantages

1 Parallax error creates difficulties with close-up work.
2 The image on the screen is reversed left-to-right.
3 Depth of field is shown on a printed scale, but you cannot check its *visual* appearance.
4 The camera is relatively bulky for its format.
5 No zoom or interchangeable lenses.

Single-lens reflexes

The SLR was developed to overcome most of the disadvantages of the twin-lens reflex camera. The design avoids parallax error completely,

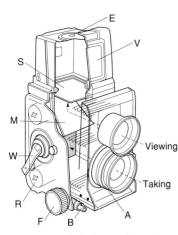

Figure 4.28 Twin-lens reflex. A: aperture and shutter setting controls. B: bladed shutter release. F: focusing knob, shifts entire twin-lens panel. R: rollfilm spool. W: film wind-on handle (folds out). M: fixed mirror. S: focusing screen. E: focusing magnifier. V: push-in hood section, forms direct viewfinder with rear eyepiece

by using the same lens for both viewfinding and photography. A hinged 45° mirror reflects the image up to a horizontal focusing screen, but flips out of the way just before the (focal-plane) shutter fires. The distance between lens and focusing screen, via the mirror, equals the lens-to-film distance. So what is sharp on the screen will be sharp on the film.

On all 35 mm SLRs a pentaprism above the screen corrects the image left-to-right and reflects it out through an eyepiece at the back of the camera, so you see the subject as it might be seen direct, Figure 4.33. Typically the screen shows 95–98 per cent of what will record on film – you get in minutely more than you expect. If you wear glasses, buy an accessory dioptric corrector lens which fits over the camera eyepiece. Then you can remove your glasses and bring your eye close enough to view the entire screen, still seeing the image clearly.

The focusing screen itself may be interchangeable. The most popular type for non-autofocus cameras has central 'crossed wedges' moulded into its surface, which shows a rangefinder-type double image of subjects not properly in focus, Figure 4.34. A surrounding ring of microprisms breaks up an unsharp image into a shimmering dot pattern. Both focusing aids are designed to work with the lens at wide aperture; stopping down partly blacks out these areas.

Most autofocusing SLRs use a *passive* electronic system to detect when the image is sharp. Some of the centre part of the picture is directed down on to a charge-coupled device (CCD) sensor (Figure 4.35). With unsharp images the system also detects whether the lens should be focused towards or away from the camera body. It may respond by signalling which way you must manually turn the lens, alongside the focusing screen ('focus confirmation'). More often it controls a motor within the camera body or lens which fast-shifts your focus setting by the required amount (full AF). Focus detection can be coupled to exposure release, so that you cannot shoot until the image

Figure 4.29 Single-lens reflexes, all based on 1920s plate camera design (A). Modern versions use formats 6 × 6 cm (B), 6 × 4.5 cm (C). 6 × 7 cm (D). 35 mm SLR cameras (E) are similarly related

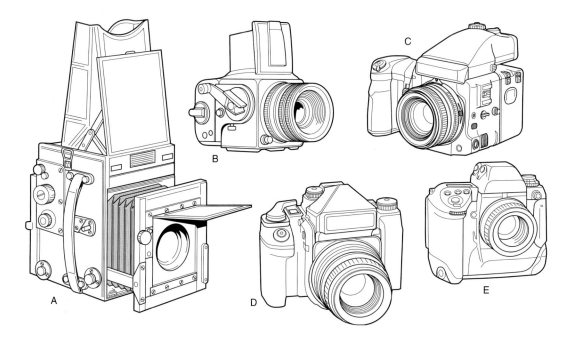

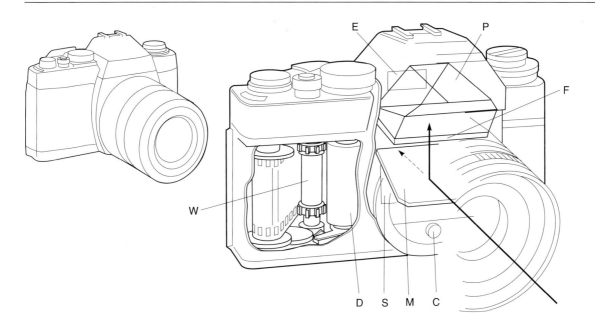

Figure 4.30 Typical manual 35 mm SLR showing basic internal structure. E: eyepiece at rear of camera. P: pentaprism. F: focusing screen. M: hinged mirror. S: shutter (film behind). W: film wind-on mechanism. D: tensioning drum for shutter blinds. C: typical cell position behind the lens for exposure measuring. For external controls see Figure 4.32

has come into focus – useful in action photography (but sometimes a handicap too).

Exposure is read through-the-lens (TTL). The camera body contains suitably positioned light sensors which view subject brightness on the focusing screen, or else read it via light reflected off the shutter blind and film at the moment of exposure (Figure 10.7). The readings made are translated by the camera's circuitry to give semi-automatic, fully automatic, or manual exposure settings; see pages 187–189. Where light is measured off the film surface the system can control the duration of a flash unit. The flash may be a 'pop-up' built-in type or, more usefully, an add-on 'dedicated' unit which links into the camera circuitry as described on page 197.

Its focal-plane shutter, and reflex design, make this an ideal camera to use with a range of interchangeable lenses of fixed or variable (zoom) focal length, described in Chapter 5. You can change lenses quickly with a positive bayonet-fitting twist action, the focusing screen revealing every image alteration given by change of focal length, the use of close-up extension tubes, adjustment of special effects attachments, etc. Lenses have 'preset' apertures, meaning that the lens remains wide open until just before shooting, for clarity of viewfinding and focusing. If you need to see the appearance of depth of field you can press an aperture preview button, Figure 4.32, provided the camera offers one. (The meter reads the image at open aperture but is programmed by the *f*-number you have set on the scale.)

Figure 4.31 Sequence of exposing actions in a single lens reflex camera. 1: composing and focusing. 2: when you press the release the aperture first closes to its pre-setting and the mirror rises. 3: shutter in front of the film fires. 4: mirror returns, aperture reopens, film winds on

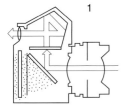
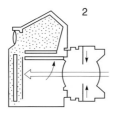
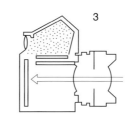
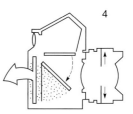

Figure 4.32 Typical 35 mm SLR external controls. Top: manual focus and wind-on type camera. Bottom: an autofocus multi-programmed model. R: release for shutter. S: shutter speed control. P: preview button. A: aperture setting. X: ISO setting. RW: rewind crank. C: exposure compensation control. H: hot shoe for clip-on flash unit. E: eyepiece. L: manual wind-on lever. F: frame counter. Z: power film rewind. With the advanced model, changes are made by selecting the mode or programme you need on command dial CD, and then operating electronic input dial ES. Settings produced appear on body-top display panel (D), and are also presented to your eye alongside the focusing screen

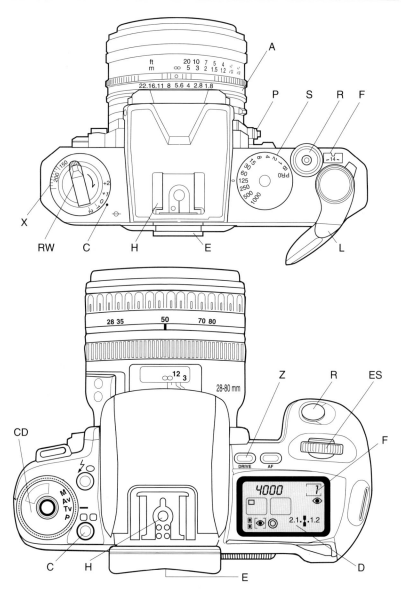

Figure 4.33 How a pentaprism works. This shaped block of glass reflects light across its 'roof' so that the (laterally reversed) image formed on the reflex camera's focusing screen is seen by the eye as right-reading

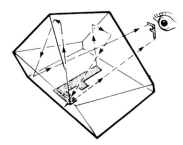

When the shutter release on an SLR camera is pressed a lot of mechanical things have to happen fast, Figure 4.31. Typically the mirror rises, the lens stops down, the focal plane shutter fires, the mirror returns, the lens opens fully, and the film is transported by motor or hand wind-on.

Manual or automatic?

All the major manufacturers of 35 mm SLRs – Pentax, Nikon, Minolta, etc. – produce a *range* of camera bodies, from purely manual (including wind-on) to multimode automatic. At one time mere ability to build computer-type micro circuits into cameras resulted in every 'bell and whistle' being incorporated, irrespective of practical usefulness.

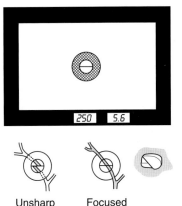

Unsharp Focused

Figure 4.34 Top: Focusing aids, and camera setting readout, as presented in the viewfinder of a manual-focus SLR. Bottom: when the image is unsharp, prisms moulded into the focusing screen (bottom right) give the image a split and offset appearance, while a surrounding ring of microprisms forms a shimmering grid pattern

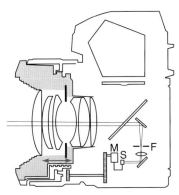

Figure 4.35 Autofocus arrangement in an SLR camera. The system samples some of the lens-focused light passed through a semi-silvered hole in the main mirror. Below aperture F (the same distance from the lens as the film) a pair of separator lenses bring the beam to two points of focus on a CCD sensor (S). The sensor's 128 segments detect the relative spacing of the two points of light, and control motor (M) to adjust the camera lens focusing position. System works with a range of interchangeable lenses

'Advanced' cameras still offer you a choice of programme modes giving settings the manufacturer considers best to cope with 'landscapes', 'portraits', 'action scenes', etc. Again you can customize such a camera to suit your preferred way of working, using a menu of twenty or more settings (from the length of the self-timer delay period to whether a new film advances when you close the camera or press the shutter button).

So although automatic SLRs are fast and reliable for set subject conditions, you may be buying a lot of modes which spend their time shut off once you have customized your camera. Again, if something does not perform as you expect, you may have to stop and thumb through a thick instruction book to discover what resettings to make.

A manually set camera is not only cheaper but having to select the three key controls – focus, aperture (with preview) and shutter speed – soon teaches you the technical principles which help enormously in creative image making. The lens you fit on your manual camera can be the same or have matching optical quality to the maker's top-of-range cameras.

Finally don't overlook the fact that most automatic or semi-automatic SLR cameras do also give you the option of switching to manual mode for lens focusing, exposure settings, etc. You can plan the camera to 'grow up' with you.

Other SLR formats

Although the majority of SLR cameras are for 35 mm film, some are made for APS and others, larger and more expensive, for rollfilm (6 × 6, 6 × 4.5, 6 × 7 and 6 × 8 cm); see Figure 4.29. The medium format cameras mostly have interchangeable backs, so you can quickly change from colour to monochrome mid-film, or fit an instant picture back (page 92) or even a digital back, Chapter 6. They are used increasingly for professional photography, thanks to modern high-resolution films and the growth of digital photography.

Along with backs and lenses you can also change or remove the pentaprism, or switch to a special purpose body for wide-angle or camera movement work (see page 306). Such flexibility means that these medium-format 'systems' have taken over from large-format view camera kits.

SLR advantages

1 You can *precisely* frame up the picture, focus, and (models with pre-view) observe depth of field, without the slowness of a view camera.
2 35 mm types offer you a choice of fast modes for setting correct exposure by using through-the-lens measurement of subject lighting (including flash).
3 Key information such as correct exposure and focus, shutter speed and *f*-number, are signalled direct to your eye from alongside the focusing screen.
4 There is a wide-ranging back-up of lenses and accessories. This makes SLR outfits versatile 'unit systems' – able to tackle most photography well.
5 Interchangeable backs on some medium format models speed up film change, increasing versatility.
6 Fully AF models adjust the lens faster than you can focus it by hand – particularly useful with subjects on the move – sport, natural history, etc.

SLR disadvantages

1 You cannot see through the viewfinder whilst exposure is taking place. This can be a nuisance during long exposures or when panning at slow shutter speeds, page 146.
2 When you are viewing at open aperture (having set a small aperture) it is easy to forget the changes that increased depth of field will give to your picture.
3 The camera is electronically and mechanically more complex (and noisy) than other designs. Relative to a compact it is more bulky, heavier and tends to be more complicated to use.
4 The range of speed settings available for use with flash may be limited, especially with medium-format models.
5 Use of passive autofocus sharpness detection relies on sufficient ambient light and subject contrast. And some systems fail to work when a linear polarizing filter is over the lens (see page 174).

Summary. Cameras using film

● No one camera is the perfect tool for every job. You will probably need at least two cameras, complementing each other in format or design features.
● All cameras using a separate lens for viewfinding suffer from parallax error. Even if there is parallax correction of framing, viewpoint difference upsets critical subject alignments – especially close-ups.
● A rangefinder system allows accurate auto or manual focusing of subjects down to about 1 m. But where you have access to the camera lens image – on SLR and view cameras – you combine focus, framing, and visual check of depth of field, whatever lens is fitted.
● A focal-plane shutter works with all lenses, permits lens change in mid-film, and allows reflex image viewing. But installed in cameras larger than 35 mm an FP shutter may not suit flash at fastest speeds, (it also sounds noisy).
● 35 mm or rollfilm magazine backs, an additional 35 mm body, or separate filmholders (sheet film cameras) all enable you to shoot a subject on more than one type of film.
● TTL metering systems accurately read image light from inside the camera, work with all lenses and attachments. Most compact cameras have a simple measuring cell facing the subject direct. You need a hand meter for cameras without built-in exposure reading.
● The larger your camera format, the better the image detail and gradation in big enlargements, the less the depth of field, and the more camera movements that may be available. Smaller-format cameras are less obtrusive, more flexible, have 'faster' lenses and allow rapid sequences to be shot.
● View cameras, basically simple, offer large-screen composition and focusing, depth of field check and camera movements. But they are bulky and slow to use, need a stand, and give a dim, upside-down image. They remain practical for architecture and still life because of movements and have features that encourage very considered compositions.
● Compacts, all-in-one cameras, offer complete exposure and focus (AE and AF) automation and can be brought into use quickly. Their direct viewfinding system is bright, but has parallax inaccuracies and

cannot show depth of field. The built-in lens is usually a zoom type. The camera's built-in flash tends to give 'red-eye' if there is no other means of positioning the flash unit. Good for candids because of speed and quietness.

- The APS sub-35 mm format system minimizes the knowledge you need to load film and shoot pictures. Closely aligned to photofinishing services, you never actually see the film or processed negatives. The (mainly direct viewfinder type) cameras are smaller, lighter, more fully automated than 35 mm. But they allow you little control beyond lens zooming and choice of picture shape.
- Professional type direct viewfinder cameras are mainly rollfilm formats; lenses are either interchangeable or zoom types; and have a manual rangefinder or an autofocusing system. Specialist designs include shift cameras and wide-angle types. Some large format baseboard cameras accept a viewfinder for hand-held work.
- Twin-lens rollfilm reflexes allow full-format image focusing and composition, up to and during exposure. But the finder shows images reversed left-to-right, suffers parallax error and normally cannot show depth of field.
- Single-lens reflexes provide critical focusing, accurate viewfinding and (if pentaprism) correct-way-round composition. Most 35 mm types offer multi-option TTL exposure automation, plus autofocus and autowind. A manual model is probably your best choice when first learning photography. Cameras are backed up by an extensive range of interchangeable lenses and accessories.
- SLR cameras lose the viewfinder picture during exposure, and there are restrictions on flash shutter speeds and camera movements. But they tackle most subjects well, within limits of format size (35 mm or rollfilm).
- Remember, a camera is only a means to an end. Don't become so absorbed in the various models that photography becomes camera collecting. They are only tools to make photographs – learn to use them thoroughly, then concentrate on the photography.

Projects

1 Organize for yourself 'hands on' experience of each of the four camera types described – view, compact, twin- and single-lens reflexes. Compare practical features such as weight and balance (hand-held cameras) and the ease of working fingertip controls. Do you feel at home with their format proportions, the clarity of focusing and ability to frame-up shots? Check prices, including any extra lenses and accessories you will eventually need, plus film processing and enlarger equipment necessary for this format.

2 Decide the best *pair* of cameras together able to cover the widest range of work you expect to do. They are likely to complement rather than repeat each other's features, but don't leave gaps – tasks that neither camera can really tackle.

3 Make a comprehensive list of the technical features you consider (1) essential, (2) useful but additional, and (3) unnecessary, in a 35 mm SLR camera. Obtain brochures on two or three competing models (similar price range) and compare them for each item on your list.

5
Using different focal length lenses, camera kits

If you are using an SLR or view camera the camera itself is only part of the 'tool box' you need for taking photographs. Ability to interchange lenses means you will soon want to explore use of different focal lengths. Even if you work with a compact camera permanently fitted with a zoom it is worth understanding how its range of focal lengths influence picture making. Remember too that there are dozens of accessories – from tripods and other supports to flashguns and camera bags – worth considering as useful practical kit for your kind of photography.

Why change focal length?

Lenses of fixed focal length (i.e. not zoom) regarded as standard for cameras reviewed in the last chapter are typically 100 mm focal length for 6 × 7 cm format; 50 mm for 35 mm (compact cameras 34 mm focal length); and 27 mm for APS cameras. As Figure 3.4 showed, most of these combinations gives an angle of view of about 45°.

To help understand why 45° is considered normal, try looking through a 35 mm SLR fitted with a standard lens, holding the camera in upright format and *keeping both eyes open*. Compare picture detail on the focusing screen with the subject seen direct. Your naked eye sees a great deal more of your surroundings, of course. But within the area imaged by the standard lens and isolated by the picture format the relative sizes of things at different distances match normal eyesight.

If you keep to the same format camera but change or zoom the lens to a longer or shorter focal length you can:

1 Alter angle of view (enlarge or reduce image detail and so get less or more subject in).
2 Disguise how far or how close you are from the subject and so suppress or exaggerate perspective in your picture.

Each of these changes has an important influence on how your picture is structured.

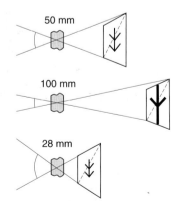

50 mm

100 mm

28 mm

Figure 5.1 Changing focal length but keeping the same picture format alters the combination's angle of view. Compare this with Figure 3.4

Enlargement of centre of 28 mm shot

135 mm

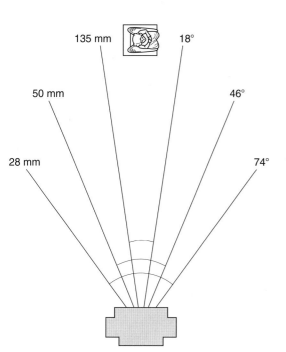

50 mm

28 mm

Figure 5.2 Angles of view given by lenses of different focal lengths used on a 35 mm format camera. Right: appearance when focal length is altered without change of subject distance. Top left: enlarging part of the 28 mm lens image proves that lens change alters magnification, but not perspective. All shots were taken at the same aperture. Note the 28 mm blow-up has greater depth of field, but enlarged grain gives poorer detail than sharply imaged parts of the 135 mm lens version

Getting less, or more, subject in

Changing the lens in your camera to a longer focal length (or zooming to 'tele') makes the image detail bigger – so you no longer include as much of the scene and the angle of view becomes narrower (Figure 5.1). At first sight you seem closer to your subject but this is only an illusion due to enlargement; see Figure 5.2. Creating larger detail this way is handy if you cannot get close enough to your subject – for example in sports and natural-history work, candids and architectural detail.

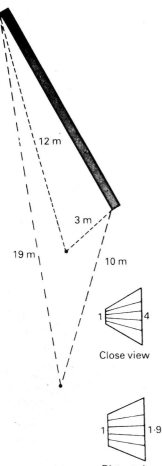

Figure 5.3 Viewpoint and perspective relationship. The apparent convergence of horizontal lines in this oblique wall grows less steep as the viewer's distance increases. See text

Any slight movement of the camera is also magnified, so if you are using it hand-held, consider picking a faster shutter speed to avoid blur. Other changes include less depth of field for the same *f*-number. A 100 mm lens gives half the angle and twice the image magnification of a 50 mm lens, assuming distant subjects.

Changing instead to a shorter focal length lens (or zooming to 'wide') gives all the opposite effects. You include more scene, noticeably foreground and surroundings, everything is imaged smaller, and there is greater depth of field. A wide-angle lens is particularly useful for cramped locations, especially building interiors where a standard lens never seems to show enough. Similarly, you can shoot views, groups, or any large subject where it is otherwise impossible to get back far enough to get everything in. The lens must be *designed* as a wide-angle. Don't try to take a standard 50 mm lens from a 35 mm format camera and use it as a wide-angle in a large format camera – the picture will probably look unsharp and dark at the corners, see Figure 5.11.

Altering perspective

By changing focal length *together with your distance from the subject* you exert an important, powerful influence on the perspective of your pictures. Perspective itself is concerned with the way objects at different distances appear to relate in size, and how parallel lines seen from an oblique angle apparently converge towards some far-off point – all of which gives a strong sense of depth and distance in two-dimensional pictures of three-dimensional scenes.

As Figure 5.3 shows, if you look obliquely at a garden wall of uniform height you see the nearest end much taller than the far end. The difference between these two 'heights' is in direct ratio to their distances from you, so if the near end is 3 metres away and the far end 12 metres, ratio in height is 4:1. But move back until you are 10 metres from the near end and the far end will be 19 metres (10 m + 9 m) away. The ratio becomes only 1.9:1, and the wall's visual perspective is less steep.

Perspective therefore alters according to the distance of your viewpoint from the subject. But if you can change lens focal length you can disguise a viewpoint change by adjusting the lens to include the same amount of subject. Imagine taking one photograph of the oblique wall using a 50 mm lens, 3 metres from its near end. If you then stepped back to 6 metres and took another shot using a 100 mm lens instead, the wall's near end would record the same size but have a less diminished far end, giving flatter perspective and therefore less apparent depth.

Use *steep perspective* (close viewpoint, plus wide-angle lens or shortest focal length zoom setting) whenever you want to exaggerate distance, caricature a face into a big nose and tiny ears, or dramatically emphasize some foreground item such as an aggressive fist, Figure 5.8, by exaggerating its relative size. Similarly use it to create a dynamic angle shot looking up at a building and exaggerating its height.

Use *flattened perspective* (distant viewpoint, plus telephoto lens or longest focal length zoom setting) to compress space, to make a series of items one behind the other appear 'stacked up', adding a claustrophobic effect to a traffic jam or a crowd. In landscapes it helps to make

Figure 5.4 Controlling perspective. Each picture here was taken with a lens of different focal length (35 mm format), but the camera distance was altered each time. The near end of the monument remains about the same height but the scale of detail furthest away is dramatically different, changing your impression of depth and distance

28 mm

50 mm

135 mm

background features dominate over the middle distance, or merges both into flat pattern. Portraits tend to be more flattering, with nose and ears shown in proportions closer to true size.

Explore these controls over perspective and learn how they can help make the point of your picture. But if overdone (the two extremes of focal length giving either telescope or fishbowl effects) they easily become gimmicks which overwhelm your subject matter. See also digital manipulation of perspective, page 287.

The appearance of perspective in a photograph also depends finally on its finished size and the distance from which it is viewed. Strictly speaking, the image appears natural in scale and perspective if your ratio of *picture width to viewer distance* matches the ratio of *subject width to camera distance* when the shot was taken. This means that if something 4 metres wide is photographed from 8 metres (ratio 1:2) the print will look normal seen from a distance twice its width – perhaps a 12.5 cm wide print viewed from 25 cm, or a 50 cm print viewed from 100 cm. In practice you tend to look at all hand-size prints from a 'comfortable' reading distance of about 25–30 cm, which usually works out right for natural perspective appearance from normal-angle lens photography. But reading wide-angle close shots and long focal-length distant shots from the same viewing position makes their steepened or flattened perspective

Figure 5.5 Walker Evans' choice of a long focal length lens and distant viewpoint made these industrial chimneys of Bethlehem, Pennsylvania, dominate over the workers' graveyard. Technique strengthens a powerful human statement

Figure 5.6 New York from the top of the Empire State Building using a 35 mm camera with 150 mm lens. From such a distance perspective and scale change between foreground and background elements are minimized. This heightens the grid-like pattern

Figure 5.7 Using a wide-angle (24 mm) lens here allowed all six benches to be included and exaggerates the much closer shadowy foreground.

Figure 5.8 Exaggerated scale gives dramatic emphasis. Shot from a viewpoint close to the fist, using a 35 mm camera with 28 mm wide-angle lens, at wide aperture

very apparent. If you want to exaggerate the illusion of compressed space and flattened perspective, print long-focal-length (narrow-angle) shots big, and hang them in enclosed areas where the viewer has to stand close, see also Figure 5.14.

Interchanging lenses in practice

On view cameras the shuttered lenses are changed complete with panels. When you fit a wide-angle, the lens has to be quite close to the focusing screen to give a sharp image. This may mean changing to a recessed lens panel, or removing the regular bellows from a monorail and using shorter 'bag bellows' instead (Figure 5.9). You must be careful not to let the front of the rail (or the front track on a baseboard camera) be included in the lens's wide angle of view.

The greatest variety of interchangeable lenses today are made for single-lens reflexes, especially 35 mm format. Originally their range was very restricted by the need for wide-angles to be placed close to the film, where they fouled mirror movement, and the awkward physical length of long focal length lenses. (This distancing problem is now solved optically by making long-focus lenses of *telephoto* construction and wide-angles of *inverted telephoto* construction.) Most small- and medium-format wide-angle optics today are of inverted-telephoto design, and virtually all long focal lengths intended as narrow-angle lenses are telephotos. This is why we tend to use the word 'telephoto' to mean the same as long focus.

Lens coverage. As Figure 5.11 shows, there are limits to the area a lens will cover with an image of acceptable quality. Designed for a 35 mm camera it will certainly perform well over a patch at least 43 mm diameter. But used on a 6 × 6 cm format picture corners show poorer definition, and on 4 × 5 in edges and corners become darkened.

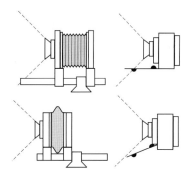

Figure 5.9 Top pair: using a wide-angle lens with a view camera, you risk including the front part of the rail or baseboard in your picture (only apparent when the lens is stopped down). Bottom: arrange that the monorail projects behind rather than in front, or use a drop baseboard. To focus the lens close enough to the film, change the monorail to compact bag bellows, or fit a recessed lens panel

Figure 5.10 Angle of view given by different combinations of lens focal length and camera format diagonal. Lenses must be capable of fully covering the picture format

Irrespective of focal length then a lens is designed to 'cover' adequately a particular picture size. You could possibly use it in a *smaller* format camera, but not a larger one. In practice you cannot make mistakes on small- and medium-format cameras because their lens mounts prevent you attaching unsuitable optics.

The lens mounts for these camera sizes also differ brand-for-brand – you cannot fit lenses from a Nikon to an Olympus body, and so on. Each maker also has different (patented) mechanical and electrical couplings between body and lens to convey information about the aperture set, to control autofocus, etc. Occasionally, when a maker develops a new body, lens mounts are changed – but this is done as rarely as possible to keep faith with previous purchasers of their equipment.

Independent lens makers produce optics to fit a range of cameras; you specify the type of body and the lens comes fitted with the appropriate coupling. The quality of the independent lenses varies more than lenses supplied by the camera manufacturer. The latter have to reach a minimum optical standard common to an entire range. The best independent brands are consistently good too, but cheapest lenses undergo less rigid quality control and may be anything from quite good to poor.

Lens kits

Wide-angles. There is no doubt that standard lenses (normal focal length) represent best value for money. Made in large quantities, they tend to be cheaper and have wider maximum apertures than wide-angles and longer focal length lenses, including zooms. However, if you often photograph architectural interiors and exteriors or need to use dramatic angles and steep perspective, the next interchangeable lens to buy after a standard is a wide-angle. As Figure 5.12 shows, a popular focal length wide-angle, giving about 70–80°, is 28 mm for 35 mm format (40 mm for 6 × 6 cm, or 90 mm for 4 × 5 in). Using lenses wider than 80° (24 mm focal length on a 35 mm camera) begins to introduce 'wide-angle distortion', making objects near corners and furthest edges of your picture appear noticeably elongated and stretched. It is like having additionally steep perspective in these zones, although you can help to disguise the effect by composing plain areas of sky, ground or shadow here.

Another feature of a wide-angle lens is that it gives greater depth of field than a standard lens at the same aperture. This can be an

	Wide-angle							'Normal'		Long focal length								
	100°	94°	90°	80°	74°	62°	56°	**50°**	**46°**	28°	24°	21°	18°	14°	12°	8.5°	6°	2.5°
35 mm ▶	18	20	21	25	28	35	40	**45**	**50**	85	100	120	135	180	210	300	400	1000 mm
6 × 6 cm ▶			38	45	55	65	70	**80**	**93**	150	185	220	240 mm					
6 × 7 cm ▶			45	50	60	70	80	**90**	**105**	165	210	240	270 mm					
5 × 4 in ▶			75	90	105	130	140	**165**	**180**	300	370 mm							
10 × 8 in ▶					210	265	285	**330**	**360**	600	740 mm							

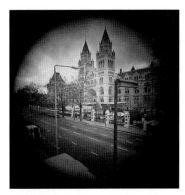

Figure 5.11 Lens coverage. The total circular image patch formed by an 85 mm lens designed to cover 35 mm format (inner frame). Used as a normal angle lens on a 6 × 6 cm format camera edges begin to darken. And attempting to use it as a wide-angle on 4 × 5 in (outer frame lines) uneven illumination and corner 'cut off' becomes obvious, particularly when the lens is stopped down. See also Camera movements, page 306

advantage, but also makes it more difficult to pick out items by differential focus. Extreme wide-angles virtually need no focus adjustment and record everything in focus – from a few inches to infinity. Also they may no longer accurately image vertical and horizontal lines near picture edges as straight, becoming 'fisheye' lenses, Figure 5.13.

Long focal lengths. Perhaps you will choose a telephoto instead of, or as well as, a wide-angle. A moderately long focal length, such as 100 mm on 35 mm format (24°) makes a good portrait lens. It will allow you to fill the frame with a face from a distance of about 1.5 metres, which avoids steep perspective and a dominating camera presence. Longer lenses will be needed for natural history subjects, sports activities, etc., which you cannot approach closely, or any scene you want to shoot from a distance to show it with bunched-up, flattened perspective.

Working in the studio on still lifes, moderately long focal length lenses are again an asset. With food shots, for example, such a lens allows the camera to be kept back from the subject, avoiding any elliptical distortion of plates, tops of wine glasses, etc.

In general, lenses with angles of view of less than 18° begin to make you conscious of 'unnatural' scale relationships between nearest and farthest picture contents. This is more like looking through a telescope than seeing the scene direct. The longer the focal length, too, the more difficult it is to get sufficient depth of field and avoid camera shake when using the lens hand-held. (As a rule of thumb the longest safe shutter speed is the nearest fractional match to lens focal length, e.g. no slower than 1/250 sec with a 200 mm lens.)

Your image contrast is frequently lower than with a standard lens, especially in landscape work where atmospheric conditions over great distances also take their toll. Image definition is easily upset in pictures taken through window glass. Another problem is the size and weight of long focal length lenses. Beyond 500 mm it is usual to have to mount *the lens* on a tripod, with the camera body attached.

Wide-angle and telephoto 'converter' attachments are available for some SLR lenses. A wide-angle device fits over the front of the

Figure 5.12 Some camera-body/lens kits. Each include normal, wide-angle and long focal length types designed for the format

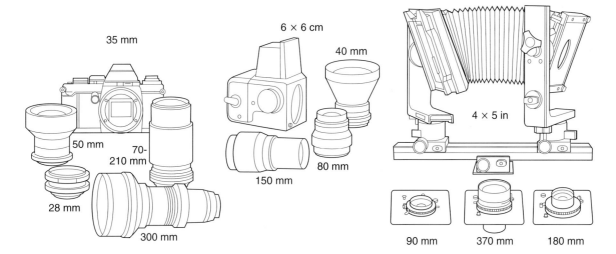

Figure 5.13 Fish-eye lens distortion. Inside an antique British telephone box, taken with a 35 mm camera and an 8 mm fisheye lens designed to give a 220° angle of view. This extreme lens forms a circular picture with vertical and horizontal lines increasingly bowed according to their distance from the centre

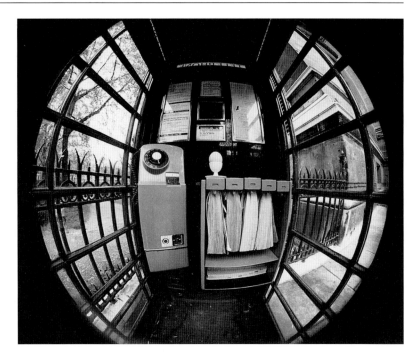

prime lens and typically reduces focal length by 40 per cent. A tele attachment fits between lens and body and typically doubles the focal length. Provided the tele attachment is a multi-element unit designed for your particular lens, image quality will be maintained. The combination has its aperture reduced by two f-number settings if focal length is doubled. Wide-angle attachments are more prone to upset your image definition near picture edges – you should always use them well stopped down.

Fixed focal lengths, or zooms?

A zoom is a lens of *variable* focal length – altered by shifting internal glass elements. It is built into most modern compact cameras which do not allow interchangeable lenses anyway. However, for cameras such as SLRs you can decide between a chosen set of lenses of fixed focal length, or have one (or perhaps more) zoom lenses. The control on the lens for changing focal length is usually a separate ring or, with some longer focal length zooms, a sleeve on the lens barrel that you slide forwards and backwards. Turning the same sleeve focuses the lens ('one-touch' zooms). A zoom lens fitted to a compact camera is altered by W and T buttons or a switch controlling a motor inside the body. This also adjusts the viewfinder optics to match the changing angle of view.

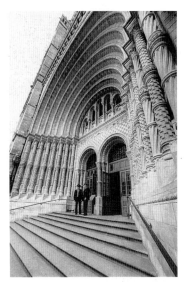

Figure 5.14 Wide-angle distortion. Extreme wide angle lenses (here 16 mm used on a 35 mm camera) gives unacceptable distortion with a subject of known shape, unless you want a special effect. However, viewing this page from 3.3 cm would make picture perspective appear normal

Good quality zooms are optically complex – the focused subject distance must not change when you alter focal length, and the diaphragm must widen or narrow to keep the f-number constant. Also aberration corrections must adjust to maintain acceptable image quality throughout the entire range of subject distances and focal lengths. The best-quality zooms give image quality as good as fixed-focal-length

lenses. Limits to their aberration correction at the extremes of zoom range typically show up as straight lines near frame edges bowing inwards or outwards. As Figure 5.16 shows, the greatest choice of zoom lenses is to be found in the standard-to-telephoto (50–200 mm) range band. But increasingly you can also get wide-angle zooms spanning 24–85 mm, or tele-zooms 200–600 mm. Perhaps handiest of all are zooms which range more moderately either side of normal, such as 28–80 mm.

The practical *advantages* of a zoom are:

1 A continuous change of image size is possible within the limits of its zoom range – far more flexible than having several interchangeable fixed focal length lenses.
2 Ability to frame up action shots, candids, and sports pictures where things can happen unexpectedly and you may be too far away or too close with any regular lens.
3 No risk of losing a picture because you were changing lenses at the decisive moment.
4 Fewer items to carry.
5 Ability to zoom (or change image size in steps) during actual exposure, for special effects.
6 On most zooms, there is a 'macro mode' facility for ultra-close work, see page 90.

Figure 5.15 A 70–210 mm zoom used at its focal-length extremes (top) and when zoomed throughout a ½ second exposure (bottom)

A zoom's *disadvantages* are:

1 Widest aperture is about 1–1½ stops smaller than a typical fixed focal length lens, e.g. $f/3.5$ instead of $f/2$.
2 It is more expensive and often bigger than any one fixed lens within its range.
3 The continuous focusing scale does not usually go down to close subject distances.
4 Some cheaper types give poorer image contrast and definition, and distort shapes when used at either limit of their zoom range.
5 Zooms can make you lazy about using perspective well. It is tempting to just fill up the frame from wherever you happen to stand. Instead, always try to choose a viewpoint and distance to make best use of juxtapositions, give steep or flattened perspective. Only *then* adjust focal length to exactly frame the area you want.

Even high quality zooms may change their maximum aperture between the extremes of zoom range, for example giving half or one stop less light at the longest focal length setting (maximum aperture is then engraved $f/3.5/4.5$, or similar). This is unimportant provided you are using a through-the-lens meter, but remember to allow for it if you are shooting at the lens's widest settable aperture and working with a separate meter, or a non-dedicated flashgun (page 195).

Depth of field always changes throughout the range, unless you compensate by altering f-number. It is greatest at shortest focal length, so whenever practical focus your zoom at its longest focal length setting, making critical sharpness easy to see – then change to whatever focal length you need.

Far fewer zoom lenses are designed to cover rollfilm formats. Not only is the market smaller, but size and weight greatly increase if the lens is to have a usefully wide aperture. (A 100–200 mm $f/4.8$ zoom may easily weigh 2180 g, against 480 g for a 80 mm $f/2$ fixed focal length lens.) Other lenses worth considering for a small- or medium-format camera kit are a shift lens (page 306) and a macro lens (see below). It is seldom worth buying lenses of extreme focal length; for example a $f/4$ 600 mm lens for 35 mm costs over thirty times the same maker's 50 mm standard lens! Instead it is possible to hire them for

Figure 5.16 Zoom range. The focal-length range of some commercial zoom lenses designed for 35 mm format. Zoom range is also given as the relationship of longest to shortest settings (×2 for 35–70 mm or 25–50 mm lenses; ×3 for 35–105 mm, etc.)

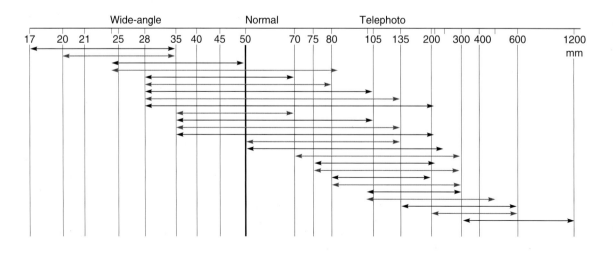

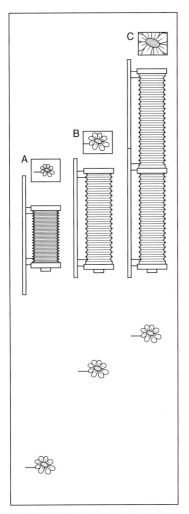

Figure 5.17 Bellows extension needed for close-ups. A: view camera focused on distant subject. B: imaging the subject life-size requires bellows twice the lens focal length. C: the same lens needs two sets of these bellows and an extension rail, to image the subject three times life-size. See also Figure 2.20

unusual jobs, when optical distortion and unnatural perspective are perhaps an essential element in a picture. For most work such devices are a distraction, and become monotonous with overuse. You will often do better by moving either closer or farther back, and using more normal optics.

Close-up equipment

The closest you can approach a subject and still focus a sharp image depends on how far the lens can be spaced from the film *relative to its focal length*. Typically this subject distance in about ten times the focal length. A 35 mm camera with standard 50 mm lens focused out to its closest subject distance gives an image about one-tenth life size. This can also be written as a ratio of 1:10, or magnification of ×0.1.

Most 5 × 4 in monorail view cameras have bellows which will stretch to at least 36 cm. Used with its standard (180 mm) lens, this allows you to approach close enough to get an image up to life-size – a ratio of 1:1 or magnification of ×1. Anything larger calls for cumbersome extra bellows (Figure 5.17). To shoot close-ups using a small- or medium-format camera you can expect to need some extra equipment. There are various options (Figure 5.18):

1 Adding one or more extension rings, or a set of bellows, between camera body and lens.
2 Changing to a 'macro' lens with its own built-in, extra-long focusing movement.
3 Using a zoom lens set to 'macro'.
4 Fitting an accessory close-up lens or adaptor over the front of your standard lens.

Of these only option 4 (or in some instances 3) is practical on cameras fitted with non-interchangeable lenses.

Bellows, or rings

Bellows allow you maximum flexibility in focusing close subjects, although at *minimum* extension their bulk often prevents you getting a sharp image of anything further away than about 30 metres. Rings or tubes are cheaper than bellows, and come in sets of three (typically 7, 14 and 25 mm for small-format cameras). These can make up seven alternative lengths, used singly or in combinations. Together with your lens's own focusing adjustment, each gives you an overlapping range of distances so you can achieve some continuity of focusing; see Figure 5.19.

Simplest bellows and tubes are 'non-automatic' meaning that the preset aperture of the camera lens no longer remains wide open until the moment of shooting. So you must be prepared to compose a dim image every time a small aperture is set. 'Automatic' extension units maintain a mechanical link between lens and body, so that the SLR aperture system still functions normally.

In all instances, your camera's through-the-lens meter still gives an accurate exposure reading. However, with options 1–3 above, if you are

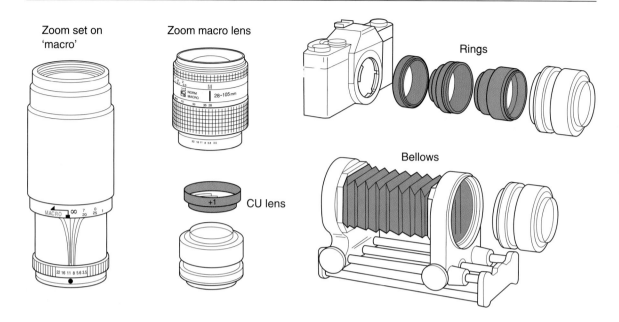

Zoom set on 'macro'

Zoom macro lens

Rings

Bellows

CU lens

Figure 5.18 Alternative ways of sharply focusing close-up subjects with a 35 mm camera

Figure 5.19 This set of extension rings (1, 2 and 3) can be used in seven different combinations. Added to the normal focusing adjustment of the 50 mm camera lens, they allow an overlapping sequence of sharply focused subject distances, from 38 cm (nearest focusing for the lens used alone) down to 10.5 cm

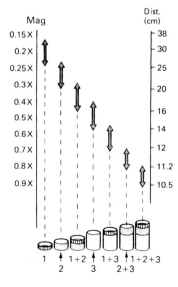

using any *other* form of metering (such as a hand meter) the exposure shown must be increased to compensate for the effect of the unusual lens-film distance; see page 191.

Macro lens

Macro lenses are designed for close-up purposes, computed to give best performance and maximum correction of optical aberrations when subject and image distances are similar. (The word 'photomacrography' refers to imaging at about 1:1 scale.) They cost more than regular lenses, and also stop down further. Typical focal length, for 35 mm format, is either 50 mm or 100 mm, with an aperture range of $f/2.8$–32.

The focusing movement on a general macro lens takes it continuously from infinity setting to 1:1 ratio or beyond. This range, plus its aperture preset facility, makes it very convenient to use. Such macro lenses give acceptable results with distant subjects too, but for close-ups offer better definition than a normal lens used in conjunction with bellows or rings.

Macro zooms

Most zoom lenses, when set to shortest focal length, allow you to select a 'macro' setting which repositions internal elements. You can then sharply image subjects within a narrow range of close distances. Typical magnification ratios are around 1:4. Some zooms give quite poor quality close-ups, showing image softening towards corners of the frame.

Quite different in terms of performance, a few *zoom macro* lenses have recently been introduced for 35 mm cameras. Such a lens allows you to zoom around from, say, 70 mm to 170 mm while working just 150 cm from your subject, yet deliver high image quality. They are very expensive (but again may be hireable).

Close-up lens attachment

If you attach a converging 'close-up lens' over the front of your standard lens its focal length is changed. Or, to put it another way, the combination allows you to focus on a subject at a distance equal to the attachment's focal length, when the prime camera lens is set for infinity. Attachments are usually calibrated in dioptres such as +1, +2, etc. The higher the dioptre the greater the magnification, and the shorter its focal length.

Adding a close-up lens means you can work *without* having to extend the normal lens-film distance, or alter exposure. They therefore suit cameras with non-interchangeable lenses.

Figure 5.20 A selection of camera accessories. 1: rubber lens hood. 2: pistol grip hand-held camera support. 3: pocket tripod. 4: focusing screen viewing hood, replaces pentaprism on some models, for waist-level shooting. 5: eyepiece cup. 6: right-angle eyepiece. 7: cable release. 8: tripod carrying pan/tilt head, also monopod. 9: bulk 35 mm film back. 10: instant picture back for 6 × 6 cm. 11: rollfilm back for view camera. 12: changing bag. 13: flashgun. 14: travelling case for view camera kit. 15: aluminium, foam-filled, general camera case. 16: padded, compartmented shoulder bag

Essentials, and extras

Choosing other accessories for your camera kit is mostly a matter of personal selection. Build them up from essentials – for example, a cable release and a tripod (with a pan and tilt top) are needed sooner or later for every camera type. Match the tripod to the camera's size and weight, and don't overlook the value of a small table tripod

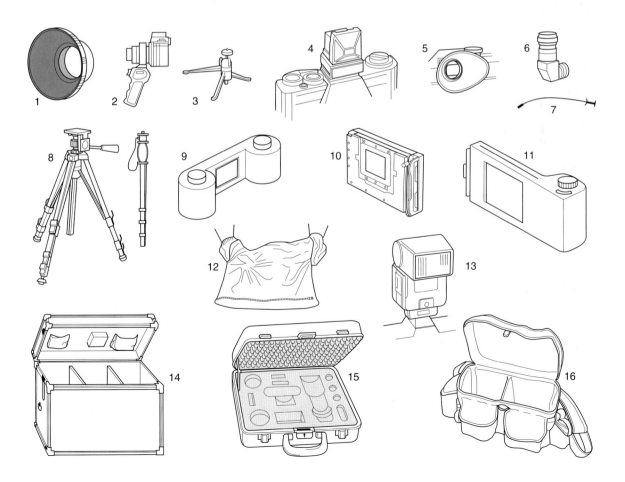

or clamp fitted with a ball and socket head. One of these will pack easily into a shoulder bag. For support in action photography – especially when you use a telephoto lens – try out a monopod, or a pistol grip camera support. These are all more portable and less obtrusive than a tripod.

If your camera has no built-in exposure meter you must have a hand meter, see page 189. You will also need filters for black and white and colour photography (Chapter 9), plus some form of filter holder to suit the front diameter of your set of camera lenses. The holder can form part of a lens hood (Figure 5.20), an accessory always worth fitting to reduce flare when your subject is lit from the side or rear. It can also protect your lens. However the hood must not be so deep that it protrudes into the field of view. Take care when using a zoom lens set too wide, and stopped down.

You will probably need a portable flashgun for use on location. This might be a powerful 'hammer-head' type sufficient to light fairly large architectural subjects, or a smaller dedicated gun which mounts on the camera (page 197). See also studio flash, Chapter 7.

There are several worthwhile accessories for viewfinding and focusing. An SLR viewfinder eyecup helps to prevent reflections and stop sidelight entering the eyepiece, which confuses the meter system on some models. A right-angle unit is helpful for low viewpoints and when the camera is rigged vertically for copying. A few 35 mm and most rollfilm SLR cameras allow the pentaprism to be interchanged. You can then fit a waist-level finder, a high-magnification finder, or an action finder which allows you to see the image from a range of distances and angles. You can also change focusing screens to suit the work you are doing – perhaps fit a cross-line grid screen for copying.

Provide yourself with ample film holders for a view camera, or film magazines for cameras (i.e. rollfilm) which accept interchangeable backs. Instant-picture film backs are a good investment for large- and medium-format professional work. They allow a final visual check on lighting, critical layout and exposure, and confirm the correct functioning of your flash and shutter equipment.

All the leading camera brands offer dozens of other accessories, ranging from backs which light-print words and numbers on every frame, to underwater camera housings, and radio or IR remote shutter releases. See also digital backs, page 103. A changing bag is a useful standby if film jams inside any camera or magazine, or you must reload sheet film holders on location. Other 'back-up' includes a lens-cleaning blower brush, lens tissue, and spare batteries.

You will also need one or more cases for your camera kit. There are three main kinds. Large metal cases with plastic foam lining have compartments for the various components of a view camera outfit plus accessories. This kind of case has the advantage that you can stand on it – when, for example, you are focusing the camera at maximum tripod height. A smaller, foam-filled metal attache case suits a medium- or small-format kit and is designed for you to cut away lumps of foam to fit your own choice of components. (Avoid cases which make it obvious they contain photographic equipment, and so encourage theft.) A tough waterproof canvas shoulder bag with pouches and adjustable compartments is one of the most convenient ways of carrying a comprehensive 35 mm outfit.

Figure 5.21 Examples of camera kits. In addition each kit needs an appropriate tripod, lens hood, filters and cable release

35 mm kit
Two bodies
28, 50, 105 mm lenses or zoom
 equivalents
Tele-converter
Extension tubes
Flashgun

6 × 6 cm kit
Body
Two magazines
Instant-picture back
50, 80, 200 mm lenses
Magnifying hood
Pentaprism finder
Extension tubes
Hand meter
Flashgun

5 × 4 in kit
Camera with standard and wide-
 angle bellows
90, 180, 240 mm lenses
Six double sheet film holders
Instant-picture back
Focusing hood or cloth
Hand meter

Horses for courses

No two photographers will agree on the contents of an 'ideal' camera kit. The three outfits listed in Figure 5.21 are each reasonably versatile within the limits of a 4 × 5 in view camera, 6 × 6 cm SLR, and 35 mm SLR respectively. For more narrowly specialized subjects you could simplify each of these kits, discarding some accessories and perhaps adding others.

For example, for *portraiture* work using a medium-format SLR, have wide-aperture normal and medium long focal length lenses (or zoom equivalent) plus tripod. Include flash, a folding reflector board (Figure 7.23), some effects filters, and several film magazines.

For *architectural* interiors and exteriors you might use a monorail view camera outfit with normal and wide-angle lens, normal and bag bellows, tripod, high-sensitivity hand meter, film holders and instant-picture back, a powerful flashgun, and colour filters.

For *sport and action* you are likely to need a 35 mm motor-driven autofocusing SLR with 28–200 mm zoom, ultra-wide-aperture normal lens (for indoor activities), 300 mm lens plus ×2 adaptor, 21 mm wide-angle lens, tripod or monopod, and an additional body. If you cover sport for newspapers one body should be digital, complete with laptop computer and modem.

Finally, whatever your type of work, regard a *radiophone* as an essential part of your kit.

Summary. Using different focal length lenses, camera kits

- Changing the focal length of a camera's lens alters image size and therefore angle of view.
- A longer focal length enlarges detail, gives narrower angle of view, less depth of field, and exaggerates blur from camera shake.
- A shorter focal length (wide-angle lens) makes image detail smaller, increases depth of field, diminishes camera shake blur. Extreme wide-angles begin to distort the apparent shapes of objects farthest from the picture centre.
- Perspective in pictures depends on your camera's viewpoint and distance relative to different elements in a scene. Results are also influenced by final print size and viewing distance.
- To steepen perspective, move closer *and* change to a wide-angle lens. To flatten perspective, move farther back *and* change to a longer focal length.
- Extreme focal lengths give such unnatural images they must be used with restraint. The most versatile kits contain moderately wide and telephoto lenses plus a normal lens, or (small-format cameras) one or more zooms covering all these focal lengths.
- Zooms provide a continuous focal length range, avoid wasted moments when lens changing, and offer zoom effects and macro focusing. But they have a smaller maximum aperture and tend to be larger than fixed focal length lenses.
- You can focus very close subjects by increasing lens-film distance using rings, bellows, or a macro focusing lens. Recalculate exposure if you are not using TTL metering. Alternatively add a converging element close-up lens to an existing camera lens.

● The most useful other camera accessories include tripod, cable release, filters, hood, flash and separate meter. Also extra film holders, magazines and spare bodies, viewfinder aids and carrying case. Don't forget to have a radiophone.

Projects

1 Get some practical experience of a range of lens types for your camera. Compare the size of image detail, the depth of field (at same f-number), the balance and weight of body plus lens, and degree of image movement produced by camera shake when hand-held. Check out the closest subject distance you can focus.
2 Take full-face head shots of someone you know, using each of a range of lenses from wide-angle to telephoto or different settings of an equivalent zoom. For each focal length adjust your distance so that the subject's eyes are imaged the same distance apart in every picture. Compare the perspective in your results.
3 Test a zoom lens by imaging a squared-up modern building or grid-type subject. Arrange horizontal and vertical lines to run parallel and close to all four picture edges. Check that these lines remain straight and in focus at longest and shortest focal length settings.
4 Try zooming during exposure. Use shutter speeds around $\frac{1}{4}$ second. Have the camera on a tripod and either zoom smoothly throughout exposure or add a brief static movement at the start or finish. Make your centre of interest dead centre in the frame, and include patterned surroundings.
5 Check out the maximum magnification you can obtain with your equipment. Image a ruler and count how many millimetres fills the width of your frame. (With rings or bellows it is easiest to set the lens as far as possible from the film, then focus by moving the whole camera forwards and backwards.)

6
Digital cameras

Digital cameras don't use film. Otherwise many of their features – viewfinder, image-forming lens, aperture, flash – are the same or are closely related to film based equipment. In fact several 'top-end' (most advanced and expensive) digital cameras have made use of host Nikon or Canon 35 mm SLR bodies. Others take the form of a digital sensor contained in a back replacing the detachable film magazine on a medium format SLR camera or the filmholder on a view camera.

The basics on camera and lens features covered in Chapters 4 and 5 therefore mostly still apply. This chapter concentrates on the practical *differences* between digital and film cameras – differences in cost and design; the way your picture is stored and retrieved; and what to expect in terms of image quality. Later Chapter 14 discusses how images from digital cameras (along with film or photoprint images turned into digital form) can be manipulated, retouched or straight colour printed by desktop computer equipment.

Overview – how images are captured

Where the film is normally located in a camera (facing the back of the lens), a digital camera has a light-sensitive receptor known as a CCD or charged-couple-device. The CCD consists of a microscopic grid of millions of pixels (PICture ELements) on a circuit flat board, Figure 6.2. On exposure to the image electrical charges are generated in proportion to how much light each pixel received. These convert into a stream of digital signals – each picture creating a 'file'. The larger the number of pixels the greater the file size and higher the resolution of detail in the image.

Captured image files (the equivalent of exposed film frames) may be stored within a camera's internal micro-processor but are most often transferred to a small removable memory card held slotted into the camera body. You can view pictures in colour, before and after shooting, on a small LCD (liquid crystal display) monitor screen, located on the back of the camera body. At this time too, any shots you have taken but don't want may be deleted and their vacated file space used for new pictures, time and again.

The quantity of pictures a full card can contain depends upon the size of each file (higher resolution images contain more pixels) and the

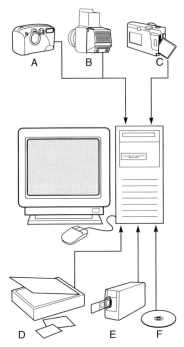

Figure 6.1 Digital image input. The main ways by which digital images are acquired by a computer system. Direct downloading via serial cable from (A) digital camera or (B) digital back. C: readout (via a reader) from memory card removed from digital camera. D: flat-bed scanner for prints. E: film scanner for negatives or slides. F: input from Photo-CD carrying film images scanned in by lab

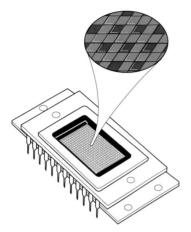

Figure 6.2 CCD image sensor. A 14 × 9.3 mm image area chip containing a grid of 1536 × 1024 (1.6 million) pixel sensors filtered red, green and blue. A CCD this size might be used in a camera with a 17 mm lens

capacity of the card you have currently inserted. It may for instance allow from 5 high resolution pictures to 180 of low resolution. At any convenient time pictures are downloaded from camera or, more often its memory card into a computer. You can then see them on a full size monitor, 'save' files prior to any necessary image manipulation, and print them out in coloured inks onto paper. They can also be transmitted (e.g. by mobile phone) to a computer system located somewhere else, such as a newspaper picture desk.

Film versus digital imaging routes

Digital image equipment now available can give you results which stand comparison with the quality of film-based photography, provided print size is not too large. The technology is relatively new – digital cameras only became a viable, marketable product in the early 1990s. (Popular film cameras have evolved over more than a century.) But in that short time improvement has been dramatic, matching the phenomenal growth of computers. In fact many basic so-called 'low end' digital cameras were introduced as computer peripherals by electronic manufacturers. Practical comparisons between digital and film based equipment should therefore be regarded as fluid. Further technical progress continues apace, causing markets to grow and prices to drop.

The main advantages of shooting digitally are:

- Speed and assurance of results, on-site. For professionals this does away with hours of delay waiting for processed test shots, or costly instant picture material. Your client can approve results as you shoot (not always an advantage!).
- No purchase of film stock or processing lab costs.
- Darkroom facilities unnecessary. No chemical chores or knowledge required. You can output colour prints using your existing desktop computer.
- Digital cameras work silently, are lighter in weight and offer faster shutter speeds than film cameras. Image storage cards cannot be fogged by light or baggage check X-rays (although affected by magnetism or heat).
- Once in the computer your digital images can be worked on with a manipulation software program allowing undetectable retouching, alterations to contrast, colours, depth of field, blur, etc. See Chapter 14.
- Digital pictures are easy to transmit electronically – as reference 'thumbnails' on the web, or high resolution images you can deliver to a client's computer screen for approval, direct to newsdesks, etc.

The disadvantages of shooting digitally presently remain:

- Maximum final print size before resolution breaks up unacceptably (Figure 6.4) relates directly to the pixel rating of your camera's CCD. Results may look great on a computer monitor screen or as small photo-finisher prints. However, for exhibition size work you need large image files – perhaps shooting with a camera having an expensive multi-million pixel sensor and feeding a powerful computer, or more often using film and putting this through a high resolution film scanner. See page 270.

Figure 6.3 Compact digital camera. This contains a 2.3 million pixel CCD. Images record onto a removable, solid state memory card. The LCD monitor on the back displays the picture just taken, and allows scrolling through previous shots. It can also be used as an alternative to the camera's direct viewfinder

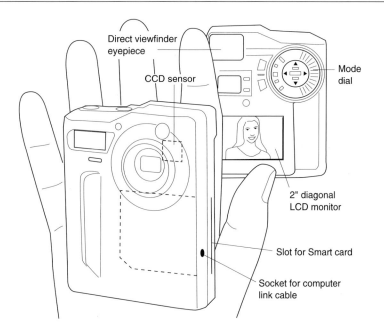

- Digital cameras are much more costly than film cameras, especially if professional quality results are needed.
- Films provide very high image resolution, tone and colour quality at relatively low cost. You can pick from a wide range of ISO speeds, contrast, etc., tailored to particular tasks.
- Hidden running costs. Your outlay on camera batteries can work out greater than the saved cost of film. Blank paper for ink-jet printers costs more than silver-halide colour paper, and printing inks sometimes more than processing chemicals.
- A compact camera's LCD monitor screen is currently difficult to use as a viewfinder in bright light and takes a lot of battery power. If the camera has a viewfinder too you can use this for shooting, keeping the monitor for viewing and editing-out results on the spot. But keep to the monitor for close-up work as this avoids parallax errors.
- Basic digital cameras suffer a brief delay between your pressing the shutter release and the picture being exposed. And after shooting there may be a 2–5 second delay while the picture file is written to the camera's memory or card.
- Unlike processed film, you cannot physically hold up and study your camera images anywhere and at any time. Electronic equipment in some form is always necessary to reveal results.
- Decisions taken at the point of shooting to erase pictures considered unwanted can backfire. With only a fraction of images shot being kept there is no opportunity to re-use initial 'out-takes' later for other markets, exhibitions, etc.

CCD limits to your final print size

Provided your digital camera has a good-quality lens, the resolution of detail the camera will give is indicated by its total number of horizontal CCD pixels multiplied by the number of vertical pixels. For example 1280 × 960 means 1.3 million pixels. See Figure 6.6.

Figure 6.4 Largest print size with acceptable quality depends mainly on the resolution of a digital camera's CCD. Top: 4 × 3 inch ink-jet print from a low-end 0.3 million pixel (0.9 MB) camera. Image quality this size is just good enough for amateur snaps or display on a computer monitor (e.g. Internet). Lower left: part of the same shot when the whole picture is printed out 13 × 9 inches. 'Noise' is breaking up detail and the regular pattern of pixels is becoming discernible. Compare with Figures 6.5 and 9.11. Lower right: image when print size increased to 33 × 23 inches

Figure 6.5 Part of a fine-grain silver halide slide, on Kodachrome 64. This has been enlarged by the same degree of magnification of the camera lens image (×32) as the lower left of Figure 6.4

Pixels are the electronic equivalent of silver halide grains in film emulsions. The smaller the pixels or grains the finer the image resolution captured. But unlike grain, which when magnified appears *irregular* (Figure 9.11) pixels are laid out in a regular grid – a kind of microscopic version of the coloured square-dot pattern you can just see in a TV screen. The human eye picks out regular pattern more readily than granular pattern, particularly since curved or diagonal lines in the image start to show jagged, staircase-like edges known as *aliasing*. Another defect, 'noise' degrades shadow areas with random pixels of the wrong colour. Final colour prints need to carry at least 300 pixels per inch (also expressed as dpi, meaning 'dots per inch') to appear indistinguishable from photoprints from film. This assumes normal eyesight and average print viewing distance.

Calculations are therefore important to tell you the maximum size final picture you can expect from a particular digital camera before image resolution becomes too poor. For example, a very basic level camera with just a 640 × 480 pixel CCD will allow you a print only about 2.1 in × 1.6 in before resolution drops below 300 dpi. (For inch dimensions you divide pixel numbers by 300.) On the other hand if the picture was simply to be used on web pages, and so viewed on a computer monitor with a resolution no more than 72 dpi, you might safely increase size to 8.8 in × 6.6 in.

Camera CCDs with 640×480 (0.3 million) pixels are known as *low-end* or VGA (Video Graphics Array) types. As Figure 6.4 shows, cameras considered *mid-range* CCD resolution, $1524 \times 1012 = 1.5$ million, allow photo-quality 5 in \times 3 in prints, while very expensive *high-end* cameras with $4096 \times 4096 = 16$ million pixels can give prints 13.6 in square.

However, two other factors apply when you are comparing camera CCD specifications. If you are a press photographer working for newspapers where only 150 dpi is the reproduction norm, a 2 million pixel camera will be ample for pictures reproduced up to 10.7 in \times 8.5 in. (But still not good if you get some great shot and later want to blow it up to appear in an exhibition or a large format book.) The other point concerns file size. A 1.5 million pixel CCD fills over 4 megabytes of memory with each picture, greatly limiting your number of shots per card. Cameras therefore often contain '*compression*' software which reduces the number of bits of data, forming a smaller image file. You can pre-select Fine, Normal or Basic and so trade off the number of images you can store against their image quality. Later, as necessary, '*interpolation*' software is used to re-expand pixel information, bulking up the original film size by inventing new pixels between adjacent pixels and giving them an averaged colour value. (This is a routine most used for low-end cameras, to end up with a reasonable size print.) Interpolation goes some way towards restoring original resolution, but detail is inevitably lost. So as a shrink/expand file route regard it as a convenience to reduce storage space and accelerate image downloading or transmission, but no substitute for an uncompressed large file from a high end CCD.

Comparison with 35 mm film resolution. So how do all these figures compare with what resolution you can expect from film? It's difficult to establish a firm pixel-comparison, differing as it does with film type and size of grain, thickness of emulsion coating, etc. (Chapter 9). With slow, 100 ISO film each 35 mm frame has been estimated to contain some 20 million pixel equivalents. Purely from a cost/quality point of view this makes a strong case for shooting with a film camera and having your processed negative or slide high-resolution scanned by a photo lab, perhaps onto an inexpensive photo-CD. The digitalized pictures are then easily downloaded into your computer for manipulation and inkjet print-out (see page 270).

Figure 6.6 The largest size photo-quality prints you can expect to make from cameras with different size CCDs, at 300 and 200 dots-per-inch printer resolution

		Pixels on camera CCD	Memory Needed†	Pics stored per card‡	Max. size print output @300 dpi	@200 dpi
Low-end systems	0.3 M	640×480 (VGA)	0.9 MB	71	2.1×1.6 ins	3.2×2.4 ins
	0.78 M	1280×1024 (XGA)	2.4 MB	26	4.3×3.4	5.1×3.6
Mid-range systems	1.5 M	1524×1012	4.1 MB	15	5×3.4	7.5×5.1
	2 M	1600×1280	5.5 MB	12	5.3×4.3	8×6.4
	2.74 M	2012×1324	7.5 MB	7	6.7×4.4	10×6.6
High-end systems	6.2 M	3060×2036	18.7 MB	*	10.2×6.8	15.3×10.2
	10 M	3280×3280	27 MB	*	10.9×10.9	16.4×16.4
	16 M	4096×4096	44 MB	*	13.6×13.6	20.5×20.5

* Not normally to camera card but direct to high capacity PCMCIA card or hard disk
† Typical (non-compressed) file size per picture
‡ 64 MB memory card

Figure 6.7 Point and shoot low-end camera designs. A: Front and back of a compact type zoom lens camera. B: This design has a pivoting lens, flash and CCD unit. The display panel acts as viewfinder. C: Camera design with a detachable imaging unit cabled to its main body, useful for close natural history work. D: A pivoting design with direct viewfinder

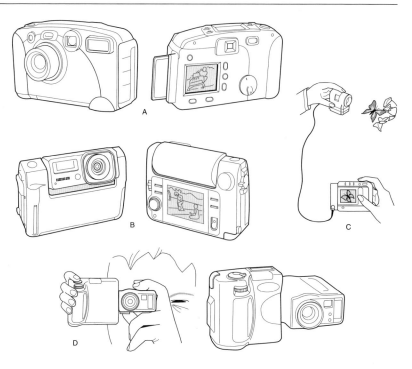

The manufacture of multi-million pixel CCD camera sensors is a high tech industry carried out in Japan, and in Europe by electronics specialists such as Philips (Holland) and Thomson (France). Also by Fairchild (USA), and since 1990, by Eastman Kodak. Chips are currently tiny in size, 8×6 mm in low-end cameras, or 24×16 mm for mid-range bodies similar to 35 mm SLRs, Figure 6.7. Others 36×24 mm match 35 mm film frame size but because of space needed for connections around their edges are more often housed in medium-format type cameras. Larger still and extremely expensive 37 mm square (16 million or more pixels) CCDs are made for digital backs fitting existing medium- and large-format cameras, Figure 6.10.

Relative cost is only one factor. Manufacturers also have to juggle CCD sensitivity to light against pixel size and count. For high sensitivity and good dynamic range (ability to respond to a wide range of brightnesses in an image from dark shadow to bright highlight) a sensor needs large pixels. But for high resolution a high pixel count is required. For the present they have to compromise between a large, costly chip unsuitable for small format camera designs, and the use of even smaller pixels with less sensitivity in competition with film. In practice the light sensitivity of CCDs for low-end cameras tends to be equivalent to ISO 100 film (see page 155). More costly mid-range cameras have chip sensitivity of ISO 200 which may be electronically boosted to over ISO 1000 but at the cost of increasing noise.

Lenses and shutters for digital cameras. One way to improve a digital camera's light sensitivity as a whole is to give it a wide aperture lens. Even low-end cameras with fixed focal length or zoom lenses therefore offer around *f*/2.8. Bear in mind too that since most CCDs are physically smaller than regular film formats lens focal lengths have to be scaled

down to provide angles of view we are already used to in photography, page 40. So a low-end camera with 1/3 inch diagonal CCD often comes with a 6 mm focal length lens, the combination giving an angle of view equivalent to a 40 mm lens on the more familiar 35 mm format film camera. Such lenses are advertised as being '40 mm equivalent'.

Such short focal length lenses provide the bonuses of great depth of field and compact size. Typically widest aperture is $f/2.8$ or $f/4$ and they also zoom within a ×3 range. On the other hand a lens for a digital camera must focus high resolution images on the chip surface – if it is unable to deliver different information to adjacent pixels, CCD pixel count has little meaning.

Bear in mind that in digital photography you will find cameras described as having *optical* zoom lenses, meaning that they change focal length to alter image size, like film camera zooms, page 86. Others offer *digital* zooms as well as or instead. This term means that the area of the CCD used for the image is cropped progressively from full to only the central part. Looking at the LCD screen the effect looks like optical zooming but this arrangement means that image resolution worsens as you zoom in.

The familiar between-lens or focal plane shutter is not strictly necessary on a digital camera. Duration of exposure is controlled electronically by triggering the CCD itself, within a typical range of $\frac{1}{4}-\frac{1}{1000}$ sec or (a few cameras) up to $\frac{1}{16000}$ sec. Some cameras can be programmed to shoot a sequence of two pictures every three seconds, or a 'burst' of 16 shots. This is followed though by a delay while exposures are read to the internal memory or memory card system.

Storing exposed shots on memory cards, disks

With the exception of a few multi-million pixel backs designed for medium-format cameras (sending pictures as they are shot by direct cabling to a host computer's hard disk, page 268) digital cameras mostly store your picture files onto removable media such as PC type cards or disks. The most popular of these are CompactFlash and SmartMedia cards. As Figure 6.8 shows, both are tiny, and being solid state devices they contain no moving parts. Cards are incompatible – cameras accept one or other but not both. These competing systems each offer advantages and disadvantages which alter as technology improves.

CompactFlash cards. Launched in 1996 and supported by Kodak, Nikon, Casio, Canon and others, these are about half the size of a credit card but 3.3 mm thick. They are claimed to be usable repeatedly for at least 10 million pictures. CompactFlash cards are made with various storage capacities, e.g. 4, 8, 16, 32, 48, 64 and 96 megabytes. Cost *per MB* on average equals two 24 exposure 35 mm colour negative films. Figure 6.4 shows how many picture files you can store according to your camera's CCD file size. Remember too that if you are prepared to set the camera to give highly compressed image files (for later interpolation) it's possible to increase either card's picture storage capacity tenfold.

SmartCards. Developed by Toshiba and supported in cameras by Fuji, Olympus, Minolta, Agfa and other manufacturers, SmartCards are slightly smaller in size than CompactFlash and only one-fifth as thick.

Figure 6.8 Removable digital image storage cards. Left: CompactFlash card supported by Kodak, Nikon and others. Lower centre: Sony's Memory Stick. Right: SmartMedia adopted by Fuji, Olympus, etc.

Figure 6.9 Downloading images from the camera by means of (A) direct wiring to computer. B: Via a memory card removed from the camera body. This can be inserted into a reader (C) or adaptors which allow the computer to read CompactFlash cards as any standard PCMCIA card (D) or SmartCards as a floppy disk (E)

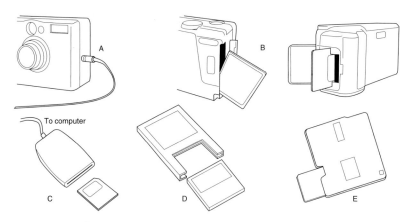

They are less rugged and have less storage capacity (from 2 MB to 32 MB), but are cheaper to buy.

Other camera-removable file storage devices. A few digital cameras (Sony) store their picture files onto a standard, 3.5 inch rotating floppy disk you insert into your camera. These disks are extremely inexpensive but their low capacity means that image files have to be heavily compressed. Other Sony cameras use a removable solid state card very rectangular in shape, called a 'memory stick'. Some high-end camera systems use PCMCIA (Personal Computer Memory Card International Association) cards, the same size as credit cards but much thicker and widely used in laptop computers, etc. The types used have capacities ranging from 85 to 340 MB. Time will tell which one or two from all these present removable storage devices will become adopted as industry standard.

Downloading pictures

All the shots you have taken can be immediately checked out on the camera's $1\frac{1}{2}$–2 in LCD panel. Pressing an erase button removes individual unwanted pictures, freeing up memory space for further image files. Some low-end cameras with built-in low-capacity memory systems will download image files (usually compressed) direct to computer. The connection is either a serial cable directly joining the two or an infra-red transmission system. But this ties up your camera for frequent downloads which are also irritatingly slow, compared to removing and reading out the contents of a card.

Cards fit into a reader connected to your computer (page 270), or even slot direct into a digital printer by-passing any computer, although this allows you little or no image manipulation. By means of a card adaptor you can convert SmartMedia into the physical equivalent of floppy disks, see Figure 6.9. Smart or Compact cards also slip into adaptors converting them into standard PCMCIA cards. Most computers contain drives for these floppies and the larger card. Once picture files are downloaded you can assess each shot filling the monitor screen, then save them onto the computer's hard disk and/or a high capacity removable disk (see page 290). Cards are then freed to go back to the camera for re-use.

Point-and-shoot 'low-end' cameras

The low resolution of early affordable digital cameras meant they were at first developed as accessories for computer systems (e-mail, etc.) rather than serious competitors to photographic cameras using film. Many remain fully automated, with fewest possible settings on offer to control the image. Lenses are non-interchangeable fixed focal length or often optical zooms with a ×3 range. Cameras mainly resemble compact film cameras with direct viewfinders and built-in flash, plus the unique addition of an LCD colour screen on the back, fed from the CCD imaging chip.

At the same time the fact that the tiny chip and lens can be located anywhere in the camera body independently of display screen, electronics and memory card components has encouraged totally new camera designs. As shown in Figure 6.7, some digital cameras have their lens, CCD, viewfinder and flash as one unit which swivels relative to the main body containing the LCD screen. This allows you great viewpoint flexibility, handy for candid shots. As a design variation the camera may allow the lens/chip unit to be detached and then linked by a 1m cable to the main body. Such an arrangement is excellent for some natural history close-ups, and when working in crowds you can hold the lens unit up above your head. Both designs call for you to use the LCD screen for picture composition and focus check.

Using the more common, compact-type digital camera it is best to work with the direct viewfinder (accepting parallax error) and reserve the battery-hungry LCD for checking results after each shot. Buttons alongside the screen allow you to bring up each picture in turn and erase or store it, or review tiny thumbnails of six or nine pictures at a time. They also enable you to over-ride the auto exposure system by plus or minus amounts for difficult subjects such as backlit scenes, page 190. Similarly you can select how much, if any, compression is applied to image files before storage (e.g. choosing between economy, normal, or highest quality) resolution.

'High-end' cameras, digital backs

High-end equipment is primarily designed by photographic camera manufacturers for professional use, with specification and price to match. It is of two kinds:

1 Advanced 35 mm SLR bodies re-configured to house a multi-million pixel CCD, downloading electronics to removable memory card and an LCD screen; see Figure 6.10.
2 Backs for attachment to your existing medium- or large-format camera in place of its film magazine or sheet film holder. Some of these backs use a relatively large (e.g. 37 × 37 mm) CCD, others scan the image with a narrow sensor strip 'array' of CCDs like a flat-bed scanner, or even take a sequence of three exposures through changing red, green and blue filters. In these last two instances image capture times can be in minutes rather than seconds, so scanning or tri-exposure backs are restricted to still life type subjects. Increasingly they are giving way to 'one-shot' designs which you can use for live subject matter lit by flash.

The advantage of an SLR body which matches into an existing system is that you can quickly switch between film and digital by changing of bodies, making use of lenses, flash units and other add-on accessories you might already own. The body also offers familiar photographic controls such as aperture priority, shutter priority, programme or manual exposure settings (page 188) plus multi-choice ways to measure the light and position the autofocus zone. Then there are the digital features such as five or six quality levels of file storage. Professional cameras of this kind now offer 6 million or more pixels and are good for most hand-held work where photo quality pictures for reproduction on art paper about 10 in × 8 in are needed.

Digital backs are used most often in studio situations, where the image files can easily be transferred direct to computer. Scanning backs in particular create huge files (270 MB or more per shot) capable of giving outstanding image quality into layouts for catalogues, etc. Photographer and art director can compute one complete page spread after another *on the spot,* ready for reproduction.

Will digital cameras take over?

Developments in the manufacture of CCD light sensors are currently intense. The cost of both low and high-end digital cameras is reducing rapidly as key components become cheaper, thanks to advances in microelectronic technology and increased volume production. (Relative to the first Kodak DCS introduced in 1992, today's digital cameras offer double the specification at less that a thirtieth of the price.) The image quality of entry level digital cameras is also fast improving. Excellent results already possible with highest-end equipment will require less financial investment. At present, however, because of the fast-changing digital world, costly kit of this kind is usually leased by the month or hired by the day rather than bought. More digital cameras will appear offering the full range of manual or, at least 'user

Figure 6.10 Mid range and high-end digital camera equipment.
A: Front and back of 2.75 million pixel SLR which accepts the same manufacturer's range of lenses made for its film cameras. You can customize this camera's controls, choosing from a wide variety of AF and AE modes.
B: Canon/Kodak combination design SLR, with 6 million pixels.
C: Digital back replacing the film magazine on a rollfilm camera. Back has a 6 million pixel CCD, is wired direct to computer

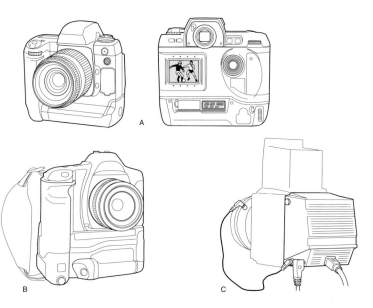

Figure 6.11 High-end digital image quality. Portrait by Bruckman captured with a 12 million pixel Phase One 'Light Phase' back, attached to a Hasselblad medium format camera in place of its film magazine. Each shot fills a 36 MB file, allows prints up to about 7 × 10 in at 300 dpi

customizable' controls photographers have come to expect on cameras for film.

For some areas of professional photography such as news coverage, particularly sports, the speed advantage in getting digital results back to base and into print is overwhelming – especially when working the other side of the world. Several British newspapers closed their wet darkrooms in the late 1990s, and digital cameras are now used routinely by major international picture agencies such as Reuters.

All professionals welcome a system by which you can review results and be *certain* you have captured the images you need before leaving a location or packing up a studio set. But then again, if in the past you made a big investment in film-based equipment and facilities it is logical to keep to these tried-and-tested tools. You can always take advantage of digital technology at a *later* stage by scanning film results into a computer to enhance and print out colour images (Chapter 14).

One hazard of digital is that you grow careless about image construction. The temptation is to bother less about unwanted items in backgrounds and foregrounds, evenness of illumination, colour of lighting, etc., on the basis that this is correctable by digital means later on. In fact the manipulation may *not* prove to be invisible, and works out far more costly in time than adjustments made at the shooting stage.

For snapshotters digital cameras will almost certainly eclipse film cameras – just as convenient video cameras have replaced cine equipment. But for serious amateurs and professionals film is likely to be used in tandem with digital for some time ahead, according to preference and application. The really essential skills in making photographic images remain the same though – picking the right viewpoint, the most appropriate lighting, best moment in time, etc. – aiming for a personal interpretation of the people, places and situations around you. Given this ability you should be able to shoot successful pictures whether by 'wet' or 'dry' technology.

Summary. Digital cameras

- The CCD sensor in place of film carries a microscopic grid of pixels, to convert the image focused on it by the camera lens into a stream of digital electronic signals. The more pixels, the higher the resolution of the digital image and the greater its recorded 'file' size.
- Most cameras carry an LCD screen to display the picture before and after exposure. Unwanted shots can be deleted. Image files are stored in the camera's memory or most often on a removable CompactCard or SmartCard.
- Final image quality depends upon CCD pixel count, any compression made of the image file (e.g. to increase card storage capacity) also size of print.
- Advantages include immediate assurance of results, no darkroom, chemicals or film or lab costs. In digital form images are easy to retouch, manipulate, and send elsewhere electronically.
- Disadvantages relative to film are mainly higher capital costs, including computer and printer. LCD screens absorb battery power, can be difficult to view.
- To match the appearance of traditional photoprints digital images should be printed out at 300 dots per inch (less for computer monitor viewing or newspaper reproduction).
- File size, rated in megabytes (MB), may be compressed on capture and later expanded ('interpolated'). This saves on card image storage space and speed of downloading, but resolution suffers.
- Relatively large, very expensive multi-million pixel CCD sensors are built into replacement backs for medium and large format cameras. Keeping sensors smaller, but with correspondingly tinier size pixels, means lower sensitivity to light. Most match ISO 100 or 200 film speed. Some offer ISO 1000 or more by means of electronic boosting, but this can result in 'noise' degrading the image.
- Digital camera lens focal length is often scaled down to relate to CCD size, so giving an angle of view equivalent to what is normal for a film camera. Lenses must provide high resolution images.
- CompactFlash cards rival SmartCards as removable, re-usable image storage devices. CompactFlash are the more costly but provide greater (MB) storage capacity. A few cameras store their pictures on floppy disk, 'memory stick', or a standard PCMCIA card.
- Low-end digital cameras are most often fully automatic compact types. They include designs featuring swivelling or detachable (wired to camera) lens and CCD units. Some high-end digital backs work on a scanning or triple-exposure basis. These create highest resolution results but are only suitable for still-life type work.
- Digital camera equipment offering high quality image resolution is still expensive but it allows the professional photographer to review all pictures on the spot, and when necessary transmit them rapidly elsewhere. Results can be immediately computer-enhanced and manipulated. However since film still scores on resolution, low cost and ISO speed range, there is presently a strong case for shooting on film, then scanning negatives or slides into digital form for manipulation and print-out.

7
Lighting: principles and equipment

In the early days of photography the principal function of subject lighting was to give enough illumination to get a reasonably short exposure. Today, of course faster lenses and films allow you far more *options*, so that lighting can be used to express (or repress) chosen aspects such as texture, form, depth, detail and mood. The way you select and organize your lighting is highly creative and individualistic – in fact you will find lighting one of the most stimulating, exciting aspects of picture making. A photographer's work can frequently be identified through its use of lighting, and you have probably noticed how often a studio portrait or a movie can be 'dated' by the way it was lit.

The illumination of your subject relies on the same characteristics of light – its straight-line travel, the effect of size of source, diffusion, reflection, colour content, etc. – discussed in Chapter 2. You can use each of them in various practical ways to alter the appearance of a subject, and they apply to any source, whether the sun, a flashgun, a studio lamp or even a candle. Of course there are 'tricks of the trade' too, some of which are dealt with towards the end of this chapter, but even these are just short-cuts based on the same logic of how light behaves.

By far the best place to learn lighting is in a studio, however basic this may be. Work with a still-life subject on a table in a large, blacked-out room, and have your camera fixed on a tripod. Make sure there is ample room to position lights or reflectors anywhere around all four sides of the table. Once you have experienced how lighting works with everything under your control, it is easier to understand the cause and effect of the many 'existing light' situations you will meet away from studio conditions.

Basic characteristics of lighting

The six features of lighting to bear in mind are its quality, direction, contrast, unevenness, colour and intensity. Start by looking at these one at a time, then see how they relate to different kinds of equipment and techniques.

Quality

The term 'quality' is used in connection with the type of shadow the light source causes objects to cast – hard and clear-cut, or soft and graduated. As Figure 2.5 showed, lighting quality depends on the *size*

of the source relative to its distance from your subject. Hardest light comes from direct use of the most compact, point-like source, such as a spotlight or projector bulb, a small flashgun, a clear glass domestic lamp, a lighted match or direct light from the sun or moon. (The sun and moon are vast in size, but because of their immense distances they form relatively small, compact sources in our sky.) All these light sources are of course very different in other respects, such as their intensity and colour, but when used direct they all make sharp-edged shadows form; see Figure 7.1.

Softest light on the other hand comes from a large, enveloping source. This might be totally overcast sky or light from a blue sky excluding the sun. It could be a lamp or flashgun with a large-diameter matt white reflector, or a cluster of fluorescent tubes. You can make any hard light source give soft lighting by placing a large sheet of diffusing material, such as tracing paper, between it and the subject. The larger

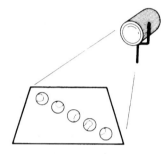

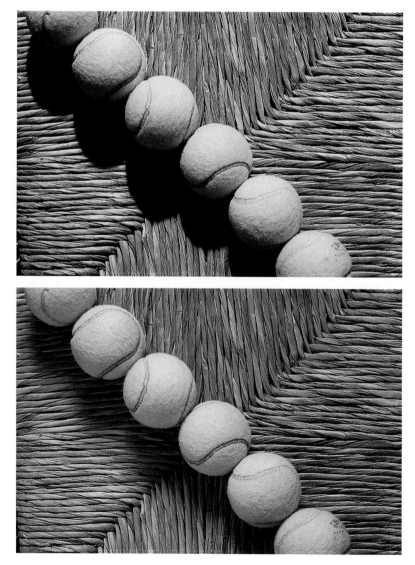

Figure 7.1 Lighting quality. Top: Illuminated by a distant, compact light source, these tennis balls cast hard-edged shadows. Bottom: The light source is effectively enlarged by inserting tracing paper close to the subject. Softer-edged shadows and more subtle modelling then appear. This 'soft, directional' lighting looks less dramatic in the studio, but often gives best results when photographed. (Outdoors the same differences in lighting quality are created by direct sunlight, and by cloudy conditions)

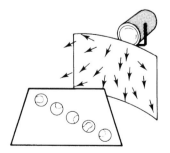

and closer your diffuser is to the *subject* the softer the lighting. Similarly you can direct a hard source on to a large matt reflector such as a white-lined umbrella, card, the ceiling or a nearby wall, and use only the light bounced from this for your subject illumination.

The opposite conversion is also possible. You can make a large soft light source give hard illumination by blocking it off with black card leaving only a small hole. Indoors, if you almost close opaque window blinds you can produce fairly hard light even when the sky outside is overcast.

The way size and closeness of your light source alters lighting quality also changes the character of *reflections* from gloss-surfaced subjects. A hard light source gives a small, brilliant highlight. Typical of this is the catchlight in the eyes of a portrait. Soft light gives a paler, spread highlight, which may sometimes dilute the underlying colour of an entire glossy surface, making it look less rich.

Direction

The direction of your light source determines where your subject's light and shade will fall. This in turn affects the appearance of texture and volume (form). There are infinite variations in height and position around your subject, particularly when you have free movement of a light source in the studio. If you must use fixed, existing, light you may be able to move or rotate your subject instead, or perhaps plan out the right time of day to catch the direction of sunlight you need.

We tend to accept lighting as most natural when directed from *above*; after all, this is usually the situation in daylight. Lighting a subject from *below* tends to give a macabre, dramatic, even menacing effect. Compare (C) with (H) in Figure 7.2. Frontal light from next to the camera (G) illuminates detail, gives small shadows, minimizes texture and flattens form. Reflective surfaces seen flat-on flare light straight back towards the lens. This is typical of direct flash from the camera.

Side lighting or top lighting helps to emphasize texture in surfaces facing the camera, and shows the form of three-dimensional subjects. Back lighting can create a bold edge line and give you a strong shape (B), but most of the subject detail is lost in shadow which also flattens form. All these changes of direction work with both hard and soft light sources, but they are more marked with hard light because of its sharp-edged shadows.

Contrast

Lighting contrast is the ratio between light reaching the lit parts and light reaching the shadowed parts of your subject. Photographic film (and CCD sensors in digital cameras) cannot accommodate as wide a range of brightness in the same scene as can the eye. Often this means that when you expose to get detail in the lightest areas the shadows reproduce featureless black, even though you could see details there at the time. Alternatively, exposing to suit shadows 'burns out' details in lighter areas.

The problem is greatest with hard side or top lighting: although the lit surfaces then show excellent form and texture there are often large shadow areas. If you want to improve shadow detail you might be tempted to add an extra, direct, light source from the opposite direction, but this often forms an extra set of cross-shadows which can be

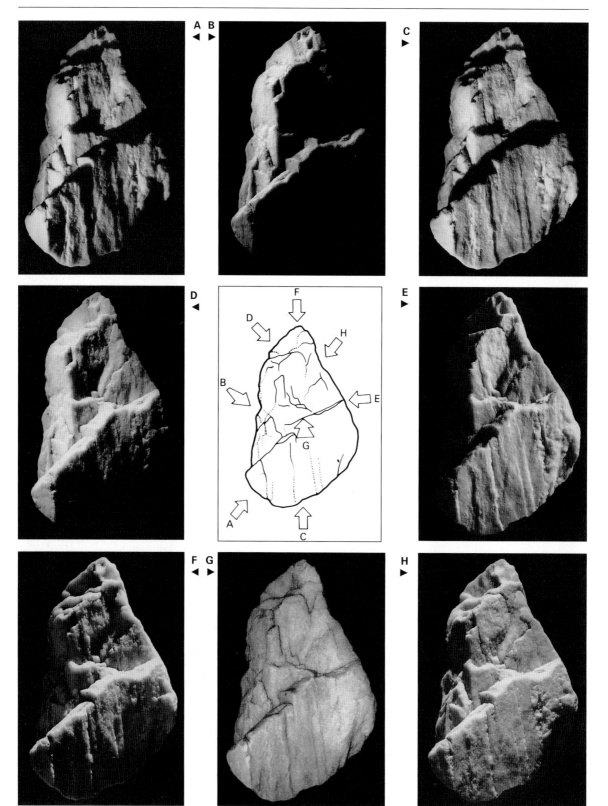

Figure 7.2 Lighting direction. The same piece of stone changes greatly in apparent shape and form according to the relative position of the light source. See central key

confusing, 'stagey' and unnatural. A much better solution is to have some kind of matt reflector board near the subject's shadow side to bounce back spilt main light as soft, diffused illumination. This is known as shadow-filling. For relatively small subjects, portraits, etc., you can fill-in using white card, cloth, newspaper or a nearby pale-surfaced wall. With large subjects in direct sunlight you may have to wait until there is cloud elsewhere in the sky to reflect back some soft light, or until the sun itself is diffused. With fairly close subjects you can use flash on the camera preferably diffused with care to add a little soft frontal light, without overwhelming the main light; see page 198.

As a guide, an average subject with the most illuminated parts lit ten times as bright as shadowed parts (a lighting contrast of 10:1) will just about record with detail throughout, in a black and white photograph. That represents $3\frac{1}{2}$ stops difference between exposure readings for the most illuminated and the most shaded subject areas of inherently equal tone. The equivalent for a colour shot is about 3:1 (see also page 182). With experience you can judge how contrast will translate onto film, but as a beginner you should remember to *use lower lighting contrast than might seem best at the time of shooting.*

Unevenness

Lighting unevenness is most often a problem when you use hard lighting from an undiffused spotlight or flashgun, too close to the subject. When you double the distance of what is effectively a point source of light, the intensity of the illumination at your subject drops to one-quarter. This means that if you have a still-life set up 1 m wide and then side light it from a position 1 m away the illumination across your subject will be four times (2 stops) brighter at one side than the other; see Figure 7.5.

If you want to avoid such unevenness (without also affecting lighting quality or direction) just pull the light source back farther, in a direct line from the set. At 2 metres the variation becomes $1\frac{1}{4}$ stops, and at

Figure 7.3 Flat-on frontal lighting given by flash from the camera illuminates all the subject detail, suppressing form and texture. Here its stark effect seems to suit the theme of this documentary picture of the Depression: 'nobody had a dime, but they had each other'

Figure 7.4 Controlling lighting contrast. All three pictures are lit by one diffused floodlight about 90° from one side. Left: no fill-in. Centre: a large matt white reflector is added left, directly facing the light. Right: using red instead of white reflector board

3 metres only 2/3 stop. Alternatively diffuse the light, narrow the set, or help yourself by positioning the darkest, least reflective objects nearest the light source.

Colour

Most light sources used for photography produce so-called 'white' light, a mixture of all colours. They are said to have a continuous spectrum, although its precise mixture may vary considerably from an ordinary domestic light bulb, rich in red and yellow but weak in blue, to electronic flash which has relatively more energy in blue wavelengths than red. As Figure 7.6 shows, most sources can be given a 'colour temperature'; the higher the Kelvin figure the bluer the light.

When shooting colour, especially colour slides, you must be careful to use lighting of the correct colour temperature to suit your film. Normally this is 3200K (for 'tungsten light' film) or 5500K ('daylight' film). Alternatively you can use a tinted correction filter to bring light source and film into alignment, such as an 85B or 80A (their effect is shown on page 165). If all your subject lighting is the same colour temperature, the adjusting filter can be used over your camera lens. If it is mixed – daylight and studio lamps, for example – you must place a filter over one of these sources to make it match the other, as well as the film. Some light sources, such as sodium street lights and lasers, do not produce a full range of wavelengths and so cannot be filtered to give a white-light result.

This colour content of your light source is much less important when shooting black and white film, although strongly coloured light will make the colours of your subject record with distorted tone values (in red light, for example, blues look and record black, reds very light); see Chapter 9.

Most digital camera CCDs have colour sensitivity which is variable. A mosaic of red, green and blue filters is present in front of each light-sensitive pixel. Then special software calculates the image colour the pixel has received by referencing these filter clusters. Cameras often offer 'auto white balance' which works like a video camera, sampling the colour content of surrounding light and adjusting the CCDs colour sensitivity so that, say, a sheet of white paper always records white no matter what the colour temperature of the lighting. Within limits you can make further colour corrections later using digital manipulation software, page 277.

The intensity of the light

Most of the effects of the *intensity* of the lighting on your subject can be controlled by what exposure settings are made, and the sensitivity of your film or CCD. With an auto-exposure camera lighting level indirectly affects depth of field and movement blur – bright illumination and fast film leading to small aperture and fast shutter speed, for example. And with very dim light and long exposure times colour film often gives distorted colours too.

The light intensity of tungsten studio lamps can be quoted in watts, and electronic flash in watt-seconds (see also 'Working from guide numbers', page 195). High-wattage lamps – say 1 kilowatt and above – are so intense they are generally uncomfortable to use in the studio. Sometimes, however, high-intensity lighting is necessary. Perhaps you are using a large- or medium-format camera with slow film and must shoot at very small aperture for depth of field. This is where powerful studio flash offers a better alternative, see below.

Flash intensity can be reduced by selecting full, half, or quarter power settings without any change in the colour of the light. Most hand flashguns measure light reflected off the subject and control their own light duration; you can further increase the effective light output of a flashgun by firing it several times during a time exposure (see Chapter 10). The best way to dim tungsten lighting is by fitting a wire gauze 'scrim', Figure 7.8, or just moving lamps farther away. It is possible to dim lamps too by reducing the voltage of the supply with a variable

Figure 7.5 Distance and evenness. Below, left: A hard light source positioned obliquely at A is too close to the subject – the nearest part of this model boat receives four times more light than the furthest end. Below, right: pulled back to position C, three times the original distance, this ratio is reduced to 1.7 times. The subject is much more evenly lit and easier to expose correctly

Ratio (A) 1 : 4
(B) 1 : 2.3
(C) 1 : 1.7

Subject area

1 metre

1m

2m

3m

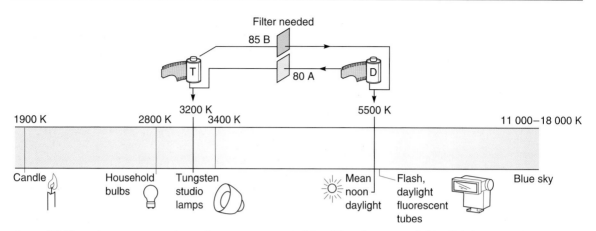

Figure 7.6 The colour – expressed as colour temperature kelvins (K) – of common 'white light' sources. Daylight balanced film (D) needs a blue 80A filter for use with 3200K lamps. Tungsten film (T) must be used with an 85B filter for daylight or flash, for correct colour rendering. See also Figure 9.29

resistor, but this is unsuitable for colour photography because dimmed lamps have a lower colour temperature and give results with a reddish cast.

Lighting equipment

As already indicated, lighting kit divides into two types – tungsten lamps, and flash. Tungsten units allow you to see precisely how the light affects your subject's appearance. Flash (flashgun or studio flash units) avoids the heat and glare of tungsten lamps, yet gives out vastly more light for a brief instant. This allows you to work with the camera hand-held, and can give blur-free images of moving subjects. The colour of flash also matches that of daylight. Most forms of studio flash contain a built-in tungsten modelling lamp to help you to predict how lighting will look when the flash goes off. Flashguns, being battery powered, free you from the need for electricity supplies when working on location, outdoors, etc.

Figure 7.7 Typical cast created when subject shadows only receive light from a clear blue sky. To show the silvery Chrysler Building the correct hue, shoot when there is sufficient cloud around to reflect back 'white' light, or pick a time of day when it is less backlit

Figure 7.8 Tungsten lamp units which give hard lighting. Compact coiled-filament lamps (A) used in a focusing spotlight (B) or open-fronted reflector lamp (C). Lamphead attachments: barndoors (D), wire gauze 'scrim' (E), acetate filter holder (F), and snoot (G)

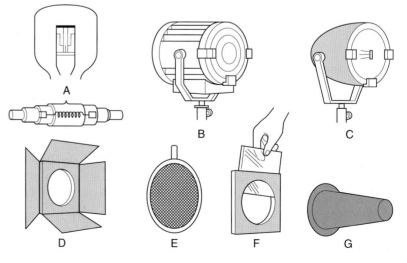

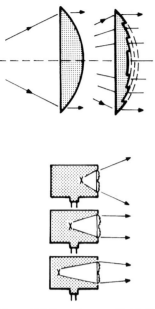

Both tungsten and flash equipment will allow you to create hard or soft quality illumination. And unlike working with sunlight they offer you complete freedom to pick the height and direction of your subject lighting.

Tungsten lighting units

Tungsten lighting is so called because the lamps contain a fine filament of tungsten metal which heats up, becomes incandescent and radiates light when electric current passes through it. Units designed to give hard lighting (Figure 7.8) use bunched filaments to produce an effect as close as possible to a point of light. The filament is sealed into a sleeve of clear quartz filled with a halogen (often iodine) vapour and is therefore known as a tungsten-halogen or quartz-iodine type. Do not finger the quartz when fitting or replacing such lamps – handle them in the small plastic sleeve provided, which slides off once the lamp is mounted in its lighting unit.

Some lighting units can simply be a polished concave reflector, open at the front. The lamp holder shifts backwards or forwards slightly within the reflector to give a narrower or broader beam. Alternatively the lamp can fit within an optical spotlight. This is an enclosed lamphouse with a curved reflector at the back and a large simple lens at the front to focus the light in a controllable beam. You shift the lamp using an external control to form either a wide beam or a concentrated pool of light, Figure 7.9.

Figure 7.9 Focusing spotlight. Top: shaped 'Fresnel lens' bends illumination like the fatter lens (left) but is less bulky, with larger cooling surface. Bottom: shifting the lamp position in a focusing spotlight adjusts the beam width. Broadest beam gives hardest, most point-like lighting; see Figure 2.5

Both these units accept fit-on accessories. Hinged 'barndoors' on a rotary fitting allow you to shade off any part of the light beam. A conical 'snoot' narrows the whole beam, limiting it to some local part of your subject. A 'scrim' reduces light intensity, usually by one stop, without altering its colour or quality, and a filter holder (spaced away from the unit to prevent overheating) accepts sheets of tough, theatre-type dyed acetate, also known as 'gels'.

You will find that each unit gives hardest quality light when the beam is at broadest beam setting. Only focus a narrow beam when you want a *graduated* patch of illumination, say on a background behind a portrait. This focus setting will also give softer edges to the shadows. To light a small area evenly and with sharp-edged shadows, first focus a broad beam then restrict this with barndoors or a snoot.

Units for soft lighting (Figure 7.10) use a large translucent glass lamp, usually with a 500 W or 1000 W tungsten filament. This is housed in a wide, often matt white, dish reflector to form a floodlight.

Figure 7.10 Tungsten lamp units for soft illumination. The larger the unit the more diffused the light. They use 3200K diffuse-glass floodlamps in (A) matt white open-fronted reflector, (B) wider dish flood with direct light shield and (C) large opal plastic-fronted box giving lighting quality similar to overcast light from a window

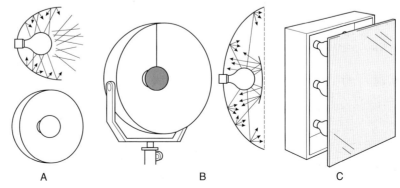

A B C

Figure 7.11 Producing soft, diffused lighting from a relatively hard source. Left: 'bouncing' illumination from a spotlight off a large area of matt white wall, or directing it through tracing paper. Right: spreading light from a small flood by reflection from a white overhead canopy, or (lower) by moving it in a wide arc over your subject during a time exposure of several seconds

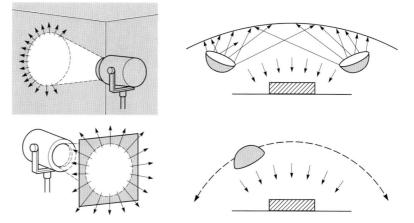

The lamp sometimes faces inwards, to turn the whole dish into a more even large-area light source. You can also buy, or make up, a grid of floodlight bulbs behind a diffusing sheet of opal plastic. (For black and white work this unit could instead contain fluorescent tubes, which give out far less heat.) The quality of illumination this gives is like overcast daylight through a large north-facing window – which is why it is called a 'window light'.

Your lighting units should have stands which allow the head to be set at any angle or position, from floor level to above head height. For location work, lightweight heads such as QI lamps can have clamps with ball and socket heads, so they will attach to doors, backs of chairs, etc. Consider too the use of a 'sun gun' – a totally mobile small, hard QI unit which can be hand-held by an assistant and powered from a belt of rechargeable batteries. Typically this gives up to 20 minutes of 300 W lighting.

When you use tungsten lighting for colour photography, make sure you have lamps that all give the same colour temperature, preferably matching your film, and run them at their specified voltage. Over- or under-running voltage by as little as 10 per cent will give a noticeable blue or orange tint to results.

Figure 7.12 Tungsten lighting for use on location. A: battery-belt powered sun gun. B: suitcase lighting kit containing three tungsten-halogen lampheads and stands. C: lightweight lamphead on clamp. D: dyed acetates E: cable and multi-sockets. F: folding lightweight reflector surfaces

Flash units

Electronic flash produces its light when a relatively high-voltage pulse is discharged through a gas-filled tube. The flash is typically 1/1000

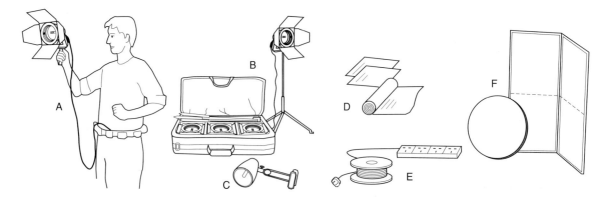

Figure 7.13 Battery-powered flash units. A: built into compact and SLR camera bodies. The SLR flash rises from the pentaprism housing to distance it from lens viewpoint. B: add-on units with tilt-up heads for bouncing light off the ceiling, etc. C: powerful 'hammerhead' type gun with rotatable head, bracket for camera, and separate power pack. All these units give hard light, unless bounced or diffused

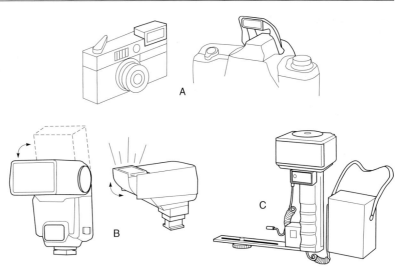

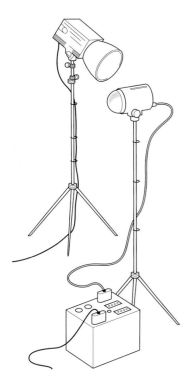

Figure 7.14 Studio/location flash units requiring an electricity supply. Each has a tungsten modelling lamp to forecast its lighting effect. Left: Monohead type unit, with both power pack and tube in the head. Right: More powerful, separate generator type, powering one of up to three heads. Both types give hard lighting if used as shown here

Figure 7.15 Head detail and fittings for studio flash. Left: Tungsten modelling lamp surrounded by the flash tube. Centre: White-lined umbrella reflector. Right: Fabric 'soft box' attachment. Both these heads give soft, diffused lighting

second or less and matches the colour of 'daylight'. Otherwise it complies with the same optical principles as tungsten lighting. There are two forms of equipment – a *flashgun* either built into or mounted on the camera for use hand-held, and freestanding *studio units* which you move around more like tungsten lamps.

Battery-powered flashguns range from the tiny units built into camera bodies, through clip-on accessory guns (brighter, and capable of tilting, Figure 7.13) to still more powerful 'hammerhead' guns which attach alongside the camera. All these tend to have short flash tubes and highly polished reflectors which give hard quality light when used direct, unless some form of diffuser is fitted or illumination is bounced, Figures 7.11 and 10.31. A plastic 'beam-shaper' condenser lens over the flash window often allows you to narrow or widen the light beam, to match the different angles of view of tele or wide-angle camera lenses. Battery flashguns contain no modelling lamp.

Studio flash is mains-operated, and of two types – *monoheads* and *generator* systems. All the electronics plus flash tube are combined in

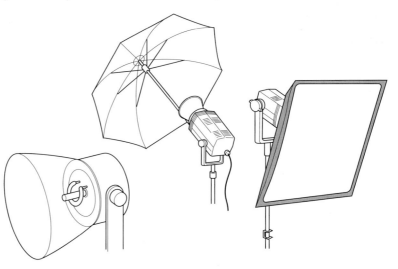

Figure 7.16 Ring flash unit with battery power-pack. Far right: the soft-edged rim shadow here is typical when using ring flash with the subject close to the background

a monohead unit, supported on a lighting stand, see Figure 7.14. A generator (or 'power-pack') system is more powerful and expensive, often hired rather than bought. Electronics and controls are contained in one unit which can feed several flash-tube heads on separate stands. Both kinds of studio flash use a small tungsten modelling lamp in each head. To do its job properly and show you how the lighting will look when the flash fires, this lamp must match the size and position of the flash-tube as closely as possible, see Figure 7.15. The modelling lamp is dimmed if you adjust the flash output of its particular head from full to fractional power. This is important when you are using several heads set to different outputs.

Lighting quality from studio flash is determined by the size and shape of tube and type of reflector or diffuser you fit to the head. Monoheads use one permanent flash-tube and rear reflector, to which a variety of accessories fit. Generator systems allow you to choose from a range of designed heads, having tubes of various shapes as well as attachments ranging from a spotlight to a large fabric 'soft box' giving a very diffused window light effect. An umbrella, white-lined or made of translucent material, will act as a large reflector or diffuser respectively, yet it is easily transportable. Umbrellas fit to generator heads or monoheads (but be careful that stands are anchored, particularly with monoheads, in case draught or wind topples them over); see Figure 7.17.

Bear in mind that the accessories, heads, or just the way flash is deployed (bounced off wall or ceiling for example) can give you lighting matching the quality of a tungsten lamp of the same size and used in the same way. The lighting principles behind flash and tungsten light sources are not as different as they at first seem. See also flash exposure, and practical techniques, pages 194 and 198.

Other artificial light sources

There is a wide range of tungsten lamps other than the 3200K studio types which are standard for artificial light colour film. For example, you will come across over-run 'photo lamps' or photofloods' and QI movie lamps, which are high intensity but operate at 3400K designed

for colour negative *movie* stock. Results on 3200K tungsten light film show a slightly bluish cast unless you shoot with a pale orange correction filter, page 171.

Domestic lamps are less bright and give out light of a warmer colour than studio lamps – the lower the wattage the more orange results will be. If you have to use such lighting pick 100 watt lamps, have an 82 A correction filter over the lens and shoot on artificial light colour film.

Fluorescent tubes can form useful studio light sources for black and white photography. You can group them vertically, in clusters, to softly light standing figures, still-lifes, etc. To shoot in colour pick 'colour matching' tubes and use daylight colour film. They are not recommended for critically accurate results, but often on location you are forced to work with them – when they form the existing light in shops, for example. If you are unlucky enough to be shooting somewhere lit with a mixture of different tube types (or tubes and lamps) try to swap them around to get greater uniformity. Alternatively change to your own flood or portable tungsten lighting instead.

Lighting accessories

As well as the attachments described on page 114, back-up items for your lighting might include reflector boards (folding ones are particularly handy, Figure 7.23), supports for paper backdrops, a boom light stand, clamps, sticky tape and black card. Blue acetate or blue-dyed 'daylight' lamps to make tungsten lighting match the colour of daylight when two kinds of light have to be combined on location can be useful. Similarly orange acetate, fitted over flash, can match it into a tungsten-lit environment.

Figure 7.17 Layout of a general studio. Window has a removable blackout. Main set, using 3 m wide background paper, is equipped with a flash soft box (window light) head. A separate monohead unit has an umbrella. Two tungsten floods are in use for copying with a 35 mm camera on pillar stand. Other lighting, stored foreground, includes a boom stand with lamphead. The half-height adjustable stand, centre studio, supports a rollfilm camera plus tray for meter, filters, etc. Card, glass, blocks, clamps, tape and tools are all vital elements

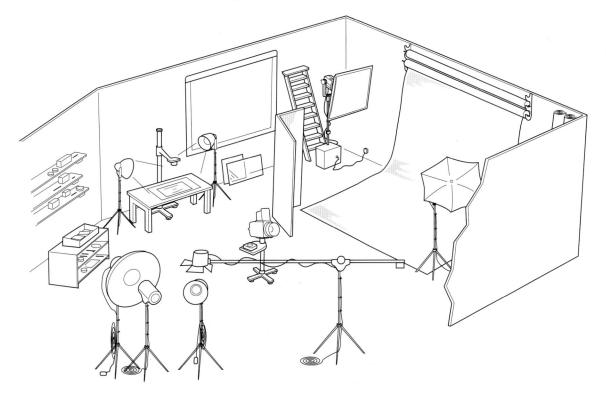

Figure 7.18 Direct evening sunlight skim-lights a Cotswold cottage wall. Hard light directed so obliquely dramatically shows up texture, provided that the subject is all on one plane

Have sufficient cable to link your units to the nearest supply, and don't exceed its fuse rating. Remember:

$$\text{Total amps drawn by lighting equipment} = \frac{\text{Total number of watts}}{\text{Voltage of the supply}}$$

So one 250 V socket fused at 13 A will power a maximum of 3250 W of lighting. When servicing the equipment check that your lighting units and plugs are all properly grounded (earthed). If you are using a drum of cable always *unwind this fully* before passing current through it, or the coils will over-heat. Check out the electrical hazards advice on page 321. Finally, don't jolt lamps while they are hot – especially tungsten-halogen types which easily short out their closely coiled filaments, and are expensive to replace.

Practical lighting problems

Figure 7.19 The same principle of single-source skim light as Figure 7.18, but using an overhead desk lamp in a darkened studio. Once again, only one plane of the subject is being shown

Think carefully what your lighting should actually *do* for your subject, other than simply allow convenient exposure settings. Perhaps it must emphasize the form and surface textures of a new building, or a small product in the studio. It might heighten features in a dramatic male character portrait, or be kind to an ageing woman's wrinkles. Your lighting will often be the best way to emphasize one element and suppress others, or reveal extreme detail throughout. It can 'set the scene' in terms of mood and atmosphere, or simply solve a technical problem such as excessive contrast in an existing light situation.

Figure 7.20 Complex still-life arrangements can be illuminated to reveal forms without confusing shadows by using a large diffused light source across the top and side of the set. Here, a window light from top left is used with a second diffused light from the right

Existing light

Learn to observe 'existing light', noticing what is causing the lighting effect you see, and how this will reproduce in a photograph. For example, look up from this book for a moment and observe how your own surroundings are lit. Hard illumination or soft, even or uneven? Which areas are picked out by lighting direction and which suppressed? Are any textures or forms emphasized? Try slitting your eyes and looking through your eyelashes – this makes shadows seem darker and contrast greater, a good guide to their appearance on a final print.

Daylight. The lighting quality of daylight ranges from intensely hard (direct sun in clear atmosphere conditions) to extremely soft (totally clouded sky in an open environment). Colour varies from 18000K

▲▲A ▲B ▼C

Figure 7.21 Supplementing uneven existing light. A: correctly exposed for the daylight-lit parts of the room, using 1/60 at *f*/8. B: flash bounced off ceiling above the camera (see diagram) set to autoflash exposure. Result has overlit foreground. C: flash positioned as B but set on manual mode and reduced to one-quarter the correct power. Exposure settings as A. Result shows realistic balance of 4.1 daylight/ flash

intense blue when your subject is in shadow and only lit from blue sky, to an orangey 3000K around dawn or dusk. (Strictly 'daylight' colour film is balanced to give correct colour reproduction at 5500K, this being a mixture of direct noon sun plus some skylight.) As for direction, this of course changes throughout the day as the sun tracks from east to west and – unless you are on the equator throughout the year – passing most directly overhead on the longest summer day. Considered use of daylight for subject matter such as architecture and landscapes calls for planning, patience and the good fortune of getting all the aspects you need together at one time. Fortunately, outdoors, the varied character of natural daylight is often an important feature in pictures. It would be foolish, for instance, to try and 'correct' the orange tint of a setting sun when an evening atmosphere is vital to the realism of your result.

Supplementary daylight. Often when you are working with existing light you will need to modify it in some way. When shooting a black and white portrait outdoors, you may find direct sunlight too harsh and contrasty, but the light changes completely if you move your subject into the shadow of a building. However, this gives an unacceptable blue cast with colour photography, so it may be better to remain in sunlight but work near a white wall, or have a reflector board (page 124) or even just a newspaper to return light to the shadow side. Another way to soften harsh shadows with close subjects such as portraits is to use a diffused flashgun on the camera. Since the latter is likely to be a battery-operated flash unit you cannot *see* the effect created unless you are using a digital camera or shooting Polaroid picture material (see

Figure 7.22 Mixed lighting. Mass celebrated at a tungsten-lit altar, with daylight illuminating the surrounding interior. In this instance the best compromise was to shoot through an 80A, blue filter onto daylight film (see page 164) or use tungsten balanced film if available. Either gives this result showing the key area the correct colour, but an exaggerated blue cast elsewhere. On daylight film without a filter the central area would reproduce orange, surroundings the correct colour

'Fill-flash' page 198), and results have to be worked out by careful calculation of exposure.

Supplementary light is often necessary when you shoot an architectural interior using existing daylight. There may be excessive contrast between views through and areas near windows, and the other parts of a room. You can solve this by bouncing a powerful light source off a ceiling or wall not actually included in the picture, to raise shadow-area illumination to a level where detail just records at the exposure given for brighter parts.

This artificial light source might be portable QI lamps or a flash unit. If you are shooting in colour, have any tungsten supplementary lighting filtered to match the daylight, and be careful not to bounce off tinted surfaces. Sometimes a dimly lit interior can be 'painted with light' to reduce contrast, by moving a lamp in a wide arc over the camera during a time exposure.

Mixtures of existing light sources which have different colour temperatures are always a problem when shooting in colour. You may be able to switch off, or screen off, most of one type of illumination and use the correct film or filter for the other. Otherwise decide which of the two kinds of lighting will look least unpleasant if uncorrected. A scene lit partly by daylight and partly by existing tungsten lighting often looks best shot on daylight-balanced film. The warm cast this gives to tungsten-lit areas is more acceptable than the deep blue that daylight-lit parts will show on tungsten-balanced film. However, much depends on what you consider the key part of your picture; see Figure 7.22.

Fully controlled lighting

If you are working in the studio, or some other area where you have complete control, try to build up your subject lighting one source at a time. Don't just switch on lights indiscriminately – each unit should have a role to play. And keep the camera on a tripod so you can keep returning to it to check results from this viewpoint every time you alter the light.

Starting from darkness, switch on your main light (soft or hard) and seek out its best position. If you are just showing a single textured surface – such as a fabric sample, or weathered boarding – try a hard light source from an oblique direction. By 'skimming' the surface it will emphasize all the texture and undulations. But take care if this means that one end receives much more light than the other – move your light source farther away.

A single hard light will probably exaggerate dips in the surface into featureless cavities. Also, if the picture includes other surface planes at different angles, some of these may be totally lost or confused in shadows. One solution is to introduce a second or 'fill' light, but without adding a second set of hard shadows. (We are rather conditioned by seeing the world lit by one sun, not two.) Try adding very diffused light – perhaps just 'spill light' from the first source bounced off a white card reflector – sufficient to reveal detail in what still remain shadows. The reflector will have to be quite large, and probably set up near the camera to ensure it redirects some light into all shadows seen by the lens. If you cannot produce enough fill-in in this way, try illuminating your reflector card with a separate lighting unit. Another approach is to change your harsh main light to something of softer quality, perhaps by diffusing it.

If your picture contains a more distant background, you can light this independently with a *third* source (maybe limited by barndoors) so that the surface separates out from the main subject in front. Again be careful not to spread direct light into other areas, if this creates confusing criss-cross shadows. In fact, when you have a great mixture of objects and separate planes to deal with in the same picture, there is a lot to be said for using one large, soft, directional light source (i.e. from one side and/or above). This can produce modelling without excessive contrast or complicated cast shadow lines, giving a natural effect like overcast daylight from a large window or doorway, see Figure 7.20.

Much the same kind of build-up can be applied to formal studio portraiture. Decide viewpoint and pose, then pick the direction of your main light, watching particularly for its effect on nose shadow and eyes. With a 'three-quarter' head shot (Figure 7.23) think carefully whether the larger or the smaller area of face should be the lighter part. Consider how much, if any, detail needs restoring in shadows by means of a reflector. If you want to stress an interesting outline you could light the background unevenly, so that darker parts of the sitter appear against the lightest area of background, and vice versa – a device called 'tonal interchange'.

You could even add a further low-powered or distant spot to rim-light hair, shoulders or hands from high at the rear. However, there is a danger of so-called 'overlighting' which puts your sitter in a straitjacket. He or she cannot be allowed to move more than a few inches for fear of destroying your over-organized set-up, and this can result in wooden, self-conscious portraits. The more generalized and simple your lighting, too, the more freely you can concentrate on expression and people relationships.

The build-up approach to lighting applies equally to tungsten units and flash sources. Studio-flash modelling lamps will show you exactly what is happening at a comfortable illumination level, changing only in intensity when the flash is fired. See also flash exposure technique, page 199.

Special subjects

Copying

The main aim when copying flat surfaced originals such as photographs, drawings, etc., is to create totally even lighting free from reflections off the surface of the original. Figure 7.24 shows the best way to approach this, using two floods at about 30° each directed

Figure 7.23 Lighting build-up: Top left: one diffused flood main light from the side the sitter is facing. Centre: a second flood added to lighten one side of the background and pick out the head outline by 'tonal interchange'. Bottom left: the further addition of a large matt white reflector board softly fills in some shadow detail

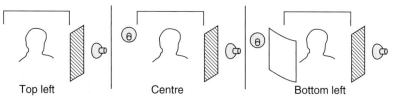

Top left Centre Bottom left

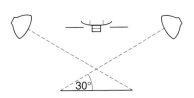

Figure 7.24 Flat-on lighting set-ups. Above: Set-up for copying artwork, etc. Lamps are at 30° to subject's surface, distanced at least twice the width of the artwork and directed towards its opposite edge. Black card near camera blocks reflections. Centre: coins photographed through (G) thin glass at 45° (see diagram, right). The camera lens (C) looks down the same path as the light from the lamp illuminating the subject (S)

Figure 7.25 Lighting simple glassware. Below left: Using a separately lit white surface some distance behind the glasses to get a silhouette effect. A spotlight, shielded from the glasses direct, illuminates white card to reflect soft highlights suggesting the roundness and sheen of the glasses. Below right: The same set re-lit to give a more delicate, luminous look to the glass. Grey card covers the background seen by the camera, and soft lighting is directed through the glasses from side and rear. A frontal reflector board returns some light to help reveal form and surface

towards the far edge of the subject. Black card around the camera will prevent its shiny parts reflecting and showing up in your picture. See also polarising filters, page 173.

Macro work

Sometimes in extreme close-up photography you want flat-on frontal illumination to light every tiny detail of a coin, etc., or some recessed item such as a watch mechanism or electronic layout. A ring flash is sometimes the answer, but you can also work with a piece of clean, thin, clear glass set at 45° between lens and subject. A snooted spotlight or similar hard light source is directed at 90° from one side so that it reflects off the glass and is directed down on to your subject, sharing the same axis as the lens.

Transparent/translucent subjects

Glassware, etc., is often best lit from the rear. Either use a large white background spaced behind the objects and direct all your lighting

Figure 7.26 'Tent' lighting. For this shot of highly reflective silver tableware a large sheet of tracing paper formed a canopy over the set, and was evenly illuminated from above by floods. In this instance, to prevent dark reflections, the camera was shielded behind white card leaving a hole for the lens

evenly onto this, or direct lights on to the glass from the sides or rear so that the background remains dark. The former gives a dark outline to the glass against a predominantly light ground. The latter produces a white outline against dark. If the glass has a glossy surface you can suggest this quality by adding a rectangular-shaped light source from near the front, simply to appear as a window-like reflection.

Highly reflective surfaces

Subjects with mirror-like surfaces such as polished silver or chrome bowls, spoons or trays impose special problems. They tend to reflect the entire studio in great detail, confusing their own form. You can treat them with a dulling spray but this may suggest a matt rather than a polished finish. Often the best approach is to enclose the subject in a large, preferably seamless, translucent 'tent' such as a white plastic garbage bag or sphere, or improvised from muslin or tracing paper. Cut a hole just wide enough for the camera lens to peer in, remembering that the longer its focal length the farther back it can be, giving a smaller and more easily hidden reflection. Illuminate the outside skin of the tent using several floods, or move a single flood over this surface, painting it with light throughout an exposure time of several seconds.

Summary. Lighting: principles and equipment

- The main ways lighting can alter subject appearance are through its quality, direction, contrast, evenness, colour and intensity. Of these *quality* and *direction* are often the most important – because neither can be adjusted later by some camera setting or printing technique.
- Hardest quality lighting is given by a relatively compact and distant light source, used direct. Soft lighting is created by a large, close enveloping, diffused source.
- The direction of the light controls which parts of your (three-dimensional) subject will be in light or shade. It strongly influences the appearance of form; also the direction and length of shadows.
- Lighting contrast needs to be kept within bounds if you want to show detail from highlights through to shadows. It is often best controlled by using a reflector placed near the subject's shadow side, or the use of additional light sources.
- To improve evenness, increase the distance from light source to subject, or diffuse or bounce the light so that it becomes spread and less 'point source' in character.
- Lighting colour, often quoted as a colour temperature (Kelvin), should suit the balance of your colour film, or be brought into line by using a colour filter over the light or lens.
- Tungsten lighting units – QI lamps, focusing spotlamps, individual floods or larger window-light units – mostly operate at 3200 or 3400K. Only the former suits tungsten-light colour film without filtration.
- Electronic flash is equally versatile with hard direct light, soft bounce light, window light, focusing spotlight and ring-light units. Mains operated studio units with modelling lamps allow you to preview their lighting effects. The colour of regular daylight and

most flash suits 'daylight' colour film balanced for 5500K. Try to avoid mixed colour-temperature lighting conditions, except for effect.

● A good lighting kit should include blue and orange correction acetates, reflectors, diffusers, stands, clamps and cables.

● When lighting a subject, try to introduce one source at a time, and consider what each must do. It is good advice to keep things simple, aiming mostly for a natural daylight effect.

● Learn to recognize the technical pitfalls of existing light – excessive contrast, unevenness, mixed colour. Be prepared to improvise to control contrast and colour, or to return at another time for the lighting quality and direction you need.

● Certain lighting 'formulae' are helpful for special subjects: for example, 30° lighting for copying, ring-flash or 45° glass for maximum detail macrowork, backlighting for transparent subjects, and a light-diffusing tent for polished objects.

Projects

1 Experiment using an ordinary desk lamp, tracing paper and card to light a simple three-dimensional still-life subject. See how much you can vary the illumination *quality*, from hard to very soft.

2 Photograph a white box in the studio on a white background, to show its top and two sides. Choose and arrange your lighting so that *each* of the three box surfaces photographs with a different tone.

3 Take two photographs of either tennis balls or eggs. In one they should strongly reveal their rounded three-dimensional form. In the other make them look like flat two-dimensional discs or ovals. The only change between each version should be in the lighting.

4 Check out the appearance of subjects when lit by direct or bounced flash, directed from various positions. If you have only a battery flashgun, tape a hand torch to it and work in a darkened room to preview results. Take pictures of the most interesting variations. See exposure, page 198.

5 Set up a still-life group consisting of two or three neutral or pale-coloured, matt-surfaced items, lit either by daylight or by tungsten lamps. Have the camera on a tripod. Take colour pictures in pairs, demonstrating radical differences due to *each* of the following changes in subject lighting: (a) quality, (b) direction, (c) contrast and (d) colour. Measure and set correct exposure for every picture, but make no other alteration. Compare results.

8
Organizing the picture

This chapter is concerned with composing the image of your subject as a picture. It deals with recognizing and exploiting visual features of scenes and framing them up in the strongest possible way, more than technological aspects of photography.

Sometimes a photograph has to be composed in an instant, as some fast-changing action is taking place, so that exactly what you include and how it looks is changing every fraction of a second. Or your picture may be constructed quite slowly, as with a still-life shot painstakingly built up item by item. Most photography lies somewhere between these two extremes, but whatever the conditions there is always the need to make decisions on picture structuring. Basically you have to pick out from a mixture of three-dimensional elements, an image that works in two dimensions (perhaps translated into black and white too) and enclosed by corners and edges.

A successful photograph can be much more than a record. It should be able to tell you more, express or interpret more, than if you were actually there at the time viewing the subject itself. To achieve this you need to be a good organizer – being in the right place at the right time with suitable equipment, and perhaps any necessary props, models, lights, etc. You should also understand your technique – best use of perspective, lighting control, depth of field, exposure, etc. But perhaps above all you need the ability to know when all the visual elements look right and 'hold together' in a way that gives an outstanding visual result.

Often composition means simplifying from chaos, having a picture structure which is balanced and harmonious. Sometimes you may want the opposite, choosing imbalance and awkwardness, a kind of off-beat confusion which is the point of the picture or the way you decide to interpret the subject. Today, picture structuring is so subjective – open to individual style and original interpretation – that there are strong arguments for *not* having rules of composition. However, when you compare pictures that 'work' and are successfully structured for their content and purpose against others which are not, most of the long-established guidelines still apply. (In any case it is difficult to be a revolutionary until you know what you are revolting against.)

Noticing subject features

We tend to take the things around us for granted. There is too little time to spare. It is easy to get into a state where we no longer really *look* at objects, but just accept them for what they are or do. Have you really examined that table, the apple in that nearby bowl, a stone brought in from the garden? Imagine that you have just arrived from another planet and, having never experienced these items before, set out to evaluate them. Try jotting down the list of *basic visual qualities* you notice about the table, for example. It has its own particular shape; it may have texture, pattern, form, colour and tone values.

Every object has individuality in this way and everybody can form their own analysis, deciding which are for them the strongest visual features. There are no academic 'rights' and 'wrongs' about such an assessment. It is personal to *you* – an opening to express feeling as a photographer and not just blandly record everything in front of the camera.

Like most people you are probably stimulated by a change of environment – a trip abroad, or just a visit to an unfamiliar building. Here you are seeing new things, therefore making new evaluations. After a while the environment becomes commonplace, objects are accepted and grow less interesting. A young child examines (looks, bites and presses) each new material it meets, naively making an analysis – hard or soft, rough or smooth. A good photographer retains this ability always to look freshly at the visual content of subjects and situations. It provides the

Figure 8.1 The humour in Elliott Erwitt's visual pun is partly the subject itself, but comes mostly from his masterly use of viewpoint, which exploits shape, scale and cropping

starting point from which to decide what features to make prominent in a successful picture; see Figure 8.1, for example.

Shape

A bold shape or outline is one of the strongest ways to identify an object or person, dramatically so in the case of a silhouette or shadow. A shape can be just a single item, or formed collectively by a mixed group of objects. In Figure 8.2 it is the shape of the hat and wearer's face that gives this portrait its stark framework. But then again, having several strong shapes invites comparison, and may relate otherwise quite dissimilar elements, as in Figure 8.19.

One way of repeating shape is by hard, cast shadow. This can produce interesting variations, as when shadow falls on oblique or undulating surfaces. Hard sidelight may cast the shadow of one elevation of something alongside another (for example a face-on portrait with a profile shadow cast on a nearby wall). Shadow shapes also tell you about things outside your picture area, Figure 8.15.

The best way to stress shape is through your viewpoint and lighting. Use both to simplify and isolate subject outline against a contrasting, preferably plain, tone. Shallow depth of field will help you disentangle shape from background details.

Figure 8.2 'An Eastern Texan' Russell Lee's documentary portrait, works strongly through its use of a bold, simple shape, and the subject's direct relationship to the camera

Figure 8.3 A mixture of materials, their textures emphasized by oblique, slightly diffused evening sunlight

Texture

Texture is concerned with surface – for example, the tight smooth skin of an apple, or the pitted surface of corroded metal. It can vary in scale from the rugged contours of a distant mountain range to a brick in close-up. The visual appearance of texture suggests the character of particular materials, and reminds you how they would feel to your touch. Texture can also be a symbol for the passage of time, from the bloom of youth to wrinkled old age. In fact subjects containing a rich mixture of textures are especially rewarding because of the ability to contrast or 'play off' one against another.

Figure 8.4 Pattern is often created by a mixture of actual forms and cast shadows, like these plants in Morocco rear-lit by sunlight. Try to use variations within a pattern, and include some core or 'break'. Notice here how many lines are prevented from running directly out of the frame

Figure 8.5 Jack Delano's very careful choice of viewpoint for this shot of Stonington, Connecticut, divides the frame into three bands of pattern. Flat-on lighting also contributes greatly in setting the relative values of fence and sky. Instead of receding, the picture seems all on one flat plane

As both Figures 8.3 and 8.16 show, textures are best revealed by oblique lighting from the side or rear. Unless you are dealing mainly with a single surface, try to work in lighting which is not excessively contrasty, to avoid empty distracting shadows. To suppress texture use either predominantly frontal lighting, or backlight which throws the subject into total silhouette.

Pattern

The human eye seems to enjoy pattern, whether repetitive and formal, or irregular and off-beat. So by finding and exploiting a visual pattern in a scene you can create harmony, even transform something consisting of many disparate parts into a satisfying whole.

Pattern may be formed from a number of elements identical in size, shape and colour but irregular in distribution, like fallen leaves. Texture often creates pattern (although you can also find pattern on virtually textureless surfaces). Similarly multiples of *shapes* give pattern, perhaps varied by the effects of perspective, or contrasting colour or tone.

Look for strong, interesting patterns within the structure of a plant, or in a row of houses, a display of goods, or a group of people. Experiment with the effect of viewpoint, focal length, lighting, and the use of filters

with black and white materials (page 171). There are no ground rules for lighting. Sometimes three-dimensional subjects, harshly side-lit, create a bold pattern of shadowed and lit areas. Sometimes shadow is cast all over your subject from an unseen patterned element, disguising true shapes, Figure 8.6. In other instances soft, frontal illumination is best to show detail and suppress confusing texture in what is turned into mainly two-dimensional pattern.

Patterns are like musical rhythms which you can sometimes make dominate, or more often use as supportive 'backing', echoing or contrasting your main theme. In fact it is often the *breaking* of a pattern that gives emphasis to your chosen main subject.

Form

Form is to do with an object's volume and solidity. It is best shown in two-dimensional photography through tone graduation (shading), although shape contributes greatly too. Forms range from the natural flowing curves of a simple vegetable like Figure 8.7 to the geometric

Figure 8.6 Overhead slats cast a powerful pattern over the farmer's truck, camouflaging its shape but also suggesting the vineyard environment

Figure 8.7 Form revealed by sympathetic lighting and richness of tone preserved in exposure, development and printing. Edward Weston took this famous photograph of a pepper softly lit by daylight

Figure 8.8 Dark, sombre, black and white tones set the low key mood of Bill Brandt's 1930s view of Halifax. (This documentary shot is often printed as a fine-art image with the top half much darker, and road and railway highlights picked out with chemical reducer, page 258)

man-made structure of a building. They include things as diverse as the human figure, the monumental form of a giant rock, or a delicate flower. Some dramatic-looking forms are transient and not really solid or physically 'feelable' at all. Cloud formations, waves, or the briefly held form of a wind-blown flag are all of this kind.

Learn to recognize form in objects irrespective of their actual function. A pile of old oil drums or a simple crumpled ball of paper can become as stimulating to photograph as a superbly designed car. Often this is the challenge – to make something that seems ordinary and familiar to others take on a new intensity of appearance. It is handled through your use of camera angle, perspective, lighting and the qualities of your final print.

Colour and tone values

The colours and tone values in a scene contribute greatly to emphasis and to mood. The relationship of object colours themselves, plus any predominant colour in the lighting (due to surroundings or the light source itself) can have a harmonious or discordant effect. Colours close to each other in the spectrum tend to blend, while widely separated colours contrast (Figure 9.25).

Figure 8.9 An emphasizing touch of colour in a late evening landscape of muted hues and silhouetted pattern. The foreground reflections give useful lead-in lines

Colour scheme is important too. A scene dominated by greens and blues suggests coldness and shade. Reds and yellows have the opposite association of warmth and sunlight. Notice how any element with a contrasting colour, or forming a small area of intense colour among muted hues, will appear with great prominence. Make sure that it really is intended to be important when shooting in colour, and remember it may lose this emphasis in black and white. Unwanted areas of colour can be subdued by cast shadow or shot against the light, or simply obscured by some close foreground object.

Figure 8.10 Aerial perspective. The visual impression of distance given by changing tone values is a powerful feature of this shot of Loch Shiel, Scotland, by Hunter Kennedy

Often a scene with quite subtle colour values makes a more satisfying colour photograph than a gaudy mix of strong colours, although of course this will depend on the mood you want to create. A crowded fairground or street will look busier packed out with many contrasting colours, while a romantic landscape is more likely to be given strength and unity through limited, perhaps sombre, colouring.

The range and distribution of tone values (scale of greys) contained in a scene has its own effect on mood. Large areas of dark are easily associated with strength, drama, mystery and even menace. Scenes that are predominantly light in tone suggest delicacy, space and softness. You can exaggerate tonal values in a picture, especially in black and white photography (because colours are not then distorted too). Use their influences to help set the scene constructively.

If the lighting is contrasty you have the option of showing your main subject in a small lighted area and setting exposure only for this (page 190) to give the rest of the scene a 'low key' effect. Or, if the subject can be in a small area of shadow and you expose solely for this instead, lit parts become bleached out, helping to give 'high key'. Remember to choose a viewpoint or arrange the subject so that the main tone of background and foreground help along the scheme of your shot. Colour filters on black and white film can help too (Figure 9.27), by darkening chosen coloured areas, such as blue sky.

Notice how the distribution of tone values adds to your impression of depth and distance too, especially with landscape; see Figure 8.10. Atmospheric conditions often make objects look paler in both tone and colour with distance. Overlapping hill folds, trees, buildings, etc., at different distances appear like a series of cut-out shapes in different tones – an effect known as aerial perspective.

Movement

Movement is very apparent to the eye (even at the extremes of our field of vision we are highly sensitive to movements, probably for self-preservation). Fast movement makes subjects appear like streaky shapes,

Figure 8.11 Moving fairground rides take on new dynamic forms when spread and blurred by an exposure several seconds long. Having the camera firmly supported records stationary objects sharp, to contrast the exaggerated movement and give a spectator's eye view. Compare with Figure 8.27

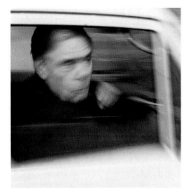

Figure 8.12 Shooting at 1/8 sec has softened detail, increased apparent movement . . . and turned a harmless motorist into the stereotype of a road-rager

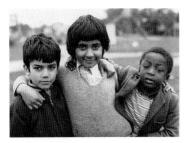

Figure 8.13 Just three boys in the park, but a picture given meaning by its multi-racial content and sense of friendship

Figure 8.14 Use your hands, or a colour slide mount, to estimate how a scene will look – isolated and composed within a picture format. Position your eye the same distance from the slide mount as your camera lens's focal length to see how much is included. Alter this distance to preview other focal lengths

especially if they are close. Looking from the side of a moving vehicle, for example, close parts of the landscape whiz past while the horizon moves hardly at all. Movement seen against other movements in differing directions gives a sense of dynamic action, excitement or confusion.

In still photography, movement is highly *subjective*. Images on the move often record as unfamiliar forms and shapes, not as when you were watching the subject at the time. This is because the exposure onto film was much longer or shorter than the eye's own perception of events. Results are said to be 'time-based'. So fast movement can be frozen, like the footballer in Figure 8.26, or the relatively slow movement of a fairground wheel (Figure 8.11) seemingly speeded-up. Eye and brain read such images of movement against our experience of the relationship of blur to speed. You can similarly deceive the viewer about speed and degree of movement by panning (Figure 8.27) or zooming (Figure 5.15).

Since movement and time are so closely linked, a *sequence* of frozen images like frames from a movie or a comic strip also reads as action. Try making a series of closely related images which show changes only in the position of figures against the same background detail. Presented as a panel of matched prints they read as actions and movement happening over a period of time. Alternatively a whole bunch of sharp or blurred images can be superimposed within just one frame. The more numerous the overlapped images the more movement seems to be taking place. Bear in mind too that even though you shoot a picture to show frozen action it can later be digitally manipulated. The computer allows you to multi-superimpose, or add a controlled degree of blur to imply subject movement in any direction you choose; see page 280.

Content and meaning

Most of the subject features discussed so far have been concerned with narrow physical detail. Shape, texture, colour, etc., all have a combined effect on the appearance of things, to be stressed or suppressed according to their interest and importance. But remember too that they are only components in your photography's hopefully much wider content and meaning.

Perhaps you choose to juxtaposition something expensive and luxurious against something cheap and tacky, to make a point about possessions. It could be strictly instructional 'what and why', showing correct actions when someone is doing a job, or using particular equipment. Or it might be some wry facial expression that reveals a relationship – say between people, or people and notices, or animals and children. These choices of content are all opportunities to express *concepts and emotions* such as craftsmanship, concern, bewilderment, aggression or joy.

Often meaning can be communicated by straight recording – the subject 'speaks for itself', like Figure 8.1. Sometimes (and this is usually more challenging for the photographer, and interesting for the final viewer) it operates through subtle use of symbols. For example, the cast shadow of a row of railings or a pile of timber can be made to look menacing, like some advancing horde. Use of 'old against new' can say something about ageing, irrespective of your actual subject. Visual communication, whether based on symbol, metaphor, or simply 'gut-reaction', is central to photography. Develop your ability firstly to notice

and then select basic subject qualities which best help you to make statements – rather like choice of words.

You could go about this by picking something you feel strongly about, perhaps an environmental or social issue. Then build up a volume of work, with pictures that strengthen each other. The total can be a visual statement with powerful meaning. Look out for examples of the work of individualistic photographers such as Martin Parr, Cindy Sherman or Don McCullin, who have each pursued (very different) obsessions through the content and meaning of their pictures.

Structuring pictures through the camera

You can only go so far in looking at the subject direct. Picture composition must be done looking through the camera, because this brings in all kinds of other influences. Some are helpful, others less so.

The most obvious change is that you now have to work within a frame having distinct edges, corners and width-to-height ratio. The viewfinder or focusing screen is like a sheet of paper – you don't have to be able to draw on to it, but you must be able to see and structure pictures within its frame and give due thought to balance and proportions of tone or colour, the use of lines, best placing of your main feature, and so on. Some viewfinder systems make composition much easier than others. A poorly designed direct-vision finder, or the upside-

Figure 8.15 Franco Fontana's 'Presence-absence' cleverly divides up the frame into strips and squares, putting some interesting shape into each. The final puzzle is to discover which are human and which are stone

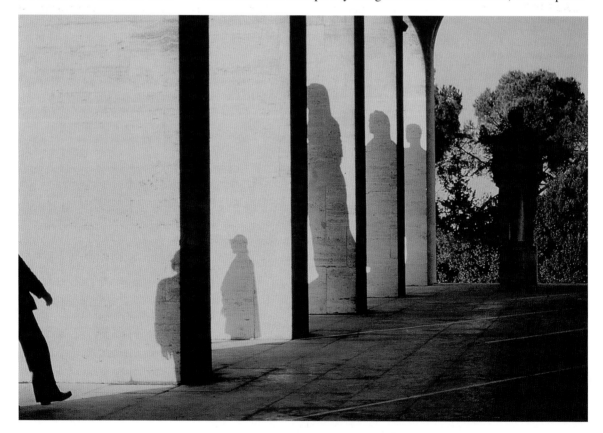

Figure 8.16 Bruton Dovecot, Somerset. A picture by Fay Godwin structured through its viewpoint and side-lighting to give a strong horizontal flow and reveal textures

Figure 8.17 Frames within frames. Reflected in this mirror the family is grouped within one shape, placed beside the food on the sideboard like a picture in a frame. Mirrors, windows and doorways are all useful devices to relate one element to another

down picture on a view camera screen, takes more time and practice to 'compose through' than the viewfinding optics of a modern SLR.

Using your camera as well as your eye means too that you add in all the techniques of photography, such as shallow or deep depth of field, blur, choice of focal length, etc. – hopefully to strengthen rather than detract from the points you want to make.

Proportions

Most cameras take rectangular pictures, so your first decision must be whether to shoot a vertical or a horizontal composition. Sometimes this choice is dictated by the proportions of the subject itself, or by how the result will be used (horizontal format for TV or computer screen, vertical to suit a show-card layout or magazine cover). Often, however, you have a choice.

Of the two formats, horizontal pictures tend to be easier to scan, possibly because of the relationship of our two eyes, or the familiarity of movie and monitor screen shapes. Horizontal framing seems to intensify horizontal movements and structural lines, especially when the format is long and narrow. In landscapes like Figure 8.10 it helps increase the importance of skyline, and in general gives a sense of panorama, and of stability.

Vertical pictures give more vertical 'pull' to their contents. There is less ground-hugging stability, and this can give a main subject a more imposing, dominant effect. Vertical lines are emphasized, probably because you tend to make comparisons between elements in the top and bottom of the frame rather than left and right, and so scan the picture vertically.

Figure 8.18 Standing stone, East Neuk. An unusual, near-symmetrical square format composition with the main subject blatantly centred, breaking a horizon which splits the frame. By Fay Godwin

Square pictures exert least influence. Each corner tends to pull away from the centre equally, giving a balanced, symmetrical effect. In fact this shape works well with formally structured symmetrical compositions such as Figure 8.18. However, many photographers find this 'least committed' of the three options the most difficult to work with.

You are of course not always restricted to a particular picture shape by the height to width proportions of your subject. A predominantly vertical subject can be composed within a horizontal format, sometimes by means of a 'frame within the frame' – showing it within a vertical area naturally formed by space between trees or buildings, or through a vertical doorway, window or mirror. It is also possible to crop any picture to different proportions during enlarging, producing either a slimmer or a squarer shape. (APS cameras have the advantage of allowing you choice of format at the time of shooting, Figure 4.23.)

Some leading photographers feel strongly against any such 'manipulation', even to the extent of printing a thin strip of the film rebate all round the frame to prove it remains exactly as composed in the camera. Others argue that keeping every picture to camera format proportions is

monotonous and unnecessary, and that cropping during printing is no different from excluding parts of the subject from the viewfinder when shooting. Professionally, too, you may often have to produce results to proportions strictly imposed by a layout (pages 146–147).

Balance

Your combination of subject and the camera's viewpoint and framing often divide up the picture area into distinctly different areas of tone, colour and detail. Frequently these are the shapes and proportions of objects themselves, but sometimes they are formed by the way edges of the frame 'cut into' things: a cropped building or person, Figure 8.15 for example, is reduced to just a part. Think of these 'parts' as areas or bands of tone, pattern, colour, etc., which to some extent you can alter to different proportions, move around, and make to fill large or small portions of your picture, all by change of viewpoint or angle.

The main division in a scene might be the horizon line, or some foreground vertical wall or post which crosses the picture, or even the junction of wall and floor in an interior. With a distant landscape, for example, tilting the camera will shift the horizon, and might alter your picture content from the ratio one part sky:three parts land, to the reverse. When most of your picture is filled with dark land detail there is an enclosed feeling, and the added foreground makes scale differences and therefore depth more apparent. With most of the picture area devoted to sky the impression is more open and detached.

A central horizon, dividing the picture into two halves, runs the danger of splitting it into areas of equal weight with neither predominating. Much depends on the range of shapes, colours and tones in each half. Occasionally, complete symmetry is useful as overall pattern surrounding and leading to a centralized main subject.

The best placing of divisions depends on the weight of tone, strength of colour, and pattern of detail they produce in different parts of the picture. One approach is to go for a *balanced* effect (Figure 8.19) where

Figure 8.19 Balance. Like weights at the end of scales, the shapes and tonal values here pivot about the old car. There is a kind of equilibrium about the bleak farmstead, but also a sense of deadness. Arthur Rothstein, FSA

weight of tone allows the centre of the picture to 'pivot' like a set of scales, but without being monotonous and over-symmetrical. On the other hand, a picture intentionally structured to appear imbalanced can add tension and will stand out amongst others; see Figure 8.24.

Line

You will improve the composition of pictures if you can use lines within your subject matter to give an appropriate structure or shape. They also help the mood you want to create.

Lines need not be complete outlines but a whole chain of spaced or overlapping shapes – clouds, hedges, a blurred movement, a back-

Figure 8.20 Linear flow. Thanks to the camera's single eye, lines can be built up within a composition from a whole chain of different objects at various distances. Fay Godwin shows this marker stone on the old Harlech road from a viewpoint which links it into criss-cross stone walling spanning the Welsh hills

Figure 8.21 Emphasis by colour, contrasting with surrounding tones. Newspaper seller in Rome. Even the 0 and 8 formed by bits of string seem to possess surreal significance here

ground shadow – which your camera's single viewpoint sees as attached or linked together. In fact lines occur wherever a clear boundary occurs between tones or colours, with strongest lines where contrast is greatest. Subject lighting is therefore influential. Lines help to hold things together, give a flowing feeling to a landscape, 'round off' a group of still-life objects, or relate things in different parts of the frame; see Figure 8.20.

The general pattern of lines in a picture has an interesting influence. Well-spaced parallel lines and L shapes have the most tranquil, stable effect. Triangles, broad ovals or S shapes seem to offer more 'flow', encouraging you to view the picture more actively. Pictures with long, angled converging lines (formed by steep perspectives, for example) rapidly attract your eye to their point of convergence. A mass of short lines angled in all directions helps to suggest excitement, confusion and even chaos. Compare Figure 8.29 with Figure 8.4, for example.

All these reactions are probably linked to our visual experiences of life. Use them constructively. If you want a dramatic, dynamic image of a fast car, shoot it from a high or low angle, with steep perspective and bold contrasts. The same approach would be destructive for a gentle, romantic portrait, where a flowing open shape and graduated tones are much more helpful.

Emphasis

Try to ensure that everything included in the frame in some way supplements and supports (rather than dilutes or confuses) your main theme. The trouble is that photography tends to record too much, so you must be able to stress your chosen main element (or elements) relative to the rest of the picture. There are several well-proven ways of doing this. One is to choose a viewpoint which makes lines within the picture 'lead in' to the main subject; see Figure 8.18. You can also make your centre of interest prominent by showing it breaking the horizon or some other strong linear pattern.

Figure 8.22 Top: the so-called 'rule of thirds'. Dividing each side of the frame by three and drawing intersecting lines forms four alternative locations for strongly placing the main subject. Bottom: the classic golden mean of ideal proportioning (for the format itself or composition of subject areas within). Starting with a square, a line drawn from the centre of one side to an opposite corner becomes the radius of an arc. This defines the base line of the final 5:8 ratio rectangle

Figure 8.23 Far right: Scott memorial, Edinburgh. An example of composition making use of the rule of thirds

Figure 8.24 No composition has to comply with rules. John Batho's 'Couple and Blue Sky' has a bold, lively effect because of its off-balance framing and restricted use of strong colours

Figure 8.25 Framing action. Both these prints are made from the same negative. By cropping to include most space in front of the boat (top version) the action seems to be just beginning. By reframing (bottom) to crop the front and including more wake it seems that events are nearly over

Another method of emphasis is to show your main element against a background, or framed by foreground, which strongly contrasts in tone or colour. Choice of lighting is again important, and camera techniques help to untangle subjects from surroundings too. Use shallow depth of field if things are at different distances; if one is moving relative to the other try panning.

There is a guide to the strongest positioning of your main subject within the frame, known as the *rule of thirds* (see Figure 8.22). This places an imaginary grid over the picture area, creating four off-centre intersections which tend to be strong locations. (A similar guide, much used in classical architecture and painting and called the *golden mean*, uses ratios of 5:8 instead of 1:2.)

Always remember such a guide but, like working only with a normal-angle lens, don't let it restrict and cramp your style. Sometimes the formality, or the tension, of your image will be better served if the main element is placed centrally, or against one edge. A shot can also be given *two* points of emphasis, and you can attract attention by placing them at opposite extremes of the frame so that the viewer scans from one to the other, making comparisons, conscious of distance and space.

Framing movement

You can alter your impression of active subjects by picture composition and choice of moment. Think of the frame as a stage. If the action is across the frame and you show the main subject at one side facing inwards the activity seems just to have started. But if it faces outwards

Figure 8.26 Ady Kerry's split-second timing and framing captures Peter Schmeichel a moment after heading the ball. Using a 180 mm lens on a 35 mm SLR it was shot at 1/500 sec f/2.8 on ISO 1600 film, push one stop (see page 212). The resulting grainy quality seems to add atmosphere to subjects of this kind

with all the space behind, the same subject seems to have travelled the distance, done the action.

You can make movement appear more dynamic and aggressive by composing it diagonally across the frame, angling vertical and horizontal subject lines, and if possible converging them too. Remember that even when no strong lines are present, a slow exposure (page 57), plus zooming and panning if necessary, will draw out highlights into powerful blur lines. Digital manipulation allows you similar effects after shooting.

The moment chosen to photograph moving objects and rapid-changing situations can make or break a picture. Fast reaction may allow you to select and capture one brief decisive moment, summing up a whole event or situation. This could be a momentary expression, a key action (like breaking the winning tape in a race) or just two elements briefly included in the same frame and signifying something by their juxtaposition. Shooting at four frames per second would seemingly cover every eventuality. But the vital moment can still fall between frames. There is no substitute for split-second manual timing.

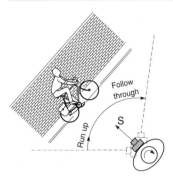

Figure 8.27 Panning a moving subject. The cyclist, right, had 1/15 sec exposure while the camera was smoothly panned sideways as shown above. Start the pan early to achieve a swing of the right speed when the shutter is released (S) and then follow through. Notice how in the foreground and background vertical details disappear and horizontal highlights spread into lines. The picture gives an impression of moving with the cyclist. In bright light, shoot with slow film and stop down fully; you may also need a neutral density filter to avoid overexposure at this slow shutter setting

Commercial requirements

If you are producing pictures purely for yourself, or for a portfolio or exhibition with a completely open brief, there may be no-one else's requirements to take into consideration. But if you are a professional photographer given a commercial assignment, it is vital to adapt your freedom of approach to the needs of the job.

Commercial photography in its broadest sense (advertising, documentary, architectural, even medical) is problem-solving. The problem may be mostly technical – how to get a detailed informative picture under difficult conditions. Or it might be much more subjective, perhaps concerned with creating atmosphere and mood.

Start off with a clear, accurate idea of all aspects of the problem via a briefing with the client, designer or editor. What is the subject, the purpose of the picture and its intended audience? You also need to know practical details such as final proportions and size, how it will be physically shown or reproduced, and what will appear around it.

Scaling down or up

If your picture is to fill a space with fixed height-to-width proportions it will be a great help to mark up the camera focusing screen accordingly, and compose within this shape. As Figure 8.28 shows, by drawing a frame with the necessary proportions on paper and adding a diagonal you can scale it down to fit within any camera format. This is where it helps to have a camera allowing easy access to the focusing screen (such as view cameras, medium format SLRs or 35 mm models with removable pentaprism).

Use a thin black grease pencil to trace the new outline accurately on to the viewing side of your screen. In the same way you can mark out the precise areas where type matter or other images must finally appear within the completed illustration.

Preplanned proportions are not practical with candid or press photography. Here they tend to follow on from picture contents rather

than lead them. However, the art editor will thank you if you can cover the same subject in both vertical *and* horizontal formats. Ideally too, avoid tight framing, and leave sufficient content around the edges to allow cropping to slightly different proportions according to layout. (Of course you are then in the hands of the editor, who can destroy your composition – some photographers purposely make uncroppable pictures to avoid this situation!)

Size

The smaller your final picture the simpler its image should be. If it is to be reproduced little larger than a postage stamp (or on coarse paper) aim for a bold, uncluttered composition, perhaps with a plain and contrasting background. The larger the reproduction and the better the paper, the more detail and tone graduation will be preserved. If you know that your final result will be displayed as a big photo-enlargement, for example, it is probably worth changing to a larger-format camera, or at least finer-grain film.

Take special care over limitations of size if you work with a *digital* image – whether it is shot by digital camera or scanned from film; see pages 99 and 270.

Managing the job

Having established the needs of the job – its 'open' aspects as well as specified layout, content and approach – you can get down to planning. If you are working in the studio, what are the most appropriate accessories to include? Will some form of set need building or hiring? If it will be a location job the right place has to be found, and hired if necessary. Models must be short-listed through an agency, interviewed and chosen.

Lighting has to be thought out too. If you have to rely on natural light, consult weather forecasts for your location. Existing artificial light needs checking for its technical suitability. Tungsten or flash lighting units, and special equipment such as a wind machine, smoke machine or portable generator, may have to be hired. If you are shooting on film choose the

Figure 8.28 Scaling. Transferring picture proportions from a (larger) drawn layout to your camera focusing screen. 1 and 2: The page designer's specified picture shape is traced and a diagonal added. 3: Aligning this tracing with the bottom left corner of the camera's focusing screen, the diagonal now shows you the position for the top right corner of the format. 4: A wax pencil line drawn at this point gives you the scaled-down format needed

Figure 8.29 The eye seems to enjoy the sensuous pleasure of curved lines in pictures. The pattern in this weeping willow root flows around smoothly, bringing you back to where you began. By Jean Dieuzaide

most appropriate stock – colour or black and white, negative or slide, plus instant picture material; see Chapter 9.

On the day, and with all necessary items brought together, you can put flesh on what has until now been the bare bones of a picture. Which are the subject's best features to exploit? What is distracting or irrelevant, and needs playing down or eliminating? Working through the camera, frame up the shot, checking proportions and balance. Is picture structure overpowering content? The main subject may require greater emphasis, through lighting, framing, relationship to other elements. Perhaps a different lens or change of viewpoint is the answer.

As shooting proceeds, instant pictures are taken to check that equipment is working properly, and to provide a quick print-out to compare against sketched layout. Later one roll or sheet of film typical of the shot will be test processed, then the remainder put through giving any modifications suggested by those first results. Of course, if you are working with a digital camera, making checks of this kind take far less time (page 105).

Summary. Organizing the picture

- Picture-building starts with recognizing the basic visual qualities of your subject and needs of your picture, then emphasizing or suppressing, and composing the resulting image in the strongest possible way.
- Look out for subject qualities such as *shape* (identification, framework), *texture* (feel and character of surface), *pattern* (harmony, rhythm), *form* (volume and solidity), *colour* and *tone* (mood, emphasis), and *movement* (time-based action).
- Subject appearance must carry through your picture's meaning and purpose. This brings in factors such as expressions and relationships, and the way we *read things into* objects and situations.
- Using a camera means working within a frame. Consider picture shape and proportions, balance of tone and colour, the use of lines to give structure and emphasis, and the positioning of your main subject.
- Seize every opportunity for a strong structural composition, even though you have to think and shoot fast. After a while composition becomes almost a reflex – but don't lapse into stereotyped pictures.
- Most professional photography is visual problem-solving. You need to (1) understand the purpose of the picture, (2) evaluate subject qualities in the light of this purpose, (3) compose the subject into a meaningful, satisfying image within the frame, (4) choose the right technical controls to carry through the idea, and (5) organize all aspects of the shooting session in a professional manner.

Projects

1 Choosing an appropriate subject in each case, produce four photographs. One must communicate texture, one shape, one form and one colour – excluding the other visual qualities as far as possible.

2 Shafts of light – created by sunlight through leaves, slatted windows, half-open doors, etc. – have inspired work by photographers and artists. Look at some examples and produce photographs based on your own observations of *interiors* (naturally or artificially lit).

3 Photograph a mousetrap twice, each picture meeting one of the following briefings: (a) An objective illustration in a catalogue distributed to hardware shops. Final size reproduction 36 × 54 mm, horizontal format. (b) A poster advertising the play *The Mousetrap* (the picture should simply and dramatically draw attention to the title, and that the play is a thriller). Final poster A2 size, vertical format.

4 Produce four pictures which portray *one* of the following concepts: power, space, growth, action.

5 Take several pictures with the main element (or elements) composed close to the *sides or corners* of the frame. Make this unusual positioning contribute positively to meaning in your results.

6 Looking through books of photographs, find examples of pictures structured mostly through the considered use of (1) lead-in lines, (2) divisions or compartments within the frame, (3) patterns or textures, (4) high key, (5) low key, and (6) shape.

9
Films, filters

Having composed and formed the picture at the back of the camera the next step is to create a permanent record of this image. Capturing pictures and turning them into electronic signals by means of a CCD panel (Chapter 6) is fast improving. For the time being, however, exposing onto *chemically coated film* remains our main camera image recording medium because of its fine quality of results and lower equipment costs. Once film is exposed and processed it can be scanned and digitalized, page 270, allowing more adjustments to be made to pictures than ever before.

Light-sensitive compounds of silver have been used from the earliest days of photography 160 years ago, becoming enormously improved in sophistication and performance over such a long period. This chapter describes the various types of modern films, outlines how they work, their practical performance and their suitability for various types of work. The biggest distinction occurs between colour and black and white materials. *Colour* records more information, allows you to use extra variables in composition, often gives greater viewer-impact, and the results relate more closely to what you saw through the camera. *Black and white* is more restrained, more of an interpretation of reality; it allows you stronger use of shapes and tonal range to show form, is cheaper to reproduce, avoids technical problems of wrong-colour lighting, and has more tolerance in exposure and processing.

Nevertheless, both kinds of film share important basic features. These include speed rating, the relationship of graininess and sharpness, response to colour values, contrast, and the various physical forms camera materials take. It is also relevant to look at lens filters here, because their use links up closely with the colour response of films.

Silver halide emulsions

Photographic materials carry one or several coatings of *silver halide emulsion* – gelatin containing crystals of a silver halide chemical, such as silver bromide. Changes begin to happen when these crystals are

Figure 9.1 Silver halide crystals. An electron photomicrograph showing them here magnified approximately ×3000

struck by light-energy particles ('photons', see page 25). A few tiny deposits of silver accumulate at crystal imperfections (called 'sensitivity specks'). But given correct camera exposure they are far too small to see as any visible change, even if you were able to examine them through a microscope at this stage. Given vastly more light, such as leaving film in sunlight for several minutes, crystals do begin to darken slightly. In the camera, however, you need only give brief exposure to the relatively dim image – accumulating just sufficient photons to give tiny build-ups of silver atoms.

Since most photons are received from bright parts of the scene, and least from where it is darkest, you have all the components of a photographic image but in an invisible or 'latent' form. Later, at the processing stage, chemicals go to work on the tiny silver deposits forming the latent image. They will be grown and amplified enormously to give a visible chemical image; see processing, Chapter 11.

How film is made

Approximately half the world's production of silver is used by the photographic industry. Bars of the metal are dissolved in nitric acid to form silver nitrate, and this is combined with a *halogen* element (typically iodine, bromine or chlorine in the form of alkali salts or *halides*, potassium iodide, potassium bromide or potassium chloride). After by-products have been removed the resulting compound consists of *silver halide* crystals, which are light-sensitive. In order that these finely divided silver halides can be coated evenly on to film base they are mixed with gelatin to form a creamy silver halide emulsion.

Gelatin is used because it is highly transparent and grainless. It becomes a liquid when heated – ideal for coating – but also sets ('gels') when chilled or dried. It holds the silver halides in a firm, even coating across the film surface, yet swells just sufficiently in processing solutions to allow chemicals to enter and affect the halide crystals, without disturbing their positions.

In detail, modern film manufacture is very complex and demanding. Mixed emulsions are given additives and held for fixed periods at controlled temperature to 'ripen'. This makes some crystals ('grains') grow larger, giving increased light sensitivity (greater 'speed') and producing less extreme contrast. Film contrast changes because, when first formed, crystals are all very small and not particularly sensitive. They are affected by light equally; see Figure 9.3. When an emulsion has mixed sizes (mixed sensitivity), however, low-intensity light affects

Figure 9.2 Cross-section of black and white film. A: scratch-resistant gelatin top coat. B: one or more emulsion layers, containing silver halide crystals. C: foundation which improves adhesion to the plastic film base. D: gelatin anti-curl backing (may also contain anti-halation dye). Compare with Figure 6.2

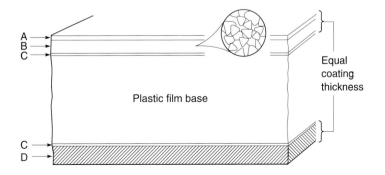

Figure 9.3 Grain size and contrast. Emulsion with slow. equal-size grains tend to be slow and contrasty. All grains become developable (far right) at one triggering light level. Mixed large and small grains (near right) can yield a range of tones related to light received. They are also faster

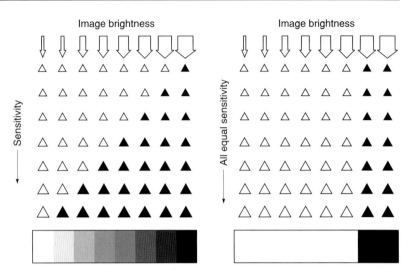

large crystals only, more light affects large and medium sizes, and brightest light affects all crystals, even the smallest. When the film is developed, these variations in light intensity therefore record as various grey *tones* rather than simply extremes of black or white.

Further additions to the emulsion alter its sensitivity to coloured light. In its raw state emulsion responds to blue and UV only, like (graded) black and white printing paper, but this can be extended to further bands or the whole visible spectrum. Meanwhile the film's base (most often polyester or tri-acetate) receives several preparatory coatings, including an anti-curl gelatin layer applied to the back to prevent the film shrinking or curling when the emulsion is coated on the front. Another layer of dark 'anti-halation' dye prevents light reflecting back from the base and forming 'halos' around the images of bright highlights. This layer may be between emulsion and base, or coated on the back of the film. In addition, 35 mm film has grey dye in the base to prevent light passing into the cassette, piped along the thickness of the film. Like anti-halation material it disappears during processing.

Emulsion coating itself is extremely critical, and carried out in ultra-clean conditions. Black and white films may need between one and four layers, while most colour films have more than ten layers of several different colour sensitivities. The final layer is clear protective gelatin. (For details of the structure of instant-picture materials, see *Advanced Photography*.) Film is coated in large rolls, typically 1.5 m wide by 900 m long. After drying, this is cut down to the various standard film sizes, either perforated (double for 35 mm, single for APS) or notched (sheet film), and edge printed.

The flowchart in Figure 9.4 shows the main forms of colour and black and white camera material for general photography. Many types are also made for X-ray, infra-red, lithographic and other special purposes. You can often shoot on one film and end up with a form of result normally produced from another – black and white prints from colour negatives, for example. But the most regular route, with fewest stages, always gives best quality. This is why it is important to know in advance what is finally needed from a job, in order to shoot on the right materials in the first place.

Features common to all films

Sizes and packings

Figures 9.5 and 9.7 show the main types and sizes of film. For APS cameras films are 24 mm wide and come in cartridges which open and self-load when dropped into the camera body. The picture format is 17 × 30 mm, but croppable at the shooting stage, see page 68. There are 15, 25 or 40 exposures per cartridge, and film is returned from the lab with its processed negatives secured inside this container.

The widest range of colour and black and white emulsions is made in 35 mm size. It is marketed in cassettes giving 36, 24, or (in some types) 12 exposures of standard 24 × 36 mm format. A few monochrome 35 mm films are available as 50 ft and 100 ft (or 15 m and 30 m) lengths in tins. This bulk film is for cameras with special film backs (page 91), or you can cut it into short lengths to refill regular-size reloadable cassettes. Doing reloads (Figure 9.6) reduces film costs but risks scratches and dust. It is a false economy for professional work.

Rollfilm, rolled in backing paper on a spool, and coded 120, is 6.2 cm wide. The number of pictures per film depends on your camera's picture format; see Figures 4.12 and 9.7. 220 film is on thinner base, allowing twice the length and number of pictures on the same spool size as 120. Some double-perforated 70 mm films are available in 100 ft cans for bulk rollfilm-back cameras.

Sheet films packed 10, 25 or 50 per box come in several standard sizes. The edge-notching (Figure 9.8) helps you locate the emulsion

Figure 9.4 Types of camera film. Main routes (red) plus crossovers leading to different forms of final result

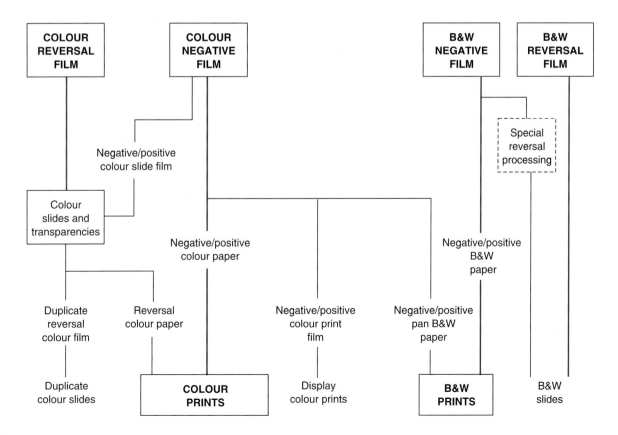

Figure 9.5 Packaged film materials. (S) sheet film, 35 mm cassette and rollfilm, (C) APS cartridge, (P) instant-picture peel-apart pack and an enveloped sheet, (B) tin of bulk 35 mm

Figure 9.6 35 mm bulk-film loader. Once it has been loaded with up to 30 m of film in the dark, you can insert and fill 36-exposure reusable cassettes in normal room light

Figure 9.7 Film sizes – main camera materials

surface when loading film holders in the dark, and has a shape code by which you can 'feel' film type, as well as identify it after processing. All films except bulk lengths have further type and batch identification data printed along their edges. Check the manufacturer's data sheet for the product to decode information.

Instant print sheet materials are mostly used as 8- or 10-exposure packs $3\frac{1}{4} \times 4\frac{1}{4}$ in and 4×5 in, or individual sheets 4×5 in and 8×10 in in special envelopes. They are of two main types (Figure 9.9), 'peel-apart' and 'integral'. Each exposure on peel-apart material is removed from the camera as a sandwich of two sheets you leave together for a timed period, then peel to reveal a right-reading print on one sheet. It is most often used in a pack holder which attaches to rollfilm cameras with magazine backs, or 35 mm cameras with removable backs. Sheet instant film slots into a sheet film holder inserted into a view camera. These peel-apart materials are still extensively used by professional photographers in the studio to produce a quick print confirming lighting, exposure, composition, etc. You have to remember though that colours may not exactly match your final results on conventional colour film. Digital backs (page 103) offer an alternative as their capital cost

Film width	Maximum picture width (nominal)	Size coding	Notes
24 mm	17 mm	APS	Perforations one edge; cartridge
35 mm	24 mm	135	Standard 35 mm; double-perforation; cassette
6.2 cm	6, 4.5 or 7 cm	120	Standard rollfilm, unperforated, rolled in backing paper; gives 12 frames 6×6 cm, 10 frames 6×7 cm or 15 frames 6×4.5 cm, etc.
		220	As 120 but double length
7 cm	6 cm	70 mm	Double perforation; bulk film for cassette loading

*Camera sheet material sizes**

4×5 in	Also instant-picture single peel-apart units
10×8 in	Also instant-picture single peel-apart units
3.25×4.25 in	Peel-apart instant picture packs (fit special backs for rollfilm, e.g. 6×6 cm cameras)

*The actual cut size of sheet film is minutely smaller, to slip into holders.

Figure 9.8 Typical sheet film notch codes. A: typical transparency film (daylight). B: transparency film balanced for tungsten lighting. C: most graphic-arts specialist films. In the dark you can 'feel' the notch pattern to discover the film type. The emulsion is facing you when held as shown

comes down. 'Integral' instant picture prints eject from the camera after exposure as a plain card which forms a picture as you watch. Its main use is in Polaroid point-and-shoot cameras which are designed with an internal mirror – otherwise pictures on integral material are reversed left-to-right.

APS films form part of a simplified handling system designed principally for amateurs not wishing to do their own processing, and so closely linked to automatic photo-finishing machinery in commercial laboratories. Unlike the slightly larger 35 mm cassettes, APS cartridges have an external visual display showing whether their contents are exposed, unexposed, etc. (see Figure 4.13). The silver halide film itself carries an additional transparent coating able to magnetically record data from the camera – for example the user's choice of three viewfinder settings for different picture format ratios, and so programmes an automatic printer at the lab to enlarge the appropriate area of the particular negative (see page 68). For 'panoramic' prints, strips top and bottom of the picture are masked off (Figure 4.23) and the rest enlarged up.

Film speed rating

Your film's sensitivity to light is denoted by the emulsion speed figure printed on the packaging. It follows strict test procedure laid down by standardizing authorities. Most manufacturers quote an ISO (International Standards Organisation) figure; see Figure 9.10. This combines previous American-based ASA ratings and European DIN ratings. The *first* part of the ISO figure doubles with each doubling of light sensitivity; the *second* number (marked with a degree sign) increases only by 3 with each doubling of sensitivity. Often the first ISO figure forms part of the film's brand name, for example Fujicolor 160. Specialist infra-red film has an Exposure Index (EI) rating.

Your film's speed rating figure is based on standard conditions of lighting, typical exposure times and the amount of development given during processing. If you intend to increase or decrease development from normal you can (as it's known) 'uprate' or 'downrate' film speed when exposing; this may be helpful when you want to alter contrast, or simply get maximum possible speed out of a film in dim conditions. In general fast films of ISO 800 and upwards are designed to best respond to up-rating and consequent extra development, see page 212. Exceptionally long or short exposures also influence film speed, see Appendix C.

35 mm films have checkerboard codes printed on their cassettes. These allow contacts in the camera's cassette compartment to sense film speed electronically and so set the internal exposure meter automatically. If you want to uprate or downrate the film's normal speed, you must do this with the camera's exposure compensation dial (Figures 4.32 and 10.20).

Figure 9.9 Instant-picture materials: Top: integral type. Bottom: peel-apart type, showing pack attached to a rollfilm camera in place of its film magazine

Speed, grain and sharpness

Graininess refers to the pattern of grain clumps in the processed image. If this is coarse it will show up as a mealy pattern and break

ISO	25/15°	50/18°	100/21°	125/22°	160/23°	200/24°	400/27°	800/30°	1000/31°	1600/33°	3200/36°
Speed		*Slow*		*Medium*				*Fast*		*Ultra-fast*	
Grain			*Fine*				*Medium*		*Coarse*		
ASA	25	50	100	125	160	200	400	800	1000	1600	3200
DIN	15°	18°	21°	22°	23°	24°	27°	30°	31°	33°	36°

Figure 9.10 ISO film speed ratings. The ASA scale is linear – if the rating is doubled the film sensitivity is doubled. DIN ratings follow a logarithmic progression – an increase of 3 means double the speed. ISO combines both

up delicate tone values when enlarged. Emulsion sharpness or 'acutance' is concerned with the degree of fine image detail the film can record. This brings in local contrast or edge sharpness, as well as grain, for an image can be fine-grained yet lack 'bite' because detail is flat and grey.

Film speed, graininess and sharpness are traditionally linked. As Figure 9.12 shows, the challenge to the manufacturer is to improve speed without increasing the size of silver halides and so also coarsen grain. And if the emulsion is simply made thicker to obtain speed by containing more halides there may be minute scatter of light ('irradiation') within this sensitive layer which worsens sharpness. Modern flat-shaped 'tabular' grains offer more speed with less sharpness loss, but your choice of film is still a trade-off between speed and image quality. Fast films are inherently grainier than slow films, and the more enlargement your film is to receive later the more important this fact becomes.

Sometimes you may choose fast film intentionally to get a granular effect, Figures 8.26 or 9.13, for example. More often this choice is made because the subject is dimly lit, and perhaps you need to stop down for depth of field *and* freeze movement with a short exposure. One way to reduce your grain problem and improve sharpness is by changing to a larger-format camera, because the film image will need less enlarging, but you will then have to stop down farther for the same depth of field.

In general graininess is increased and image sharpness reduced if you overexpose and/or overdevelop. In black and white photography there are numerous fine-grain and high-resolution developers to choose from, but they may reduce film speed too; see Chapter 11.

Figure 9.11 Typical examples of the image grain given by (left) ISO 25/15°, (centre) ISO 125/22°, and (right) ISO 1000/31° films. Each film was processed normally in its recommended developer and is reproduced here enlarged approx ×32, equivalent to a print 45 × 30 inches from the whole of a 35 mm format image

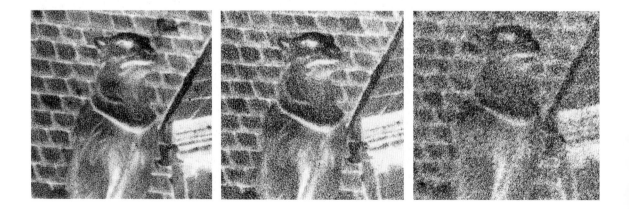

Figure 9.12 Relationship between film speed, sharpness and graininess. The faster the speed (emulsion C) the lower the resolution and the coarser the grain tends to be, relative to slower emulsions A or B. It is comparatively easy for manufacturers to make trade-offs between the three factors but difficult to increase the triangle area

Sensitivity to colours

Monochrome films. Film emulsions are sensitized during manufacture to some or all the colours of the spectrum. The vast majority of black and white films are given panchromatic colour sensitivity ('pan'). This means that they respond – in monochrome – to virtually the whole of the visual spectrum as well as to shorter UV wavelengths (page 313). In fact this response does not quite match the human eye's concept of light and dark colours. Pan film 'sees' (reproduces on the print) violet, blue and orange-red as somewhat *lighter* in tone and greens *darker* in

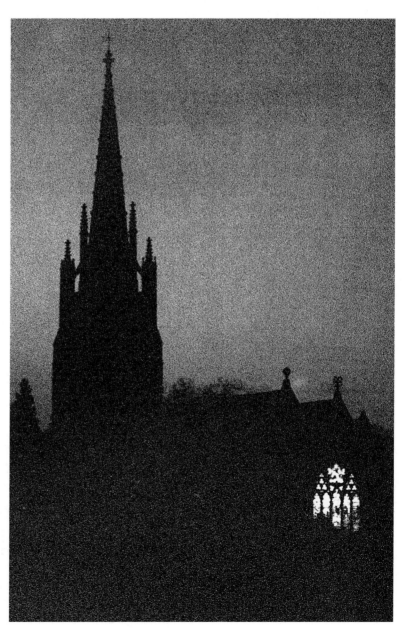

Figure 9.13 Using a grainy film. A moody, low-key shot taken on ISO 1000/31° film, then given extended processing and enlarged onto contrasty paper to help emphasize the negative's grain pattern.

tone than we would judge them to be. The difference is generally accepted, and is of some value in allowing slow pan materials to be handled under very deep green darkroom safelighting. For a more exact match you can shoot using a yellow camera filter.

A few black and white films are made insensitive to the red end of the spectrum beyond about 590 nm, and are known as orthochromatic ('ortho'). These films reproduce red as black on the final print, and orange as very dark. Ortho materials – mostly sheet film – are useful for photographing black and white photographs or drawings not involving colours. You can conveniently handle them in the darkroom under red safelight illumination. They are also used for some forms of medical, forensic and scientific photography. Ortho film speed rating is lower when the subject is lit by tungsten light rather than daylight or flash, because the former contains a higher proportion of red wavelengths.

One or two films, very slow and intended for the printing darkroom rather than camera purposes, are made with blue (and UV) sensitivity only. You can also buy special films for camera use that are insensitive to almost the whole visual spectrum but respond to infra-red and UV; see *Advanced Photography*.

Colour films, both negative and slide types, often have a stack of six or more emulsion layers. They use three different kinds of colour sensitization. The top emulsion is sensitive to blue only; others respond to blue and green; and the remainder primarily to red. A yellow filter may be incorporated below the blue-sensitive layer so that blue light cannot proceed farther into the film. Therefore you effectively have a multi-layered emulsion responding to blue only, green only, and red only – the three thirds of the spectrum. (Later each of these three emulsion types will form its image in a different *coloured dye*, to reproduce the final image in full colour; see page 313.)

The relative sensitivity of the different layers (colour balance of the film) is carefully controlled during manufacture. Most colour films are balanced to give accurate colour reproduction when the subject is illuminated by daylight or flash (5000–6000K). You can also buy a limited range of tungsten-balanced films which have slightly slower red-sensitive layers to give correct reproduction of subjects lit by red-rich 3200K tungsten lamps. Apart from 'daylight' and 'tungsten' colour balance films, one or two exceptional materials are sensitized to infra-red or laboratory light sources.

Figure 9.14 The reproduction of the coloured pencils shown below when photographed on (centre) ortho, and (far right) panchromatic monochrome films

Choosing films for black and white

Negative types for general use

The majority of black and white films are designed to give you a negative image in black silver. In other words, the latent image recorded in the camera is strengthened into visible black silver during developing, then the remaining creamy halides are removed leaving the film with a negative image (subject highlights darkest, shadows lightest) in clear gelatin.

General-purpose pan films range from about ISO 25/15° to ISO 3200/36°. The slower the film, the finer the grain and the better its ability to resolve detail. Contrast – the range of grey tones formed between darkest black and complete transparency – is *slightly* greater with slow films than fast films. This tendency is taken into account in the recommended developing times, which tend to be shorter for slow films.

Films between ISO 100/22° and ISO 400/27° offer a good compromise between speed and graininess. ISO 400/27° film gives prints with a just visible grain pattern (noticeable in areas of even grey tone, such as sky) when 35 mm is enlarged beyond 10 × 8 in, although this depends upon negative development and the type of enlarger light-source used; see pages 211 and 227.

In general it is best to use the slowest film that subject conditions sensibly allow, especially when working on 35 mm. For occasions when you want to give long exposures to create blur in moving objects, this too will be easier on slow film (see also neutral density filters, page 173). However, slow film may prevent you from stopping down enough for depth of field, or necessitate a tripod in situations where it is impractical. Fastest film is necessary for reportage photography under really dim conditions, and action subjects or hand-held telephoto lens shots which demand exceptionally short shutter speeds. Bear in mind that if you are after a moody – grainy but acceptably sharp – image from a well-lit landscape or portrait you could use ISO 3200 film with a deep grey neutral density filter over the camera lens.

Chromogenic types. A few monochrome negative films, such as Ilford XP2 Super and Kodak T400CN, give their final image in a brownish dye instead of silver. Extra components in the emulsion layers form tiny globules of dye wherever silver is developed. The processing you must give these films is known as 'chromogenic' and finally bleaches away all silver, leaving your image in dye molecules alone. Since chemicals and processing stages are the same as for *colour negatives* (page 215) it is easy to hand your exposed film into a high street mini-lab anywhere for rapid black and white results. APS size monochrome film is also chromogenic, for the same machine processing reasons.

Another advantage of chromogenic films is that they are more able to tolerate inaccurate exposure – especially overexposure – than silver-image types. You can choose to rate your film anywhere between ISO 125/22° and 1600/33°, provided you develop accordingly. However, although results are fine grain the grain is less 'crisp' and image sharpness slightly poorer than silver image film. They also cost more for self-processing, and you don't have the

Figure 9.15 High-contrast line film reproduces ink drawings (as here), diagrams, lettering, etc., in pure black and clean white only

choice of developers possible with the other films. Chromogenic films are popular with some news and documentary photographers because they suit a wide range of shooting conditions.

Special purpose monochrome film

Line film. Some materials – mostly sheet film, but also 35 mm in 100 ft lengths – are made with high-contrast emulsions. They give negatives with few or no greys at all between dense black and clear white, when processed in the appropriate contrasty developer. Line films (and the more extreme 'lith' films) are intended for photographing pen-and-ink drawings, etc., which contain only pure black and pure white and need to reproduce in this form. Emulsions are very slow and fine-grain, and most often have ortho sensitivity for easy darkroom handling.

You can also use line film to simplify regular images of full-tone-range scenes into stark, graphic black and white. Compare Figure 9.16 with 10.19. Since this sort of material only has a speed of about ISO 8, and its high contrast demands absolute exposure accuracy, it is best to shoot your picture first on normal film, then reproduce this onto line film by copying, or through printing in the darkroom. (Bear in mind though that you can make changes much more easily by digital means using an image manipulation software program, page 275.) Line negative film is also excellent for making slides of black-on-white line diagrams, which then project as bold white-on-black images.

Films for monochrome slides. There are three film types that allow you to make monochrome slides direct with a 35 mm camera. These are:

1 Special slow, fine-grain 35 mm films (e.g. Agfa Scala) which must be sent to a nominated laboratory for black and white 'reversal' processing. The film is returned containing positive, full-tone-range pictures ready for projection.

Figure 9.16 Line films can also be used to copy and convert a normal contrast print into a stark graphic image. Original shown on page 192

Figure 9.17 35 mm instant-slide film, with pack of processing fluid (A). Both are inserted in hand-cranked, daylight processing unit (B). See also Figure 11.28

2 Instant-picture film you process yourself within 2–3 minutes, using a simple unit (Figure 9.17) requiring no darkroom or washing facilities.

3 Suitable regular negative-type films, such as Kodak T-max 100, which you then reversal process using a special kit of chemicals (page 217).

All these materials can give excellent quality monochrome slides, with rich tone range, fine grain and extreme sharpness. But, as with all reversal-processed materials such as colour slides, you must get your exposure correct at the time of shooting because little adjustment is possible later.

Instant black and white print materials. There is a limited range of monochrome instant-print materials, mainly intended for professional use. They work on the 'peel-apart' basis (Figure 9.9) and come in pack form or as individual sheets in special envelopes. Speeds range from ISO 50 to ISO 3200. Two of the slower materials by Polaroid give you a high resolution film negative for enlarging, in addition to an instant paper print. Processing times are around 15–30 seconds, according to type.

All these are used mostly as 'proofing' materials to make on-the-spot lighting, layout and colour-translation pre-views when shooting a black and white assignment using regular film. It is a reassuring check on all your equipment before (and after) an important job. Instant material is approximately three times the cost of normal film.

Films with extended sensitivity. Occasionally a monochrome film is researched for a narrow, specialist purpose, then marketed for wider use because of its abnormal image qualities. Ilford's SFX for example, originally designed for speed-trap traffic cameras, has infra-red added to its panchromatic sensitivity. When 35 mm or roll film is exposed with a red SFX filter over the lens, subjects such as portraits record with darkened eyes, pale lips and a slight overall image softness.

Far more extreme, Kodak infra-red 35 mm and sheet film which was developed for aerial survey and medical purposes, has far less panchromatic response. It reproduces blue skies in landscapes black, foliage white and skin tones ghostly pale when exposed through a very deep red filter; see *Advanced Photography.*

Films for colour photography

Negative types. By far the greatest volume and range of camera material today is made as colour negative (or 'colour print') film. All the high street labs are geared up to process and print it at competitive prices. From colour negatives you can also make black and white prints, either using silver halide material or by scanning into and printing out from a computer (page 270), and professional labs can produce colour or monochrome slides.

Colour negative films carry in effect three types of black and white emulsion, recording blue, green and red respectively. They reproduce the image in *negative* tones and *complementary* colours. To understand this term 'complementary' colour, remember the colour spectrum of white light (Figure 2.3) shown again overleaf. If you remove all the red wavelengths from the spectrum, what remains appears not white but greeny-blue (called 'cyan'). Cyan is therefore said to be complementary

Figure 9.18 Complementary colours. When one-third of the spectrum (one of the primary colours red, green or blue) is removed from white light, the remaining mix of wavelengths appears cyan, magenta or yellow respectively. So each of these colours is a combination of two primaries and can be said to be 'complementary' to the missing third. In a sense they are 'negative versions' of red, green and blue

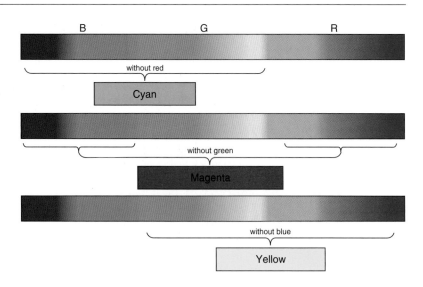

Figure 9.19 Colour negative image. Compare the original pencil colours (top) with the complementary colours in which they have recorded on negative colour film

to red – opposite or negative to it in terms of coloured light. In the same way removing green from white light produces a purply-red ('magenta'), and if you remove blue from white light you get a dominance of yellow. *Cyan, magenta* and *yellow* are said to be complementaries of *red, green* and *blue* light. (Note: these differ from the complementary colours in paints and pigments.)

The way that natural image colours formed by your lens in the camera are turned into their complementary colours in the processed film, is shown in Figure 9.20. Each emulsion layer in the film also contains a *colour coupler* chemical – a yellow dye former in the blue-sensitive layer, a magenta former in the green-sensitive layer, and a cyan former in the red-sensitive layer. Couplers only turn into their designated colour dye when and where the silver halides to which they are attached are affected by light, and so develop to black silver. When towards the end of this chromogenic processing the silver is removed, what was originally the blue-sensitive layer contains an image in which all parts of the picture containing blue record as yellow. Similarly, in other layers, parts of the image containing green record as magenta, and red parts as cyan. Wherever the scene was some other colour the image is recorded in more than one layer, while white or grey records in all three. Viewed as one, the 'stack' of layers gives you the familiar colour negative image (plus a characteristic warm tint remaining in clear areas). Follow this through in the reproduction of the coloured pencils, Figure 9.19. During enlarging similar layers in colour paper give 'a colour negative of a colour negative', recreating subject colours and tones.

Figure 9.20 How colour negative films reproduce colours. Near right: black silver develops and complementary dye forms where each layer responds to subject colour (compare this G and R response with Figure 9.18). Far right: silver and remaining halides are removed, leaving negative image in dyes alone

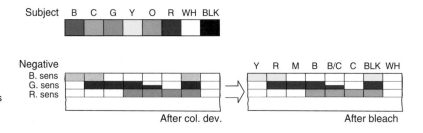

Colour negative films for general use

Colour balance. The vast majority of colour negative films are balanced for use with daylight or flash. If you shoot with them in tungsten lighting instead results show a warm orange/yellow cast. It is possible to make colour correction during darkroom printing or digital manipulation, but this may create difficulties and restrictions owing to the amount of change required. It is better to shoot with a bluish conversion filter over the lens (page 165). A very few roll and sheet films are made colour balanced for 3200K tungsten lighting – if used with daylight or flash an orange filter is necessary.

Film speeds, and colour contrast. You have greatest choice of film speeds in 35 mm and to a lesser extent rollfilm formats. Typically they run ISO 100, 160, 200, 400 and 800. Small format films of ISO 1600 or 3200 give coarse grain pattern but thanks to improvements in emulsion chemistry combine this with good image resolution. These fast films are also designed to be up-rated when needed to double their box speed, then push-processed in the standard developing kit for all colour negatives known as C-41; see page 215. Sheet films differ very little in speed, typically around ISO 100. 35 mm colour negative film of ISO 200 or 400 gives good trade-off between speed, graininess and resolution for most situations apart from press photography.

The colour qualities of your final picture can range from natural or subtle to bold and vivid. Fine judgement of what looks best depends on subject and use – a striking shot advertising colourful products is helped by film giving slightly bolder contrast and colours but this would not suit delicate flesh tones in, say, the portrait of a child. Adjustments can again be made in colour printing, but to minimize compensations at this stage (particularly if you use an outside lab for prints) some films for professional photography are made in a choice of colour strengths. So the same film name, whether fast or slow, may be followed by the suffix NC for 'natural colour' or VC for 'vivid colour'. The NC version is usually the best choice for natural flesh tones in studio portraiture; VC would enhance a subject with a rich predominant colour, especially in flat, existing light.

Slide and transparency films

Colour films designed to give positive images direct often include the suffix *chrome* in their brand name rather than *color*, which is used for negative types. Fujichrome rather than Fujicolor. Chrome films are also collectively known as colour reversal films, because of the special reversal processing they must be given. Results from rollfilms and sheet films are normally referred to as transparencies, and 35 mm results as slides. These materials are mainly used by the professional; as most colour pictures for reproduction on the printed page are traditionally preferred in this form because of their high image resolution (unlike most prints which have had to pass through a lens twice).

All reversal films have a multi-layer structure, making use of blue-, green- and red-sensitive emulsions, and most have yellow, magenta and cyan dye forming couplers, similar to those in colour negative film. However, results have stronger contrast and saturation of colour, plus a lack of 'masking' (see *Advanced Photography*), which means there is none of the overall pinkish tint characteristic of colour negatives. Viewed

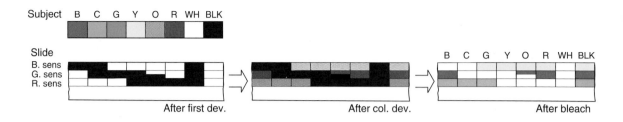

Figure 9.21 How slide films reproduce colours. Above: black silver develops only where layers respond. Centre: remaining emulsion is turned into black silver plus dyes. Right: all silver is removed, leaving positive image in dyes alone

on a light box or projected as slides, reversal film images show a wider range of colours than it is possible to achieve on paper prints.

During the first part of processing only black and white developer is used, forming black silver negatives in the various layers. Dyes are then formed where the *unused* halides remain so that when all silver is removed a positive, correct-colour image remains. For example, referring to Figure 9.21, green (e.g. foliage) in your subject records on the green-sensitive layer and is developed as black silver there. The blue- and red-sensitive layers in this foliage area are not affected by the light and so form yellow and cyan, which together make the final image here look green.

Virtually all reversal colour films need chromogenic processing using developing kit E-6 and this, like C-41 for negatives, can be carried out by photographer or laboratory. Only Kodachrome, which is an older film type, needs a much more elaborate processing procedure (K-14) which is offered by one or two laboratories in various countries.

Colour balance. Colour balance must be more accurately matched to type of lighting than with negative materials, as corrections are not possible later except by digital means. The majority of colour slide films are balanced for daylight and flash but there are also several films designed for 3200K tungsten-light. Daylight film needs a bluish filter if used with tungsten light; tungsten-balanced film needs an orange filter with daylight or flash (Figure 9.22). Image colour is easily 'burnt out' by accidentally overexposing or darkened by underexposing, so here again you have to be more accurate – little correction is possible later, apart from some speed-rating compensation of complete films during processing.

Film speeds and colour contrasts. Again, the widest range of reversal films is available in 35 mm format, from ISO 25 to ISO 1600. Most (up to ISO 1000) are also made as rollfilms. Sheet films range in speeds from ISO 64 to 160. Tungsten balanced films are typically ISO 64. Most reversal films of ISO 200 or faster can be up-rated and then push-processed to double their normal speed rating – either to correct overall exposure errors or help when you shoot in dim lighting. Some make a feature of their up-rating potential and allow four times the speed rating shown on the box, although changes in image contrast and increased graininess become your limiting factors. (When you know in advance that light will be poor it is usually wisest to shoot on fastest film, rather than up-rate normal speed material.)

Processed results from reversal films are brighter and richer in hue than colour negatives. They must have the brilliance of appearance expected in a final image, as opposed to an intermediate tailored to

Lit by: Daylight Tungsten photo lamp Tungsten studio lamp

 5500 K 3400 K 3200 K
Film:
Daylight type Daylight type Daylight type

 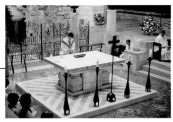

Tungsten type Tungsten type Tungsten type

 85B 80B 81A 80A

Result Result Result
from filter from filter from filter

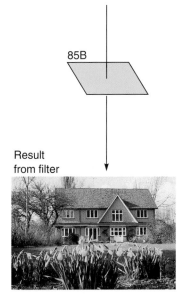 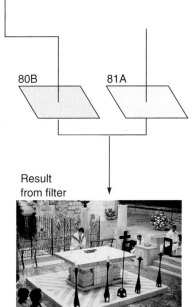

Figure 9.22 Colour films, especially slides, exposed to subjects lit by a source of the wrong colour temperature show a cast. You shoot using an appropriate conversion filter. (Note: 3400K tungsten lamps, regularly used for TV and movie lighting, require filtering on both daylight and tungsten type stills-photography film)

match up with the characteristics of neg-pos colour printing paper later. Different reversal films produce subtle differences in image colours owing to different image dyes used by the manufacturer. According to subject and mood you can shoot with a very saturated colour film; or one saturated but 'warm'; or one specially optimized for skin-tones; or again film giving a slightly warm colour balance for outdoors in cloudy conditions. Take care though not to mix reversal films from various manufacturers when covering any one assignment. Shots showing differences in hue and contrast then stand out like a sore thumb.

Special reversal materials

Special low-contrast transparency films are designed for duplicating slides, while others with boosted contrast are used for copying coloured line drawings, or low-contrast specimens photographed through the microscope, etc. You can also obtain false-colour infra-red Ektachrome for medical and aerial work, or special colour effects; see *Advanced Photography*.

Instant-picture materials. Instant-picture 35 mm colour slide materials are made by Polaroid and known as Polachrome. These are processed in the same mechanical unit as black and white instant slides. They work on an 'additive screen' basis, internally quite unlike conventional multi-layer colour materials. Results are not yet up to the standard of regular colour transparency materials or instant black and white slides.

Storing film – before and after exposure

'Professional' and 'amateur' films

All the main film manufacturers designate some of their range (negative and slide) as *professional* and include this word on the pack. The main difference between professional and 'non-pro' or amateur film is that the former is designed to give its best, exactly specified performance the moment it leaves the factory. So provided you give it *immediate refrigerated storage* at 13°C or less, as suggested for the product, it will record with great film-to-film consistency. Professional film must be processed immediately after exposure too.

Amateur films are planned for a slightly different storage scenario – in which they remain at room (or shop) temperature for an average time after delivery, and there is a more variable time delay between exposure and processing. In practice, amateur films are about 25 per cent cheaper than professional films of the same speed. They are in no way inferior for professional work, but it is advisable to make checks for possible batch-to-batch variations. Having done this, colour consistency is better maintained if you keep them in refrigerated storage as for professional films.

Length and type of storage

The main hazards to avoid – before and after exposure, and before processing – are damp humid conditions, chemical fumes, and fogging to light or to radiation such as X-rays. Exposed films are more likely to react than unexposed ones; and fast film rather than slow.

Figure 9.23 Film types: Top to bottom: monochrome rollfilm negative, 35 mm colour negative, reversal colour (slide) film, reversal monochrome film

Speed loss is the most common effect of overlong storage. Colour film is especially vulnerable to change because alterations to the finely adjusted relative speeds of its different emulsion layers upset colour balance. Remember that the expiry date stamped on the packaging is only a guide – so much depends on storage conditions (including before you bought it). Stored in the general compartment of a domestic refrigerator, sealed film should remain usable beyond this date without changes.

However allow time for your film to warm up, unopened, between removing it from the refrigerator and shooting. Unsealing too soon may cause condensation to form on the emulsion. Recommended periods are 1 hour for cassettes and sheet film, or 3 hours for cans of bulk film. Remember too that instant-picture materials only function at their expected speeds when at 18–30°C. Below about 10°C most will not work at all, so take care to warm up the pack under your coat when working outdoors in winter.

If you cannot process exposed film straight away store it in a cool, dry, dark place. If it goes back into the refrigerator keep it in a taped-up foil bag or airtight box, as without this your film is no longer protected from humidity. If possible include a packet of desiccating crystals such as silica gel within its container to absorb any moisture.

Regard radiation from X-ray inspection machines used to check luggage at airports as a potentially serious hazard. Disclaimer notices are often deceptive. Fast film (ISO 400 and over) can end up with serious orange-brown streaks after processing if you leave them in bags loaded into the aircraft's luggage bay. Carry films with you and ask (argue if necessary) for them to be hand-searched. Radiation fogging effects accumulate, building up even small dosages at every check-point. As inspection technology keeps changing the risk factor to film becomes greater or lesser – you can never be sure of the dosage given, particularly from old equipment in foreign airports. Professionals returning with large batches of exposed film from a major shoot may have to discover an air freight carrier who can guarantee that the shipment will not be X-rayed.

So which film is 'best'?

Despite the future erosion of silver halide photography by digital capture you are spoilt for choice by today's vast range of films – especially if you shoot on 35 mm. It makes good sense to narrow your field: use as small a range of films as your work allows, and get to know them thoroughly. Real familiarity with a film's characteristics is most likely to give technically consistent, reliable results. Just remember the existence of other materials for special tasks.

The main factors to consider when choosing film are:

1 *What is to be the final result?* Print or slide/transparency; colour or black and white; a large print to hang on the wall, a set in an album, or for reproduction on the printed page or transmission via the Internet? If your picture might be used now or in the future in a whole variety of ways shoot colour negative. And if there is any likelihood that a large display or exhibition print will be the end product go for a film format larger than 35 mm. If pictures will illustrate a magazine or book, or be used for a lecture, colour reversal film might be best. If you plan to scan your pictures into a desktop

Figure 9.24 'Armadillo'. Taken by Jim Mackintosh Photography for SECC Glasgow. An effective example of the use of colour in architectural photography. A split filter tinted only in its upper half was used over the camera lens. See page 174

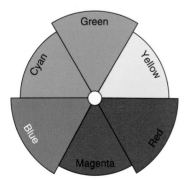

Figure 9.25 Simplified colour wheel, based on the spectrum of light 'bent' into a circle. Oversize segments blue, green and red are the primary colours of light. Yellow, magenta and cyan are complementary colours, and (for filtering purposes) the most opposite to each primary

computer, however, colour negatives give better results because of their lower contrast. Remember too that colour negatives can be darkroom printed in monochrome, or scanned-in 'grey-scale' (page 270).

2 *Relate the film to type of subject and lighting conditions.* Will its contrast, colour brilliance and grain (if any) best suit the image quality and/or mood you want to achieve? Will the film's speed and colour balance link up with the strength and colour of the lighting (remember likely depth of field and movement blur requirements too). Perhaps you will be working in changing lighting, and conditions where exposure may be difficult to measure accurately? In which case pick a film which is most tolerant of over- or underexposure.

3 *Will you process and print it yourself, or use a lab?* For self-processing use a tried and tested combination of film and developing which gives excellent results on *your* enlarger (or through your computer's film scanner). Is there a reliable, caring lab able to handle the work for you and return it promptly – preferably knowing the kind of result you like, via personal contact?

4 *Personal preference.* Beyond a certain point colour, contrast, and 'crispness' or 'subtlety' of image quality is *subjective*. Get to know one or two films which really suit your style, and help give a recognizable look to all your work.

5 *How expensive is film and processing?* If you are working professionally this comes lower down the list because your time, travel, studio and lighting hire, etc., are all more expensive elements (especially if you have to reshoot because inferior materials and back-up were used).

Always test out a film you have never used before, prior to using it on an assignment. And where practical buy your transparency film in batches all of the same coating number (printed on the box). If most of your photography is 'constructed' – using models in the studio or on location, working to layouts, etc. – use instant-picture material in a suitable camera back as well. Here it helps to pick material with the same ISO speed as your regular colour film, so that camera settings (which affect depth of field, etc.) remain the same for test and shot.

Filters – how they work

Colour filters help you to alter the contrast between grey tones representing subject colours when shot on monochrome film, see Figure 9.27. Used with colour film they allow you to shoot using light sources for which the film is not balanced (e.g. daylight film in tungsten light) without getting an overall colour cast, Figure 9.22. And by means of pale filters you can gently 'warm up' or 'cool down' your colour images. The rule is that a filter passes light matching its own colour, and absorbs (darkens) other colours – particularly those farthest from it in the spectrum; see the colour wheel opposite. To check out filter effects, first find yourself a bold, multi-coloured design – a book jacket or cornflake packet perhaps, or a motif like Figure 9.25. View it through a strong red filter (even a sweet wrapping will do). The whole subject appears red, but check how *light* or *dark* the original colours now appear. Strong blue and green subject areas are relatively darker in tone, almost indistinguishable from black areas. This is because the light wavelengths they reflect cannot pass the filter.

Red parts of the subject, however, look much paler than before, practically the same as white areas since they reflect as much red light as the white areas do (the other colours that white reflects are absorbed by the red filter). The same tonal changes occur when the light source illuminating your subject is filtered instead of your eye or camera lens.

Uses of col. filters on B/W film	Exposure increase factors: D/light Tungs.	
Deep red	×8	×5
Darkens blue skies		
Turns red stains white		
Changes green against red into black against white		
Orange	×4	×2
Like red but less extreme		
Yellow-green	×5	×4
Tones down blue skies		
Compensates pan film oversensitivity to blues		
Green	×8	×8
Darkens blue skies		
Turns green stains white		
Changes green against red into white against black		
Helps reveal detail in landscape foliage		
Blue	×6	×12
Lightens blue skies		
Turns red stains black		
Changes blue against deep yellow into white against dark		

Figure 9.26 Colour filters with black and white film. Colour chart (top row) photographed on panchromatic film through a deep red (centre) and deep green filter (bottom)

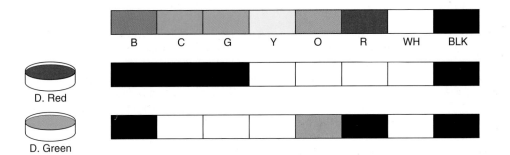

Figure 9.27 Filtering to improve sky detail. The top picture was shot on pan film without any filter while the sun was diffused by a patch of thin cloud. A deep red filter was added for the bottom picture, shot a minute later when direct sun side-lit the building. Notice how filtering has darkened the mid-blue sky, the green grass and deep blue flag. The red tiles, however, appear lighter. (The filter was marked ×6, and since exposure was not read through the lens, two and a half stops extra was given, see page 192)

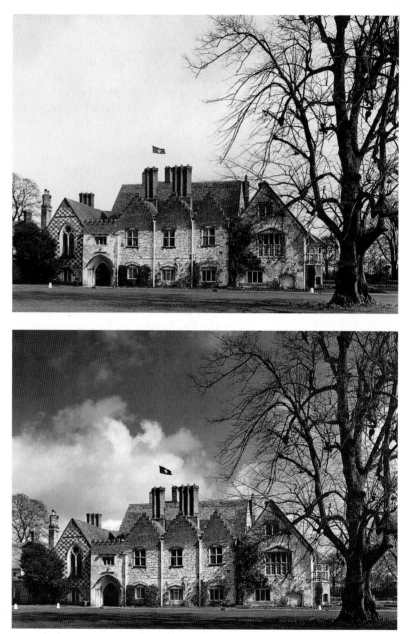

The form that filters take. Colour filters are sold as thin square sheets of dyed gelatin or polyester which you either hold over the lens or cut down to fit a filter holder. These are relatively cheap but soon pick up finger marks and scratches if used often. Some filters are made in glass and sold in circular mounts which screw into the front rim of your lens. The majority of dyed filters are now manufactured in optical (CR 39) resin, square in shape to slip into a holder. Remember that a glass or resin filter slightly alters the position of sharp focus, so always focus with your filter in place, especially if shooting at wide aperture. Gelatins have no such effect. It's difficult to fit a filter over the front of

a wide-angle lens without corners of the picture darkening ('cut-off'). Some wide-angles therefore have 3 or 4 *internal* colour filters which a dial on the lens barrel will bring into use.

Using a colour filter reduces the image light, but this is taken into account by a modern exposure meter located close to or behind the lens because it reads through the filter. When you are using a hand meter you will have to increase exposure by a 'filter factor', shown in the table in Figure 9.26 (see also page 192).

Using colour filters in black and white photography

Blue sky and white clouds normally record with the sky much paler grey than it seemed at the time, because film is more sensitive than the eye to blue. Clouds may therefore barely show up unless you photograph (on pan film) through an orange-red filter. Light is then absorbed by the filter, making white clouds stand out boldly against what is now dark sky, Figure 9.27.

No change takes place if the *whole sky* is white with clouds, and there is little effect if the sky is only weak blue (containing a high proportion of white light too). You should also consider any other colours present. If the sky is part of a landscape with green foliage, for example, the green darkens as well. If you use a deep green filter here instead this will darken sky tone almost as much, but *lightens* the foliage instead. The table in Figure 9.26 lists the typical uses of other filters.

Whereas deep coloured filters are known as 'contrast' filters, one or two paler types, normally yellow or pale yellow-green, are known as 'correction filters'. They make colours record in grey tones closer to their *visual* brightness instead of that given by unfiltered panchromatic film. This is really only important for critical technical photography – with most work the difference hardly shows. However, for landscapes with blue sky you could work with a yellow filter as standard.

Using colour filters with colour materials

Colour filters are used with colour films either for correction or for special effects.

Correction filters. There are two kinds of colour correction filters. Firstly a small number of often quite strong 'colour conversion' filters (Figure 9.22) allow you to shoot film balanced for one colour temperature in lighting of another. The second group consists of a wide range of mostly paler 'colour compensating' (CC) filters in six colours and various strengths (Figure 9.28). These allow you to 'fine-tune' adjustments towards warmer or colder results due to batch variations, working conditions, non-standard light sources, etc. They are especially important with colour transparency materials, which, unlike colour negatives, cannot easily be adjusted at the printing stage.

Conversion filters with *odd* reference numbers are yellowish or orange, for lowering the colour temperature of the light. Filters with *even* numbers are bluish and raise the colour temperature. These set filters change a particular light source by the amount required for a particular film type. For example an 85B, which is orange, changes daylight to the colour equivalent of 3200K tungsten lighting to suit

Figure 9.28 Some gelatin sheet colour compensating filters. The numbers relate to their strength, the final letter to colour

light source	Film type: D/L	Tungs.
Daylight	No filter	85B
Flash	CC10Y*	85B + CC10Y*
Tungsten 3400K	80B	81A
Tungsten 3200K	80A	No filter
Tungsten 100W lamp		82A
Fluorescent (basis of test)	CC40M	CC50R

*A few small flash units

Figure 9.29 Colour conversion filters

tungsten-balanced film. An 81A, much paler pink, changes the slightly too-blue light of 3400K photolamps to 3200K to suit the same film.

An 80A and an 80B filter (*even* numbers, and both blue) change 3200K and 3400K tungsten lighting respectively to match daylight and so suit daylight-balanced film. These are particularly useful filters because manufacturers offer so few films balanced for tungsten light. An 85B filter is always worth having in your camera case for roll and 35 mm materials if daylight scenes and tungsten lit shots are likely to be recorded on the same film. If subject lighting is mixed (a tungsten lamp used to 'fill in' and reduce contrast in a daylight-lit interior, for example) you can use the filter in sheet acetate form over one source to match it to the other. (Never use a *lighting* acetate for the lens; its poor optical qualities will upset image definition.)

Colour compensating filters, on the other hand, are best bought as gelatins of various tints and strengths. The most useful ones are yellow, red and magenta, in CC10 and CC20 strength (used together these form a CC30). Filters are most often needed on the lens:

- When using light sources (such as some fluorescent tubes) for which no one colour conversion filter exists.
- To fine-tune your image colours, based on the appearance of processed slide film tests. If, for example, the test film shows a slight bluish shift, view it through yellow CC filters of different strengths until neutral *midtone* subject areas look neutral again. The rule then is to use a CC filter *half* this value over the lens when you reshoot.
- To help counter the effect of reflective coloured surroundings – green vegetation, room decorations, etc. – which may otherwise tint your subject.
- To give the scene an intentional slight all-over colour bias which strengthens mood, helps blend and coordinate a colour scheme.

Colourless filters, used for both monochrome and colour films

Several important filters are equally useful whether you are shooting in black and white or colour.

Ultra-violet

Ref. (density)	Allows you to increase	
	aperture **or**	time
ND0.1	0.3stop	×1.25
0.2	0.6	1.5
0.3	1	2
0.4	1.3	2.5
0.5	1.6	3
0.6	2	4
0.7	2.3	5
0.8	2.6	6
0.9	3	8
1.0	3.3	10
2.0	6.6	100

Figure 9.30 Neutral density filters

UV-absorbing filters look like plain glass because they only absorb wavelengths our eyes cannot see. The sun's short-wavelength radiation is most readily scattered by particles in the atmosphere – a reason why sky looks blue here on earth and distant haze in landscapes has a bluish appearance. On films, however, this scattered UV records too, increasing the mistiness of haze and, on colour film, exaggerating its blueness. The effect is especially notable with landscapes at high altitude and near the sea. A UV absorbing filter therefore helps to record the subject appearance you actually *see*. Modern camera lenses often incorporate a UV absorber within their optics.

Better still, for colour films, use a 1A 'skylight' or 'haze' filter, which has a barely perceptible pink tint. It's worth having this filter on for all landscape work shot on reversal film, to prevent excess blue. (All warm-coloured filters act as UV absorbers.)

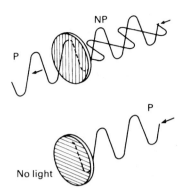

Figure 9.31 Polarized light. Top: unpolarized light, shown vibrating in two of many directions at right-angles to its path of travel, becomes restricted to one plane when passed through a polarizing filter. (It would be polarized this same way if reflected off a shiny non-metallic vertical surface.) Bottom: polarized light stopped by a polarizing filter turned 90° to the light's plane of polarization

Neutral density

Grey, colourless filters affect all wavelengths equally and just cut down the image light by set amounts. They are made in various strengths, see Figure 9.30. A ×2 or ×4 ND filter is useful when you have fast film loaded but want to use a slow shutter speed (to create blur) or a wide aperture (for shallow depth of field), or just need to shoot in intense lighting without overexposing.

Polarizer

A polarizing filter also looks grey, and can be used as an ND filter, but has unusual extra properties which give it several applications. As Figure 9.32 shows, normal, unpolarized light waves vibrate in all planes at right-angles to their directions of travel. Polarized light is restricted to one plane. Unlike some creatures, our eyes cannot tell the difference between polarised and unpolarized light, but polarized light exists around us – in light from parts of blue sky at right-angles to sunlight, for example, or light reflected off any shiny non-metallic surface at a low angle (about 33° to the surface).

A polarizing filter has a special molecular structure. Think of its effect on light waves as like an egg slicer or narrow parallel railings: when its 'lines' are parallel to the plane in which polarized light is vibrating, light is transmitted, but when they are at right-angles the polarized light cannot pass. In practice you look through the filter, rotating it until an unwanted reflection disappears, or the sky darkens, and so on.

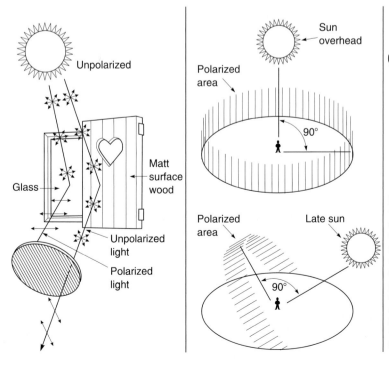

Figure 9.32 Using a polarizing filter. Left: to absorb light reflected from a glass window – most strongly polarized at 33° to the surface. Light scattered from the matt-surfaced wood remains unpolarized, and passes through the camera filter. Centre: rotating the polarizing filter darkens parts of blue sky at right-angles to the sun's direction. Above: all reflections removed from glass by polarizing the light from the lamps and fitting another filter (turned 90°) over the camera lens

Figure 9.33 Suppressing reflections with a polarizer. Left: pattern of tables on a roof terrace with shiny brick flooring, no filter. Right: the same view, using a polarizing filter rotated to the position giving maximum effect

Whole lake surfaces or every window of an office block can be cleared of reflected skylight if you have the right viewpoint. Blue sky can be darkened in colour as well as in black and white photography, making clouds prominent. The colour of glossy objects such as glazed ceramic or shiny plastic becomes more intense when the sheen they reflect from surroundings is removed. If you are copying subjects like paintings behind glass, a polarizing sheet over each light plus another on the lens allows specular reflections off any surface, and at any angle, to be suppressed. (*Note*: regular linear polarizing filters, upset the exposure-reading or focus-sensing mechanisms in some SLR cameras. You must use a *circularly* polarized filter instead – they have a similar effect on the image.)

Special-effects filters and attachments

There are dozens of different colour filters for special effects. Some are so strong and assertive they destroy more pictures than they improve. 'Graduated' filters, however, have a tint which fades off into clear glass halfway across the disc. They allow you to tint just the sky (or ground) in landscapes, see Figure 9.24. When used vertically they can change the colour of one half of a street of buildings. Graduates that are almost colourless or grey are the most useful for reducing light from the sky and so allow bright cloud detail to record at the same exposure needed for darker land.

Figure 9.34 Effects attachments. Top: faceted multi-image unit. Bottom: graduated tobacco tinted filter, for skies in landscapes, etc. The holder for the square shaped filter allows adjustment of its positioning up or down, to suit the placing of the horizon. See Figure 9.24

Always check the effect through the lens at your chosen *f*-number, because the aperture setting affects whether the change of colour will be very graduated or more abrupt. (Such filters cannot be used precisely with direct viewfinder cameras.)

Use fast film with deep coloured effects filters. They cut down light considerably and you will want a choice of apertures for different results. Suitable subjects include relatively colourless scenes – clouded seascapes or open landscapes (particularly under snow), stone buildings, sand dunes, silhouettes and stark shapes against fairly plain backgrounds.

Attachments: Colourless special-effects optical attachments (they do not strictly *filter* anything out) include multi-image refractors, dif-

fusers, and 'starbursts'. None of them call for increase in exposure. Multi-image units are simply faceted glass discs which form an overlapping repeat pattern of part of the normal image formed by your camera lens. The number of images depends on the number of facets – typically 3, 4 or 5. The longer your lens focal length the farther apart these images are spaced. Such attachments must be deeply hooded from stray light, or image contrast will suffer.

Diffusers spread light parts of the image into dark parts, diluting shadow tones and colours, lowering contrast and helping to give an atmospheric, often high-key effect, like faint mist. 'Starbursts' have a grid of finely etched lines which turn brilliant highlights into radiating spokes of light like a star. The number of 'rays' depends upon the number and angle of the lines. Diffraction sometimes adds a slight colour effect too.

Other lens attachments have finely etched lines to create 'rainbow' effects around brilliant highlights by diffraction of light, Figure 9.35. It is vital to have one or more really intense point light sources in the picture – the sun, spotlights, or speckled reflections from water – otherwise these attachments just give a slightly diffused low-contrast image.

Effects attachments are helpful for 'jazzing up' product photography, enlivening disco shots, etc. But they are easily overused. Like the Effects menus offered in digital manipulation software programs (page 271), results then become familiar and boring.

Filter kits

The most worthwhile filters are also the most versatile – for example a polarizing filter and a UV or haze type, both of which are best in

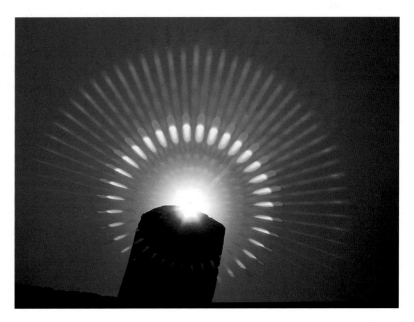

Figure 9.35 A rainbow or 'colour-burst' diffraction attachment adds a graphic effect to the brilliant spill of sunlight topping a simple post. (Take great care not to dazzle your eye looking through an SLR eyepiece unless the lens in fully stopped down.) An intense highlight in relatively dark surroundings is ideal for giving brilliant spectral patterns. This attachment also suits shots of disco spotlights, industrial welding, etc.

glass form. For colour work you should carry appropriate colour balance conversion filters, plus a few CC types. These could be gelatin. Medium red (or orange), deep yellow, and green filters in either gelatin or glass are the most useful for black and white, although your warmer colour-conversion filters may do double service for some of these. The most versatile 'effects' filters might be a graduate in either pale grey or brownish tint, to reduce sky overexposure and warm up grey clouded landscapes.

Summary. Films, filters

- Camera films have silver halides, plus gelatin and other additives, forming a light-sensitive emulsion coated on a plastic base. During manufacture, grain size and resolution, speed and contrast (all inter-related) are brought to specification, and the material is sensitized to chosen bands of the spectrum.
- Exposure in the camera forms a *latent* image. Later this is amplified by chemical processing to give a visible, permanent result.
- Light sensitivity is mostly quoted as an ISO rating – containing one figure which *doubles* with the doubling of speed, and another (with degree sign) which *increases by three*. In practice effective speed figures vary with the processing you choose to give.
- Most black and white films have full-spectrum panchromatic sensitivity. Ortho materials are insensitive to red wavelengths.
- Slow films have finer grain, better resolution, slightly more contrast than fast types. Line and lith films give extreme contrast, when appropriately developed. Some monochrome films which produce a final negative image in dye rather than black silver are processed in the same chemicals (C-41) as colour negatives. You can also shoot 35 mm black and white slides – regular or instant picture type – and larger-format instant prints and negatives. Infra-red and SFX films give dreamlike landscapes, strange portraits.
- Colour film emulsion layers are effectively sensitive to B, G and R. Colour negative film contains couplers, forming negative images in complementary yellow, magenta and cyan dye during chromogenic developing. Slide and transparency colour films first form black and white negatives, then the remaining emulsion is processed into Y, M, C dye images, finally creating a positive result.
- Colour film emulsions are balanced to suit set light sources. The two main types are for daylight/flash, and for 3200K tungsten lamps. Use each type for other white-light sources with a colour conversion filter over the lens or light source. Negatives allow you further adjustment during printing.
- Many faster colour and monochrome films can be exposed uprated in their ISO speed, then push processed.
- Instant-picture materials include colour or monochrome slides; also colour prints (integral or peel-apart).
- 'Professional' films are more finely adjusted in performance than amateur types; often marketed in *natural* and *vivid* colour image strengths, geared to subject and aesthetic preference.

- Slide and transparency ('reversal') colour films are less tolerant of exposure error, give more contrasty images than colour negatives. Daylight type film needs a bluish (80A) filter in tungsten lighting.
- Colour filters (gelatin, glass or acetate) *lighten* the tone of subjects their own colour, and *darken* complementaries in terms of monochrome photography. The richer the colour of the filter and subject the stronger this effect.
- Colour correction filters are used with colour films to convert the colour temperature of your subject lighting to suit the colour balance of your film.
- Colour compensating (CC) filters allow you fine adjustment of colour balance for correction or mood. Graduated, split, colour spot, diffraction and other tinted lens attachments give special colour effects.
- UV, neutral density and polarising filters, and many colourless effects attachments such as multi-image, diffusers, and starbursts, are usable for both black and white and colour work. Polarizers can darken polarized light from a blue sky, or reflections off shiny (non-metallic) surfaces. The effect varies according to the direction of your subject lighting and the angle you rotate the filter to on the lens.
- Get really familiar with the practical performance of a selected range of films. Establish a technique which makes the most of your materials. Remember you can check your equipment, technique and composition as you shoot, via instant prints.
- When you choose your film for a job it should match up to type of subject, lighting, and the size and form of the final image required.
- Protect all film from excess humidity, chemical fumes, X-radiation. Refrigeration reduces how much the stored emulsion changes with time.

Projects

1 Check the visual effects of colour filters. Set up a slide projector in a darkened room and either use its light to illuminate a colourful poster, or simply project a slide containing many strong colours. Use a series of deep colour filters (see Project 2) in turn in front of the lens and notice which parts of the poster or slide image darken/lighten in tone.

2 Check colour casts. Using a *daylight* slide film, shoot subjects (1) in daylight, (2) in tungsten light with and without an 80A filter, (3) in fluorescent light with and without a correction filter for the film, see Figure 9.29. Also (4) in daylight with an 85B filter. Using the same subjects, try shooting the same sequence again on a *tungsten* light film. Compare processed results – examine the distorted colours given by mismatching, and consider them for creative effects.

10

Exposure measurement

Strictly speaking, 'giving the right exposure' means making sure that your film receives the correct amount of image light (photons). In practice it is much more than this. Exposure can be used to give *emphasis*, by being correct for one chosen object in a scene, allowing other parts which are lighter or darker to be over- or underexposed. Exposure control is also the key to getting fine *tonal qualities* in your final pictures, whether prints or slides. And apart from its accuracy, the actual way you give exposure, via chosen permutations of lens aperture and shutter speed, has important side-effects on the image. As shown in earlier chapters, these strongly influence the appearance of things at different distances and the way that movement is recorded.

The exposure measuring and setting help provided by the camera itself varies considerably. At one extreme, a fully automatic compact will measure the light and instantly set controls according to an intelligent program, without even telling you what is going on. Total automation ensures a high percentage of accurate exposures *with 'average' subjects*, but takes many creative decisions out of your hands.

At the other extreme most view cameras offer no light-measuring facilities, and leave you *all* the decisions on shutter and aperture settings – often a slow business with the aid of a hand meter. The middle ground is catered for by cameras with manual (or semi-automatic) controls. Here you have to bear in mind the side effects of the settings you make but often use them to improve your shot.

This chapter looks at what 'correct' exposure means and what we should aim for using different films. It discusses equipment for measuring and setting exposure, their different modes of use, and how to avoid mistakes with problem subjects. Shooting with flash brings in its own exposure features, discussed towards the chapter end. Although *film* is featured throughout, most of these exposure topics apply equally to digital cameras too.

Factors that determine what exposure to give

The main factors that should be taken into account when you or your camera equipment measure exposure are:

1 Lighting. The intensity and distance of the light source, including any light loss due to diffusers, acetates, etc., or atmospheric conditions between source and subject.

2 *Subject properties*. How much your subject reflects the light – its tone, colour, surface, from a black cat in a coalstore to a milk bottle in the snow.

3 *Film speed*. Its ISO speed rating, possibly modified if you intend to up-rate or down-rate it and then alter processing. Speed may also be affected by film colour sensitivity relative to subject light source (page 155). The ISO rating also becomes less if you give extremely long exposures in dim subject illumination, see reciprocity failure, page 314.

4 *Unusual imaging conditions*. Light absorption due to lens filters and attachments, or an image made dimmer by extending the lens forward to focus close-ups; see page 191.

On top of these come important *interpretative* considerations. For example, would it improve the picture to expose wholly for the brightest parts of the scene and make darker parts black; or expose for shadows and let light parts 'burn out'? These judgements can only be made by you, and carried out perhaps using the camera's exposure over-ride dial if it has one.

The exposure read finally has to be given to the film by a combination of:

● *Intensity:* the lens aperture. Bear in mind that this choice will affect depth of field, and to some extent definition.
● Also *Time:* the shutter speed. This influences the way any movement of subject or camera will reproduce, and the spontaneity of expression or action.

As Figure 10.1 shows, intensity and time – aperture and shutter – interrelate. Within limits (page 314), halving the intensity and doubling the time maintains the same total of photons of light energy reaching the film as would twice the intensity and half the time.

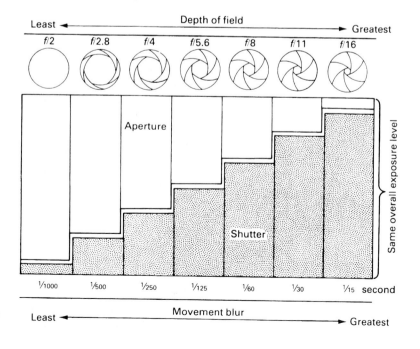

Figure 10.1 Aperture/shutter-speed relationships. Identical exposure can be given through a range of intensity/time settings. For example, each combination here will give the same light effect to the film. With a manual set camera you can choose between them, paying attention to depth of field and blur effects

Exposing different film types

Film manufacturers aim for a product which gives you good image quality; wide tolerance (to exposure errors, wrong colour lighting, etc.); and records the picture in such a way that it is easy to successfully print onto paper. But just what constitutes 'correct' exposure varies somewhat according to film type – monochrome or colour, negative or slide.

Black and white negatives

The more exposure a negative film is given, the darker the image tones in the processed result. Figure 10.2 shows how progressive increases in exposure makes all tones grow darker. Subject highlights, the term given to its lightest parts, are the first to become solid and lose their details. Then this quickly spreads to mid-tones and finally to shadows. You often find too that, when enlarged, grain is more apparent in overexposed negatives and general light spread throughout the emulsion reduces sharpness.

Going the other way, underexposure makes subject shadows reproduce so 'thin' they lose their detail, becoming indistinguishable

Figure 10.2 How exposure affects image appearance. In these three strips each image was given four times the exposure of the one to its immediate left. (A) is grossly underexposed and (E) is grossly overexposed. The subject is correctly exposed in (C).
Top row: Colour negatives. Notice how shadow details become indistinguishable from clear film ('off the toe of the curve') in A. In E highlight detail and colours are choked

A B

Middle row: Colour slide film. Being a reversal material underexposure (F) gives dark, detailless shadows which also lack colour. Overexposure (J) bleaches all but the subject's darkest shadows

F G

Bottom row: Monochrome negatives. Like the colour negative subject shadow details in K are missing – these areas will print as flat grey. Overexposed O has flattened contrast, midtones and highlights too dense

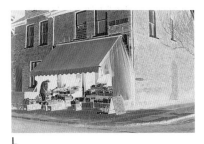

K L

from the clear film edge ('rebate'). Then the same fate occurs to mid-tones, and finally to subject highlights too.

Results like these can be shown on a graph called a 'characteristic curve' for the film (see Figure 10.3 and Appendix D) with image light intensity values from shadows to highlights along the bottom axis ('log relative *exposure*') and final tonal *density* from palest up to darkest parts of the negative along the other. 'Correct' exposure should place all the image light intensities as densities on the lower part of the curve, yet not below the point where it flattens out, showing that densities are no longer separable and detail disappears.

The more contrasty your picture, the more accurate the given exposure must be – for it will then take less overexposure error to bring highlights into the state of being unacceptably dense, and less underexposure to make shadows too thin; see Figure 10.4. These conditions are said to offer least exposure latitude.

Colour negatives

A correctly exposed colour negative should meet requirements broadly similar to those for a black and white negative. However, it is even more important to avoid underexposure – empty shadows

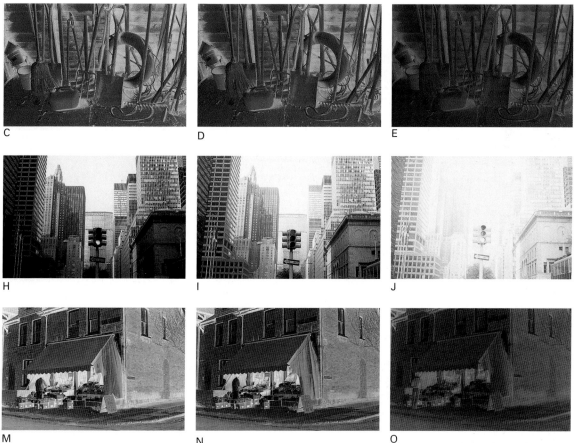

C D E

H I J

M N O

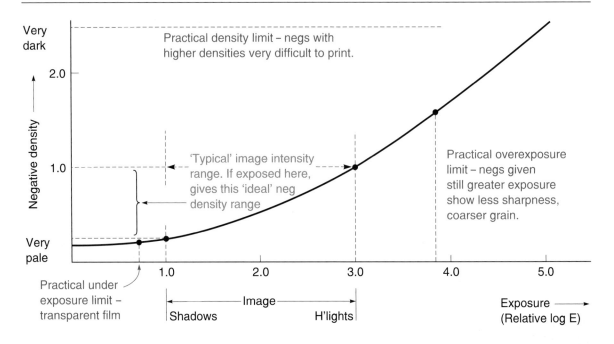

Very
dark

*Practical density limit – negs with
higher densities very difficult to print.*

2.0

Negative density ⟶

1.0

*'Typical' image intensity
range. If exposed here,
gives this 'ideal' neg
density range*

*Practical overexposure
limit – negs given
still greater exposure
show less sharpness,
coarser grain.*

Very
pale

1.0 2.0 3.0 4.0 5.0

*Practical under
exposure limit –
transparent film*

◄———— Image ————►

Shadows H'lights

Exposure ⟶
(Relative log E)

Figure 10.3 Characteristic curve of a monochrome negative film. Every image is a *range* of light intensities, so highlights are shown farther right than shadows on the exposure scale here. When an image is overexposed, its shadows-to-highlights values all shift right and so record as denser on the negative, although shadows may still just fall within the ideal range. When it is *underexposed,* values shift left showing resulting densities are too weak, although highlights may still be acceptable. Compare with Figure 10.2

often print with a different colour cast, and since there is little choice of contrast grade with colour paper (see *Advanced Photography*) it is difficult to prevent thin negatives printing grey and flat. Processed colour negatives are also deceptive in appearance. The presence of the overall orange mask tint makes you think the image is denser than it really is. It may help if you assess negatives holding a piece of processed, unexposed film (as at the start of a film) close to your eye as a filter.

Published data for colour negatives shows three colour-negative characteristic curves (Appendix C), one for each of the blue, green and red responding layers. If the film was exposed to light of the wrong colour balance without a correction filter one emulsion becomes effectively faster than another. Within reason this may be corrected by filters during colour printing. However, with a wide-tone-range (contrasty) scene, shot at incorrect colour temperature, it may even be possible for one of the emulsions to have underexposed low-contrast shadows while at the same time another has overexposed highlights. Printing will not correct the distortion this gives. So bear in mind that colour negative films when shot in lighting of the wrong colour have less exposure latitude than black and white negative films. Take several 'bracketed' exposures, see page 183.

Slides and transparencies – colour or black and white

Positive images on film are much easier to judge for exposure because you can make direct comparison with what you remember of the original scene. As Figure 10.2 showed, the more exposure you give these reversal-processed films, the *lighter* your result – with highlights especially becoming bleached of colour and tone. Underexposure has a darkening effect, particularly of subject shadows where colours

eventually become engulfed in black. Of the two, overexposure is generally more objectionable than underexposure. This is partly because we tend to 'read' pictures by their light parts and accept dark shadows more readily than burnt-out highlights. Again, a slightly dense transparency is more acceptable for colour printing or scanning into digital form for printed reproduction than one where light parts of the image are literally missing.

The published characteristic curves of reversal materials (page 316) slope the opposite way to negative films, and have a steeper angle. In practical terms this means they are more contrasty, desirable in images that must look bright and rich in tone when projected as slides or displayed with back-lighting. However, such a characteristic means you have less room for exposure mistakes. Overexposure quickly bleaches your image's highlights and pale areas into detailless clear film; underexposure brings its shadows down to detailless black. So slides and transparency materials demand more accuracy in measuring exposure – they offer less exposure latitude than regular colour or black and white negative films. And as with all films, this shrinks still further when the picture you are recording contains harsh, contrasty lighting.

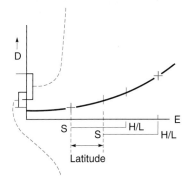

'Bracketing' and clip tests

The simplest insurance against error, if circumstances permit, is to make several 'bracketed' exposures. With black and white film take one picture using the settings you *expect* to be correct, then shoot others giving half and twice this exposure. With colour negative film, bracket using closer increments, shoot one frame a half-stop underexposed, plus frames half a stop and one stop overexposed. For slides and transparencies, bracket at half stops too, but erring more towards underexposure than overexposure. If your camera has an exposure-compensation dial (page 192) the quickest way to bracket is by turning this to the required + or – settings. Better still for difficult scenes, several advanced 35 mm SLRs offer 'auto-bracketing'. In this mode one pressure on the release exposes a burst of 3 or 5 frames at 2 frames per second, each at a different exposure setting. You pre-set the increments ranging from one-third to twice the measured 'correct' exposure.

Further modify your bracketing routine according to the exposure latitude. For example, a contrasty image (harsh lighting and/or a subject with strong inherent contrast) will give absolutely minimal latitude. You should therefore take more bracketed exposures with smaller differences between each. Reverse this approach if exposure latitude is exceptionally wide.

Figure 10.4 Exposure latitude. The amount you can alter exposure but still (just) get a negative which will give an acceptable print. The more extreme the difference between shadows (S) and highlights (H/L) in your image, the less latitude you have in exposing without exceeding ideal limits

With most materials you can gain further protection by planning out all or part of one film as test exposures, to be processed and examined first. Use an extra magazine back, a separate 35 mm body or marked sheet-film holders to accumulate one extra anticipated 'correct' exposure of every subject you shoot during a day's location work, additional to your main run of exposures. Process this test set of shots normally and check them to decide which, if any, films will need adjusted processing (page 216). Alternatively, make sure you include three bracketed exposures at the *start* of a 35 mm film or *end* of a

Figure 10.5 Simple exposure guide – for an ISO 100/21° film

Bright or hazy frontal sunlight, pale sand or snow surroundings	$\frac{1}{125}$	$f/16$
Outdoor open setting, cloudy bright (no shadows)	$\frac{1}{125}$	$f/8$
As above but heavily overcast	$\frac{1}{125}$	$f/5.6$
Outdoors, open shade	$\frac{1}{125}$	$f/5.6$
Indoors, domestic interior by existing (hazy) daylight	$\frac{1}{125}$	$f/4$
Shop interior, fluorescent tubes	$\frac{1}{30}$	$f/2.8$
Indoors, domestic incandescent lamps	$\frac{1}{15}$	$f/2$
Light trails from traffic at night, fairgrounds	10	$f/11$
Floodlit sports arena	$\frac{1}{60}$	$f/2$
Portraits by street lighting	$\frac{1}{30}$	$f/2$
Landscape lit by full moon	30	$f/2.8$

Figure 10.6 The light-measuring cell of the meter built into a basic compact camera. This gives a direct, overall reading of your subject. (Take care not to obstruct it with your finger or the camera may overexpose)

Figure 10.7 Various light measuring cell locations designed for through-the-lens metering in SLR cameras. A: viewing most of the image from above the SLR eyepiece or pentaprism. B: reading through a semi-silvered part of the mirror. C: reading light reflected off the shutter blind or film once the mirror has risen

rollfilm. These are then easily clipped off and test processed (a service offered by most professional labs) to decide any changes required for the remainder of your film.

Measuring exposure (continuous light)

Apart from checking tables, the normal way of finding correct subject exposure is by measuring with a hand meter or some form of light meter inside the camera. Learning how a hand meter is used will help you understand the more common internal meter, which was born from it.

Tables and guides. Never despise that simple table of recommended exposure settings packed with your film, see Figure 10.5. Some day your meter or camera may not be working. Another emergency routine to remember is the following:

> *Use one divided by the film's ISO (arithmetic) speed as your nearest shutter speed. Then set f/16 for bright sun, or f/8 for cloudy-bright conditions or their equivalent, e.g. with ISO 100 film use 1/125 sec at f/8.*

The trouble with tables and guides is that they deal with subjects and situations only in the broadest terms. Tables that try to be more comprehensive often end up becoming incomprehensible.

Using built-in meters – how they work

An exposure meter built into the camera has a tiny silicon light-responsive cell measuring your subject, or the image itself, and able to transfer its readout direct to aperture and shutter settings. In most compact cameras the cell faces the subject from behind a window alongside the lens or viewfinder. SLR cameras measure image light from *behind* the lens, so taking into account the image-dimming effects of close working, filters, etc., and of course adjusts how much of the scene it reads with any change of focal length.

Several cell positions can be used within an SLR body. One or more cells may view the image on the focusing screen (from above the

Figure 10.8 Exposure meter measurement area. 'Contour lines' show the relative distribution of light sensitivity across the picture format. Here the system is centre weighted – most influenced by subjects composed centrally

Figure 10.9 A multi-sensor chip located in the base of an advanced SLR. This evaluates image brightness based on 21 sampling areas. According to the mode you pick light measuring ranges from overall averaging to centre spot reading

Figure 10.10 (right) Spot reading. In this mode you must carefully choose and align one or more subject areas you wish to read – in this case shadows and highlights within the marker on the focusing screen. Then average by making exposure settings for half way between the two readings

pentaprism eyepiece, for example) while another below the mirror looks up towards the film. The 'off the film' (OTF) cell views the image as it appears on a reflective pattern on the front of the shutter blind, and on the emulsion itself after the mirror has risen and during exposure. This allows it to measure and control the period of a time exposure as it actually takes place, as well as flash exposures (page 196).

For most situations though light passing through a semi-silvered part of the main mirror is reflected downwards to light sensors located in the base of the camera (Figure 10.7). Advanced cameras have here a honeycomb or 'matrix' of ten cells or more arranged to measure different parts of the image area, giving them different priorities – more in the centre than the corners for example. And by selecting 'spot' metering mode only the very centre cells sample light, so you can measure from a small chosen area, Figure 10.10.

Usually you switch on the meter with a half pressure of the shutter release (it switches itself off later after a timed period). Some compact cameras have a lens and viewfinder shield you slide open to switch on the meter and unlock the shutter release. Output from the light-sensing cells feeds to an internal microchip central processing unit. This also receives information from other parts of the camera, namely the ISO speed read off the cassette and conditioned by any setting you made on the exposure compensation dial, the *f*-number set on the aperture ring, and/or the shutter speed chosen. The CPU instantly computes and typically sends control signals to aperture and/or shutter, as well as displaying the required settings alongside the internal focusing screen and on top of the camera body; see Figure 10.11.

To make full use of built-in metering it's helpful to understand (a) the area of your picture being measured, and (b) the effect of different 'modes' your camera offers to translate light readings into shutter and aperture exposure settings.

Measuring area

Most meters built into compact cameras take a 'centre-weighted' averaging light measurement of your subject. This means that the reading is influenced more by central areas and least by the corners of the picture. Precise layout of this 'sensitivity map' (Figure 10.8) varies in different SLR cameras – some pay more attention to the bottom of the (horizontal) frame to reduce sky influence in landscapes. Overdone

Figure 10.11 Some of the ways the settings made by a light reading are signalled in the viewfinder (or LCD body top panel, above) of different SLR cameras. Top row: Camera in aperture priority (Av) mode – the meter needle shows what shutter speed it has set. Far right: Manual mode – you alter either shutter speed or aperture, until OK signal (green diode) lights up. Below, centre: Alternative way of displaying (in green) the meter's setting in Av mode. Below, far right: The same display when in shutter priority (Tv) mode. You set shutter speed and the camera now sets aperture. The red signal here warns of the risk of camera-shake at 1/15 second

Figure 10.12 Typical exposure auto-program for a camera with *f*/1.4 standard lens. Working from top to bottom of the green graph line, as scene brightness drops (the exposure needed increases) the program progressively widens the aperture and slows the shutter speed. Note speeds safest for hand-holding are retained until *f*/1.4 is reached. Camera may signal 'shake' or 'use flash' at 1/30 second and slower. If you select '*Tele*' program instead (shown here for a lens of *f*/2.8 maximum aperture) shutter speeds of 1/250 second or faster are held as long as possible. '*Wide*' program (*f*/2 lens) pays equal attention to aperture and shutter changes

though, this creates problems in other, upright, pictures. Centre-weighted measurement is surprisingly successful, but you must still remember that *largest areas* of tone in your picture have greater influence than smaller areas. Learn to recognize your composition's key tone, such as face skin tone in a portrait. Then if necessary make it fill up more of the frame just while the reading is taken; see page 188.

Advanced SLR systems measure by multi-segment ('matrix') metering, Figure 10.9. The various outputs from different parts of the frame are then compared against an in-built computer program based on thousands of subject field trials. 'Fuzzy logic' fills in gaps in the

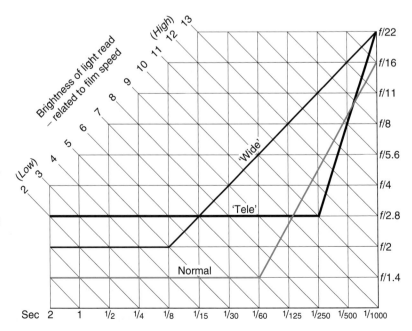

Figure 10.13 Right: the main components in a multi-mode exposure setting system built into a camera. Below left: set to 'aperture priority' mode. Light reading, film speed and your chosen f-number are input, and the CPU translates this data into the correct shutter setting. Your aperture and the camera's chosen shutter speed are also displayed. Below right: set to 'program'. The CPU inputs light and ISO data, outputs a figure to a program (see Figure 10.12) which then sets the most suitable shutter/aperture combination

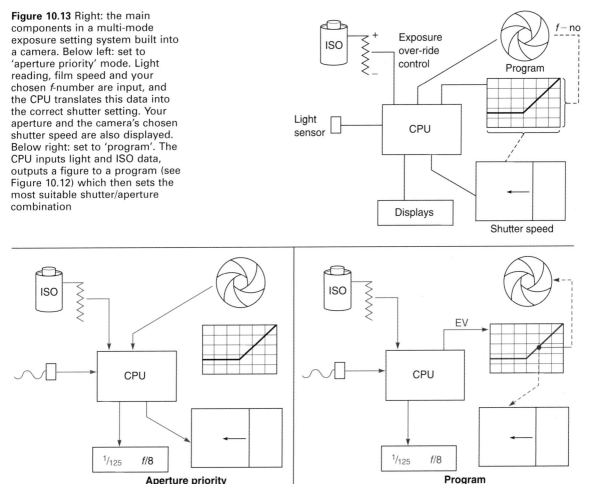

sampling process. Some cameras additionally offer you the option of spot metering, which measures only within the small area shown by a circle or rectangle in the centre of the focusing screen. You can then align this spot and get the camera to hold this reading. Or take separate readings of darkest and lightest key elements (Figure 10.10) and the metering system averages between the two. See also Spot meters, page 191.

Exposure setting modes

Fed by the light measurements and the other exposure information it needs, the camera's CPU makes its choice of settings in various ways, according to 'mode'. Some cameras offer only one (typically auto-program) mode, others a choice of four or five that you select according to shooting needs and personal choice. Each offers its own advantages.

So-called *manual mode* is the most basic and flexible arrangement. You turn the camera aperture and/or shutter speed controls, and the meter signals when a combination will give correct exposure. For

A B C D E

Figure 10.14 Conditions which often fool a general or 'centre-weighted' exposure reading. Although the figure in all these pictures received the same lighting, in A the large area of dark background causes the meter to give a low reading and so make settings which overexpose the face. Coming in close (B) and reading only off the face ensures correct portrait exposure (C). Similarly (D) a bright background leads to underexposure of the face unless you take a close-up reading to get result (E). Working with an auto-exposure camera AE lock must be applied, see text

instance, you can set the shutter to 1/125 second (for hand-holding) then change apertures until a signal – usually a green diode beside the focusing screen – lights up. Or you could set f/16 to maximize depth of field and then change shutter speeds until the same OK signal is given. Often manual mode also allows you to over or underexpose the shot you are taking half or one stop by working to a different coloured signal; see Figure 10.11. However, this system requires longer to set correct exposure than any other mode.

Aperture priority (Av) goes a step farther – saving time if you must work at a particular aperture, perhaps after having checked depth of field with the lens preview button depressed. In this mode you set the aperture and the camera automatically sets the shutter speed required for correct exposure. The arrangement can be very helpful for close-ups, where depth of field is critical; also for night-shot time exposures (most cameras can set up to 30 seconds or so). This mode will also handle a very wide range of light-intensity conditions, since cameras offer far more potential shutter settings than f-numbers. However, you may easily discover that you are hand-holding the camera at a slow shutter speed, resulting in blur.

Shutter priority (Tv) mode works the other way around. You set shutter speed and the camera selects what f-number the lens aperture will close to when you take the picture. (As with most modes, a signal warns if the exposure required is over or under the setting range available to the camera, in which case you should set a different shutter speed.) Shutter priority is useful for sports work and any action or interpretative photography where you must maintain control over the appearance of movement. Or it may be just that you prefer to shoot a hand-held series at a safe 1/125 second, or 1/250 second with a longer lens, and accept whatever depth of field lighting conditions permit.

Programmed modes allow the camera to take over both shutter and aperture settings, running through an intelligent program – from shortest time/smallest aperture, to longest time/widest aperture, according to inputs of light reading and film speed (shown in Figure 10.12 as Exposure values). The chart illustrates a typical standard lens program in which there is a progression of both shutter and aperture changes until, with decreasing light, the lens's widest aperture is reached (in this instance f/1.4). From here onwards exposure time only increases, usually accompanied by a camera-shake warning light at speeds slower than 1/30 second.

Programs like this are often built into compact cameras as hidden systems which do not reveal to the user any technical information other than giving 'shake' and 'out of range' warnings. They are sufficiently effective for most amateur photography subject conditions.

On SLR cameras, however, having one standard program may not be suitable when you use telephoto or wide-angle lenses. Some cameras therefore offer two additional programs – 'tele' and 'wide'. As Figure 10.12 shows, on *tele* the camera reacts to decreasing light by maintaining fast shutter speeds as long as possible, to counteract the ever-present risk of image blur with long-focal-length lenses. When *wide* is selected the camera makes equal alternating changes of aperture and shutter speed, bearing in mind that camera shake is less likely. This choice of program is either left to the user, or may be selected automatically when you fit on a telephoto or wide-angle lens.

In practice, having a multi-mode AF camera will probably mean that you rarely use more than two or three of these options. The most popular modes tend to be manual and aperture priority. A fully auto program is handy for rush situations, while shutter priority is preferable if you do much action-freezing photography or use telephotos hand-held. In all modes it's helpful if the camera displays what lens and shutter settings are made, to allow you to pre-visualize and if necessary over-ride the effect of aperture and shutter on picture appearance.

TTL meters that are built into rollfilm cameras or form add-on accessories to view cameras are less comprehensive than 35 mm types. Most rollfilm SLRs, for example, offer a system providing centre-weighted measurement and a choice of either manual or aperture-priority setting modes. A TTL meter for view cameras (Figure 10.18) uses a probe you move around the image plane to make spot readings. However, for the most part medium and large format cameras are still used in conjunction with a separate, hand-held exposure meter.

Using a hand-held exposure meter

These are the oldest 'photoelectric' measuring aids, but in modern form still used today, mainly by professionals working with large or medium format cameras. A typical basic meter (Figure 10.15) is a self-contained unit with a small light-responsive silicon photocell (SPC) or a cadmium sulphide (CdS) cell behind a window. This sensor forms part of a circuit including a battery and current-measuring device.

Essentially you programme the meter with the ISO speed of your film, point it towards the subject, and read off the exposure required. To do this last part you note the number picked out by a needle moving over a scale, and set this against a pointer on a large dial. The dial lines up a complete series of *f*-numbers against a series of shutter speeds. Each will give correct exposure – you are left to choose any of these paired settings according to depth of field and image movement considerations. Other meters do away with moving parts – you feed in either the *f*-number or the shutter speed you want to use, then a liquid crystal display on the meter shows the appropriate shutter speed or *f*-number with which they should be paired.

Reading the light

There are several ways to take readings with a hand meter, according to working conditions and personal preference. These are: (1) a general or 'integrated' reading of the subject, (2) two or more 'brightness-range' readings of the subject, (3) a grey-card reading, or (4) an incident-light reading of the light source. (Methods 1–3, which all measure reflected light, can also be carried out with a TTL camera meter.)

Figure 10.15 Hand meter. Top: A light-sensitive cell behind a circular window in the centre of the front end gives general, reflected light readings. The white plastic dome slides over this window for making incident-light readings: Bottom: The large calculator dial must be programmed for film ISO speed. The numbered light reading shown by the needle is next set in the 'SCALE' window. You can then read off shutter settings against *f*-numbers at top of dial

Figure 10.16 Alternative methods of using a hand meter: A: direct, general reading from the camera. B: close separate measurements of lightest and darkest important areas, then averaging the two light readings. C: reading off a mid-grey card receiving the same lighting as your subject. D: incident-light reading through the meter's diffusing dome. Meter here points from subject towards camera

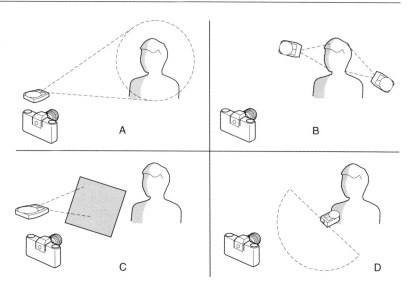

1 *For a general reading*, you just point the meter from the camera towards your subject. The meter's angle of view usually approximates that of a standard lens, so it 'sees' a matching area of the scene. The meter averages out all the various light values this contains (naturally being more influenced by the values of large subject areas than small ones). Then it gives an exposure reading that would place this single imaginary 'average brightness' about midway between under- and overexposure on the characteristic curve.

Like using a compact camera with an overall reading meter, the trouble with a general reading is that the most important element in your picture is not always the largest. The face in a portrait may occupy less than 50 per cent of the picture area, the rest being background (Figure 10.14). In one version you might use a dark background and in another a much lighter one, without any change to the illumination on the face. Yet the meter, taking over 50 per cent of its reading from the background in each case, will give low reading for the first shot and so overexpose face skin tones, and a high reading for the second version making the face underexposed.

A general reading is therefore only satisfactory if your shot has a fairly equal distribution of light and dark areas in which you want detail. Subjects like Figure 10.19 (top), for example. It often works with softly lit landscapes (tilt the meter down slightly to read less sky and more land, if this is where details are more important). Another problem is that zooming or changing to a different focal length lens can make camera and meter have very dissimilar angles of view. Used from the camera position the meter then reads a larger or smaller area than is included in your picture.

2 *For a brightness-range reading*, you first decide which is the lightest and which the darkest part of the scene where detail must still just record. Take separate readings of both, bringing the meter suffi- ciently close in each case to exclude everything else. (Don't cast a shadow on to what you are measuring, however.) You next split the difference between these light measurements and read off exposure for the resulting figure.

Figure 10.17 A spot meter. The eyepiece shows you part of your subject magnified, a centre circle marking the light measuring zone. Having programmed ISO film speed and shutter setting, the meter signals the required *f*-number

Figure 10.18 An add-on meter for a 5 × 4 in view camera. This is carried on an open frame the same size as a film holder. The movable probe then allows selective 'spot' readings from any chosen parts of the picture area

Brightness-range readings therefore make the best possible exposure compromise between subject extremes, and also remind you how much contrast is present. If shadows require over 6 stops more exposure than highlights consider reducing lighting contrast by adding a reflector or flash, or wait for changing conditions, or alter your viewpoint. Last resort, be prepared to accept loss of detail at one or other end of the scale, and pick which is least objectionable.

The trouble is that two readings take longer than one and you may not be able to approach parts of the subject close enough (but see substitute readings, page 193).

3 *For a grey-card reading* you measure from a mid-grey card, held so that it receives the same light as your subject. (Kodak make a standard 18 per cent reflectance card for the purpose.) Exposure given according to this one reading should coincide with the average of darkest and lightest areas.

You must use a card large enough to fill the meter's field of view (Figure 10.16), and avoid casting a shadow on it when reading. Carrying a card is not very practical on location, although it may suit studio work, particularly copying; see page 193.

4 *For an incident-light reading*, the hand meter has a white plastic diffusing dome which covers its measuring window. Then you hold the meter in the same lighting conditions as the subject, *pointing towards the camera*. It therefore takes into account all the (scrambled) light reaching the subject, rather than the subject's reflective properties. The plastic dome transmits 18 per cent of the light, so you end up with much the same situation as a grey-card reading, but in a more convenient form. Enthusiasts for incident-light metering point out it is simpler and less likely to give overexposed highlights than most other techniques, so it is especially suitable for reversal films.

Spot meters

A spot meter, Figure 10.17, is a telephoto version of a reflected-light meter. It has an eyepiece for aiming the meter from the camera position. Inside you see a magnified view of part of the subject, with a small measuring area outlined. The meter's angle of view over this area is typically only 2–3°. Having set your film's ISO speed, you press a trigger-like button to get a reading, and the exposure settings are displayed inside and/or outside the meter. Spot meters are extremely convenient for taking brightness-range readings if you cannot easily approach your subject, and when shooting close-ups. However, you can get totally inaccurate exposures if you don't carefully consider which subject parts to sample.

Conditions hand meters do not consider

All the above methods of meter-reading exposure for a subject should give you the same result, if used properly. Bear in mind though that a hand meter does not take into account:

● *Close-up focusing conditions.* Increasing the lens-to-image distance to focus sharply a close subject makes the image dimmer. Inside the camera, this is like moving a projector farther away from a screen (the film). The projected image grows bigger but less bright, following the rule that twice the distance gives twice the image size

Figure 10.19 Top: This sort of subject – with more or less even distribution of light, dark and midtone areas – is ideal for exposure reading by either general or centre-weighted measurement. Bottom: In this shot the most important element is the distorted reflection, occupying only about 25 per cent of the frame. A general reading here would underexpose the reflection. It is better to take a spot reading off the reflected building, or briefly recompose it to completely fill the frame while taking a general or centre-weighted reading. (If necessary set Exposure Lock to stop the camera reverting to a faulty measurement when you finally re-compose to shoot)

Figure 10.20 Exposure over-ride dial, on camera body. As shown here all pictures will receive half the exposure the camera would normally set

and one-quarter the light over the film area. You must therefore increase the exposure the hand meter suggests, as near as possible by the factor shown in Figure 10.23. (Increases here are based on the formula shown in Appendix A.)

● *Use of filters.* Most filters used over the lens cut down the light, so increase the exposure shown on the hand-meter by the factor printed on the filter rim or quoted by the manufacturer. Remember with colour filters that this factor may alter with the colour of your subject lighting together with the film's colour response. Read the data sheet in with your film. An unknown filter factor may be checked by comparing readings with and without the filter in front of the meter. With strong colour filters however the response of some measuring cells slightly mismatches film colour sensitivity and so creates variations.

● *The effects of exceptionally long or short exposure times.* As with internal meters, hand meters don't take account of reduced film sensitivity when long exposure times are given. See reciprocity failure, page 314.

Subject

Figure 10.21 Making a substitute reading off your hand, for a distant face. Both must be in the same lighting. By turning your hand you can match both lightest and darkest parts, and so make brightness-range readings

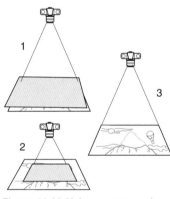

Figure 10.22 Using a grey card to read exposure when copying drawings. (1) covering the whole subject imaged by the camera. If the original is larger than your card, move your camera closer (2) until the card fills the frame. But don't refocus, or cast shadows. (3) Finally keep to the exposure settings made, remove the card, and copy the whole drawing

Figure 10.23 Close-ups shot using a camera without TTL metering need additional exposure. See table, right. To measure magnification, have a ruler alongside your subject. Divide this into its image size shown on the focusing screen

Practical exposure tips

Point-and-shoot cameras apart, an exposure measuring system (built-in or hand-held) allows you choices and control at three main points: (1) the ISO speed set for the film, (2) the parts of the subject you actually measure, and (3) the alternative ways of dividing exposure between lens and shutter.

If you must get more sensitivity out of the film in dim light, or subject contrast is very flat and needs a boost, try uprating. This means raising the film-speed figure (or using a 'minus' setting on the exposure-compensation dial on auto-setting cameras). In both cases you then follow this up with extra development. Take care to use a film the makers describe as suitable for uprating treatment. Another reason for setting an inflated figure is as a temporary measure just to get meter response in dark conditions.

Downrating or use of 'plus' compensation helps to reduce contrast and grain when followed up by *reduced* development. This applies principally to monochrome films, it is unwise to downrate and hold back colour films beyond one stop, see page 216. Downrating alone is a way of compensating for subjects measured by general reading against the light or with large bright backgrounds, which you know will otherwise result in settings which make them underexposed. Or you might use it to allow for a film's anticipated reciprocity failure when given a long time exposure (page 314). Consider your plus or minus settings on the exposure-compensation dial as a lighten/darken device for purely creative purposes too, like the controls on many instant-picture cameras.

Always think carefully about what area(s) of the subject you measure. Decide the priorities between various tones of your picture. If there is only one really key tone, and the camera does not have spot reading, try to make it fill up the whole frame. With a close-up you can do this by just moving forward (don't refocus – extra extension may change the reading). If your key subject is inaccessible, take a substitute reading from something convenient that matches it in tone. The eye is good at judging comparisons. A grey card has already been suggested, but you can read off your hand, lining it up and turning it at angles in the light to match a far subject tone (Figure 10.21), or find some part of the ground or sky with the right-looking tone.

It sometimes helps to carefully 'redistribute' your framing of the image making the size of each tone area relate to its exposure importance. For example, twisting the camera may just include the lightest and the darkest important tone 50:50 in the frame, so your one

Magnification (Subject height divided into the height of its image)	Increase exposure by:
0.3	×1.7
0.5	×2.3
0.7	×2.9
0.8	×3.2
0.9	×3.6
1.0	**×4**
1.3	×5.3
1.5	×6.3
1.7	×7.3

Figure 10.24 The control panel on the back of a small monobloc type studio flash-head. A: Flash power control. Allows full (250 Ws) or four fractional levels of flash. B: IR/light sensor. Acts as a slave trigger

reading averages the two. Make exposure settings and then re-compose your shot as you want it.

Copying line drawings, photographs, paintings, etc., often brings problems over how best to take a reading. Areas of dark and light are unlikely to be equal. Sometimes you can 'home in' on a midtone of sufficient size in a photograph or painting, but the best approach is to read off a grey card (or take an incident-light reading). You can see how important it is when using a built-in metering system, that it allows you to take a reading and then retain the settings unchanged after reframing the picture, removing the grey card, and so on. You will have to activate an 'auto-exposure lock' (AE-L) button on some cameras, otherwise the meter goes on taking new measurements.

A more specialist problem concerns exposure reading when using a *moving* light source to 'paint with light' an architectural interior or still-life, spreading the light and forming a softer, more even source, page 123. Provided the lamp is moved in an arc maintaining the same subject distance throughout the exposure, you can accurately read the light when it is still.

Whatever your technique for measuring the light, deciding the best way to deliver the exposure by means of aperture and shutter controls is always something of a balancing act. Each shot has to be considered on its depth versus movement merits. Occasionally, requirements and conditions work together to give plenty of options, as with a scenic landscape with all its elements static and distant, in strong sunlight. At other times, they all conspire against you, as in a dimly lit shot of moving objects at different distances which must all record in detail. In this instance you must think how to improve conditions – perhaps by adding (flash?) lighting, altering camera viewpoint to reduce the range of distances, or uprating or changing to faster film but still keeping within grain and sharpness tolerances.

Measuring exposure for flash

Getting exposure correct when you light by electronic flash (page 117) differs in several ways from continuous light source techniques. Basically, when a flash unit is switched on, a steady current is drawn

Figure 10.25 Flash equipment. Studio units and add-on portables, showing light sensor and synchronized firing controls. Power comes from batteries (B) or (studio units) household supply which charges capacitors (C). These discharge through flash tube (F) when the circuit is closed by camera synchronizing connections, test button (T) or light-sensitive slave. M: tungsten modelling lamp. S: sensor, measuring the light off the subject and self-regulating the duration of flash

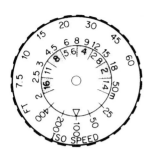

Figure 10.26 Simple exposure calculator dial based on distance × f/number, for a flashgun with a guide number of 36 (metres)

into electrical 'storage tanks' which cause a 'ready' : when fully charged. Firing the flash allows this s discharge as a pulse through gas in the flash tube and light. Then the unit recycles (recharges) itself ready f

A harmless, low-voltage circuit is used to actual either (a) directly, through contacts that come together in the camera shutter or a test push-button on the flash unit, or (b) indirectly by means of a trigger that immediately responds to light from another flash, or even to sound or some other stimulus. Electronic flash goes off instantly when fired, its light duration ranging from about 1/500 to 1/30,000 second according to type and conditions of use. So provided your shutter is synchronized to have the image reach the film at this moment, it is primarily the *flash* that determines exposure time, rather than the shutter itself.

You can use flash at any shutter speed with a between-lens shutter; similarly with a 35 mm focal-plane unit, provided your flash always delivers a 'long peak'. Most guns give a flash of shorter duration, and when these are used with a focal plane shutter at its fastest settings the blinds or blades block out part of the picture (Figure 4.8). This is why the shutter's fastest 'safe' speed often has a different colour on the setting scale, or is marked (⚡) or X. On programmed cameras this speed (or slower) is automatically set when you switch on the dedicated flash unit.

Some older shutters, such as between-lens types on view cameras, have an 'X/M' selector switch near the flash synchronization lead connection. This must be set to X.

With any camera you can always use an 'open flash' firing routine too, provided your subject and camera are static, and any ambient light around is quite weak. Open flash involves holding open the shutter on 'B' and firing the flash by its test button. Several repeated flashes can be given this way if your flash equipment is not powerful enough for the aperture you need to use.

Working from guide numbers

The most basic way to estimate flash exposure is to use the guide number (or 'flash factor') quoted for the unit. The GN is the distance between flash and subject, multiplied by the f-number required, when using film of a given ISO speed. Unless otherwise stated, figures are always quoted for ISO 100/21° film, and for distances in metres. So using a flash with a 36 guide number you set $f/8$ for a subject 4.5 m (15 ft) from the flash, or $f/11$ for 3.3 m (12 ft), using ISO 100/21° film. This might be built into a calculator dial like Figure 10.26, which can also include other film speeds and the use of the flash at fractions of full power, if this is possible. Self-regulating flashguns set to 'manual' work with a similar kind of calculator or table. Guide numbers are also quoted to compare the output of different flash units.

The much greater power output of studio flash units is more frequently quoted in 'watt-seconds' (= joules). The guide number of a typical 1500 W/s power pack unit is 160 (metres) using the head with a bare tube and reflector. This ratio varies with the head design, GN often being reduced to one-fifth when the same head is set behind the diffusing material of a softbox, for example; see Figure 7.15. Studio flash working from a generator (power pack) can also feed several heads, in which case output is divided by the number of equal power heads.

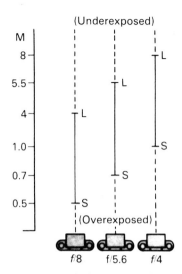

Figure 10.27 Self-regulating flash. Distance S to L shows the self-regulating working range of a typical small flashgun (set for ISO 100/21°) at various apertures. S: shortest flash duration. L: longest duration

Disadvantages. In practice guide numbers alone do not take sufficient account of the reflective properties of your particular subject and its surroundings, and whether flash is direct, bounced, diffused by softbox or colour filtered. Also the manufacturer-quoted number tends to apply to favourable conditions, such as direct lighting of a pale-skinned person in a small room with pale-toned walls!

Using a self-regulating flash

Battery flash units – add-ons or built into the camera – mostly incorporate their own exposure reading system. In an add-on gun, this typically consists of a fast-acting sensor set behind a small window on the main body of the unit, facing your subject. The sensor has an angle of view of about 20°, and so reads the flash illumination reflected back from everything within the central area of your picture. The flash gun has to be set for the ISO film speed and the *f*-number you intend to use.

In the case of a compact with *built-in* flash the camera's own next-to-lens light sensor may act as the flash sensor, and is already fed with ISO speed and aperture information. (Alternatively autofocus cameras set aperture based on subject distance measured by the AF system, simply working to a guide number.)

According to the light received back from the subject, the unit instantly regulates flash duration to give correct exposure. For example, it might clip flash to 1/30,000 second if the subject is close or bright and therefore gives a strong light reading, or extend it to full (typically 1/500 second) duration with a distant or dark subject.

The range of subject distances over which a self-regulating flash will maintain correct exposure is reasonably deep, but as Figure 10.27 shows, the wider the lens aperture set, the farther the working range moves away from the camera. Distances double for every two stops' change of aperture, as with guide numbers. Most of the time a setting about midway in the *f*-number scale gives a good working range unless you are shooting from very close or far away. With the exception of smallest units, electrical energy is returned to storage when shorter flashes are used. The shorter the flash the less time you have to wait for it to recharge.

Disadvantages. Although a self-regulating unit is a quick, convenient way to control exposure, its method of measuring light reflected from

Figure 10.28 Three forms of self-regulating flash exposure control. Left: A compact camera's light sensor beside the lens measures and controls the duration of its built-in flash. Near right: similar sensor system within a clip-on gun (must be programmed for ISO and aperture set). Far right: the same gun, if dedicated to the particular SLR, uses the camera's 'off-the-film' exposure reading circuit instead

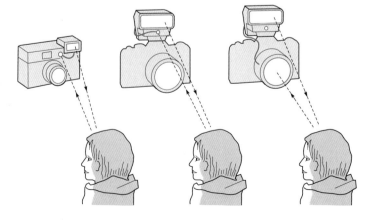

Figure 10.29 Comparing light-output and performance. A cross-section of commercial flash units, from a small unit built into a compact camera, to powerful, generator type studio equipment

Type	Guide no.		Duration		Recycle time (seconds)		Col. temp.
	m	*ft*	@Max. power	@Min. power	@Max. power	@Min. power	
	20	66	$\frac{1}{2000}$	$\frac{1}{40,000}$	10*	0.6*	5600 K
	36	119	$\frac{1}{3000}$	$\frac{1}{30,000}$	8*	0.4*	5600 K
1500 Ws	60	197	$\frac{1}{200}$	$\frac{1}{20,000}$	5*	0.3*	5600 K
	196	640	$\frac{1}{400}$	$\frac{1}{600}$†	3	0.8†	5500 K
6000 Ws	390	1280	$\frac{1}{200}$	$\frac{1}{300}$	7	2	5500 K

† Quarter power *Relates to non-rechargeable batteries

your subject is fairly crude. It is over-influenced by the relative areas of light and dark objects within your picture, like any other general reading meter. Also the constant angle of view measures a larger or smaller proportion of your picture area if you use tele or wide-angle camera lenses. When shooting close-ups, no account is taken of light loss in the camera system owing to close focusing conditions (page 191).

SLR dedicated flash systems

A 'dedicated' flash takes self-regulation one important stage farther for SLR cameras. Multi-circuits between a suitable add-on flashgun and camera allow them to communicate with each other. As long as the camera has TTL exposure measurement 'off the film' this internal metering takes over the role of the flash unit's sensor, with the bonus of automatically taking into account *f*-number, ISO speed, close-up imaging, filters, etc. You also have use of the camera's exposure-compensation dial to cope with difficult subject conditions. The SLR camera's focusing screen of course shows how much subject is being measured, whatever the lens focal length. The flashgun may, in return, communicate data such as 'charge ready' and 'exposed within range' confirmation signals directly into the display you see alongside the focusing screen.

Disadvantages. You cannot use any choice of add-on flashgun and camera – they must be matched to each other, the camera having OTF metering. Extra flash-heads must all be wired to the camera, as its internal metering system does not allow them to be set up independently and fired by a slave trigger (Figure 10.33). As with all add-on guns, it is still possible to mis-match light distribution from the flash reflector and the camera lens's angle of view, giving, for example, too narrow a beam so that only the centre of a wide-angle shot is illuminated.

Flash meters

A flash meter, Figure 10.30, is used in a similar way to a hand-held incident-light exposure meter. You set it for film speed, hold it at the subject position facing the camera, and fire the flash, whereupon the meter displays the lens aperture required. Meters can be used 'cordless',

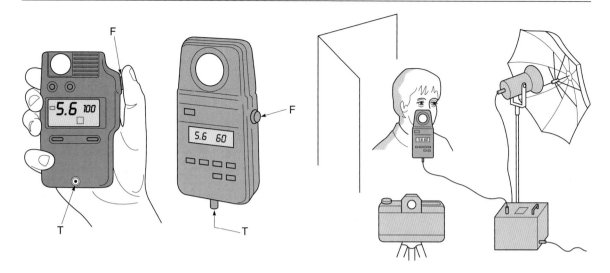

Figure 10.30 Hand-held flash meters – various brands. Several will also measure continuous light sources. All these meters are normally used with flash in incident light reading mode, at the subject facing the camera. T: Trigger cable socket. F: Firing button when in cabled mode

meaning that you need an assistant to push the test firing button on the flash if it is beyond arm's length. Or a long cable links meter and flash unit so that you press a button on the meter to fire the flash. Flash meters are calibrated to within one-third or one-quarter of a stop, and give extremely accurate results when used carefully. Several do double duty, acting as continuous light-source exposure meters too.

Disadvantages. A separate flash meter is really only practical where time and conditions permit you to take a trial flash reading before shooting – they are ideal in the studio, for example. Meters are also rather costly, and you have to remember that they do not automatically take into account camera filters or close-up focusing conditions which affect exposure in the camera.

Practical flash exposure tips
Bounced flash

As discussed in Chapter 7, bouncing flash off a ceiling, wall or similar large surface area is a convenient way of softening lighting quality and improving evenness. However, you greatly reduce its intensity. When working by guide numbers the rule for a white bounce surface is: (1) halve the regular flash guide number, and (2) divide this new number by the *total* flash distance (i.e. flash to surface to subject) to discover your *f*-number. Flash meters, and dedicated flash, will take bounce light conditions into account in measuring exposure. It's very important with a self-regulating flashgun that the sensor always *faces the subject* when the flash is directed upwards or sideways onto a bounce surface. This is usually taken care of in gun design, where the part containing the flash tube pivots and twists but the sensor remains fixed and forward-looking.

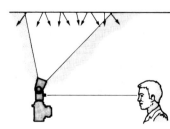

Figure 10.31 'Bouncing' flash. The light sensor must continue to face the subject direct. Illuminate the ceiling above the camera, not subject – otherwise you risk shadowed eyes

Fill-in flash

Flash on the camera is a good way to lower subject contrast in side, top or back-lit ambient lighting situations. Of course, you cannot expect to fill-in whole buildings this way, but it is useful for portraits and average size

Figure 10.32 Fill-in flash. Near right: existing light only, no flash, 1/60 second at *f*/11. Far right: same exposure with the addition of flash from the camera set to one-quarter correct power for this subject distance. You need a powerful flashgun for fill-in flash outdoors beyond about 2.5 m, unless shooting early or late in the day

room interiors. (Make sure, when shooting in colour, that flash and ambient lighting are the same colour temperature – in unalterable tungsten light conditions fit an orange 85B filter over the flash tube and shoot on tungsten film.) Diffuse and direct the flash from close to the lens to avoid casting additional shadows, and arrange to underexpose the flash aiming for a flash/existing-light ratio of about 1:4 (colour negatives).

Advanced compacts and SLRs often offer a 'fill-flash' mode by which settings are made for the existing light but the camera's built-in flash also fires, at quarter power.

Using more than one flash head

Like any other controlled lighting, there will be times when you want to use two or more flash sources from different positions, especially in the studio. With studio flash one arrangement (Figure 10.34) is to have separate units independently plugged into the electricity supply. The generator (or monobloc) powering one head is connected to the camera by synchronizing lead, or has a trigger which reacts to a battery-powered infra-red or radio pulse transmitter you mount in the camera's hot shoe. The other pack or packs have a light sensitive 'slave' trigger plugged onto its synchronizing lead socket (or may be built-in, just needing to be switched on). This ensures that the second flash fires in instant response to the one linked to your camera.

These 'slaved units' can then be moved around in the studio with the freedom of tungsten lighting. Each can be turned down to half or quarter flash power; its modelling lamp dims pro rata, to show you the effect of having sources at different intensities. Another, cheaper arrangement is to have just one generator, plug several heads into it and

place them in different positions. This means more leads to trip over, but only one link from the pack is needed to your camera. Remember, though, that power output from the pack is then *split* (for example, a 1500 watt-second unit gives 750 W/s each to two heads).

The best way to measure exposure when using several heads is by flash meter. But if you use a guide number system instead, work according to the GN and distance of your *main* light flash source only, ignoring the others. A flash meter allows you to exactly measure the lighting ratio between main and fill-in units. First turn on the main flash source only, and fire it with the meter near your subject, facing the light. Secondly turn on the fill-light only instead, and read this facing its light. The difference between the two shows the light ratio. To avoid excessive contrast it's best not to go beyond 4 stops difference for slide films, 5 for colour negatives.

With smaller battery-operated flashguns (Figure 10.33), you will need several complete units on stands wired or slaved to the camera. If guns are dedicated, you *must* have each one wired back to the camera to control their output. Then exposure measurement is simple – you just use the camera's TTL meter for flash as normal.

If your flashguns are self-regulating but not dedicated types (or a mixture), it is least confusing to set them all to manual, wire them to the camera or a trigger for firing purposes, and then measure exposure by meter or just work from the guide number for your key source. Lack of modelling lamps is a big disadvantage with all battery flash when using several heads – you need experience and skill to predict where to place each one.

Speedy recycling

The faster your flash unit will recycle, the more rapidly you will be able to take pictures. This is important in most action and press photography, where any delay waiting for the flash to come up to power could lose you an unrepeatable image. And it is vital if you are shooting a sequence by motor drive.

Figure 10.33 Using several heads at once. Top: two dedicated flashguns controlled from their 'off the film' metering camera by direct wiring. Bottom: set-up using self-regulating guns set to manual, the two off-camera being triggered by light slaves fitted below their heads. These respond to light from a small flash used on camera. (If frontal lighting is objectionable, IR triggering could be used instead)

Figure 10.34 Some two flash-head set-ups in the studio. Below: A pair of monoheads. The one shown left here is triggered when its slave sensor (S) reacts to light from the unit sync wired to camera. Centre: Two more powerful generator type flash units, wired in the same way as the monoheads. Alternatively (far right) using two heads from a single generator. Maximum power light output is then split

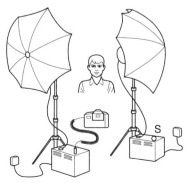
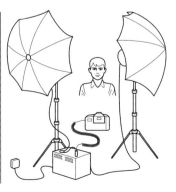

Figure 10.35 Multiple flashes on one frame of film. A sequence of six flashes fired from a hand flashgun in a darkened room, from one side of the model. The camera shutter was locked open on B throughout. This flashgun was totally separate from the camera, and fired manually using the test button. Notice how the almost stationary trunk and legs build up exposure, while hands and fingers receive only one flash each. Set an *f*-number for half-way between these extremes

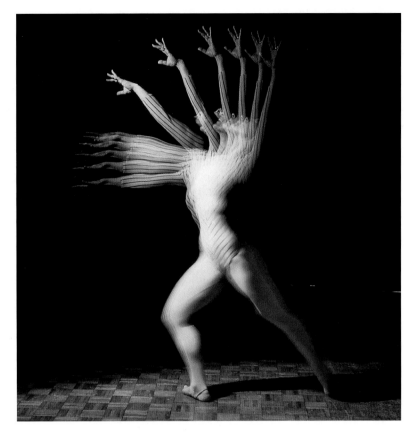

One way of working is to use a flash unit with a powerful generator turned down to a fraction of its full output. For example, one such unit allows you to select 1/100th of full power, and then recycles in 0.25 second, giving an extremely brief flash.

Regular studio flash units on full power take around 3 seconds to recycle, see table, Figure 10.29. They easily overheat if you try to make them fire and recycle in continuous sequence. Special models are therefore made with rapid-firing facility, but give a fraction of normal output.

Summary. Exposure measurement

- Exposure level alters image tonal and colour qualities; can be used to give emphasis, help interpretation.
- The exposure needed depends on lighting, subject characteristics, film sensitivity and imaging conditions. It is given to the film through the combined effects of the *intensity* of the image light, and the *time* it acts on the emulsion. Exposure can be quoted in *f*-numbers and shutter speeds.
- With negative films, avoid underexposure, which produces empty flat shadows. Severe overexposure gives grainier, less sharp results. Overexposure is worse than underexposure if you are shooting on reversal materials – slides and transparencies. Contrasty scenes allow you least exposure latitude. Where possible, intelligently bracket your exposures as insurance.

- The response to light by a film is published as a performance graph or 'characteristic curve'. Where the graph flattens out (tones merge) at bottom and top represents under and overexposure zones.
- A camera meter located behind the lens may read light off the film surface during time exposures, and for flash. Here it takes into account changes in focal length, close-up focusing and filters. Reading patterns range from centre-weighted averaging, to spot.
- Camera settings may be made by the meter direct, working through a program, or you can choose from manual, aperture priority, and shutter priority modes. A fully programmed AE system gives good assurance of correctly exposed pictures – but not necessarily with the visual qualities you had in mind.
- Your three main exposure decisions are the ISO rating you set for your film, the subject parts you measure (emphasis), and how exposure is distributed between shutter and aperture (movement and depth of field effects).
- Substitute readings, and recomposing different areas of subject within the frame just while you measure exposure, often improves accuracy.
- Since view cameras (and many rollfilm cameras) have no built-in meter, you will need to use a hand-held meter. Remember then to increase exposure for close-ups by $(M + 1)^2$ and for any filter used.
- General, overall readings are quick and convenient, but inaccurate when important areas are relatively small. Grey-card or incident-light readings measure exposure independently of the subject. Averaged brightness-range readings (ideally taken by spot metering) take longer but reveal scene contrast, too.
- Flash exposure can be based on *guide numbers* (*f*-number × distance), measured by *flash meter* (most practical with studio units), or a *sensor* on a self-regulating flashgun, or the camera's *TTL system* in circuit with a dedicated gun.
- Electronic flash synchronization (X sync) suits between-lens shutters at all speeds. Focal plane shutters often impose a limiting top speed.
- Self-regulating flash units, independent or dedicated, give shortened flash (and faster recycling) when there is a strong reflected-light measurement from the subject.
- When you bounce flash *halve* its guide number at least; remember to measure the *total* light-path distance. Avoid coloured ceilings/walls.
- With multi-unit set-ups, synchronize one studio flash to the camera and 'slave' the rest. Set self-regulating units to manual, have them wired or slaved to the camera. Check exposure (and lighting contrast) by flash meter, or work with the GN for the key light only. If you have dedicated flash units, wire them all to the camera, then use the TTL camera meter.
- Fast-recycling flash is essential for rapid sequence work. Use a powerful gun at fractional setting, or a specially designed flash unit.
- To fill in and reduce the contrast of ambient lighting, use on-camera flash set to fill-flash mode. If this is not offered make the camera settings correct for existing light and reduce the flash to 25 per cent correct output.

11
Film processing

Film processing is a responsible job, essentially a consistent, controlled routine. It is done by using processing solutions; from these the gelatin of the emulsion absorbs chemicals, which then react with silver halides, in the case of developers differentiating between exposed and unexposed crystals. Using liquid you can also wash out by-products and chemicals from the emulsion without disturbing the actual image.

Processing is ideally suited to automatic machinery, which gives very consistent results but is expensive to set up and really only justified for photographic departments and laboratories which have a high through-put. This chapter therefore concentrates on the processing of different kinds of camera films in small quantities, by hand. You may well decide, like most professionals, to have colour films processed by a local laboratory, but to do your own black and white work. After all, colour film processing is very standardized, chemical costs are quite high, and the capacity and keeping qualities of most solutions are limited. Black and white film processing lends itself to much wider personal choice of developer/film combinations and manipulation of developer and development, and is generally less rigorous in terms of temperature control.

For all forms of film processing you can use light-tight tanks. Provided these are loaded with film in darkness, permanent darkroom facilities are not essential (unlike printing, Chapter 12). Consistency is maintained through timing, and careful control of temperature and solution agitation. You can also give additional or less development – usually by adjusting timing – to alter the characteristics of the final image. These changes mostly affect density, contrast and grain.

Processing itself is often mundane, but requires concentration and care over detail. You must avoid contaminating one chemical with another, and be sure to wash by-products out of the emulsion. Times and temperatures have to be closely monitored. Wet film is very vulnerable to physical damage too, including scratches and dust which, when enlarged, may ruin final results or call for hours of retouching. In short, although processing is not difficult, the fact remains that a few moments' carelessness can mean the loss of dozens of unrepeatable pictures.

Figure 11.1 35 mm and rollfilm hand processing tanks. A: stainless steel 120 film reel tank and lid. B: steel reel loader for 35 mm; cassette fits in cradle, guide bows film across width to load from reel centre. C: tank bodies for processing two and three reels at a time. D: plastic rim-loading reel and tank for 35 mm; see also Figures 11.6 and 11.7

This chapter begins by discussing the equipment and general preparations needed before processing any kind of film. It then looks at the routines, choices and controls over results when processing black and white negatives, colour negatives, and slides.

Equipment and general preparations

Before you start you will need some essential items of hardware, chemicals which may require mixing or diluting for use, and a suitable place to work. Your chief item of equipment is a processing tank. This must hold roll or 35 mm films in open coils (Figure 11.1) or sheet films suitably separated, Figure 11.8. Chemicals or wash water can then circulate over the unobstructed emulsion surfaces to affect them evenly. You also require a photographic thermometer, preferably a digital type, and various graduated measures ('graduates') for measuring and mixing solutions, as well as a plastic mixing rod.

For small tanks in particular you require chemical storage bottles, a funnel (to return solutions to containers), a hose for washing, and photographic clips for hanging up films to dry. You can time processing from any watch or clock, but it is easier to use an electronic timer you programme for the complete sequence of stages, including agitation periods. Also have some means of maintaining solution temperatures during processing, and if possible a drying cabinet.

Figure 11.2 Film processing accessories. G: graduate and mixing rod for mixing and diluting. S: solution storage containers and funnel. T: thermometer – electronic digital (alternatively a mercury or dial type). M: minutes timer. F: clips for hanging up film. W: wash hose to push down into hand tank, and thin protective latex gloves

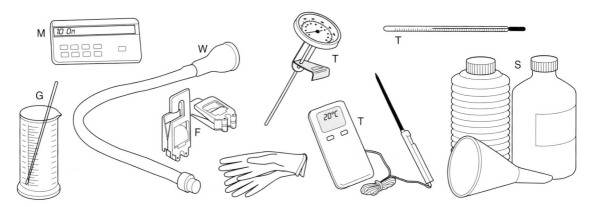

Solution preparation

Whenever you are preparing chemical solutions take care over health and safety. It is always advisable to wear latex or plastic gloves to protect your hands from direct contact with liquid or powder chemicals. When dissolving dry chemicals or diluting concentrated solutions, do this near a ventilator or open window, and avoid inhaling vapour. Figure 11.4 lists some common photographic solutions which require care in this respect. Don't add water to powdered or liquid concentrated chemicals, always the reverse. Read the warnings on labels, and keep all solutions away from your eyes and mouth as well as from cuts or grazes. *Never* have food or drink near chemical preparation areas. And make sure all your storage bottles are correctly labelled and cannot be mistaken for something else. (For further advice see page 320.)

Take care not to allow accidental contamination of chemicals. Contamination will often make expensive solutions useless and, worse still, ruin films – especially colour films. To begin with, make sure all items that come into direct contact with photochemical solutions are made from appropriate inert materials such as PVC plastic, stainless steel or glass. Copper, bronze, galvanized iron, chrome or silver plated materials, zinc, tin or aluminium are all unsuitable, because they react with chemicals and fog film. Absorbent materials such as wood or polyurethane soak up solutions and then contaminate the next thing they touch. Only a drop or so of some chemicals can totally neutralize others. Be careful not to contaminate accidentally through poorly rinsed graduates or storage containers, by solution carried over on a glove, thermometer or mixing rod, or by mixed-up bottle caps.

Processing chemicals are bought either as complete kits containing all stages (as for colour film processing) or as individual items (such as black and white chemicals). In both instances, they may be concentrated liquids or premixed powders which need dissolving. Occasionally, with unusual solutions, you might have to weigh out and mix chemicals according to a published formula, see Appendix D. Most often they are pre-packed, in which case follow the instructions in with them meticulously with regard to the *order* in which the contents of any sub-packets are to be dissolved, and the *temperature* of the water. Failure to do so may either oxidize your solution or make the powder impossible to dissolve.

Often concentrated liquid chemicals must be diluted by *part*. For example 'one part stock solution to eight parts water' or 1 + 8. Parts may mean any unit of volume, as long as you use the same unit for concentrate and water. 1 fl oz with 8 fl oz water (total 9 fl oz) or 1 pint with 8 US pints (total 9 US pints) are both 1 + 8 solutions. It is also useful to know how much concentrate you need for a set volume of working solution. The formula is:

$$\text{Parts concentrated solution} = \frac{\text{Final working volume}}{\text{Parts water} + 1}$$

In other words, the amount of concentrated developer to prepare a 12 litre tankful of one part stock to five parts water is $12 \div 6 = 2$ litres.

Occasionally you have to use a *percentage* solution (handy when a chemical is used in different amounts in various solutions). The 'percentage' of a solution means the ratio of chemical to the final

Figure 11.3 Half-full concertina storage container which can be compressed (left) to minimize air left in contact with solution. This extends the life of developers by reducing oxidation

AVOID skin contact or inhaling fumes from:
Chromium intensifier
Selenium toner/powder
Formalin/formaldehyde
Dish cleaner
Iodine bleacher
Lith developer
Hydroquinone
Sepia (sulphide) toner
Blue toner
Stabilizer
Acids of all kinds

Do NOT store chemicals or solutions in a refrigerator.

Figure 11.4 Safety precautions with processing chemicals. See also Appendix E

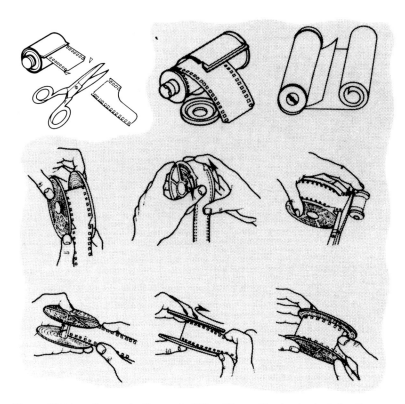

Figure 11.6 35 mm tools. Left: film retriever, inserted into a 35 mm cassette in daylight, pulls out the tip of exposed film which has been wound in. Right: opener to remove the end of the cassette, in darkness

Figure 11.5 Loading reels. Top: cut off the 35 mm film leader in light. If your film has wound in completely use a film retriever to pull out the end. Next remove the spool of film from its cassette in the dark. (Top right: when loading rollfilm instead its backing paper is unwound in the dark until you reach end of film.) Centre: a plastic 35 mm reel is loaded from rim inwards. Rocking both flanges in opposite directions draws the film in fully. Cut off and tuck in end. Bottom: loading a stainless steel 35 mm reel, clip the film to the centre core, then gently turn the whole reel to wind it in, bowing film gently between your fingers. Again cut and push end into the groove

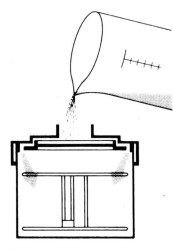

Figure 11.7 Light-trapped lid allows solutions to be poured into and out of a hand tank in normal lighting (stainless steel type shown here)

quantity of its solution in water. For example, a '5 per cent solution' is five parts of chemical made up to a total 100 parts with water. In the case of solid chemicals, this is worked as weight per volume. So both 5 grams of solid chemical made up to 100 ml with water (total 100 ml), and 5 ml of liquid chemical made up to 100 ml (total 100 ml) are 5 per cent solutions.

Processing tanks (35 mm and rollfilm)

Hand processing tanks and reels are made of either plastic or stainless steel. Reels have open ends with a spiral channel for the film (Figure 11.5). The stainless steel types are more expensive, but quicker to dry between processing runs, and easier to keep clean. They are quicker to load once you are practised, but unlike some plastic types are not adjustable to accept film of different widths.

Having cut off the shaped leading end of the film cleanly, you open the 35 mm cassette in darkness (using an opening tool or a bottle opener) to remove your spool of film. With rollfilm, unroll backing

Figure 11.8 Deep tanks. Sheet films are clipped in individual hangers, which hang in solution within tanks. For processing larger quantities racks hold many hangers, or films in reels. Films must be moved (in darkness) between separate tanks of developer, stop bath and fixer. Tanks are best housed in a flat-bottomed PVC sink, which can also act as a water-jacket. See Figure 11.11

Figure 11.9 Small-volume sheet film processing in (left) stainless steel daylight tank, or (centre) rotary drum. The latter maintains both film drum and chemical containers in a temperature-controlled water bath; see side view (right)

paper until you reach the film itself. Plastic reels are mostly loaded from the outer rim; steel reels always from the centre outwards, keeping the film slightly bowed across its width. You must not kink the film and form dark crescent-shaped marks, nor buckle it so one part of the coil touches another, leaving unprocessed patches. A loading aid (Figure 11.1) makes it easier to fill centre-loading reels in the dark.

Tank bodies hold single reels, or you can buy various taller versions taking multiple reels. Once each film is on a reel, placed inside the tank body and sealed from light by the lid, you work entirely in normal lighting, pouring solutions in and out in turn through a light-trapped opening in the lid.

Processing tanks (sheet film)

The most common way of hand-processing sheet film is in a series of 15 litre PVC 'deep tanks' (Figure 11.8), one for each stage of processing. An extra floating lid rests on the surface of solutions, such as developer, prone to oxidation with the air; it is removed completely during processing. Each tank has a main lid which is loose-fitting but light-tight, so that you can switch on white light to check time, etc., once films are in the solution.

You remove each sheet film from its holder in darkness or correct safelighting (page 237) and clip it into a stainless steel hanger. You can lower hangers individually into the first tank of solution, where they are supported by a ledge near the top. For batch processing, hangers can first be slotted into a rack, which makes them much easier to agitate.

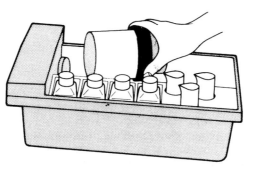

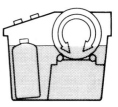

Similarly several standard reels containing roll or 35 mm film can be fitted within a cage-like stainless steel rack for batch handling in the same way. You must switch off the white light and open the tank lid each time you agitate films or transfer them to the next tank.

Alternatively you can process up to six or so sheets of film in one of two ways. Firstly, they may be curved and fitted within a horizontal PVC drum, which fits on a motorized cradle like a colour print drum processor, Figure 11.9. This is economical, as the rotating tank needs only a small volume of each solution to be inserted and drained in turn through a light-trapped entry funnel. Agitation is continuous. Secondly, the films may be slotted without hangers into a small rectangular 'daylight' developing tank. This has a lid with a light-trapped inlet and outlet, so you can pour processing solutions, wash water, etc., in and out of the closed tank in normal lighting.

Agitation

Giving your film correct agitation is of great importance. Too little, and by-products from the emulsion gradually diffuse down the film towards the tank bottom leaving the image with pale-toned streamers. Excessive, over-energetic agitation creates currents from hanger clips or film perforations which give uneven flow marks. Most small tank development times are based on 'intermittent' agitation – typically a period of 5 seconds every $1\frac{1}{2}$ minutes. This is given by inverting the film tank or rotating the reel, or lifting and tilting sheet films (Figure 11.10).

Figure 11.10 Agitating film during processing. Above: basic routine for agitating a rack of sheet films, in darkness. Far right: with a daylight 35 mm or rollfilm hand tank, tap it gently on the bench to dislodge air bells at the start of development. Then use inversion technique at regular, specified intervals throughout processing

It is vital that you adopt a *consistent* agitation routine, or the processing will vary. In motorized processing the action of drum rotation, or continuous passage of the film through solutions between moving rollers, provides the agitation; see page 203.

Temperature control

Have developer(s), in particular, ready at just the right *temperature*, and maintain this within tolerances for the solution while they act on the film. *(Temperature latitude* is as little as ±0.25°C with some colour developers, but much wider for fixers, etc.) The best way to hold temperature with a small tank is to have a 'tempering unit' (Figure 11.11). This is an enclosed jacket containing electrically heated air or water, thermostatically controlled within narrow limits. Alternatively stand your tank, and graduates of chemicals, in a bowl or deep tray filled with water of the required temperature.

Figure 11.11 Temperature control.
A: simple water-jacket for the film
tank. B: commercial tempering
unit using warmed air (hand tank
fits in centre). C: stainless steel
tempering coil you connect to the
warm water supply. D: immersion
heater. C and D are for deep tanks

Larger volumes of chemical in deep tanks hold their temperature more
readily. To alter temperature use a thermostatic immersion heater, or a
tempering coil through which you pass and discharge to waste warm or
cold water. Make sure your thermometer will cope with the higher
temperatures (e.g. around 38°C) required for some colour processing.

Working layout

Keep your 'dry' working area – where you will load your rollfilm tank
or hangers – away from the 'wet' chemical preparation and processing
areas. If necessary, small tanks can be loaded in any (clean) light-tight
cupboard or even a changing bag, then moved somewhere else for
processing itself. Deep tanks, however, need to be in a blacked-out
room (page 223). Both large and small tanks will have to stand in an
empty sink for washing stages. Have a hose from the water supply
pushed down into the open rollfilm tank. For sheet film use a purpose-
made wash tank (Figure 11.13) with water inlet jets. Both arrangements
are designed to allow water to overflow and go to waste.

The quickest and safest way to dry film is in a drying cabinet.
Unwind roll and 35 mm film, attach clips at each end and hang them

Figure 11.12 Changing bag made
of light-proof material, with
elasticized armbands. Right: tank,
film, scissors, etc., are placed
inside through zip opening before
starting to load film, far right.
Make sure that everything needed
(including the tank lid) is in the
bag before you start opening the
cassette or rollfilm. Bag can also
be used for loading sheet film
holders

Figure 11.13 Film washing. Simple use of hose pushed fully into the opened reel tank (near right), and wash tank for sheet films (far right)

Figure 11.14 Film drying cabinet, glass fronted type. Accepts 35 mm, roll or sheet film, in mixed sizes

vertically. Sheet film can remain in hangers. See also wetting agent, page 214. The built-in air heater will dry them in 10 minutes or so, or you can just leave them several hours at room temperature. (Never change from one rate to the other part way through drying, or you create drying marks.) You must of course dry films well away from dust, fluff, grit or chemicals – which could settle on the delicate emulsion surface. If you intend to reuse reels or hangers immediately for further processing, first make sure they are *absolutely* dry.

Processing black and white (silver image) negatives

What happens

Your first processing solution is a developer, containing developing agents (such as metol, Phenidone, hydroquinone) and supportive ingredients including an alkali, preservative and restrainer chemicals; see page 317. During development, electrons are donated to the film's light-struck silver halide grains. This leads to the formation of vastly more silver atoms until the latent image the film carries grows visible as an image in black metallic silver. In return the developer receives potassium bromide discharged from the emulsion in proportion to the silver formed, plus exhausted developing chemicals devoid of their electrons. (As these by-products accumulate they gradually weaken and slow the developer.)

Inside the tank during development the image of your subject's highlights appears first, then its midtones and finally shadows. The density (darkness of tone) of highlights builds up faster than shadows so that image *contrast* steadily increases with development. However, developing also has some effect on unexposed grains, eventually giving a grey veil of 'fog' to shadows and clear rebate areas of the film if you overdevelop excessively. At the end of the required period development is halted by rinsing the film, or better still treating it briefly with an acidic 'stop-bath' which neutralizes any carried-over developer.

The next processing solution is fixer, known as 'hypo' (containing acidified ammonium or sodium thiosulphate). Fixing means converting all remaining silver halides – undeveloped, still creamy looking and light-sensitive – into invisible soluble by-products, which you wash from the emulsion in the final stage of processing prior to drying. Usually fixer contains a gelatin hardening agent too, which strengthens the processed emulsion and hastens drying. From the latter half of fixing onwards you can work with the lid off your tank if you wish, as results are no longer affected by light.

Kodak D76	Normal contrast
Ilford ID11	fine grain; good
Kodak HC110	compromise
(1 + 7 or 1 + 15)	between fine grain
Aculux 2	and full emulsion
	speed
Microphen	Speed enhancing
Verispeed	(up to 3 × ISO)
Perceptol	Finer grain at the
	expense of speed
Rodinal	High acutance,
	low max. density
Kodak D23	Low contrast
Kodak Technidol	
Kodak D8	High contrast
	(regular and line
	films)
Dokulith	High contrast
	(lith films)

Figure 11.15 Some black and white film developers

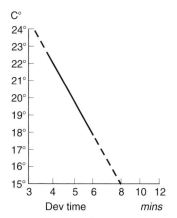

Figure 11.16 Time/temperature graph for a typical normal contrast developer (dilution and agitation specified). Temperatures below 18°C cannot be fully compensated for by increased time, and much above 22°C here times become too short for tank processing to be even

Degree of development

With any one type of film, and assuming it is correctly exposed, the amount of development it receives depends on:

1 *Type of developer*, its dilution, and general condition (e.g. how many films it has processed, and how much contact it has had with the air). You have dozens of negative developers to choose from. Some are general-purpose fine-grain types like D76 or ID11, others are speed-enhancing (primarily for fast emulsions), or high-acutance (for medium or slow materials), or high-contrast (for line films); see Figure 11.15. Their keeping properties vary according to type of formula. Diluting a developer reduces the contrast it gives (even though you extend time). Dilution is also necessary if processing time must be increased to avoid unevenness. However, this adding of water further shortens solution-keeping properties because more oxygen reaches its chemical contents.

2 *Solution temperature*. The higher the temperature, the faster the development (Figure 11.16). But if you work a solution much above or below its recommended temperature (which is typically 20°C/68°F) each component of a developer may react differently. At low temperatures some of the developing agents become inert. At high temperatures you risk over-softening the emulsion gelatin, and development times become too short for even action. In general, only temperatures within the range 18–24°C can be fully compensated for by change of time.

3 *Timing*. Within limits imposed by the type of developer and film, the longer your development time the greater the image contrast and density (highlights more than shadows). Grain and fog level tend to increase too. Change of timing is the most practical way of controlling the amount of development you give, see 'pushing' (page 212). But avoid times less than about 4 minutes when tank processing, as it is difficult to get an even effect. Timing must also be increased each time a solution is re-used.

4 *Agitation*. This needs to be rigorously standardized, as discussed on page 208.

Choosing developer

You need to find the developer(s) which best suit the film, the shooting conditions, and the type of negative you prefer. Another factor is whether to use 'one-shot' (dilute from stock, use once, and throw away) or a long-life reusable solution (increasing your times gradually with each film batch and replenishing when necessary with some fresh chemicals). The latter type is essential for deep tank use because of the large volume of solution. One shot is ideal for small tank processing because it is less fuss and ensures consistency, although it may cost more. Extremely energetic developers (Dokulith lith developer for example) have such a short life at working strength they are best used 'one-shot', so you will probably have to tray-process line sheet films.

Start by using one of the developers recommended on the film's packing slip. A reusable fine grain developer like D76 (diluted 1 + 1) or HC110 (1 + 15) is remarkably versatile, suitable for most continuous-tone films and subjects, given appropriate timing. Alternatively, an 'acutance' developer such as Rodinal gives high edge-sharpness with

Figure 11.17 Suggested 35 mm film normal development times (20°C)

Developer:	D76 (1+1)	Perceptol	HC110 (1 + 15)	Rodinal (1 + 25)	Aculux 2 (1 + 9)	Microphen (1 + 1)	Varispeed (1 + 9)	Dokulith
Film								
Agfa Pan								
AP×25	13	10		6	7	7.5	5	
FP4 plus	8	9		6	6.5	7	4.5	
HP5 plus	11	11	4.5	7	9	12	6	
Tri X	10	10	5	7		11	5.5	
T Max 400	12.5	11		5	12	10	6	
Lith								2.5
Kodak Tech								
Pan 25							4	

Processings	Timing
1–2	Normal
3–4	Normal + 6%
5–6	Normal + 12%

. . . then discard

Figure 11.18 Development time increase with successive use of the same solution (D76, single reel tank)

Kodak T Max 400

Exposed rated as:	Mins. in T Max Dev (1 + 4)	Temp (°C)
ISO 400	7	20°
800	7	20°
1600	10	20°
3200	9.5	24°

Figure 11.19 Push processing. Extending the developing time or raising temperature increases effective film speed, but taken beyond two stops (ISO 1600 here) graininess and contrast increase, shadow detail becomes lost

Figure 11.20 Characteristic curves for this film show that when a subject in which highlights (H) are 100 times brighter than shadows (S) is correctly exposed (see exp. axis) and developed to a CI of 0.45 the resulting negative has a density range of 0.8. Developed longer, to CI 0.56, the negative is more contrasty and has a 1.1 density range. Relate these ranges to printing papers, Figure 12.21

slow films and has some 'compensating' effect, restricting maximum density yet giving a good range of other tones.

'Pushing' and 'holding back'

Fast films are most suited to extra development (push processing) to enhance speed, because they are less likely than slow films to become excessively contrasty. ISO 400/27° film can easily be rated at ISO 1250/32°, for example, if processed in speed-enhancing developer, or shot at ISO 800/30° and given ×1.6 normal time in regular D76. Such a routine may be necessary for dim-light documentary photography, or simply when you know you have accidentally underexposed. Don't overdo this if the subject is contrasty though (it's better to use faster film in the first place). Remember too that the extra grain will reduce detail. Slightly extended development helps to improve negatives of very low-contrast images, preferably shot on slow film to avoid excessive grain.

Reduced development (holding back) is less common, but will help when you have accidentally overexposed or want to record a contrasty image. The best approach is to use a superfine-grain, speed-losing developer such as Perceptol, or D76 diluted 1 + 3. This holds back most films to half their normal ISO rating. (Limits are reached when your negative holds detail throughout an extreme-contrast subject but is too flat and grey to give a satisfactory print.)

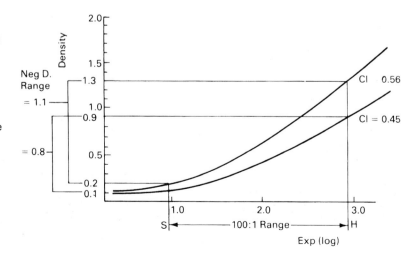

Developer effect can be shown by changes in the film's characteristic curve, Figure 10.3. As you give more development time the shape of the curve steepens, giving increasing negative contrast. There is an old adage in photography to 'expose for the shadows and develop for the highlights'. In other words, make sure you give enough exposure to put shadows on the rising toe near the bottom of the curve, then control development to get sufficient (but not too much) density in highlights. Degree of development is given a 'contrast index' figure. A CI of 0.45 produces a negative of an 'average' subject (say 100:1 tone range) which prints on normal-contrast paper using a condenser enlarger. Work to 0.56 for a diffuser enlarger (page 227).

Processing stages following development

As soon as the development time is up, you pour out developer and refill with stop-bath or water, or (deep tanks) transfer hangers in darkness into

Figure 11.21 Effects of exposure and development on a normal contrast, silver-image monochrome film. Top row: all underexposed and given (L to R) under, correct and over-development. Bottom row: all overexposed and given same development as top row. Centre: correct exposure and development. Underexposure combined with over-development gives highest contrast ('pushing' technique). Overexposure with underdevelopment ('holding back') produces lowest contrast

Figure 11.22 Some monochrome silver image processing faults. A: slight fogging to light before processing – typically reel loading in an unsafe darkroom. B: partly fogged towards the end of development. C: extremely uneven development because the tank contained insufficient solution. D: rollfilm showing black crescent-shaped kink marks, and clear patches where coils have touched during development. E: general abrasion and crease marks due to rough handling in reel loading. F: circular uneven drying marks, due to splashes or droplets clinging to the emulsion when drying after processing

the stop or wash tank. After agitating throughout the 15 seconds or so required here, you next treat the film with acid fixer solution, preferably one containing hardener. After about 1 minute it is safe to look at the film in normal light. It may take a little longer for the fixer to make all creaminess disappear from the emulsion and twice this period for film to be fully fixed. Agitate at the beginning of fixing and then about once every minute. Both stop-bath and fixer are long-lasting and can he used many times, see Figure 11.23.

Washing in running water takes about 15–20 minutes, less if the emulsion was unhardened. (See page 318 for residual silver permanence test.) Finally add a few drops of wetting agent to the last of the wash water, to reduce surface tension and so encourage even drying. Then carefully hang up the films to dry in a dust-free atmosphere.

Assessing results

As a general guide, a correctly exposed and developed continuous-tone negative should represent the detail in deepest subject shadows as just perceptibly heavier than the clear, unexposed film rebate. Tones representing the subject's brightest important details must not be so dark you cannot still read printed words through the film when laid emulsion down on the page of this book and viewed in sunlight.

Figures 11.21 and 11.22 show some common negative faults. It is important to distinguish *exposure* errors from *development* errors, and faults originating in the camera from those caused while processing. Unsharp images are not caused by processing, whereas uneven patches of density usually are. Dark, light-fog marks limited to picture areas alone often mean a camera fault; fog across the rebates as well may be either a camera or a processing mishap.

Figure 11.23 Working life of typical black and white film processing solutions. Figures for processing capacity assume that times are appropriately increased with each re-use

Solution	Processing capacity (35 mm films per litre)	Keeping properties without use	
		Stock in full container	Working sol. in deep tank
Developer			
D76	5 × 36 exp.	6 months	1 month
Lith	use once only	6 months*	–
Stop-bath (typical)	12 × 36 exp.	indefinitely	1 month
Fixer			
Regular and rapid	30 × 36 exp.	2 months	1 month

*Separate A and B solutions

Processing chromogenic (colour and black and white) negatives

What happens

Colour negative films, and monochrome dye-image negative films, can both be processed in the same C-41 process chemical kit. In the first solution (colour developer) the developing agents form a black silver image, but this time exhausted agents react with dye couplers to simultaneously form a different coloured dye image in each emulsion layer. The reaction is known as chromogenic development. In the next solution (a bleach), development is stopped and the black silver is turned into silver halide so that it can be fixed out together with all the remaining unprocessed halides. The fixer may be incorporated in the same solution (then called 'bleach/fix'), or be a separate stage following a brief wash. You are now left with dye images only; see page 162. The film is washed to remove fixer and all soluble by-products, and then finally, according to the chemicals used, may require a rinse in stabilizer to improve dye stability and harden the emulsion before hanging up to dry. Some C-41 chemical kits do double duty by allowing you to process (RA-4) colour paper too.

Processing tolerances

All this takes place at a higher temperature than silver negative processing. The higher the temperature, the more accurately it must be held, so it is essential that you use an efficient tempering unit.

Development is the really critical stage. Colour negative films only tolerate very limited development changes because *colour* is affected along with density and contrast. All chromogenic black and white and some colour-negative films designed for the purpose allow greater adjustment of developing times. These you can 'push' or 'hold back' to compensate for shooting at a higher ISO rating or for (slightly) overexposing. Overdone, the resulting colour negatives may show colour casts that are different in shadows and highlights. Pushed film has a high fog level and grain, while held-back film gives negatives too flat to suit any colour paper. Never try these techniques purely to compensate for image contrast, as in black and white work.

As a rough guide, increase development time for colour negative film by 30 per cent for one stop underexposure, or reduce normal time 30 per

C-41. For colour and chromogenic black and white negatives

Stages	Kodak 37.8°C (100°F) min	Paterson 38°C min	Temp (°C) tolerance
Colour dev	$3\frac{1}{4}$	3	±0.25
Bleach	$6\frac{1}{2}$	–	24–41
Wash	$3\frac{1}{4}$	–	24–41
Fix	$6\frac{1}{2}$	–	24–41
Bleach/fix	–	3	24–41
Wash	$3\frac{1}{4}$	5	24–41
Stabilize	$1\frac{1}{2}$	$1\frac{1}{2}$	24–41

Figure 11.24 Processing stages for four, or three bath C-41 kits. (These are occasionally updated, and so should be taken only as a guide.) Times differ slightly according to whether you are processing in deep tanks, a small hand tank, or a drum processor

E-6. For colour slides

Stages	Kodak 38°C (104°F) min	Tetenal 38°C min	Temp (°C) tolerance
1st dev	7	6.25	±0.3
Wash	2	2.5	±1
Reversal bath	2	–	±1
Colour dev	4	6*	±1
Wash	–	2.5	20–40
Pre-bleach	2	–	20–40
Bleach	6	–	33–40
Fix	4	–	33–40
Bleach/fix	–	8	33–40
Wash	3	6	33–40
Stabilizer	–	1	30–40

*Includes fogging agent

Figure 11.25 Reversal processing stages for colour slide and transparency films, using six and four bath kits. As with C-41 processing these times will differ slightly according to your processing equipment

cent for one-stop overexposure. All other steps remain the same. Whenever you judge processed dye-image films, both colour and monochrome, bear in mind that results appear partly opalescent and 'unfixed' until completely dry.

Processing colour slides and transparencies

Apart from Polachrome and Kodachrome, all general-purpose colour slide and transparency films require the use of an E-6 process chemical kit. Like colour negatives there is no choice of developer – only complete kits, Figure 11.25. Some kits cut down on time and the number of stages by combining solutions, but give equivalent results which barely differ in sequence or effect.

What happens

The first solution, a slightly contrasty black and white developer, forms black silver negatives in each of the emulsion layers. Next, film is washed to halt the action and remove developer, and the remaining halides 'chemically fogged' to give an effect similar to fogging by light. This is achieved either by a reversal bath or by chemicals contained in the next solution, colour developer.

The colour developer has a similar (chromogenic) function to developer used for colour negatives. The silver halides fogged by the previous solution are developed to metallic silver in each layer. At the same time special exhausted developing agents that are formed react with dye couplers attached to the halides undergoing change. The result is yellow, magenta and cyan *positive* dye images, although at this point they are masked by the presence of both negative and positive silver images. The last stages are bleaching, fixing and washing to remove all the silver. You are then left with the positive dye images alone.

Warning: In reversal processing contamination of the first developer with the smallest traces of colour developer – even fumes alone – can give results with grey blacks generally off-colour.

Processing tolerances

As with C-41, solution temperatures are higher than in regular black and white processing. The critical solutions are first developer (±0.3°C) and colour developer (±1.0°C), with the others 20–40°C or 33–40°C, in kits for processing at 38°C. Most brands of reversal colour material can be successfully 'pushed' or 'held back', which you do by altering the first development time (Figure 11.27). All other times remain constant. Regard one stop either way (i.e. doubling or halving ISO speed) as the normal limits, with pushing up to two stops as more of an emergency treatment or for grainy effects.

In general, pushed processing increases graininess and contrast, and leads to shadows empty of detail. But in moderation it can improve shots of low-contrast subjects and help when you must have maximum emulsion speed. Held-back processing reduces contrast, which is useful with contrasty subjects, such as when copying slides. The precise effect of altered processing on final image colours varies with different brands

Figure 11.26 Results of adjusting the timing of the first developer stage of E-6 slide film processing (Ektachrome). Left: Overexposing 1 stop and holding back. Centre: Correct exposure and normal processing. Right: Underexposing 2 stops and giving appropriate push processing (when enlarged, grain is very apparent)

Figure 11.27 Modified E-6 processing to 'push' or 'hold back' slides and transparencies

and types of film. Fast films survive push processing far better than slow ones. Usually pushing gives coarser hues, and holding back produces less brilliant colours and warmer highlights. Any slight colour cast (due to lighting conditions or subject surroundings, for example) seems to become exaggerated.

Most custom laboratories offer a compensation processing service, but at extra cost. Some of the most common reversal processing faults are shown in Figure 11.32. Remember not to judge results until the film is fully dry and has lost its milky appearance.

For camera exposure:	Or meter ISO setting:	Typically alter 1st developer time by:
2 stops under	×4	+90%
1 stop under	×2	+30%
Correct	Normal	
1 stop over	×0.5	−30%

Processing other film materials

Black and white slides from conventional film

You can reversal-process some black and white negative films to produce direct black and white slides. It is best to use slow film (ISO 100 or less), which you shoot at 2.5 times its official ISO rating. Unsuitable films give flat slides, often with a greenish tinge to blacks.

Processing involves similar steps to colour film reversal processing – producing first a black and white negative, then bleaching, fogging, and re-developing in black and white developer to get positive images. Commercial kits such as the Kodak T-Max 100 reversal kit or Tetenal's reversal kit cover the five chemical stages. Alternatively 35 mm film such as Agfa Scala is specifically designed for reversal slide making, and processed by one or two laboratories.

Instant-picture slides

Processing Polaroid instant-picture slides (colour and black and white) is a mostly mechanical task. You insert the film and its appropriate 'processing pack' into a special processing tank unit, Figure 11.28. Following the instructions, the pack's container of thick processing fluid is punctured and feeds by gravity onto a 35 mm wide plastic band.

Figure 11.28 Instant-picture slide processing. 1: processing unit, exposed 35 mm film and appropriate processing pack (film is wound emulsion outwards, and therefore exposed with its base towards the camera lens). 2: end of film and the applicator band of the processing pack are attached over stud on drum. 3: cover closed, lever ruptures pod of processing fluid; allow 5 seconds for fluid to drain on to applicator band. 4: winder draws film and fluid-soaked band into tight contact around drum; allow 60 seconds for processing to take place. 5: reversed gearing returns film to cassette, and band (plus stripped-off top emulsion layer) to the pack. 6: removing the processed slides from the cassette: used pack is discarded

The fluid-coated band is clipped to the end of the exposed film, and wound up in face contact with the exposed emulsion through rollers and on to an internal core. Here the processing agents develop exposed halides in the top emulsion layer to a silver negative, and cause *unexposed* halides to migrate to a lower gelatin layer. They become anchored here and convert to black silver (by a controlled form of dichroic fog) to form a positive image.

You wait a short period for processing to complete, then turn a handle which winds the film back into its cassette, and the band back into its pack. As the latter does so it splits off the damp top layer of the film containing the negative image, and carries this away with it. Opening the unit you discard the pack and contents, and pull the barely damp strip of processed slides from its cassette. Temperature latitude for the whole process is 17–30°C (60–85°F).

Instant *colour* slides (Polacolor) are processed with a similar sequence of steps. Image colours are recreated from a pattern of microscopic blue, green and red filters printed on the film base, like the pattern on the face of a colour television screen; see *Advanced Photography*.

Processing by machine

Automatic machines for processing conventional films range from small rotary drum units to dip-and-dunk and roller-transport machines. Given sufficient tanks and appropriate temperature/time programming they can all tackle C-41, E-6 or conventional black and white processing.

Drum units (Figure 11.9) are the least expensive machines and simply mechanize what you would otherwise do by hand. In automatic versions the film drum is filled from chemical reservoirs, rotary agitated, emptied, washed through, etc. Chemicals are usually 'one-shot' and so discarded, but some (bleach/fix for instance) are stored for further use. After the final stage you remove your film or batch of films for drying.

Figure 11.29 Large-volume film processing machines. Roller-transport type, near right, contains racks of rollers (see detail). Rollers turn continuously; with this unit you insert individual films in the darkroom end, and they appear from the drier into a normally lit room. 'Dip-and-dunk' machine, far right, processes film in batches. Tanks are open, so developing stages must take place in a darkroom

Figure 11.30 A minilab printing unit for APS films

Figure 11.31 The leading end of a processed APS film showing in addition to picture areas: (A) data magnetically logged frame-by-frame in the camera (determining the format to be printed, etc.). B: manufacturer's optically printed bar code type film data. C: magnetic data recorded by the lab (number of prints off, etc.)

Equipment used by commercial labs

Dip-and-dunk machines work by physically tracking and lifting batches of sheet film in hangers and roll or 35 mm films suspended on clips, from one tank to another, in a large darkroom-size unit. Transport is at a steady speed, but by having tanks longer or shorter, different periods in each solution are made possible. Finally films are lifted and passed through a drying compartment.

Roller-transport machines also use a sequence of tanks but these are filled with many motor-drive roller units (Figure 11.29) which pass sheets and lengths of film up and down through the tanks and finally through an air-jet drying unit. An emulsion area monitoring system replenishes tanks with fresh processing chemicals pro-rata to the amount of film put through. Since both dip-and-dunk and roller machines need large tankfuls of expensive chemical solutions, they are only viable for regular, high-volume film processing. Few commercial laboratories now have sufficient demand to justify running machines for conventional black and white processing. If you want to use a lab for your monochrome work it will be easiest to shoot on a chromogenic-type 35 mm film (page 159), which any lab can put through their C-41 line; see also *Advanced Photography*.

Mini-lab roller transport machines provide film processing, printing and paper processing all linked up as either one or two stand-alone units. As mini-labs are designed for full operation in daylight, they are ideal for installations in retail shops. APS films in particular are designed for this form of photofinishing. The equipment pulls out and detaches the film from its cartridge and splices it end-to-end with other films before processing. It also reads digital information recorded by

Figure 11.32 Some E-6 colour slide processing faults. A is correctly processed. B: fogged to low-level light before processing. C and D: fogged during processing. E: contamination of first developer with fixer (including fix spots). F: colour developer contaminated with bleach

Solution	35 mm films (36 exp) per l	Working sol. in full container
E-6 slides		
First developer	9*	2 months
Reversal bath/ pre-bleach	20	2 months
Colour developer	20	3 months
Bleach and fix	20	3 months
C-41 negatives		
Colour developer	8†	6 weeks
Bleach	16	indefinitely
Fix and stabilizer	16	3 months

*Extend time after 6 films by 8%
†Extend time after 4 films by 8%

Figure 11.33 Working capacity and keeping properties of colour reversal and colour negative processing solutions. This is updated from time to time, as chemical compositions change

the camera along the film edge, which automatically adjusts image format ratios (see Figure 4.13) and degree of enlargement at the printing stage, as well as helping to set accurate filtration and exposure. Finally each processed APS film is reattached into its original cartridge and output together with the trimmed and sorted print order.

Permanence of processed results

Correctly processed film images should remain stable for many years. Anticipated life without any perceptible change for dye images, unprojected and stored at 21–24°C and 40 per cent relative humidity, is 10–20 years (fast films) and 40–100 years (slow films; also black and white silver images). Two ways to ensure maximum permanence with black and white films are: (a) use two fixing baths, giving 50 per cent of the fixing time in each. Then, when the first is exhausted (Figures 11.23 and 11.33), replace it with the second and make up a new second bath from fresh solution; (b) rinse films after fixing and treat in hypo clearing agent prior to washing. This also allows washing time to be reduced by 75 per cent.

Store negatives in sleeved ring-file sheets, made for the purpose from inert material. Slides can be mounted in card or glass mounts, 'spotted' to show correct image orientation for projection (Figure 11.34) and stored in archival quality pocketed plastic sheets which hang in a filing cabinet. Give each image a reference number. (Use the frame number near the edge of rollfilm and 35 mm negatives as part of this reference when film is stored in strips.)

Figure 11.34 Storing results. Left: slides are mounted and 'spotted' top right when the image is inverted but right way round. Placed in the projector this way, your picture appears correctly on screen. Diagonal line drawn across the top edge of a set of slides shows up any missing or disordered. Centre: negative file for rollfilm negatives. 35 mm negatives are similarly stored. Right: suspension file system. Slides are stored in transparent sheets with pockets holding 20–24 at a time

A good way to maintain a film file index is to hold it on computer disk, using an image-based software program. Here it is also easily cross-indexed for date, subject, client, invoice number, etc. If you scan in your work (Chapter 14) the computer can display 'thumbnails' a dozen or so at a time based on a selective listing for any permutation of headings you choose, to locate particular pictures. This can also be linked into e-mail and the Internet transmission of your pictures for sales or reference; see also page 301.

Summary. Film processing

- Key skills in film processing are (1) preparing solutions, (2) loading the hardware with film, in darkness, (3) ensuring correct temperature, timing and agitation, and (4) drying the wet film without damage.
- Protect yourself from breathing in or touching chemicals. Always add chemicals *to* water. Avoid solution contamination through contact with unsuitable materials or other processing solutions, particularly colour chemicals.
- Concentrated chemical may need dilution by *part* (e.g. 1 + 8) or be used as a *percentage solution* (e.g. percentage of chemical to final solution volume).
- 35 mm and rollfilm tanks accept film in single or multiple reels, have a light-trapped inlet/waste for solutions to act on the film in sequence. Drum processors work similarly but are motor-driven and use small volumes of mostly one-shot chemicals. Sheet films may be processed in small tanks like rollfilm or, more often, in a sequence of deep tanks – films being transferred between each solution in the dark.
- Use a tempering unit, tempering coil or thermostatic immersion heater to maintain the temperature of solutions and tank. Agitation during processing must be consistent, not under or overdone.
- Black and white negatives should be exposed for shadows, developed for highlights. Development increases contrast, density, graininess and fog level. The degree of development a film receives depends on solution type, condition and dilution; temperature; agitation; and timing.

- Black and white developers are general-purpose or specialized (high-acutance, contrast, speed-enhancing, etc.); 'one-shot' or reusable (regularly extending times, or replenishing). Normal processing temperature 20°C (68°F).
- 'Push' black and white film by extending time or using high-energy developer. 'Hold back' by diluting developer, reducing time, or using speed-reducing superfine-grain formula. Watch out for the effects these changes have on image contrast, grain. Black and white negative contrast indices of 0.45 and 0.56 suit condenser and diffuser enlargers respectively.
- When assessing results featureless subject *shadows* are a sign of negative underexposure; low contrast and grey *highlights* a sign of underdevelopment.
- Colour (and monochrome dye image) negatives need C-41 chemistry processing. E-6 chemistry is used for most forms of reversal slide and transparency films. Temperatures are higher than black and white, latitude much less. Invest in an accurate, preferably digital thermometer. Main chemical stages for negatives: colour developer, bleach/fix, stabilize. For slides: first-developer, reversal (some kits), colour developer, bleach/fix.
- Suitable negative or reversal type films can be 'pushed' or 'held back' one stop or more by adjusting the timing of the first (development) stage.
- Processing machines – drum units, dip-and-dunk, roller transport – offer semi or complete automation. Rotary processing drum apart, their cost in hardware and chemicals is unjustified for small-volume workloads. Virtually every lab is mechanized to offer fast, reliable, straight processing of C-41 films. Cost is less than the chemical kit you must buy when small batches of film are user-processed. Most labs handle E-6 too. Black and white films (unless chromogenic) are best user-processed – then you can make your own choice of developer.
- For maximum black and white image permanence use two-bath fixing, treat film with hypo clearing agent at the wash stage, and store carefully.
- Remember health and safety when using chemicals, Appendix E.

Projects

1 Compare film/developer combinations for your favourite monochrome films. By practical experiment discover the times needed for different developers to give negatives which best suit *your* printing set-up. Try pairing up slow films with Rodinal or Perceptol, and fast films with Microphen or Varispeed. Compare with the more all-purpose D76 or HC110.
2 Test out the image quality effects of up-rating and then push processing. Shoot both contrasty and low-contrast subjects on ISO 400 black and white film with correct exposure and development. Then repeat, pushing film speed to ISO 800, 1600 and 3200. Make the best possible enlargements from each. Try the same with colour slide film. This time, use two projectors to compare pairs of results.

12

Black and white printing: facilities and equipment

Vital though the negative may be, it is the final print which people see. Your ability to produce first-class print quality is therefore of utmost importance: good prints cannot be made from poor negatives, but substandard prints are all too easily made from good negatives if you lack the essential skills.

This chapter is concerned with darkroom organization, enlargers and other equipment. It looks at the choice of printing materials, then discusses basic print-processing chemicals and procedures.

Darkroom organization

Film processing in small tanks can take place almost anywhere (provided you can initially load the tank in darkness). But, like deep tank processing, printing on a professional basis really calls for a permanent darkroom set-up.

There are four basic requirements for a darkroom: (1) it must be light-tight, (2) it needs electricity and water supplies, and waste outlet, (3) the room must have adequate ventilation, and a controllable air temperature, and (4) layout should be planned to allow safe working in a logical sequence, including easy access in and out. Requirements (3) and (4) are just as important as the other, more obvious, facilities. After all, you should be able to work comfortably for long periods, so shutting out light must not also mean shutting out air. If others are using the darkroom too, it is helpful if people can come and go without disrupting production.

General layout

Size naturally depends upon how many people use the room at one time, how long they need to be there, and the work being done. An 'all day' printing room for one person might be 20 cubic metres (70 cubic feet) e.g. $2.5 \times 3.2 \times 2.5$ m high, plus $4\,m^2$ of floor space per additional user.

The best entrance arrangement is a light-trap or labyrinth (Figure 12.2). This will prevent entry of light, provided it is properly designed and finished in matt black paint. It allows you free passage without having to open doors or pull aside curtains (both can become

Figure 12.1 A one-person general black and white darkroom, for small-format developing and printing. Note clear separation of 'wet' and 'dry' areas. Film and print drying take place elsewhere. D: developer. S: stopbath. F: fixer. W: wash

Figure 12.2 Various light-trapped darkroom entrances. A and B layouts are often the easiest way to adapt an existing doorway. C is a commercially made revolving shell you step into, then rotate it around you. Unlike the others, it does not promote ventilation. All labyrinths must have an internal matt black finish

contaminated and sources of chemical dust and fluff). It is especially useful if you are carrying trays, etc. Equally important, the light trap will freely pass air for ventilation. Elsewhere in the room you should have a light-proof air extractor fan, or better still an air conditioner. Ideally aim for a steady inside air temperature of 20°C (68°F). If you *have* to use a door instead, make sure there is a light-trapped air grill within it or somewhere in the wall nearby.

Inside, rigorously divide your space into 'wet' and 'dry' areas. The wet area should contain a PVC flat-bottomed photographic sink about 6 inches deep with integral splashback, and large enough to hold at least three of your largest print trays. Have one water outlet fed through a hot and cold mixer unit, and positioned sufficiently high for you to fill a bucket or tall container. This, and one or more cold-water outlets, can be threaded to firmly accept a hose coupling to a wash tank or tray. As Figure 12.1 shows, the sink might also have dish racks underneath, a shelf above for storage of small items, and a bench on one side with PVC draining top for larger containers of concentrated developer, fixer, etc.

Have your 'dry' bench on the opposite side of the room, far enough away to avoid splashes. Here it can accommodate enlarger, printing papers, negative file, etc., as well as allowing space for *loading* dry film tank reels. Fit closed storage cupboards below the bench. Have ample power points at bench height along this side for your equipment, plus a sealed outlet higher on the wall near the wet bench for an immersion heater or tempering unit. The latter should be controlled by ceiling-mounted pull switches – you must not be able to operate switches with wet hands.

For your working illumination, have one safelight no closer than its recommended distance (page 237) directly above the processing sink. Unless your room is quite small, have another safelight suspended centrally near the ceiling for general illumination (not too near the enlarger, or it becomes difficult to see projected images). If necessary install another small safelight illuminating a wall clock or process timer. Have all safelights controlled by one pull-switch near the door.

For white light, use a ceiling light bulb (not a fluorescent tube, which may glow faintly in the dark). Operate this from a wall-mounted pull-switch, its cord run *horizontally* along the length of the darkroom at above head height. Then you can reach and switch it on to check results wherever you may be standing in the room.

Choose a wall and ceiling finish inside the darkroom that is as pale as possible, preferably matt white. Provided your room is properly blacked out, generally reflective surroundings are helpful. Your safelight illumination will be more even, and working conditions less oppressive. But keep the wall around your enlarger matt black – like the room entrance, white light will be present here.

Dry benches can be topped with pale-toned laminate and the floor sealed with a seamless, chemical-resistant plastic material. Discourage dust and dirt from accumulating by having a flat surface to walls, with no unnecessary ledges or conduits. Bare cold-water pipes near the ceiling are often a menace, gathering a film of condensation which then drips on to work. Do your drying of pictures (film drying cabinet, print dryer) and the dissolving of any dry chemicals, plus all image-toning processes, out of the darkroom in some separate well-ventilated area.

Equipment: the enlarger

The enlarger is your most important piece of printing equipment. It is designed like a vertically mounted, low-power slide projector. A lamphouse at the top evenly rear-illuminates your negative, held flat in a slide-in carrier. An enlarging lens at an adjustable distance below the negative focuses a magnified image on to the baseboard of the enlarger, where the printing paper is held flat in an easel or masking frame. Sliding the whole enlarger head (Figure 12.3) up or down the supporting column alters the *size* of the image on the baseboard. Adjusting the distance between lens and negative alters *focus* (needed for every change of size). And changing lens aperture by *f*-stop intervals alters *image brightness*, just as it does in the camera.

When choosing an enlarger the issues you must decide are (1) the range of negative sizes it should accept, (2) the most appropriate lens, (3) the type of negative illumination, (4) the largest print size you will want to make, and (5) whether – perhaps at some future date – you may want to use it for colour as well as black and white printing.

Negative size

A 35 mm-only enlarger is small and cheaper than one of similar quality accommodating several negative sizes. If you also use rollfilm cameras or are likely to do so, get an enlarger for the biggest format and adapt it downwards for the others (you cannot adapt *upwards*). As well as interchangeable negative carriers you will need lenses of different focal

Figure 12.3 Enlarger: basic condenser type. Arrowed solid lines show the path of illuminating light through condensers and negative (N), directed into the lens. Broken lines denote light refracted by lens. Adjustment 1 shifts lens, to focus the image. 2 raises/lowers lamp relative to lens position, adjusting for evenness when needed. 3, movement of the whole enlarger head, alters image size

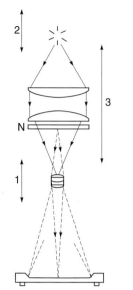

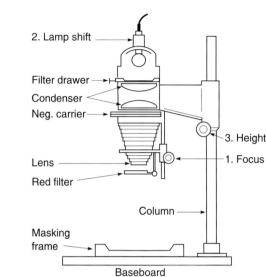

Figure 12.4 Diffuser type enlarger head (this one is also suitable for colour printing). Dials raise filters into the light beam. Light scrambler box scatters and diffuses the illumination to give even light and colour. Reflex layout makes it easier to cool the high-intensity lamp, and reduces headroom

Figure 12.5 Enlarger lens, f/2.8. A large aperture scale and 'click' stops make it easy to adjust in the darkroom. Your lens must be of high quality, otherwise all your work is affected

lengths to get a useful range of print sizes off each format, and if the enlarger has condenser lighting (see below) this requires adjusting too.

Enlargers for 4 × 5 in or 9 × 12 cm negatives are much more substantial. It is helpful to keep a separate enlarger for these large formats: many do adapt down for smaller films, but you will find it awkward to keep changing fitments when a mixture of negative sizes is being printed.

Lens

Enlargers normally come without a lens fitted, as you must choose from a variety of focal lengths and prices. Unlike lenses for cameras, an enlarger lens is designed to give its maximum resolution when the 'subject' (in this case the negative) is closer than the image. Typical focal lengths are 50 mm for 35 mm format negatives, 80 mm or 105 mm for rollfilm sizes, and 150 mm for 4 × 5 in. In effect, focal length is a compromise. If it is too long you will not start to get sufficient-size enlargements until the enlarger head is near the top of the column. Too short, and the lens has insufficient covering power (page 85) resulting in negatives appearing to have darkened corners (white on the print), especially at large magnifications. You will also find it is difficult to position the lens close enough to the negative; and when making small prints there is insufficient space below the lens to shade or print in; see page 247.

The wider the maximum aperture, often f/2.8 or f/4 for a 50 mm lens, the easier it will be to see and focus the image. However, prints will very rarely be *exposed* at this setting because exposure time is then inconveniently short; see page 246. Aperture settings are boldly marked for reading under darkroom conditions, and easily felt by 'click' settings at half-stop intervals. Always buy the best enlarger lens you can afford. False economy here can undermine the fine image qualities

given by *all* your camera lenses. Take care not to put fingermarks onto the front, lower, lens surface. And occasionally check the back, upper surface for any accumulated dust.

Illumination

Your film image, held in the negative carrier, must be evenly illuminated. Light from the lamp to the film either passes through a *diffuser* or a *condenser* system to achieve this. Many enlargers have a diffuser head which makes the negative appear as though lit by a lightbox or viewed against overcast sky. This soft light design lends itself to built-in colour filtering systems, so heads with dial-in filters for controlling variable contrast paper (page 236) or for colour printing are mainly of this type. The white plastic diffuser located a short distance above the film absorbs a lot of illumination, and to counteract this most enlargers use a bright, quartz-iodide light source. A heat filter and a lamphouse designed with 90° turn of light path prevent negative overheating.

A *condenser* head gives hard illumination. The lamphouse contains one or more simple but large condenser lenses (diameter exceeding negative diagonal) to gather diverging light from a tungsten lamp and direct it through the negative to focus into the enlarging lens itself. The negative appears to the lens as it would look to the eye if rear-illuminated by a spotlight, or direct sunlight.

This harsh direct light has the effect of making projected images slightly more contrasty than when given diffuse illumination. The contrast enhancement strengthens the appearance of fine detail, and also picks out grain more crisply. (It also shows up scratches and any other surface blemishes on the film.) Regular condenser lamphouse enlargers use an opal tungsten lamp, which one or a pair of glass condensers focus into the lens. The lens therefore sees the negative evenly lit. In a condenser head though you must be able to shift the lamp itself up or down a few inches, or add an extra condenser lens. This is to maintain even light whenever (a) you make an extreme change of print size, or (b) whenever you change lens focal length. (In each instance the negative-to-lens distance changes considerably.)

Both types of enlarger illumination have their virtues. Condenser systems give you a brighter image useful for big enlargements.

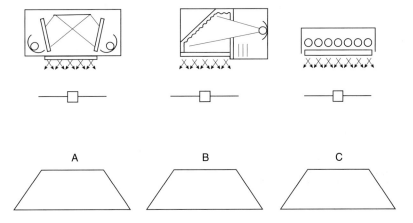

Figure 12.6 Interchangeable diffuser enlarger head designs. Near right: Dual-lamp system for variable contrast paper. Lamps are filtered yellow and magenta by adjustable amounts. (Relate to Figure 12.11.) Centre: Colour head, also suitable for VC paper. Far right: Cold light head. This contains a fluorescent tube and gives lowest image contrast

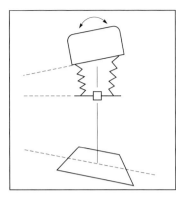

Figure 12.7 Some enlargers have tilting heads, to correct images with unwanted converging lines

Diffusers are best for damaged or contrasty negatives. On some models you can change one lamphouse unit for another. As discussed on page 213, it is best to process negatives to a contrast index which suits your particular enlarger. Then you can make fullest use of printing paper (page 232) to adjust contrast up or down to 'fine tune' individual pictures.

Print size – largest and smallest

Enlargers not only allow you to make prints much *bigger* than the negative, but *reduced* size 'thumbnails' too. The maximum size magnification you can get from your negative depends on the enlarger lens focal length, and the lens-to-paper distance the height of the column will allow. More precisely, magnification is:

lens-to-paper distance divided by focal length, minus one

For example, if your enlarger column can raise the lens 60 cm above the baseboard, you can make a 30 × 45 cm enlargement from a 6 × 9 cm negative (magnification of ×5) using a 100 mm lens. The taller the column, the bigger the enlargement possible, within the limits of your darkroom ceiling height. For still bigger enlargements the enlarger head may be designed to rotate through 90° so that it projects the image

Figure 12.8 The 'throws' necessary for a 35 mm enlarger (50 mm lens); and rollfilm enlarger (80 mm) to achieve various image magnifications. Most 35 mm standard column enlargers allow the lens to be raised at least 60–70 cm above baseboard

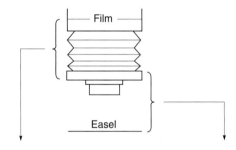

Focal length	Distance negative to lens	Magnification	Distance lens to paper
50 mm	6.6 cm	× 3.0	20 cm
	5.5 cm	× 10	55 cm
	5.25 cm	× 20	105 cm
80 mm	12 cm	× 2.0	24 cm
	10.4 cm	× 3.0	32 cm
	8.8 cm	× 10	88 cm

Reductions:

Focal length	Distance negative to lens	Magnification	Distance lens to paper
50 mm	10 cm	× 1.0	10 cm
	11.5 cm	× 0.75	8.6 cm
	15 cm	× 0.5	7.5 cm
80 mm	16 cm	× 1.0	16 cm
	18.6 cm	× 0.75	14 cm
	24 cm	× 0.5	12 cm

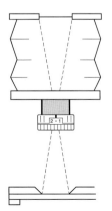

Figure 12.9 Enlargers may also allow you to make reduced size prints, provided the lens will move far enough from the negative, see lower half of table, right. If bellows are too short add a camera extension tube. Check that the image remains evenly illuminated

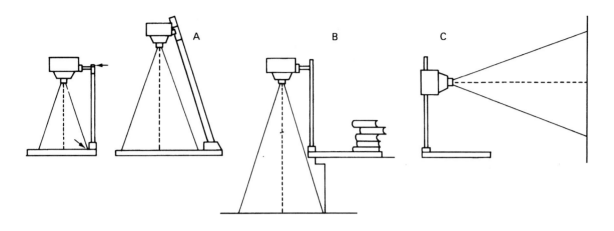

Figure 12.10 Making big enlargements: typical limiting factors are the height of column, and the column base fouling the image area (left). Solutions include (A) angled, extended column and larger baseboard; (B) turning the enlarger head to project from bench down on to the floor; or (C) rotating the head to project on to a distant wall

horizontally on to a distant wall. Some bench models turn to work vertically downwards onto the floor; see Figure 12.10.

At the other extreme, for prints smaller than the negative dimensions, you need to be able to lower the enlarger head and position the lens sufficiently far away from the negative; see Figure 12.9. If the bellows will not stretch this far, try fitting a camera-type lens extension ring.

Contrast control filters

In order to alter the contrast of variable contrast printing papers (page 236), all modern black and white enlargers offer some way of tinting the light. This can be a simple filter drawer between lamp and diffuser or condenser. You buy a set of six or more 'above-the-lens' acetate filters, Figure 12.12, to use in the drawer one at a time. Changing the filter colour changes the contrast characteristics of your printing paper. Alternatively you can clamp a filter holder below the lens and using a set of smaller *gelatin* filters alters the light at this point. (Filters must be the more expensive gelatin type, otherwise their use below-the-lens will upset image definition. You must keep these filters completely free of finger marks too.)

Figure 12.11 Alternative ways to control variable contrast printing paper. A: drawer for (acetate) filters between lamp and negative. B: holder on lens for (gelatin) filters. C: lamphouse with internal dial-in VC filtration system. D: Colour printing lamphouse (see Figure 12.22)

Far more convenient, a variable contrast lamphouse unit allows you to *continuously* vary filtration, just by turning a numbered dial which moves built-in filters in or out of the light beam above the negative. If you plan later to colour print, a colour lamphouse unit (with yellow, magenta and cyan dial-in filters) will also serve variable contrast

Figure 12.12 A simple set of acetate filters for a variable contrast paper, marked with contrast grade numbers

monochrome paper, although you may then have to adjust exposure time with each change of filtration; see page 247.

Other features

Red filter. It is very useful to have a swing-across red filter below the enlarger lens, see Figure 12.3. This will allow you to see the image projected on to the actual light-sensitive paper without actually exposing it – helpful when preparing to shade, print in, or make a black edge line (page 251). The filter is also an alternative means of starting and stopping exposure when you are shading or printing-in, provided you are careful not to jog the image.

Negative carrier. Most negative carriers are 'glassless' – holding the film flat between metal frames. You may occasionally need a glass carrier when enlarging a sandwich of two films, which might otherwise sag in the middle. However, sandwiching between glass creates problems because (a) you have four more surfaces to keep clean, and (b) when glass and film are not in perfectly even contact light-interference causes a faint pattern of concentric lines, called Newton's rings, to appear over the image. Other optional features include metal sliding masks within the negative carrier to block light from any rebate or part of the image you are cropping off (reduces potential flare).

Remote controls for head shift and focusing positioned at base-board level are a convenience; and an angled column (Figure 12.10) will avoid the column base fouling images when you make big prints. Enlarger movements (a pivoting head and lens panel) are helpful when you must alter image shape without losing all-over sharp focus. This will allow you to give some compensation for unwanted converging verticals due to shooting with a camera pointing slightly upwards. See also digital adjustment of perspective, page 287.

Enlarger care

Make sure that your enlarger does not shift its focus or head position, once set. The head must not wobble when at the top of its column, nor the lamphouse and negative overheat because of poor ventilation or use of the wrong voltage lamp. Regularly check that no debris has accumulated on top surfaces of condenser lenses or diffusing panel. (Both add shadowy patches to negative illumination, becoming more prominent in the projected image when you stop down the enlarging lens.) Dust, grease or scratches on enlarging lens surfaces, however slight, scatter light and degrade the tonal range of your prints. This shows mostly as dulled subject highlights, and shadows which print smudged and spread.

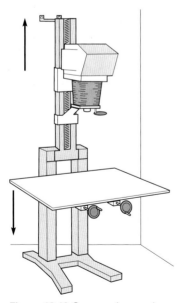

Figure 12.13 Some enlargers have their controls for focusing and raising/lowering located under the baseboard. This is especially useful with column extension units which allow the baseboard down to floor level. The enlarger column is bolted to the wall

Equipment: accessories

Items for the 'dry' bench

The enlarger is easiest to use with a timer, wired between the lamp and supply. This will also have a switch to keep the enlarger on for focusing. You must have a masking frame (or 'easel') for the

Figure 12.14 Accessories for the 'dry' bench. 1: focusing magnifier. 2: compressed air to remove any dust from film. 3: adjustable masking frame. 4: enlarger timer. 5: 'dodgers' for shading. 6: card with choice of various shaped apertures for 'printing-in'. 7: set of mounted gelatin lens filters for VC paper

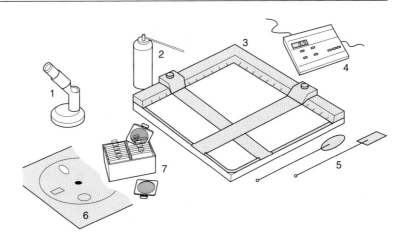

enlarger baseboard, with metal masks adjustable to the print size you need. The frame provides a white surface on which to focus the image, and a means of positioning and holding the paper flat during exposure, with edges protected from the light to form white borders. You will probably also need a focusing magnifier (or 'grain magnifier'). This allows a small part of the projected image to be reflected on to an internal focusing screen which you check through a magnifier (Figure 12.14). Remember that if you plan to use variable contrast paper with an enlarger not possessing a dial-in head, you will also need a set of filters. Other important accessories include tools for shading (page 248), a glass-top contact printing frame (page 244), and a can of compressed air or blower brush for removing any dust or hairs from film and glass surfaces. Some photographers consider an enlarging exposure meter (either an adapted hand meter or an 'on-easel' exposure analyser) an essential aid; see page 246.

Figure 12.15 Items for the 'wet' side of the darkroom. 1: Trays for solutions, including larger tray as water jacket. 2: graduate, and funnel. 3: Plastic tongs to gently grip a corner of your print when agitating or removing it. 4: Chemicals. 5: Dish thermometer. 6: Hose connector to tap, to dish wash prints (see also Figure 12.28). 7: Clock timer. 8: Heated panel, alternative to water-jacket. 9: Safelight for shelf above sink. 8 and 9 must be designed for safe use in wet surroundings

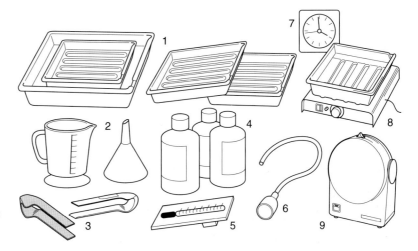

Items for the 'wet' bench

Have sufficient trays for developer, stop bath, and preferably two fixing baths. You will also want a wash tray or tank suitable for the papers you are using (resin-coated or fibre base). If it is difficult to maintain developer at working temperature, either use a larger tray to enclose your tray of developer and act as a water jacket, or use a dish heater, Figure 12.15. Have a large mixing graduate and containers of concentrated print developer, stop bath, acid fixer and hardener.

A dish thermometer is essential (preferably alcohol-type, for easy darkroom reading), as well as a wall-mounted clock with clear minute and second hands. Two pairs of plastic print tongs – each distinctly different for developer and fixer trays – will help keep your hands out of chemical solutions. Finally, don't forget a roller towel, and a waste bin you empty daily to avoid darkroom contamination from chemicals drying out of discarded prints. See processing procedure, page 238.

Printing papers

Black and white printing papers differ in their type of base, surface finish, size, image 'colour', and emulsion contrast (graded or variable). This offers you an enormous range of permutations, and has done much to keep monochrome photography going as a creative medium.

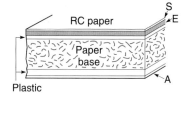

Figure 12.16 Cross-sections of RC and (single weight) fibre bromide papers. S: supercoat of clear gelatin. E: emulsion. B: whitening baryta coating. A: anti-static layer

Base type

There are two main kinds of paper base – resin-coated and fibre. This difference is more than cosmetic, because their processing and washing times, drying and mounting procedures are different. Resin-coated materials (known as 'RC', 'plastic' or 'PE') consist of paper, sealed front and back with waterproof polyethylene, then face-coated with emulsion and protective supercoat; see Figure 12.16. Because the base cannot absorb solution except along its edges, RC prints wash and dry in about one quarter the time required for fibre papers. When dry, prints do not curl, and have good dimensional stability. Like colour papers, which are all RC based, they are also well suited to machine processing (page 242).

The more traditional type of paper has an all-fibre base. It is first surface coated with a foundation of baryta (barium sulphate) as a whitening agent, followed by an emulsion layer and gelatin supercoat. The total processing cycle for fibre papers is almost an hour, and a glazer is necessary if you want to give glossy paper a highly glazed finish (Figure 12.29). However, final prints are less likely to crack and otherwise deteriorate, especially when displayed over long periods. Fibre prints are also easier to tone, hand-colour, mount and retouch.

In practice, the vast majority of amateur enlargements and commercial prints, especially long runs, are made on RC papers. RC is also convenient for contact prints. But for archival prints and exhibition quality images, fibre paper is still difficult to beat. A further influence is the silver-enriched thick emulsion papers, made only with fibre base, capable of outstanding tone range and aimed at the quality-at-all-cost fine art market.

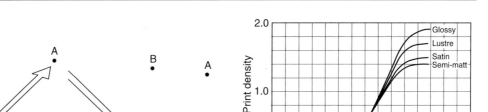

Figure 12.17 How paper surface affects the appearance of maximum black in a print. Left: although when seen from position A, gloss paper reflects a glare spot, from B and other positions black appears intense. Centre: matt paper scatters a little light in *all* directions – black looks less rich from every viewpoint. Right: paper characteristic curves show the surface effect on maximum possible print density. A typical negative prints with its subject shadow detail more compressed on matt than glossy

Thickness and tint

Regular fibre-base papers are made in single weight (about the thickness of this page) and double weight. Single weight is cheaper, but easily creases during processing if used for prints larger than about 12×10 in. A few special-purpose papers are made on lightweight, 'document' thickness base or premium-weight (300 gsm) art paper similar to postcard. RC paper is mostly made in so-called medium weight, just slightly thinner than double weight.

At one time, many papers could be bought with a cream or an ivory tinted base instead of white, but with the exception of products such as Kentmere Art Classic, these have tended to go out of favour because they limit the tone range of image highlights. In fact, white bases often incorporate 'optical brighteners' which glow slightly under fluorescent or daylight illumination and so further extend image tone range. See also pre-coloured special effects papers, page 255.

Surface finish, size

You have a choice of surface finishes ranging from dead matt, through what are variously called semi-matt, satin, lustre or pearl, to glossy. Simple warm air drying gives RC glossy paper a shiny finish whereas *fibre-base* glossy dries with a semi-matt surface unless it is put through a glazer after washing.

The combination of base brilliance and surface texture has great influence on the maximum white and black the paper offers you. As Figure 12.17 shows, glossy finish produces richest blacks, when lit correctly. Matt cannot give much beyond a dark grey – which may suit moody, atmospheric pictures. Both papers, however, appear with similarly deep blacks when they are compared wet, so be prepared for changes when prints made on matt paper are dried. Photographs for reproduction should be made on white glossy paper (glazed or unglazed), *never* on paper with an assertive surface pattern which interferes with the mechanical screen used in ink printing processes; see *Advanced Photography*.

Figure 12.18 shows the most common printing paper cut sizes. Some papers are also sold in rolls, with widths ranging from 8.9 to 127 cm. As you can see, some larger sheets can be cut down to give exact numbers of a smaller standard size – one reason for keeping a trimmer in your darkroom. Paper is marketed in 10 or 25 sheet packets and (smaller sizes) boxes of 50 or 100.

5 × 7 in	12.7 × 17.8 cm
7 × 9.5 in	17.8 × 24 cm
8 × 10 in	20.3 × 25.4 cm
9.5 × 12 in	24 × 30.5 cm
11 × 14 in*	27.9 × 35.6 cm
12 × 16 in	30.5 × 40.6 cm
16 × 20 in†	40.6 × 50.8 cm
20 × 24 in‡	50.8 × 61 cm

* Gives four 5 × 7 in
† Gives four 8 × 10 in
‡ Gives six 8 × 10 in

Figure 12.18 Standard dimensions of black and white printing paper

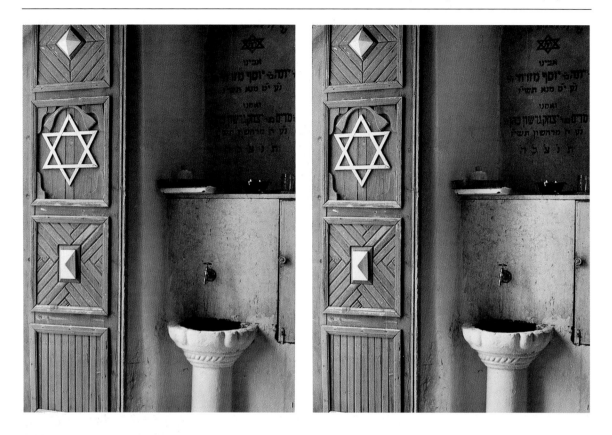

Figure 12.19 Monochrome image 'colour'. Left: a print on bromide paper. Right: the same negative printed on warm-tone (chlorobromide) paper and processed in warm-tone print developer

Image 'colour'

Most printing papers have an emulsion containing a mixture of silver bromide and silver chloride light-sensitive halides. Those with a high silver bromide content (*bromide* papers) give 'cold' tones, neutral black in colour, in the recommended developer. Papers with more silver chloride than bromide (*chlorobromide*) and/or use crystal structuring give a 'warmer', slightly browner, black. The warmth of tone is responsive to your choice of print developer, see page 238. The silver chloride content is slower in speed than bromide, and also develops slightly faster – so your chosen length of development makes a big difference to 'colour' too.

Choosing between bromide or chlorobromide paper depends mostly on subject and personal preference. The warmer tones of chlorobromide (Figure 12.19) suits landscapes and portraits, and is popular for exhibition work. But it is unsuitable in pictures for regular monochrome reproduction, because printers' standard black ink will lose the subtleties of warm tone unless printed by four-colour.

Contrast

You can control the contrast of your prints by purchasing different boxes of *graded* papers – grade 1 (soft), grade 2 (normal), grade 3 (hard), etc., or use just one box of *variable-contrast* paper and achieve similar changes by filtering the colour of your enlarger light.

Figure 12.20 Contrast. The same (normal contrast) negative printed on four different contrast grades of the same paper. Clockwise from top left: Grade 1 (soft), grade 2 (normal), grade 3 (hard) and grade 4 (extra hard). Hardest paper gives fewest grey tones between white and maximum black. Grade 1 does not reach maximum black before whites begin to grey with this image – it suits much more contrasty negatives. Variable-contrast paper gives similar results by change of colour filters

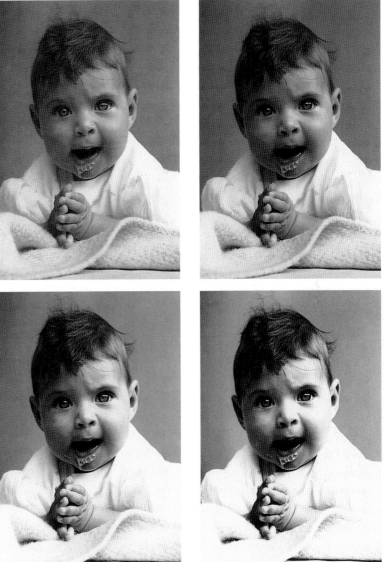

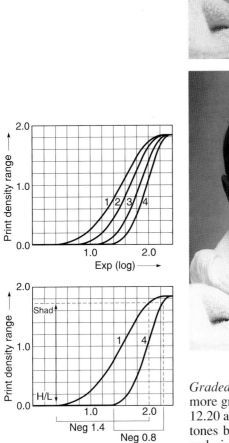

Figure 12.21 Top: the response of four grades of one manufacturer's bromide paper expressed as characteristic curves. Bottom: a relatively contrasty negative (1.4 density range) printed by diffuser enlarger on grade 1 paper gives a similar result to a lower contrast 0.8 negative on grade 4

Graded papers. With fixed graded papers the lower the number the more greys it can form between maximum black and white. As Figures 12.20 and 12.21 show, soft grades form a relatively gentle 'staircase' of tones between these extremes, whereas hard grades rise more steeply and give a harsher and more abrupt range of greys.

Basically, this choice of contrast allows you to compensate for contrasty, or flat, negatives. For example, a fairly harsh continuous-tone negative gives results printed on grade 1 similar to a softer negative printed on grade 4. In practice, choice of grade depends on many factors – type of subject, enlarger illumination, the visual effect you want to achieve, how the picture will be used, and so on. Often by exaggerating contrast beyond how your subject actually *looked*, you can strengthen a bold design.

Figure 12.22 How filters control variable contrast printing paper. Different proportions of the high- and low-contrast emulsions present in VC paper are used according to your chosen colour filtration. Increasingly deep purple or magenta filters absorb more of the green content of the light and so make the paper become more contrasty. Increasing yellow suppresses blue and gives the opposite effect. See Figure 12.12. Durst numbers suggest settings when using a colour head enlarger – combining two filters here keeps the light output the same so that the exposure time remains constant

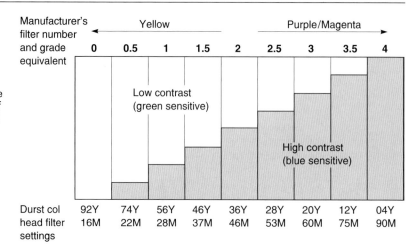

Manufacturer's filter number and grade equivalent	0	0.5	1	1.5	2	2.5	3	3.5	4
Durst col head filter settings	92Y 16M	74Y 22M	56Y 28M	46Y 37M	36Y 46M	28Y 53M	20Y 60M	12Y 75M	04Y 90M

Bear in mind that the degree of contrast related to grade number – 1, 2, 3, etc. – is not absolutely consistent between one manufacturer and another. Also some papers are made in one or two grades only; others (white smooth glossy, for example) come in six grades.

Variable-contrast papers. These are known as Multigrade, Polymax, or just VC, according to brand. Variable contrast papers carry no grade number. They work by having a mixture of *two* emulsions. For example, one is contrasty and sensitive only to blue light. The other is low-contrast and sensitized towards the green region of the spectrum. So you can use one of a range of filters from deep yellow (gives grade 0) to deep magenta (gives grade 5) in the enlarger light-path to achieve the contrast you want. Without any filter at all the paper prints as grade 2. If your enlarger has a colour printing head, you can dial in appropriate filters here. See settings, Figure 12.22. With enlargers fitted with special heads for variable-contrast paper you select grade numbers on a dial or baseboard keypad to adjust filtered light beams automatically.

Variable-contrast paper offers you the advantage of not needing to keep an expensive stock of grades as well as different sizes. With a good filtering system you can get the equivalent of five different grades (plus half-grades). Uniquely too, it also allows you to *vary* contrast across a print, by exposing one area of the image at one grade setting and the rest at a different setting. See shading, page 254.

Choosing a printing paper

All these combinations of features – resin or fibre base; surface; contrast; image colour – are confusing at first. You seem to be spoilt for choice. But when you visit a big photo store or check out the catalogues it's clear that not all papers are available in all forms. Most papers are made with a white base, glossy or pearl (semi-matt) surface and give a predominantly neutral colour image. If you are a newcomer to monochrome printing it is easiest to learn first with graded paper; next graduate to a variable contrast type, and then explore warm-tone papers.

Safelighting and printing paper sensitivity

Darkroom safelighting should be as visually bright and easy to work under as possible, without of course fogging your paper. The colour filter screening the light bulb or fluorescent tube must pass only wavelengths to which the material is insensitive (Figure 12.24). However, no filter dyes are perfect, and if the safelight is *too close*, or contains a light source *too bright*, or is allowed to shine on the emulsion *too long*, fogging will still occur. See testing project, page 243. Follow the distance, wattage, and maximum safe duration recommendations for your particular safelight unit.

Regular bromide, chlorobromide and multigrade papers are safe under a 'light amber' safelight, such as Kodak 0C. Some materials such as lith paper have orthochromatic sensitivity however, to improve otherwise extremely slow speed. They therefore need *deep red* coloured safelighting as required for ortho films. As Figure 12.24 shows, you can use the same deep red safelight for regular papers, but not the reverse.

Figure 12.23 Panchromatic printing paper. The colour negative (centre) shown as printed on regular black and white bromide paper (left) and (far right) on pan bromide paper. The panchromatic bromide paper gives more accurate grey-tone representation of colours. (For positive colour image see page 162)

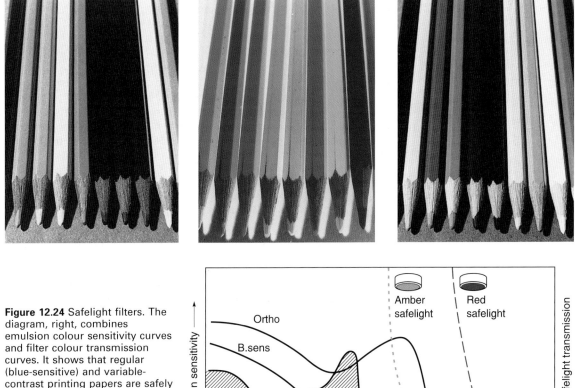

Figure 12.24 Safelight filters. The diagram, right, combines emulsion colour sensitivity curves and filter colour transmission curves. It shows that regular (blue-sensitive) and variable-contrast printing papers are safely handled under 'light amber' safelighting. But notice from curve overlap that ortho printing materials, such as lith paper or film, would fog to amber, so they require deep red safelighting instead. Red is also safe for the other two materials, but unnecessarily dark

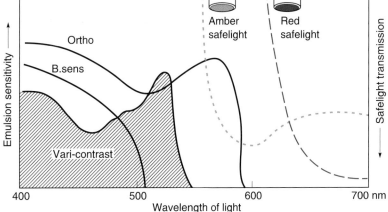

There are also a few *panchromatic* printing papers such as Kodak Panalure, designed to give correct tonal response to subject colours when you make black and white prints from colour negatives. Such negatives printed on to regular blue-only sensitive bromide paper make subject reds and yellows too dark, blues too light. In other words, results are like a black and white photograph taken through a blue filter. (Other panchromatic papers are chromogenic types – designed for processing in RA-4 colour paper chemicals in order to suit colour lab print processing machines.)

Panchromatic paper can be handled under a deep green pan film safelight, or is safe under dark amber Kodak 13 safelighting because of its slow speed. Safest of all, work in total darkness (remembering to have an audio timer for processing). Always check the label on any unfamiliar photographic paper for the safelight colour you must use, the recommended minimum distance and the specified lamp wattage.

Processing procedure

The facilities on the *wet* side of your darkroom come into play each time you remove an exposed sheet of paper (Chapter 13) from the enlarger baseboard. Processing monochrome paper follows the sequence develop-stop-fix-wash similar to processing film, but with two important differences. Firstly, because you are using open dishes under safelighting *you can watch the image gradually developing up on the paper*. This is a fascinating, truly magical, aspect of photography. Secondly, each chemical stage of processing is briefer than the time needed for film; see Figure 12.26.

Developing prints

The most commonly used print developers are Phenidone based (e.g. Ilford PQ) similar to regular film developer, page 211, although in a more concentrated form. (Some 'universal' developers serve both film and paper functions, given different dilutions.) Unlike the development of negatives, however, it is important to produce an acceptable image *colour*, along with good tone values, rich black and clean white. Graininess is not a consideration – paper is so slow and fine-grained that any graininess seen in prints is the enlarged structure of the negative, although often emphasized if printed on contrasty glossy paper.

Developers formulated for use with *bromide* papers tend to be energetic, and give a good neutral black provided you fully develop. A range of 'restrained' developers are made for *chlorobromide* papers, giving different degrees of warm tone according to formula. See Figure

Figure 12.25 Final image colour depends on your choice of print developer as well as type of paper

	Image colour	On chlorobromide	On bromide
Warm ↑	Brown-black	Agfa Neutol WA Tetenal Variospeed W	
	Neutral brown	Neutraltyp, Neutol NE	
	Neutral black	Kodak Dektol, Neutol BL	Dektol, Ilford PQ Universal
↓ *Cold*	Blue-black		Neutol BL, Ilfospeed

	Developer (20°C)	Stop bath (18–21°C)	Fix (1) (18–24°C)	Fix (2) (18–24°C)	Optional holding bath	Hypo-clear (18–24°C)	Wash (1) (Not below 10°C)	Wash (2) (Not below 10°C)	Total
RC	1 min	5 seconds	1 min	1 min	As needed		2 min	2 min	7–8 min
Fibre	1½ min	5 seconds	4 min	4 min	As needed		15 min (40 min D/W)	15 min	40–50 min
					or	2 min	5 min (12 min D/W)	5 min	22–24 min

Figure 12.26 Processing sequence for prints using trays. The times given are typical, but you should refer to detailed instructions for each processing solution. The 'holding bath' is a rinse tray, used to accumulate prints during a printing session into batches for washing. Times for fibre papers assume single weight unless shown D/W

12.25. It is important that you fully develop prints, at correct temperature. Aim to standardize this aspect of printing – having chosen the paper and developer, do all your controls through exposure manipulation and (variable contrast materials) filtration of the enlarger.

Dilute an ample amount of developer from stock solution for your printing session and discard it at the end. Take care not to exceed the maximum number of prints your volume of developer or fixer can handle, Figure 12.27. Work with a tray of developer slightly larger than your paper size, and first slide the exposed print under the solution emulsion up, or place it face down in solution and immediately turn it over. Commence rocking the tray gently – for example, by raising each side in turn about 1 cm and lowering it smoothly. Continue this throughout the development period, then lift the sheet, drain for 2–3 seconds and transfer it to the next solution.

If you want to develop several sheets at once, first ensure you have an ample volume of developer solution. Immerse prints at regular intervals, then draw out the sheet at the bottom of the stack and place it on top. Continue this, leafing through the pile continuously (this substitutes for rocking) until development time is up. Then transfer them in the same order to the next bath. To avoid contamination, pick them from the developer with one hand and immerse them in the next tray with the other.

Stop bath and fixing

The solution filling the second tray should be stop bath or, last resort, running water. It has the same development-halting function as with films. If possible use a stop bath containing indicator dye – this changes the solution colour to warn you when it is nearing exhaustion. Next, the paper must be fixed to make remaining halides soluble and so form a permanent image. Unlike film fixing you cannot easily see the creamy halides disappearing from the white paper base, so it is important to adopt an efficient routine. Use an acid hardening fixer, either normal (containing sodium thiosulphate) or rapid (ammonium thiosulphate), diluted to print strength. This can be a single bath which you monitor and discard after, say, 25 prints, 10 × 8 in, per litre. Better still, have two-bath fixing, giving half the recommended fixing time in each. The second bath, which should be fresh solution, is used successively to replace the first bath each time this becomes exhausted and is discarded.

Make sure your prints are agitated from time to time in the fixer. Don't let them float to the surface. It also helps fixing if you keep the paper face down. Acceptable limits for accumulation of silver salts in the fixer are

Dev.	Stop bath	Fixer
Dektol	*with*	*regular*
(1 + 2)	*indicator*	*1 + 7*
		or rapid

Throughput:

30*	Until colour change	26*

Keeping properties without use:

(full container, stock)

10 months	indefinitely	2 months

(working sol. in dish)

24 hours	3 days	7 days

* Number of 10 × 8 in sheets per litre

Figure 12.27 Typical working life of some black and white print processing solutions

much lower for papers than for films. So avoid solution that has been used for film fixing – it may still work on films and seem to fix prints too, but has such a concentration of silver complexes that compounds are formed in the paper emulsion that cannot be removed during washing. Don't overfix, either. Rapid fixer, in particular, can begin to bleach image highlight detail, and with fibre papers sulphur by-products can bond themselves into the base. From here they will not wash out, and start to attack the silver image perhaps months or years later.

Time and temperature

Typical times and temperature tolerances for dish processing are shown in Figure 12.26. Notice the timing difference between RC and fibre papers. Most RC papers incorporate developing agent in the emulsion – inert, but activated when placed in the regular developer solution. Here it is immediately able to start acting on exposed halides, so this arrangement shortens the period needed for development to about 45–60 seconds, making such papers suitable for machine processing (page 242). With all RC papers, the stages following development are shorter too. The emulsion absorbs new solutions quickly as the plastic base carries over so little of the previous chemical.

Only when you have sufficient experience in judging the image under safelighting can you begin to develop 'by inspection', and so make *slight* corrections for exposure by adjusting the development time within acceptable limits (±30 per cent at most). This is really practical only with those fibre and RC papers offering longer developing times. Insufficient development gives you grey, degraded blacks; over-development also begins to lower contrast with papers incorporating developing agent. So it is in your best interests to try to work strictly to the recommended time and temperature.

Washing prints

RC paper needs a relatively short period of washing, provided it is efficient. Remember that sheets are plastic, so you simply need to keep a flow of water over the emulsion surface. A shallow flow tray, or a wash tank fitted with a print rack (Figure 12.28), will complete washing in about 3 minutes. If prints are just left in running water in an ordinary tray or sink for 3–4 minutes make sure they are agitated, not allowed to clump together.

When washing fibre paper however you must allow time to let by-products soak out of the porous base as well. It will help greatly if you first place prints in hypo clearing agent (typically 2 minutes treatment) prior to washing. This agent causes an 'ion exchange' helping to displace the fixer more readily from all layers of the material. The best wash arrangements are either soak-and-dump, using a siphon to completely empty a dish or sink at regular intervals, or some form of cascade system. Typical wash time is 30 minutes for single weight, 40 minutes for double weight. This can be reduced to one-third or less if hypo clearing has been used. See also archival print processing, page 294.

Wash water temperature is not critical, preferably 10–30°C for RC paper, 18–24°C for fibre type. Excessive soaking – say several hours at 24°C, or overnight at any temperature – may cause emulsion to start

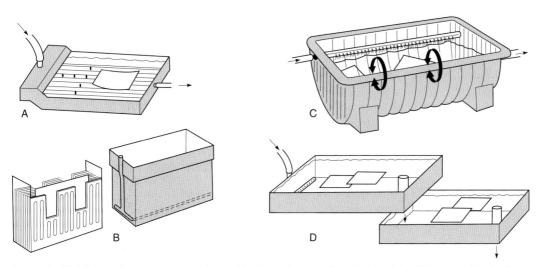

Figure 12.28 Print washing equipment. A: small volume tray washer designed for RC papers. B: plastic rack and wash tank for RC. C: tank for fibre base papers. This uses water flow to keep prints apart. D: cascade system. Newly processed prints go into the lower sink, are later transferred to the upper sink for the second half of their wash period. The tube pushed into each waste outlet maintains solution level. C and D suit both types of paper

parting company with the base. It may even begin gelatin disintegration, especially if you used a non-hardening fixer.

Drying

Figure 12.29 Print drying. A: Fan assisted warm air dryer, for up to two RC prints at a time. B: Fast, hot-air dryer for RC paper only; print must be inserted covered by a film of water, direct from tray. C: Ambient air-drying, using muslin racks or line pegging (D). E: flat bed heated dryer, with glazing sheet for fibre base glossy paper

Your print drying method is important because it has to give a flat, unbuckled finish; it can also affect print *surface*. The simplest but slowest technique is ambient air-drying. You must first remove surplus water from back and front print surfaces with a rubber squeegee. Then leave prints on absorbent material such as cheesecloth or photographic blotting paper, face up for RC paper, face down (to reduce curl) for hardener-treated fibre prints. Or you can peg them on a line with plastic

clothes pegs at top and bottom – fibre prints in pairs back-to-back, RC prints singly. Drying may take several hours at room temperature.

To speed up the drying of RC prints, use a heated air drying unit, Figure 12.29, or blow them over with a hair dryer (temperature not exceeding 85°C). Better still, pass the *thoroughly wetted* prints through a roller-transport hot air RC dryer, designed to deliver dry prints in about 10 seconds.

For fast drying of fibre prints, have a flat-bed glazer/dryer, which uses tensioned canvas to press the paper against a heated metal surface. Placing the back of the print towards the heat gives a final picture surface similar to air drying. To get a shiny finish with glossy fibre paper, you squeegee it face down on to a polished chrome glazing sheet, so the gelatin supercoat sets with a matching mirror-like finish when dry. Unless this is done, glossy fibre papers will dry semi-matt. You can at any time remove the glaze from fibre paper by thoroughly resoaking the print and then drying it faced the other way. (Avoid hot-glazing other fibre paper surfaces, *and RC prints of any kind*. The former take on ugly patches of semi-gloss, the latter will melt at 90°C or over and adhere firmly to the metal and canvas.)

Manufacturers of premium fine-art fibre papers recommend air drying unless you are glazing glossy. The fact is, anything touching the emulsion during drying is a potential source of damage. There is always a risk, when using a glazer for other fibre paper surfaces, that the canvas will either mark the final emulsion finish, or chemicals previously absorbed from drying insufficiently washed prints will transfer into your print. However, this is still the best drying method for thin-base prints, which tend to curl badly if air-dried instead.

Machine processing

Resin-coated papers lend themselves to automatic machine processing. Units are often bench or floor standing within the darkroom, Figure 12.30. You feed your exposed print in through motorized rollers and the equipment feeds them through tanks of regular developer, rinse, fixer, and wash; then passes them directly through an RC paper dryer. Such machines are expensive but produce a fully processed dry print in about 2 minutes – or up to 450 prints, 10×8 in size, every hour.

A processing machine can be economically justified when there are several people working on enlargers in a constantly used darkroom – it effectively does away with the wet bench. Without sufficient through-put however the transport system and stored chemicals may deteriorate, resulting in faulty prints.

Figure 12.30 Black and white print processing machine. A roller-transport unit that delivers washed, dried RC prints. Exposed prints are fed in at the front, delivered back onto top of machine. This unit is located wholly in the darkroom

Summary. Black and white printing: facilities and equipment

- A printing darkroom must be of adequate size, light-tight but ventilated, stable in temperature, away from dust and pollution, allowing easy access, and serviced by electricity and hot and cold water.
- Divide darkroom layout into wet and dry areas. Consider chemical and electrical safety carefully, Appendix E. Have the room well illuminated by safelighting, with walls mostly light toned. Avoid ledges, pipes, etc., which encourage dust and condensation.

- Enlarger choice factors: negative size(s), type of illumination, lens, and maximum print size. Condenser illumination enhances image contrast, grain and detail, but picks out any negative blemishes. Be prepared to adjust condensers for a lens change, and extreme changes of image size. Process negatives to best suit your enlarger's illumination system.
- To calculate the image magnification an enlarger will give, divide the lens-to-paper distance by focal length, then subtract one.
- RC and fibre papers differ in the times required for processing, washing, drying; also in drying treatment, dimensional stability and archival permanence. Fibre papers include silver-enriched emulsions and premium weight base.
- Other printing paper variables: tint, surface, size, neutral or warm-tone emulsion, contrast (graded or variable). Safelights must be appropriate colour, wattage, distance. Even then, don't exceed maximum safe exposure time.
- Choose a developer remembering image colour – particularly with chlorobromide papers. Aim to standardize your development time and temperature. Use a stop bath, then acid hardener fixer. Don't use exhausted fix or fixer used for negatives. Avoid overfixing too.
- Have a wash system that efficiently removes soluble salts. Fibre papers are helped by a hypo clearing stage. Dry RC prints by heated air dryer, or natural air. For fibre prints either heat-dry (essential if glazing), or hang up thicker papers to air dry.

Projects

1 Find out the range of print sizes you can make. Physically check the upper and lower limits of image magnification your lens(es) and enlarger design allow, while still maintaining an evenly illuminated negative. Remember the use of extension tubes.

2 Test your darkroom safelight. Set up a typical negative in the enlarger (preferably including some pale tones, such as grey sky). With safelights on, make a correctly exposed print, including masked white borders, and tray-process it normally. Call this print A. Next expose and process another print exactly the same way but with the safelight *off*. Call this B.

 Now expose a further print, without the safelight on. Before processing, position it emulsion-up on a large card placed on top of the developer tray. Cover 25 per cent of the print with opaque card and switch on the safelight. After 1 minute cover 50 per cent, after 2 minutes 75 per cent, then leave the final 25 per cent a further 4 minutes before switching the safelight off again. (This gives you tests of 0, 1, 3 and 7 minutes respectively). Call this print C and process it in darkness, the same way as print B.

 Wash and dry your prints and analyse results. If all three prints are identical your safelight conditions are safe. If A shows lower contrast, or greying highlights or borders relative to B, you have serious fogging. Confirm safelight colour, check for bleaching or light leaks, and reduce intensity or increase distance. If C shows highlight degradation in any of the fogging test strips it carries, remember to avoid exposing paper for this long. If such a period is too short to be acceptable, take corrective measures. Finally test again.

13

Black and white printing: techniques

With well-organized facilities and a basic understanding of darkroom materials and procedures you can now get down to printing your work. The most important aspects of learning to print are (a) being able to distinguish really first-class print quality from the merely adequate, and (b) mastering the skills to control your results fully. Other requirements, such as speed and economy, will come with experience – but unless you have standards to strive for and the knowledge of how to achieve them, you will too easily accept second best. This chapter concentrates on the basic controls possible in making prints by silver halide means. It also looks at some chemical methods of altering your final result.

Making contact prints

Try to produce contact prints – negative size prints made by having the film in direct contact with the paper – from all your new negatives as soon as they are processed. Then you can safely file away the films, and just handle the paper sheets to pick and choose which shots to enlarge, mark up possible cropping, etc. To make contact prints, use the enlarging equipment described in Chapter 12, plus a contact-printing frame (Figure 13.1) or at least a 10 × 8 in sheet of clear plate glass. Set up the empty enlarger so it projects an even patch of light on the baseboard slightly larger than your paper. Reduce the lens aperture about two stops and (assuming you are not using panchromatic paper) set the red swing-over filter in the light beam.

Switch off white room lights. Place a sheet of grade 1 or 2 paper, or variable-contrast equivalent, emulsion upwards within the projected patch of red light. Lay out the negatives emulsion downwards, on top, pressed down by the glass. If you use a contact frame, you can first slip negatives into thin transparent guides on the underside of the glass. This is especially helpful when printing more than one contact sheet off a film, or working in the dark using pan paper.

Exposure varies according to the intensity of your light patch, and negative densities. As a guide, having switched off the enlarger and swung back the filter, use your timer to bracket trial exposures around 10 seconds. (Give different parts of the sheet 5, 10 and 20 seconds as

Figure 13.1 Contact-printing equipment. Top and centre: contact print units for 35 mm and 120 rollfilm strips of negatives. Strips slip into thin transparent guides on the underside of the glass. Bottom: basic arrangement using plate glass

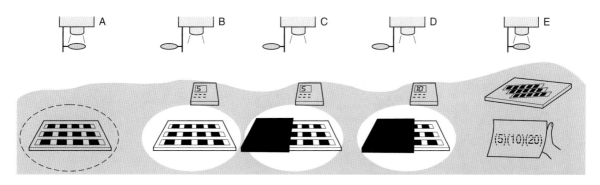

Figure 13.2 Above and right: Test-exposing a contact sheet. (A) use the red filter to help pre-position glass and paper within the light patch. By covering one-third of the paper after 5 seconds (C), then two-thirds after a further 5 seconds (D), and giving a final 10 seconds, bands receive 5, 10 and 20 seconds exposure

shown in Figure 13.2.) Remove and process the paper, waiting until it has reached and remained in the fixer for at least 1 minute before you view results in white light.

Rinse the contact sheet and hold it out of the solution; prints look deceptively pale under water. They also darken slightly when dried. The darkest band of density on your print received the longest exposure time. If results prove you were wildly out in guessing exposure, a further bracketed test may be required. But the chances are that you can

Figure 13.3 The final sheet of contact prints. This one was given 10 seconds overall

now decide from the most promising band of density what exposure will be correct for your next and final contact sheet.

Of course, if the set of negatives you are printing vary greatly in density, the correct contact-sheet exposure will have to be a compromise between darkest and lightest frames. Variations will be less if you use soft rather than hard contrast paper. It is important that contacts show the detailed picture content of every frame, even if their print quality has to look rather flat at this stage. You can also help matters by 'shading' or 'printing-in' individual frames which otherwise print much darker or lighter than the majority (page 248). Make sure the finished contact sheet carries your film's reference number, perhaps written on the back of the paper.

'Straight' enlarging

Decide the shot you want to enlarge, based on composition, sharpness, expression, action, etc., selected from the contact sheet. If there are several near-identical frames which differ mostly in density, pick out all these negatives. Then decide from the technical quality of each one which negative will print best. Check sharpness, and look especially to see that there is sufficient detail present in important highlight and shadow areas. Ensure that both surfaces of the film are free of marks or debris before inserting it into the negative carrier, emulsion downwards.

Adjust the masking frame to your paper size, allowing for any white borders. Then switch off the darkroom's white lighting, switch the enlarger on and open the lens to full aperture. Raise or lower the enlarger head until the wanted part of the projected image fills the masking frame area, focusing the image and if necessary readjusting height until composition is correct. (Never focus with a thick red filter over the lens – it will alter the focus setting, and when removed the image may be unsharp.) At this point, if you have a condenser enlarger, you could remove the carrier and check the projected light patch for evenness. Adjust lamp or condensers as necessary.

Next, stop down the lens two or three *f*-settings – more if the negative is rather thin. The reasons for stopping down are (1) to give a conveniently long exposure time (10 seconds or so, for example, gives you more time to locally shade exposure – see below – than something as short as perhaps 1 or 2 seconds), (2) to get peak image performance from the lens, and (3) to compensate for any slight focusing error, by extending depth of focus.

Look carefully at the image on the easel, and decide the most likely paper grade. If you have an enlarging exposure meter calibrated for your enlarger and developer, set this for the paper or filter in use. Take a spot reading from part of the image you expect to print mid-grey, and read off the time needed. But even if you use a meter, print results are so subject to final visual judgement that it is still helpful to make a bracketed series of test strips. This is why many black and white printers consider that metering is just time-consuming. With experience, it is possible to look and guess test exposures closely enough.

Use the metered or guessed time as the centre point of a geometric range of exposures on a half sheet of paper (Figure 13.5). Think carefully how to position these strips – for greatest information, each one should include both darkest and lightest parts of the image. After

Figure 13.4 Spot measurement of exposure from an area chosen to print mid-grey, using an enlarging meter with a probe. The meter will have been calibrated from previous tests using your equipment and materials

Figure 13.5 Test-exposing an enlargement. By holding an opaque card stationary in the light beam, different areas of a half sheet of printing paper can be given a range of exposure times

exposure and processing, judge the best strip, looking especially at key areas such as flesh tone in a portrait, and checking how much detail (present in the negative) has printed in shadows and highlights. If the best strip looks too harsh or too flat, change to a different paper grade – or with variable-contrast paper alter the filtration. Adjust exposure for this change if necessary and test again. Should exposure time now become awkwardly short or long, alter the lens aperture: opening it one stop allows time to be halved, closing it one stop allows it to be doubled. (Aperture has no effect on contrast.) Finally take a full sheet of paper, position it under the enlarging easel masks and give the exposure time you consider correct.

Controls during enlarging

Local control of exposure

A single 'straight' printing exposure often fails to suit every part of the picture. The reason may be that the negative density range, while well matched to the paper for most subject tones, exceeds it at one extreme or the other. Perhaps a patch of shadow becomes solid black or highlight detail looks 'burnt out', when midtones are correct for density and contrast. Perhaps subject lighting was uneven, or you simply want to darken and merge some parts of a composition in order to emphasize others. In fact there is hardly a picture that cannot be improved in some way during printing by locally reducing exposure (known as 'shading', 'holding back' or 'dodging') or extending it ('printing-in' or 'burning-in').

To *lighten* part of the picture insert your hand, or red acetate or opaque card, into the light beam during part of the exposure. Have your shading device about halfway between lens and paper, and unless you are shading up to a hard edge, such as a horizon or the side of a

Figure 13.6 Always position exposure test bands across an enlargement so that each one includes both light and dark parts of the image, as here. If these three bands had been run vertically instead, two would have shown information about sky and foreground only

A B C D

Figure 13.7 Shading and printing-in. Large areas at one side of the picture are conveniently shaded with the edge of your hand (A). To make isolated 'island' areas lighter, shade with a 'dodger' (B) made from card and attached to thin flower wire. To darken isolated areas, print-in through a hole in opaque card (C) or form a shape between cupped hands (D)

building, soften the shadow edge by keeping it slightly on the move. To *darken* a chosen area, follow up the main exposure with an additional period when you print-in using a hole in a card, or the gap between your cupped hands; see Figure 13.7. Feather the edge of your exposure-controlled area in the same way as for shading.

To decide how long to shade or print-in, make the best possible straight print first. Then, with the aid of the red filter, place pieces of printing paper across excessively dark or light image areas and make test-strip exposures at shorter and longer exposure times respectively. If necessary sketch out a shading 'map' (Figure 13.9). This will remind you where and by how much you must shade during your main exposure, and the same for extra exposure afterwards. The harder the contrast of your paper, the greater these exposure differences will have to be. If burning-in will take an unacceptably long time, you can halve it by carefully opening the lens one stop after the main exposure, provided you do not shift lens or paper. Just remember to stop down again before exposing the next print.

Sometimes an area being heavily printed-in to black contains some small highlights which still appear as grey shapes, no matter how much additional exposure you seem to give. The best solution then may be to fog over these parts. Either print-in with the enlarger turned out of focus, or fog using a small battery torch fitted with a narrow cowl of black paper (Figure 13.10). Keep the enlarger on, red-filtered, to show you the exact image areas you are treating with white torch light.

Local control of contrast

Shading and printing-in are like retouching: if done well, no one should know they have taken place. But when they are overdone you will find that shadows look unnaturally flat or grey, and burnt-in highlights veil over, again with lost contrast. This will happen most readily when parts of the subject were exposed on the tone-merging 'toe' of the film's performance curve (Figure 10.3), or near the top end where irradiation again destroys tone separation. Perhaps the cause is general under-exposure or overexposure respectively, or just subject range beyond the capabilities of your film.

Either way, these tone-flattened areas need extra contrast, which you can best achieve with variable-contrast paper using selective filtration. Imagine, for example, that you need to shade and contrast-boost a simple patch of shadow in a picture which otherwise prints with grade 2 filtration. You (a) shade this shadow throughout the *entire* period while the rest of the picture is being printed, then (b) change to grade 4 or 5 filtration, and (c) carefully print the shadow area back in, to the level of exposure it would have received if shaded normally.

Figure 13.8 Print shading. Top: a 'straight' print given 22 seconds shows pale sky, and dark detail at top and right side of memorial. Middle: test pieces for sky (given 35 seconds) and memorial (10 seconds). Bottom: working from the test information this print was exposed for 22 seconds, during which memorial areas were shaded for 4 and 5 seconds – see the shading plan below. Then the sky was printed-in for an extra 14 seconds

Overall = 22

+ 14 − 4 and − 5

Figure 13.9 A rough sketch made as a reminder of the different exposures needed for various areas of the picture, right

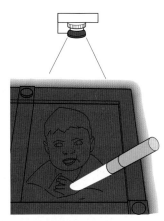

Figure 13.10 Local fogging-in with a battery torch darkens small unwanted light parts, which then blend with dark areas.
Alternatively print-in normally, but defocus the lens

Figure 13.11 Vignetting. Below: To fade out picture edges hold a card with a large cut-out shape almost stationary throughout exposure

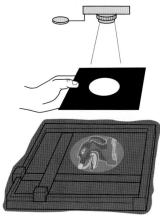

Figure 13.12 Right: Typical vignetted result. Having the card fairly close to the paper avoids the vignette printing dark and 'dirty' near the centre

Overall reduction of contrast

Sometimes, perhaps due to an emergency situation, you have to print a negative so contrasty that it is beyond your softest filtration or graded paper. Three techniques are then worth trying, either singly or all together:

1 Make the enlarger illumination less hard. If you have a condenser enlarger, place a piece of tracing paper on top of the condenser or in the lamphouse filter drawer. Light output will probably be quartered, so widen the lens aperture and increase exposure. Negative contrast will be reduced by about one grade.

2 Reduce paper contrast by 'flashing'. This is a tiny amount of controlled fogging to light – not enough to make the paper look grey, but sufficient to overcome 'inertia' and raise the image exposure received in highlight areas to a developable state, with very little change to darker tones. To do this, first expose the paper normally. Then, while it is still in the masking frame, hold tracing paper just below the lens and give a second or so 'flash' of what is now totally diffused light. You must discover the best amount of flash exposure by trial and error.

3 Change to a low-contrast print developer, which still gives a good black but a more graduated range of greys. See Beer's developer (Appendix D); also contrast masking in *Advanced Photography*.

Figure 13.13 The picture above contains strong shapes cut through by edges of the frame. Printing-in a black edge line (right) helps to pull the main elements of the image together

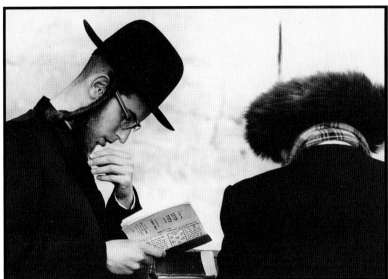

Figure 13.14 Arrangement for fogging in a black edge line to the picture area. The narrow gap must be even all round

Overall increase of contrast

An excessively flat negative, provided it still contains sufficient shadow and highlight detail, will usually print on a grade 5 paper. However, other worthwhile techniques to boost contrast include:

1 Chromium-intensifying the negative, page 318 (only suitable for silver-image film).
2 Developing your printing paper in a line developer, such as D8.
3 Printing on lith paper using lith developer, page 255.
4 Changing from a diffuser enlarger to a condenser enlarger, or from a condenser to a point-source enlarger.

Variations

Vignetting away edges

To avoid clear-cut borders completely, you can turn to the old nineteenth-century style vignettes, which have the picture fading out to white paper like the dog's head, left. Cut a large hole – typically oval – in a sheet of opaque card. Have this held ready the correct distance between lens and paper before starting exposure, checked with the red filter over the lens. Then swing back the filter and expose, keeping your vignetting card in position at the same height (moving slightly) to shade all four sides of the paper for the entire exposure.

Adding edge lines

You sometimes have one or more dark subjects against a light background, shapes which become cropped awkwardly first by framing in the camera and then by white print borders. Figure 13.13 shows one example. To lessen the isolation of these two pieces of the image it helps to add a thin black line between picture edge and border. You can do this by felt pen as an after-treatment, but for single or short print runs photographic fogging gives best results. Use thin black card cleanly cut to a size a few millimetres smaller than the picture area set on your

masking frame, Figure 13.14. Expose a print in the usual way, but, without removing it from the easel, cover the emulsion with the card, weighted down with a few coins. Use red-filtered enlarger light to check that a small gap is left *evenly* all around the edge. Then remove the negative carrier and fog the paper to unfiltered enlarger light, giving the same exposure time used before when the negative was in place.

Photograms

A photogram is basically made by laying an actual object on top of your printing paper and then exposing it to light from the (empty) enlarger. The resulting print is a negative shadow image – opaque objects create white shapes and transparent or semi-transparent items appear as grey tones. First ensure that your enlarger forms an even patch of light larger than the sheet of paper. Then stop-down and using a strip of normal grade paper discover the exposure time which just results in a full black

Figure 13.15 Below: photogram of a cut-glass bowl resting on the printing paper. The bowl was turned slightly four times between giving one quarter the correct exposure for a dark background

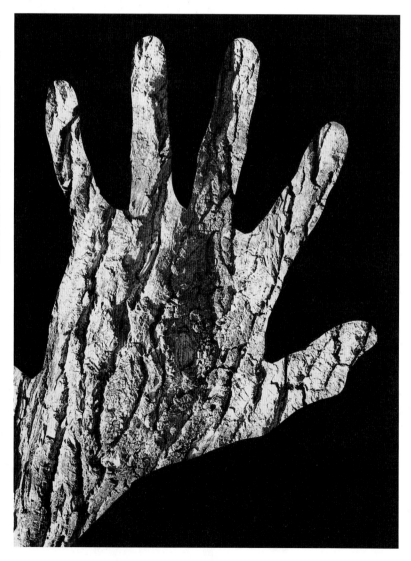

Figure 13.16 Right: Photogram made by exposing an enlargement of a negative of tree bark, then placing a hand on the paper and using the enlarger (with negative removed) to fog the uncovered part

Figure 13.17 Here a decorated glass dish rested on the paper. The negative of the man was enlarged and exposed through the enlarger, then the whole sheet exposed to the raised and empty enlarger, shading the face throughout with a dodger

when processed. Do a test photogram with this as your main exposure, but also explore shifting or removing some objects after half or three-quarters of this time. Try objects like a scattering of nails and screws, glassware (Figure 13.15), feathers or flowers.

Prints from prints

This involves contact printing from an existing enlargement, and results in a negative print. Figure 13.18 for example was produced by face-to-face contact printing a resin coated bromide print. Avoid fibre based paper which shows a fibrous pattern when trans-illuminated. Printing this way results in the picture becoming laterally reversed – if this creates problems make your original enlargement with the negative inverted in the carrier.

Figure 13.18 Negative print made by face-to-face contact printing the enlargement shown on page 192 onto another piece of grade 2 paper. The sandwich was pressed down hard under glass and given 25 seconds exposure under the enlarger (negative carrier empty) with the lens set to its widest aperture

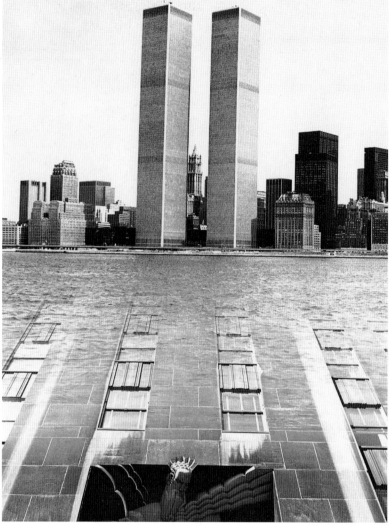

Figure 13.19 Double printing. Top left: test print from Manhattan skyline negative, shading the bottom half throughout. Above: test print from converging building negative, shading the top half throughout. Right: the two exposures made in sequence onto one sheet of paper

Double printing

Having exposed a sheet of paper to the image from one negative, you can then expose it to another. This of course gives superimposition – the shadows and darker tones of one image showing up mostly in highlights and paler tones of the other. But by shading part of the first image, and then printing this area of the paper back with the second image, one scene can be made to *merge* into the other – often with interesting surreal effect; see Figure 13.19.

Variable-contrast paper is ideal for this work because you can adjust filters to compensate for any contrast differences between negatives. It also helps to have two enlargers, each set up with a negative so that you only shift the paper from one baseboard to the other. You can even carefully cut card shapes and tape-hinge these to the easel as flaps, to help mask out unwanted parts of one and then the other image along a sharp-edged boundary.

Unusual printing materials

Tinted-base papers

Various brightly tinted bromide papers are made by manufacturers such as Kentmere. You need quite contrasty negatives because the pre-coloured base has a contrast-reducing effect. Print processing is the same as for regular papers, and gives a neutral black image. Similar results are possible by soaking any fibre-based print in a cold water fabric dye. However, with some coloured paper products you can also treat your processed print in a special bleach supplied by the same manufacturers. The bleach removes the black silver and also the dye in the image area alone. Results therefore turn from a black image on coloured base to a white image on coloured base. If you then treat this print in suitable dye you get a two-coloured result.

Photo-linen

This is an emulsion-coated white linen you process like bromide paper but limit washing to about 10 minutes. It comes in a single, grade 2, contrast. Results have a textured surface and the linen can be embroidered, sewn together in panels as a wall hanging, etc., as well as being toned (page 259) or hand coloured. The material costs about 2–3 times the price of bromide paper.

Using lith paper

A few manufacturers, such as Sterling, include among their products extreme-contrast lith-type paper. Provided you process in a lith developer – such as Tetenal Dokulith – this paper gives stark black and white prints from continuous-tone negatives, also exaggerating their grain and sharpness. However, its main interest lies in the range of tones – from brown-black to yellow – you can achieve by gross overexposure and underdevelopment; see Figure 13.20.

Some lith papers are orthochromatic, and so will need deep red safelighting. Choose a negative that is rich in pattern or texture, and pin-sharp. First make test strips based on the exposure you would give with normal bromide paper but bracketed with only about 20 per cent differences of time. Process fully in lith developer (typically 2 minutes) followed by regular stop bath and fixer. Decide what you consider correct exposure, ignoring the extreme contrast.

Now make a full print giving *four times* this exposure time, or opening up the lens two stops. Greatly dilute some of your previous working-strength developer, 1 part developer 5 parts water, and develop this print purely by inspection, removing it quickly from the developer at whatever stage the image looks best. When you view your fixed print in white light it will show a mixture of black shadows and tinted midtones, with generally normal contrast. Increasing exposure by large amounts and reducing development still further produces more colour and lower contrast. Do any shading or printing-in as normal.

Common print faults

Always check any unexpected faults on your print first of all against the corresponding image on the negative. Assuming that the negative itself is free of blemishes, the most common faults in printing and their causes are:

Figure 13.20 A normal contrast negative printed four ways onto a lith type bromide paper, processed in a lith developer. This page, top: 10 seconds exposure and full development. Bottom: 8 seconds exposure and full development. Both prints have a rich black, contrasty image-enhanced look – each reproducing only a small part of the negative's range of tones (compare water surface and background woods). Opposite page, top: exposed 20 seconds with enlarger lens opened one stop. Processed by inspection in diluted developer. Bottom: exposed 30 seconds with lens open an additional stop. Processing as above. The greater the overexposure and underdevelopment the 'warmer' the midtones and the lower the contrast

- White specks and hair shapes, due to debris temporarily lying on the paper surface, the negative or any carrier glass. If marks are very unsharp the dirt may be on a condenser or diffuser surface between negative and lamp.
- Uneven patches of density, which may be quite large, caused by not submerging the print quickly and evenly in the developer. Perhaps development time was impractically short.
- Small whitish patches with distinct edges, caused by water or wet finger marks on the emulsion before processing.
- A purple patch, or purple all over. Print insufficiently fixed, and therefore reacting to white light.

- Fine black lines, often short and in parallel groups, caused by physical abrasions of the (dry) emulsion, perhaps from dropping the paper on the floor or slipping it roughly under the masking frame masks.
- One or two short, thick black marks fairly close to a print edge. Caused by over-energetic gripping by print tongs in the developer.
- Only part of the image is sharp (e.g. centre but not edges; one side but not the other). The negative is bowed, or at an angle to the paper.
- Part of the picture shows an offset, double image. Probably caused by the masking frame, lens or negative being jogged between your main and printing-in exposures.

- Grey, muddy image, with smudged shadow detail and sometimes veiled highlights. Caused by grease, dust, or temporary condensation (from moist hands during shading?) on the lens.
- A slight fog-like dark band close to the print's white border, due to light spread from the rebate of the negative.
- Contact prints unsharp. Insufficient pressure between cover glass and paper.
- (RC papers only) Collapsed blisters in the emulsion surface, where it has parted company with the base. The print was not fully covered by a film of water when passed through a roller RC heat dryer.
- White areas, including borders, veiled with grey. Extreme over-development, or fogged by your darkroom safelight (see safelight testing, page 243).

Chemical afterwork

Once the darkroom side of black and white printing is over, you can still make radical changes to a picture by various chemical processes workable in normal light. These include bleaching, toning and colour tinting.

Image reduction and bleach-out

The two most useful forms of print reducer are Farmer's, which you use to progressively *lighten* the image, and iodine bleach, which *completely removes* parts of the image down to white paper. Formulae for each appear in Appendix D, and you can also buy them pre-packaged. Remember health and safety in handling these chemicals, page 320.

Farmer's reducer

This is also known as ferricyanide reducer or 'ferri'. Basically it is a combination of potassium ferricyanide, which changes the print's black silver image back to silver halide, and hypo (sodium thiosulphate, fixer) which makes the halides soluble so that they can be washed from the paper. Farmer's reducer can be used as a sequence of two separate solutions, but it is much easier to see the reduction effect with both chemicals present, even though the mixture does not then keep and must be used 'one-shot'.

Use Farmer's reducer to lighten just those areas of the picture you have been unable to shade sufficiently. Alternatively, applied to the whole print, it will 'clear' veiled highlights and give extra sparkle to light tones – which it reduces more quickly than darker tones.

The print you want to work on should be fully fixed, rinsed and squeegeed on to a clean flat surface. Dilute the Farmer's reducer with water until tests on a scrap print show that its image-lightening action is fairly slow, and therefore controllable. Then apply it to your main print by cotton-wool swab. Keep stopping the action by hosing over the print surface with water (remembering that if you go too far, reduction cannot be reversed). When the image has altered to the visual result you require, give the print normal fixing, washing and drying.

Iodine bleach

This is the best bleacher for giving a 'clean' complete erasure of the image. It is a dark brown solution containing iodine and potassium

iodide, which combine with the silver to form a silver halide. This in turn is fixed and washed out. Use the bleacher to convert small black spots into white spots, for subsequent spotting-in with dye or water colour; see page 297. It is also excellent for 'shaping-out' subjects from their backgrounds.

Thoroughly blot off the fixed, rinsed print you want to bleach, and apply the undiluted solution with a brush or (for large areas) a swab. A deep brown stain immediately appears, but you can see the black image fading away beneath it. When this bleaching is complete, soak the print in a tray containing some fresh fixer for 5–10 minutes until the treated areas are completely stain-free and white. Then wash and dry the print normally. Discard the fixer because of the iodide by-products it now contains.

When 'shaping out' a very complex subject you can first dry your print, paint over or cover parts you do *not* want to bleach with a waterproof resist, and then place the whole sheet in a tray of the bleacher. Afterwards peel off the resist at the refixing stage.

Toning

Toning changes the black image into a colour, by either coating the silver or converting it into another, coloured, chemical or dye. The paper base remains unchanged. Some toned images (sepia, red) are at least as permanent as the original silver. Others (blue, green) are not.

Figure 13.21 Changing local tone values with reducer. Below, left: straight print from negative. Right: this print had nearly twice as much exposure. Then after processing, the fallen branch was lightened back by repeatedly applying dilute Farmer's reducer on a large watercolour brush

You may want to tone your print to subtly improve tonal richness and increase its permanence, using selenium or perhaps gold. Or you might sepia-tone, either to create an antique-looking image, or as a preliminary to tinting (see below). Stronger toning colours should be used with restraint, unless you need a gaudy effect.

Image colours given by two typical toners are shown in Figure 13.23. These are sold as prepared chemicals, or can be made up (see Appendix D). You can also buy ready-to-use comprehensive kits such as 'Colorvir' or Tetenal Multi-toner, offering a whole range of colours. The kit contains separate packs of yellow, magenta and blue toner. By mixing these units in different proportions different toning colours are formed.

Some toners require two stages. First, you bleach the area you want to tone in a ferricyanide solution (without fixer), then you redevelop this bleached image as a coloured chemical image in the toner. Redevelopment can take place in normal room lighting because only halides representing the image are present, so fogging is impossible.

Others are *single* solution toners, and gradually displace or form an amalgam with the black silver, starting with palest tones first. Yet others (typically those in kits) use *dye-coupled development*, in which the existing image is first bleached, then redeveloped in a developer plus a chosen colour coupler, and finally bleached again to remove the black silver simultaneously reformed during the redeveloping stage. This leaves an image in dye alone. Notice the similarity with colour film processing.

Whichever toning formula or kit you use, you can choose to change the whole image to a coloured form or, perhaps by means of a paint-on resist (see above), tone just selected areas only. Unaffected parts which remain as black silver can next be toned a further colour. Another way of working is to duotone, meaning that shadows and dark tone values in your picture remain black while midtones and paler parts take on colour.

The way you achieve this two-tone effect will depend on the formula and colour. With sepia toner, for example, you dilute the bleach bath, which then allows you time to remove your print before silver from the

Figure 13.22 Bleaching out background. Above: a straight print shows a moss-covered tree stump with confusing background. Right: by carefully applying iodine bleacher with a swab and brush, and finally refixing, unwanted parts of the image are reduced to white paper

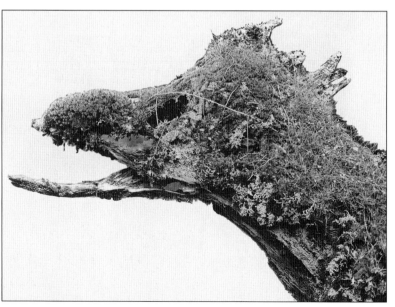

Figure 13.23 Chemical toning. Above: untoned print on bromide paper. Centre: after bleaching and full sepia toning. Far right: blue single-solution toner (often gives a patchy effect if the print is overwashed)

darkest shadow areas has been affected. Then in the toner, only paler, bleached tones become fully sepia. In single-bath toner (e.g. blue), you treat the print just long enough to start affecting the lighter tones.

Prints for toning should be fully developed in the first instance. Toners such as sepia slightly *lighten* the image, and others such as blue slightly *intensify* it, so anticipate this when making the original print. You will also find that final colours differ somewhat according to whether the print is on a bromide, chlorobromide or lith emulsion paper.

Tinting

Tinting means hand-colouring your print with watercolours, dyes or oil paints. Oils are applied by brush; other paints by brush, spot-pen or airbrush. The main advantage of tinting over colour photography is that you can choose the colour of every single element in your picture – restrict colour to something you want to emphasize or show in an interpretative way. There is little point in aiming for an accurate, objective record. See Figure 1.13.

If you colour over a normal black and white image, its black silver will mute most of your hues. Instead, work with a print which is warm in image tone and slightly pale. You might sepia-tone the print for example, or make it in the first instance on chlorobromide paper processed in warm-tone developer. Remember that tinting, unlike toning, colours both the image and clear parts of the paper. In fact colours show as stronger and more pure in highlight areas.

Water-based colours, dyes

These are applied to the print while it is still damp. Blot off the print surface and with a swab add a wash of colour to largest areas first. Build up sufficient density of colour gradually. Work down to the smaller areas using a brush, always blotting off the print after each

Figure 13.24 'Girl On The Tube' by Tansy Spinks. A print on lith paper was given blue split-toning to enhance its dreamlike image. This, plus the unsharpness and de-personalized male figures, contribute to a sense of isolation

colour application. When only tiny coloured details remain to be done, dry the print and mount it (page 295), then add these final tints using a small brush or, if you are working with dyes, a fibre tip pen. See page 297.

Oil-based colours

Here you must work on a dry, mounted print. Squeeze artists' oil colour (Marshall's Oils for example) on to a palette and pick up and apply small amounts at a time, using a fine brush moistened in turpentine. Again work from the largest to smallest areas. Progress is slow because a coloured surface must dry for about 24 hours before you can add other coloured details on top. Oils also alter the surface texture of your paper. However, colours can be erased or changed more readily than with water-based tints, by means of a cotton bud dipped in turpentine.

Airbrushing

Colouring of prints can also be handled with a miniature paint spray known as an airbrush. This is powered by compressed air from a can or an electric pump and compressor unit, and projects a fine spread

Figure 13.25 Opposite: given a subject like this, which is mostly one colour, toning the print can add great strength and richness. 'Theo's grandmother's walnuts' by Jean Dieuzaide, is a sepia-toned fibre-based print

of spirit- or water-based dye or pigment. Control is by a single button – pressing it down controls air flow, and pushing it forward or back allows paint to flow in a narrow or broad spray from a small internal reservoir. Airbrushing is a good way to create smooth, graduated areas of colour or tone, but takes a lot of practice. Colourists today increasingly turn to digital methods of altering prints, as described in Chapter 14.

Summary. Black and white printing: techniques

- Contact prints are an important way of proofing/filing all your film images. Aim for maximum information of picture content in every frame.
- Select and clean negatives for enlarging; remember to stop down, and give a geometric series of test strip exposures, each strip spanning shadows and highlights.
- Make local density changes by shading and burning-in; make local contrast changes by altered filtration (variable-contrast paper).
- To reduce printing contrast, use softer grade paper or a lower number filter with VC paper, diffuse the enlarger illumination, 'flash' expose the paper or change to softer-working developer.
- To increase contrast, use harder grade paper or VC filtration, consider negative intensification, line developer, lith materials, or change to a condenser or point-source enlarger.
- Check print faults against your negative. Most white marks are caused by light obstruction, black marks by fog or rough handling, patchiness by careless processing.
- Materials and methods worth exploring: lith paper, tinted bromide papers (with bleach stage), adding edge lines, vignetting, and double printing.
- Photograms can give unexpected, unique images. Try removing objects part way through exposure, combining object shapes with an image projected through the enlarger, and printing from prints.
- Dilute Farmer's reducer will lighten print density and brighten highlights. Halt its effect at any point with water. Stronger-acting iodine bleach will remove chosen image parts altogether. Follow both by re-fixing and washing.
- Toning chemically changes a black silver image into a colour. Use it for special effects; to enrich print tone values; increase permanence (selenium or gold toning); or (sepia) as a preliminary to hand tinting. Some toners reduce image permanence.
- Toners may work as single solutions. Others require the print to be bleached, then toned during a redevelopment stage. Yet others use bleaching and dye-coupled development (wide choice of couplers), followed by optional silver bleach. Prints can be toned overall or just a selected area, or only image midtones and highlights (duotone effect).
- Tinting, by applying water or oil colours, allows total control of colouring and is often best used subjectively. Work from largest to smallest areas. Graduated tone or colour can be applied by airbrushing.

Projects

1 Make a 'ring-around'. Pick an interesting negative and make a wide-ranging set of prints

 (a) on various types, contrasts and surfaces of paper, and
 (b) using different developers.

 Mount these on a card for reference.

2 Make strong linear and tonal designs by means of photograms. Try:

 (a) Numerous opaque objects – paper clips, beans, etc. – which you shift around the paper or partly remove after one-quarter, half and three-quarters the full black exposure.
 (b) Positioning some objects on a glass sheet a few inches above the paper; others in surface contact. Hold tracing paper just below the enlarging lens to make the raised objects form soft-edged shadow shapes. The others remain sharp and are therefore emphasized.
 (c) Place a few larger objects on the paper. Expose these with a moving torch following each circumference – like a paint spray around a stencil.

3 Make two suitable prints of a landscape or cityscape, identical in size. Use a dye-coupled toner kit to multi-colour tone one of these prints. Tone different areas – sky, vegetation, buildings, etc. – separately, and allow some parts to remain black and white. For each colour, work by applying bleacher carefully only to the part being toned. The other print should be selectively sepia-toned and hand-tinted with water colours, working to a similar colour scheme.

14

Digital image manipulation

Computers have affected all our lives. For photographers they have opened up exciting new ways of 'digitally processing' images – retouching, manipulating and generally improving results, without need of chemicals or darkroom facilities. Linked to a desktop scanner and an ink-jet printer, a home computer now allows you to make excellent colour or black and white prints from any of your camera-shot material. Images can also be sent out in disk form or within pages on the Internet.

This chapter gives you a flavour of digital post-shooting techniques from a practical point of view. It is based on the use of a PC, for although many colleges and design studios use Apple Mac computers the same software and procedures increasingly apply. The huge numbers of home PCs also means that you are more likely to be able to do digital work at home. Time spent on regular practice is of great importance in the early stages of learning.

When digital manipulation programs first became available to photographers in the 1990s, endless arguments began over whether this is electronic 'cheating' rather than 'true' photography. Such ethical issues are discussed later, on page 290. Leaving these aside for the moment you should get first hand experience of the new techniques yourself, not shy away from them. Undoubtedly, creativity and imagination are what count most in photography but it would be foolish not to explore the potential of the latest tools now available to you.

Overview

Digital manipulation allows you to do conventional photographic tasks like shading, spotting, printing-in or adjusting contrast and colour in a quicker and more direct way than in the darkroom. Results can be seen at once on your computer monitor screen and any mistakes corrected without having to go as far as having to make a print. Additionally you can alter depth of field; add movement blur; realistically merge several images into one another; and cover over a defect or unwanted element by cloning from detail nearby. Changes like these are impossible, or at least very laborious, to achieve by darkroom techniques. The computer

Figure 14.1 'Cat's Eyes' by Nicky Coutts. A strong example of digital manipulation to relate human/creature attributes. This is one of a series in which the photographer subtly transferred human eyes to animals and birds. All have a sense of the uncanny, making the point that we don't allow creatures to self-reflect, rather we reflect upon them

allows you to alter an image in several directions at once yet never lose the original, which remains intact in case of accidents or changes of requirements. And finally you can transmit thumbnail versions of your picture to anywhere in the world for instant approval.

On the other hand probably more over-blown photographs have been produced digitally than by any other means. Ability to just select from menus containing dozens of digital 'effects' in a mindless way encourages shallow, gimmicky pictures. Unimaginative photographers press buttons and are delighted with their garish results. Such work discourages creative people (many of whom have been put off anyway by having to learn computer skills).

Figure 14.2 Layout of a digital workroom for the manipulation and production of monochrome and colour prints up to A4 size. C: computer tower with entry for CD, floppy-disk and hard disk drives. F: film scanner for 35 mm negatives and slides. S: flat-bed scanner accepting paper prints, also used for photogram making. P: ink-jet colour printer. R: CD-ROMs relating to various image manipulation software programs. The computer is controlled mainly via the mouse or the graphics palette shown next to the 19 inch high-resolution monitor. Compare with Figure 12.1

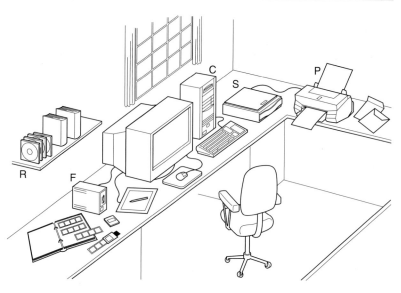

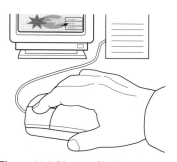

Figure 14.3 Mouse. Shifting the whole mouse moves the cursor (arrow here) anywhere on screen. Single or double clicking a button calls up whatever tool, command bar icon, etc., the cursor has been positioned over. See Figure 14.11

Two important features of digitalized image manipulation need to be recognized:

1 It takes time, patience and a good memory to master computer controls and (particularly) to use the right chain of commands demanded by the software program you have installed. Computers are basically idiot machines; software programs adopt a curious logic of their own; and most of the jargon is in language very different to terms long used in photography.
2 Severely limit your use of the special effects command. Like fisheye lenses or effects filters, results may look good at first but quickly become repetitive and boring. Digital manipulation is arguably at its best when used *imperceptibly* – to remove a road sign or parked car in an architectural shot for example, or lighten or darken areas of a print too complex to shade or burn-in successfully in the darkroom. Remember too that used skillfully it can help to communicate a strong visual *idea* (Figures 14.1 and 14.41) for even though manipulation is apparent, it greatly strengthens meaning.

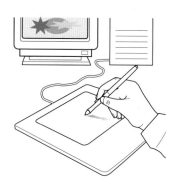

Figure 14.4 Graphics palette. Together with its cordless pen this serves the same functions as the mouse. It makes it easier to trace around a complicated shape, draw freehand or sign your name. A small switch on the pen provides the equivalents of mouse clicks

The hardware

The computer itself

As shown in Figure 14.2, the computer itself is the centre of the digital system. Some are tower shape, others flatter desktop units which fit under the monitor. A good size mini-tower has the most room and easiest access for expansion if you plan future upgrading – extra drives or memory for example. Key components housed within the tower include the following:

● *Hard disk.* This acts like an electronic filing cabinet, storing the computer operating programs such as Windows and Photoshop you initially load in, plus all the files of pictures you choose to save. The capacity of the hard disk is measured in gigabytes (GB); 4 GB is just

Figure 14.5 The main ways an image in digital form can be downloaded into the computer. It is then displayed on the monitor and can be saved as a named file on the computer's internal hard disk

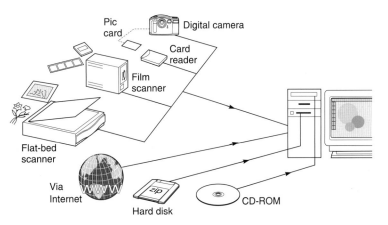

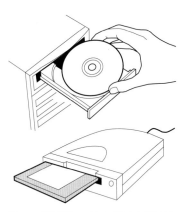

Figure 14.6 Top: Inserting a Photo-CD, e.g. made from your film by the processing lab. Below: images on a Zip hard disk load into a separate drive unit which is wired to the computer, or often built into the tower.

Figure 14.7 An adapter to read CompactFlash camera cards into the computer

Figure 14.8 Positioning a monochrome or colour print face down on the glass of a flat-bed scanner

adequate but something over 17 GB will allow you to store hundreds of pictures.

- *Processor.* Next the computer's brain, known as the central processing unit or CPU (containing 'Intel Pentium' technology, for example) which determines how fast digital information is transferred. Aim for 350 megahertz (MHz) here. Too slow a processor means you frequently wait minutes for tools to transform large images.
- *Memory.* Another important internal component, random access memory (RAM) determines the working area of the computer. The more RAM the more information can be transferred. RAM is measured in megabytes (MB). 64 MB is adequate but aim for 128 MB or more to work with image files.
- *Graphics card.* This circuit board ensures a high quality monitor screen image. As a minimum go for an 8 MB card.
- *Drives.* Unlike all the above, these units provide entry slots for discs on the front face of the computer. Typically one accepts CD-ROMs (Compact Disc Read-Only Memory). Manipulation and many other programs are supplied in CD-ROM form. Other compact discs include Photo-CDs carrying film images which may be scanned in cheaply by your processing lab. A Zip drive for high capacity removable hard disks is usefully built-in. This will allow you to send digital files to a custom lab to have large prints made, provided they are of sufficient resolution (Figure 6.6). Some computers offer a drive for older floppy disks, only suitable for small files.

Most of the above components can be individually upgraded later (or added if not originally fitted) provided the tower has enough room. Monitor, scanners, printer and any other peripherals plug into panels at the back.

Peripherals

Monitor. Since you will spend hours looking at this screen it should be a high resolution type, at least 15 inches diagonal (which gives an A4 viewing area). A 17 or 19 inch monitor is ideal. Whatever its size the display needs a resolution of 1024×768 pixels and 24 bit colour depth.

Mouse, keyboard and palette. These allow you to physically communicate with your computer. Unlike word processing, the

keyboard is little used in digital image work. Its main function is to title your saved pictures. One or two keys are also used in conjunction with tools such as cloning (page 275) or to provide short cut alternatives to much-used controls. Mostly you will be working with a mouse and/or a graphics palette and pen, page 268. Both steer movement of the cursor anywhere on screen. Pen and mouse carry buttons you click to select tools or cue a command pointed to by the cursor. Keeping a button held down while on the move enables these devices to drag sliders, and reposition fly-outs or the picture itself on the monitor's screen.

Flat-bed scanner. A glass-top box containing a tracking light source and scan bar, this is able to convert monochrome and colour prints up to A4 (some up to A3) into digital images which feed into the computer. Resolution needs to be at least 1200×600 pixels. The scanner will also allow you to make photograms, page 284. Some flat-beds also scan film images but don't really have sufficient resolution for such small originals, which need a film scanner instead.

Film scanner. Produces a relatively high resolution scan (typically 2700 dpi, giving over 8 million pixels from a 35 mm slide and negative). Film scanners made for rollfilm or sheet film originals are much more expensive. Unless you regularly shoot using these medium or large formats it is cheaper to use a lab to scan them onto a Zip disk or CD.

Card reader. A digital camera when attached by cable to the computer (Figure 14.5) will download the pictures it has taken. However, removing its memory card and inserting this into a card reader instead gives a much speedier transfer, and frees the camera for use elsewhere.

Modem. Millions of low resolution Internet images can be accessed on screen by surfing around on the World Wide Web; see page 301. You can also transmit your own work. For this a modem unit is necessary to convert analogue images (which telephone lines need) into a digital form acceptable to the computer.

Printer. To print out your final image as 'hard copy' on paper calls for a printer using ink-jet, dye-sublimation or laser technology. Of these an ink-jet unit (using five or six ink colours, plus black) is the cheapest way to make high quality prints. But make sure it will print out at least 300 dots per inch in preferably 30 bit depth colour. The size of the image file you feed it with from the computer must also be sufficient for your intended print size; see Figures 14.10 and 6.6. Start by printing

Figure 14.9 Film scanner. This accepts 35 mm slides or negatives in glassless mounts or uncut strips (foreground unit). APS films must first be inserted into an adapter (left) where C houses and opens the cartridge and W allows you to wind film through until the chosen frame appears in the window

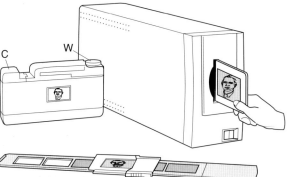
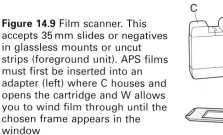

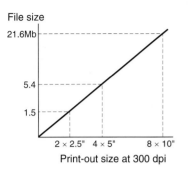

File size

21.6Mb

5.4

1.5

2 × 2.5" 4 × 5" 8 × 10"

Print-out size at 300 dpi

Figure 14.10 The minimum image file needed to give 24 bit 'photo quality' ink-jet prints of various sizes

Figure 14.11 The geography of a typical monitor display when using image manipulation software. A single or double click when the cursor is on a tool symbol (see page 274) or command bar text often produces a fly-out where you must use the cursor to click on further choices or move sliders to alter contrast, colour, magnification, etc. Any dialogue box or tool bar which blocks part of your image can be repositioned by clicking onto its top strip, keeping the mouse button depressed and dragging to some other part of the screen

onto a 'photo-quality' paper the same brand as the printer and inks. Later it is worth exploring the huge range of different surfaced papers now produced for ink-jet printers by manufacturers of photographic bromide paper.

Software programs

When you buy any software program it normally comes as a CD which you insert into the computer and download onto your hard disk. Once installed the CD can be removed and you call up your program internally as and when required, plus the picture you want to work on. The hard disk has ample capacity to hold several different programs and you can transfer your picture from one to another if you want to work on it for a while with a particular tool.

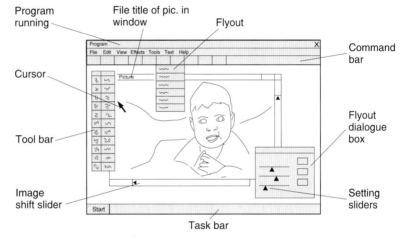

Program running — File title of pic. in window — Flyout — Command bar — Cursor — Flyout dialogue box — Tool bar — Image shift slider — Setting sliders — Task bar

A wide range of photo-manipulation (also known as image-editing) software is available. Some are all-embracing, other smaller programs act as 'plug-ins' to their bigger brothers and contain for example special effects or wide ranging ways of incorporating photographs with graphics into show-cards, posters, etc.

The industry standard software for professional manipulation of photographs is 'Photoshop'. This program is expensive but extremely comprehensive. It offers an enormous menu of image changes, with many adjustment options for each one. Consequently there are longer chains of commands than any other program. This makes Photoshop less accessible and user-friendly for beginners than more limited software, such as PhotoDeluxe or PhotoSuite. If you have no experience of digital image manipulation it is much easier to start with one of these entry-level programs. They are also relatively cheap. The image changes they offer are those most frequently needed, each one being tagged with on-screen advice covering what to do next; see Figure 14.16. Later, when you are practised and confident in using a basic program you can upgrade to Photoshop or other advanced software, working with their extra features and chains of command without confusion and frustration.

The bulky manuals supplied with manipulation software are often *too* comprehensive. Time is wasted trying to find simple, direct routes from what you presently have on screen to what you want to produce. The best solution (particularly if you don't often work digitally) is to compile your own notes covering the most useful changes and just listing the precise sequence of commands needed to achieve them. See page 280, for example. The picture manipulations shown later here have all been made using PhotoSuite II or Photoshop 5. Updated editions of these programs are brought out regularly and so details shown may differ slightly from what is now current, but still give you a flavour of what is possible.

What you see on screen

Each software program differs somewhat in the layout it presents to you on screen, see page 271. Figure 14.11 shows the most common features you see once you have brought up your program, then opened or scanned-in the picture to be manipulated. In the very top left corner for example there appears the name of the software program you are running. In the far top right is an × in a box – you position the cursor and click onto this when you want to close the program again.

The *command bar* carries options including File; Edit; Filter; and Help. Cursor placing and clicking on any of these produces a 'fly-out', listing further options under that heading. In the case of File the fly-out lists Open; Save As; etc. Then clicking on *Open* presents the listed titles of all the pictures saved onto your hard disk. A further click on the image you want makes it appear on screen, within the window area. Its title appears top left, and another × box top right allows you to return the picture back to file when you have finished with it.

Manipulating tools can be clicked on from the vertical toolbar on the left (many of these release a further sub-range of symbols, discussed on page 275). The tool shown with a magnifying glass symbol allows you to enlarge the image, continuously or in steps. By cursor clicking onto and moving horizontal or vertical sliders along two sides of the enlarged picture you *scroll* it up-and-down or sideways to centre the bit you want to work on. Some commands or tools make a 'dialogue box' fly-out. Here you have to set choices – such as moving a *Brightness* slider with the cursor (Figure 14.14) to lighten or darken the image. This has an effect equivalent to giving more or less exposure in the darkroom.

How programs differ

The monitor screens opposite show a picture file opened in three different software programs. In the top one (Photoshop 5) the word 'Window' has been clicked in the top command bar. It produced the fly-out allowing you to bring various dialogue boxes on screen. In this instance *Navigator* was chosen and appears top right. The box features a slider you drag with the cursor as a further way to enlarge the picture in the image window of the monitor. Its effect is like raising an (autofocusing) enlarger in the darkroom.

A thumbnail version of the whole picture also appears in the dialogue box, framed in a red rectangle. As the main picture is made bigger the rectangle gets smaller. Dragging the rectangle to cover a different part of the thumbnail causes the enlarged contents of the image window to shift in tandem. So this is the equivalent of moving the easel around under the enlarger.

Figure 14.12 The monitor screen appearance when running different software programs. Top: Photoshop, the industry standard, offering hundreds of image adjustments but because of its vast array of choices is not very friendly for the beginner. Centre: PhotoDeLuxe and (bottom) PhotoSuite II. This type of lower cost program offers most of the key controls, page 275, although with fewer fine-tuning options. Written fly-outs guide you in what a selected tool will do. (From time to time software programs bring out new editions with changed layouts. These three were current in 1999)

At bottom right a previously selected fly-out (accessed by clicking in turn on Image>Adjust>Brightness>Contrast) contains two sliders. One produces the effect of giving less or more exposure, the other changes image contrast as if you were dialling in different VC bromide paper filtration. Unlike darkroom work though, the computer monitor instantly shows you the image's changed appearance. When you judge that results are about right clicking an 'OK' or 'Apply' tab sets the image in its new form.

The centre and bottom screens in Figure 14.12 show how two entry-level programs present the image. The centre one, PhotoDeluxe, has tabs with drawings illustrating the kind of changes on offer in Special Effects. Clicking on any of these produces a fly-out dialogue box ready for you to set the finer details of your chosen effect. PhotoSuite II, the third example in Figure 14.12, displays an explanatory panel of text when you position the cursor over any of the tools and before you click to select them.

All programs offer 'undo', typically accessed Edit>Undo, to take changes back a step if you are dissatisfied with what you have just done. They all offer a 'Help' command too, see Figure 14.33. It delivers you a fly-out index leading to a panel of words and drawings explaining how to get to whatever you are trying to achieve.

Figure 14.13 Part of the tool bar used in Photoshop 5. 'Selection' tools allow you to pre-select the picture area you intend to manipulate or crop. These and several of the 'painting' tools produce fly-outs from which you must make sub-choices

Learning the ropes

At first sight a tool bar like Figure 14.13 is a bit intimidating, particularly when tool symbols shoot out a row of fly-out options when you first click onto them. But given time and practice you will grow familiar with what each of them means. Some you will never use,

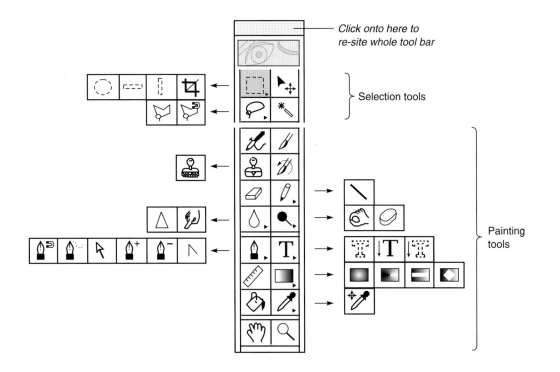

Figure 14.14 Image brightness and contrast controls, as presented on dialogue boxes in (top) PhotoDeLuxe and (bottom) PhotoSuite II

Figure 14.15 Clicking on Undo, accessed by first clicking Edit, removes the last change you made to your image. Undo is vital if you make a mistake

Figure 14.16 The fly-out guidance information which appears when the Clone symbol is selected from the tool bar in PhotoSuite II

others are key controls needed for almost every picture. Many of the symbols are easy for a photographer to recognize – the dodger for example and the hand symbol, shaped to burn in, see Figure 13.7. The eraser, and the set-squares for cropping your picture are self-explanatory too.

A good way to start learning digital image manipulation on your own is to pick a few key controls and then experiment with them one at a time. If you have a bad memory make notes stringing together the precise sequence of commands, tools and dialogue box settings you must click onto to achieve a particular image change. (The trouble with computer work is that omitting just one command will stop progress and usually there is nothing to tell you *why*.)

The next section of this chapter discusses the practical uses of a selection of key controls, particularly those which give results similar to or better than what is achievable using darkroom techniques on silver halide materials.

Key controls

Brightness/contrast. This is the most basic image adjustment device and the one you are likely to use more than others. Bear in mind though that, just like printing in the darkroom, limits to improvements lie in the quality of your original camera image. Neither control will conjure up shadow detail lost because of gross underexposure, for example. But almost every picture will benefit from some overall density and contrast adjustment owing to subject lighting conditions, minor exposure errors, or the need to help along the mood of your shot. Again, if the image as it appears on your computer monitor is not quite matched to the printer it may be necessary to have the picture darker or lighter on screen in anticipation of changes when it comes out on paper.

Instead of darkening or lightening *overall* you can click on a burn or dodge tool, spray can or brush, which then becomes the cursor, and apply changes locally. A fly-out or similar dialogue box shows you various 'brush sizes' which apply to all these tools. They range from a tiny spot (good for small well-defined parts of the picture) to large soft-edged brushes better for working in patches. If, however, you have a large area to change, such as sky, these tools will have an uneven effect. It is better to first encircle the sky area using a selection tool like Photoshop's 'Lasso'. Set the tool to a feathered edge – the equivalent of keeping your hand on the move when shading under the enlarger. Then when you use the brightness/contrast sliders only the sky will change; see Figure 14.17.

Undo. You will use this almost as much as brightness/contrast, especially when you begin. Some programs only allow you to undo the last action you have undertaken – for example encircling sky would be one step, darkening it another. The best programs allow you to step back many stages, important if you have to 'unravel' a string of badly judged manipulations and start again (but not from the beginning).

Clone. This impressive tool is unmatched by darkroom techniques. The cloning (or in Photoshop the 'Rubber Stamp') tool works by copying pixels from one part of your image to another. So if, say, you want to remove an aircraft vapour trail across blue sky in a landscape you can work as follows: (1) Enlarge up the image until only the white trail fills the screen. (2) Select clone tool and set a suitable 'brush size', i.e. just

Figure 14.17 Top right: Straight print from a monochrome film negative. Below, top: dodger tool in use to lighten the road sign. Below, lower: detail of feather-edged mask applied before darkening the whole of the foreground. Bottom right: final ink-jet print after digital correction of selected areas is completed

wider than the trail blemish. (3) With the help of the keyboard, see below, select and click onto somewhere in the sky nearby. This becomes your source or 'pick up' area. (4) Next reposition the cursor in the white vapour trail. Then, keeping the mouse button held down, you brush the cursor over the trail and watch the white become blue sky.

Cloning is an instance where you have to use your keyboard as well. To change and pick up pixels from some other part of the image you must hold down the Ctrl key (Alt in Photoshop) while you click on a new source area. This tool is remarkable for making parked cars vanish by cloning from another bit of road and pavement. Similarly road signs, litter, and even people (Figure 14.20) can be replaced by cloned surroundings. Most often however cloning is used as a fast, simple way to eliminate spots and similar defects whatever their tone or colour. See also page 298.

Rotate, crop. Image rotation (Rotate and crop>Rotate symbol in PhotoSuite; Image>Rotate Canvas in Photoshop) allows you to correct a slightly tilted shot such as a landscape with the horizon running down hill. Most often though it is just needed when an upright negative or print scanned in horizontally has to be turned 90° in the monitor window. Selecting the Cropping tool frames your picture with a broken line. 'Handles' on each of the corners and sides of the frame can be clicked on with the cursor and dragged inwards or outwards to re-frame

Figure 14.18 The Photoshop command Variations (accessed via Image>Adjust) presents your picture in a range of different colour balances. This is like making a whole series of tests before colour printing in the darkroom

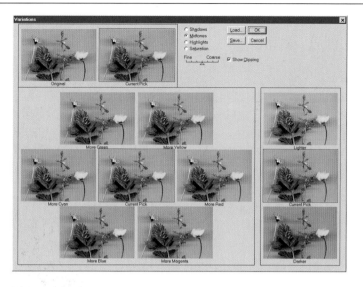

your shot. Pressing a Crop button (Image>Crop in Photoshop) the computer then only displays your cropped result. If possible crop your picture before starting any retouching, otherwise you may waste time working on areas which are later removed.

Colour balance. This is important to help to correct shots taken in lighting of the wrong colour temperature, page 164. Some programs offer you a ring-around like Figure 14.18 (accessed in Photoshop via Image>Adjust>Variations). A display of thumbnails then previews how your shot will look if given different colour adjustments and you click onto the one giving the most accurate looking result. For further fine-tuning it is possible to change mostly highlights, or mid-tones, or shadows. All programs also offer fly-outs with sliders allowing you to adjust colour balance by separately increasing/decreasing the amounts of red, green and blue present, see Figure 14.12 centre. Incidentally a colour shot can be converted to monochrome ('grey-scale' in computer language) by using a sequence such as Effects>Colour to B/W in PhotoDeluxe, or Image>Adjust>Mode>Greyscale in Photoshop. The Digital Notebook entries on page 321 list paths to achieve other useful image changes.

Figure 14.19 Below, left: straight ink-jet print from an original colour slide. Below, right: print from a PhotoSuite manipulated version. Segments selected to be changed in colour were traced over by hand, then 'flood filled' with a colour chosen from the program's palette

Figure 14.20 Moving the monk. Right: the original shot as scanned in. In PhotoSuite the image was reversed left to right, then the freehand selection tool used to roughly outline the figure on screen. This area was copied to the program's 'clipboard', the remaining file closed, then re-opened again from the original scan (right way round). The monk image retrieved from the clipboard was superimposed at the doorway. The eraser tool used close around the figure in its new location next restored bits of doorframe and stonework covered by the rough-cut. Finally, right, the original monk still present under the wall plaque, was covered over completely by cloning from adjacent stonework and paving

Working on pictures

Modifying chosen areas

The sequence, Figure 14.17, shows how the computer lets you dodge and burn-in one part of a picture after another. (Photoshop can display a temporary pink tint to show you the areas you have protected from change in the next brighten or darken step.)

In Figure 14.19 PhotoSuite's 'flood fill' tool was used to realistically change the colours of selected segments of an umbrella. In each instance the new colour was picked out from a palette displayed under the picture (Figure 14.12 bottom) when the commands Edit Photos> Flood fill>Colorize were given.

Resiting elements

Digitally moving elements in a picture to new positions allows you to re-compose shots after they were taken. First you must select and

Figure 14.21 Halloween group. Above: three component images for montaging. In the two pictures shot in a garage faces have mixed expressions or are partly obscured. A slide of a woodland scene was chosen as background component

'copy' (effectively cut out) the item to be moved, and 'paste' it over the picture in the new place you have chosen. Finally where the moved item was originally positioned must be filled over convincingly using bits cloned from background nearby.

There are various routines for doing this resiting. In Figure 14.20 the figure of the monk was roughly shaped out and temporarily saved in PhotoSuite's 'clipboard' memory by clicking a symbol on the command bar. A clipboard stored image can be brought back, altered in size, moved to anywhere and finally pasted permanently in position by mouse click. (In fact half a dozen monks in different sizes could have been brought back this way and scattered throughout the scene.) Figure 14.20 only required the use of clone, erase, and selection tools.

Montaging several shots

Montaging different pictures together takes repositioning a stage further. Take care though that the various component images relate realistically in the quality, contrast and the direction of their lighting, as well as perspective. Montaging is particularly useful when you have photographed a group only to discover that different people have eyes shut, look glum, etc., in every shot. Figure 14.21 for example shows two groups shot flash-on-camera and containing a mixture of expressions plus an obscured face. Using PhotoSuite, two central children were rough cut from the right hand version and stored on

Figure 14.22 Above: two children from the centre section of one group were copied, this bit of image being slid over their faces in the other group, cleaned up all round by eraser and the whole file closed. The tree shot was next scanned in, and the manipulated group file re-opened and superimposed. Finally the garage background was erased completely from around the children to give the result right

clipboard. Closing the file of this group and opening the file of the group on the left instead, the two children were next retrieved from the clipboard, pasted over the centre of the group and cleaned up around their outline with the eraser.

The composite group image file was then closed, a background tree image opened and the composite group re-opened on top. Erasing carefully around the circumference of the grouped children removed the garage and revealed the spooky trees image lying underneath. There are several other digital routines for assembling montages – using 'layers' in Photoshop for instance. All of them call for the time and patience to carefully trace subject outlines, although being able to greatly enlarge your picture on screen makes this task easier.

Figure 14.23 Photoshop's 'Gaussian Blur' (via Filter>Blur) used to reduce depth of field in an image originally sharp throughout

Reducing depth of field, adding blur

Starting off with a picture which is sharp throughout, it is possible to reduce depth of field by digital means. First you draw around the areas you pick for de-focusing (in Figure 14.23 each end of the row of stone faces). Clicking Filter>Blur>Gaussian blur produces a dialogue box for setting and previewing the strength of the effect. To simulate depth of field it should be applied progressively, giving several treatments to the areas of the subject which were nearest and furthest from the camera.

In Figure 14.24 Photoshop (Filter>Blur>Motion>Circular) allows you a post-shooting effect like zooming the camera lens during exposure. Compare this with Figure 5.15. Unlike camera work you can set any centre point for your zoom by dragging the graphic pattern in

Figure 14.24 'Blur' (zoom) control turns this original static image into an action shot

Figure 14.25 Above: Photoshop 'levels' dialogue box (Image>Adjust>Levels) gives a histogram of the picture right. Expanding or contracting this alters contrast

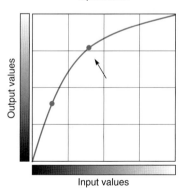

Figure 14.26 Photoshop 'curves'. Top graph: 45° line means the image remains unaltered. But the cursor can nudge the line into various distorted shapes, giving image changes as shown right

the dialogue box. A variation, 'spin' is easy to apply selectively to the wheels of cars that were in fact stationary. Alternatively spin or zoom a background scene alone, and paste a sharply defined product into the foreground.

Controlling with 'levels' and 'curves'

Both these are more technical options for controlling image appearance, provided by Photoshop. Choosing Image>Adjust>Levels makes a dialogue box appear containing a histogram – a graph plotting the number of pixels present in your image for every brightness level, from darkest shadow to brightest highlight. In the histogram of the crane (Figure 14.25) for example, there are least dark pixels because it contains few shadows; lighter mid-tones dominate.

An experienced look at a picture's histogram tells you whether it was correctly scanned-in or downloaded. Moving sliders in the histogram's dialogue box reduce or expand overall image contrast, and by moving the middle arrow of the top slider you can change the mid-tones without affecting either shadow or highlight areas.

Curves on the other hand present what amounts to an image control panel in the form of a graph, see Figure 14.26 (top). *Input* tone values are shown along the horizontal axis and *output* values along a vertical

axis. As it is first displayed the graph carries a straight 45° line, meaning that no manipulation is taking place. But you can use the computer cursor to click onto any part of the line and drag it into almost any shape, the image alongside altering its appearance as you do so. For example, by dragging it in two places into an upward curve, see left, the picture is given steeper contrast in shadows, flattened out tones between mid-tones and highlights. When pulled into the curve shape below left, the mid-tones appear flattened, highlight and shadow areas remain contrasty.

A more extreme distortion, bottom right, turns everything between mid-tones and deep shadow into negative form. And by keeping the line straight but re-angling it 45° from top left to bottom right gives you a full tone range colour negative. If you are a photographer familiar with reading a characteristic curve, page 315, making smooth changes this way is not difficult to pick up.

Working in monochrome and duotone

Although computer hardware and programs are predominantly geared to colour images they are also well suited to black and white work. You can utilize most digital manipulations and produce monochrome pictures with a rich tone range from any good quality ink-jet printer.

Figure 14.27 Below: Duotone and tritone versions of the monochrome picture on page 131. Your choice of hue and weight of colour in addition to black is set via the Photoshop dialogue box above

Figure 14.28 'Trapped' by
Catherine McIntyre. An
imaginative computer-constructed
collage, of positive and negative
elements, plus gentle use of duo-
tone colour

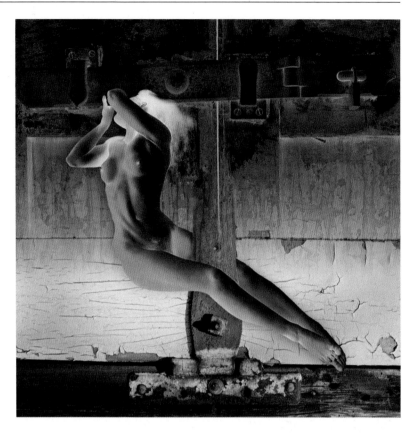

(Set this to print out using all its five or more inks, not just black alone.)

Your original shot does not have to be on black and white film – a colour negative or slide image is also suitable. Working from colour film, first remove all its original colour information by selecting the entire image and then clicking on Touch up>Fix colours (PhotoSuite II) or Advanced>Effects>Colour to B/W (PhotoDeLuxe) or Image> Adjust>Mode>Grey scale (in Photoshop). Monochrome images can of course be montaged in with other, full colour elements; see page 285.

Some programs allow you to mix a colour into your black and white image – either to achieve results resembling a chemically toned bromide print, page 259, or achieve a 'duotone' effect. The Photoshop 'Duotone Options' dialogue box allows you to program up to four different inks, including black. Each ink has a curve box to adjust what tones its colour will affect. For example, in the top box black is best left least changed from 45° to ensure that your image has a basic structure and shadows have sufficient 'body'. Clicking on Ink 2 makes a palette of ink colours appear, from which to make your pick. Pull this ink's curve around until it differs in shape or position to the black ink and is generally less strong. Most results are best left here in duotone, but you can add shades of further colours with increasingly outlandish results. Of the four examples at the foot of page 282, both top left and bottom right versions are duotones; the other two tritones. Muted colours work best, and it is important not to let any colour overweigh your picture's black content.

Figure 14.29 Making a digital photogram with a flat-bed scanner. Above: for 3D objects such as these flowers a white lined cardboard box is substituted for the regular lid. Because of light fall-off and a depth of field of only about 2 cm this results in a mid-grey, unsharp background (right)

Figure 14.30 Photogramming the spines of old books for the pictures opposite. Scanning took place with the lid open in a darkened room to create a black background. Avoid putting too much weight on the glass

Digital photograms

Digital equipment offers an interesting range of opportunities for making pictures without the use of a camera. A 35 mm film scanner will accept tiny flat objects sandwiched between glass in a transparency mount. Flower petals, translucent woven fabric, grass seeds can all be scanned directly to digital files this way; similarly slides or negatives sandwiched together in the same mount to form composite images. Better still use a flatbed scanner with the lid removed. This is much more versatile owing to its large A4 pattern and the freedom with which you can lay out items on top.

Photogramming allows you to generate and file a range of images for further use as backgrounds. Textured paper, sacking, books, knitting, ferns, timber, etc., can provide you with a small library of image files. Use them montaged in behind camera-shot subjects totally different in scale – human figures, commercial products, landscapes. Figures 14.32 and 14.40 are both examples where out-of-scale combinations have been brought together.

Inevitably you have to work within the limitations of flatbed technology. Lighting for example is flat and frontal, although this can be modified somewhat using mirrors at the side or allowing your subjects to cast shadows upwards onto a surface held a few inches above (Figure 14.29). Depth of field is quite shallow too and cannot be altered. It extends for little more than half an inch above the glass top surface. 'Deep' three-dimensional subjects fade away into soft focus and darkness, but this feature can sometimes be used for dramatic effect. Similarly, lightweight items stiffened with wire will vary in sharpness when set up horizontally at different distances above the glass. Always avoid shiny objects such as polished metal in photograms – contrast will be beyond the range of the system.

Remember of course that your picture is scanned in from *beneath* the glass so everything must be laid out upside down. Only a test scan will show you on the monitor how things will look and what adjustments of

Figure 14.31 Top left: Flowers photogram cropped, roughly cut out and superimposed over scanned-in books. Using the erase tool the right half of this picture has had its grey background removed up to the actual flower outlines. Top right: Gaussian blur effect applied to the books photogram file only. Centre left: horizontal blur effect on books only. Centre right: same blur applied to flowers only. Bottom left: books converted to 'greyscale' (monochrome). Bottom right: flowers set to zero brightness, books given Gaussian blur

Figure 14.32 Urban Leaf. Combination of a photogram and an old aerial photograph. The skeleton leaf was first sandwiched between glass in the enlarger and enlarged onto bromide paper. This print, and the aerial print, were next flatbed scanned to form digital files. In PhotoSuite the aerial file was opened first, then the leaf file opened on top. Brushing over different patches with the erase brush reveals parts of the fields and river within the leaf. It was finally printed out with duotone green applied to mid-tones

positioning are necessary. Another factor is that a flatbed slowly *scans* what lies on it, taking many seconds to travel from one end of the glass to the other. This means that everything should lie still, but on the other hand dragging, shaking or lifting an object off the glass during the scanning period is also worth exploring. Results vary according to how drag direction relates to the direction of the scan.

Figure 14.33 The 'Help' option on the command bar of most software programs produces a fly-out like this. From an index of a hundred or more entries you can make advice appear right alongside the picture you are working on

Adjusting perspective

Several manipulation programs offer different ways of distorting image shape. One side of your subject can be made to look smaller and the other side larger. This changes a flat-on shot of, say, a line of washing into a perspective view tapering away into the distance. The chief value of shape control though is its ability to correct converging verticals. You don't have to use camera movements or a shift lens to get the top of a tall building in and keep its sides looking parallel.

Figure 14.34 Correction of converging verticals. Below left: the original image. Lack of space meant it had to be shot with the camera tilted upwards. Centre: selecting the whole picture and then clicking on Edit>Transform>Perspective frames the picture within a broken line which can be narrowed at the bottom. Right: the appearance of the corrected image (note some loss of the picture at top left and right)

Figure 14.34 shows how Photoshop brings up lines framing your original picture. Dragging their corners or sides, you can then compress the bottom and expand the top. When applied this distortion redraws the vertical lines of the building parallel. However, to maintain a final rectangular picture, the program has to crop off some of the left- and right-hand picture content towards the top. (The same applies if you tilt the enlarger easel for correction purposes in the darkroom, Figure 12.7.) The height of the building also appears slightly elongated but is corrected by slightly expanding the overall width of your picture relative to its height. In Photoshop this is done via Edit>Transform>Scale, and then finally pressing Enter on your keyboard.

Figure 14.35 Drop shadow applied to this image 'lifts' the picture off the page. It gives the viewer a sense of looking at a separated flat surface, as if mounted on board. Below: the PhotoSuite drop shadow dialogue box allows you to pick shadow direction. Sliders adjust the shadow's width, darkness and softness of edge. A drop shadow can also be tinted

Figure 14.36 Here the actual subject shape has been given a drop shadow. First the vehicle's background was carefully erased out to white, then a mid-grey drop shadow of generous width applied

Edge lines and drop shadow

Practically every program allows you to add a precision edge line around your picture, to help prevent some images 'running out' (page 251). In PhotoDeLuxe, for example, you select Advanced>Effects>Outline. In the dialogue box which appears, you set the width (in pixels) the colour (from a palette) and the opacity or darkness of the line.

As well as, or instead of, a line it is possible to set a 'drop shadow' as shown above. This gives your picture an apparent 'lift' separating it from the surface of the page. It becomes like an artwork hung on the wall, losing the 'window on the world' directness of most photographs. Pale drop shadows are now very often applied to photographic illustrations in brochures and books. A further variation is to make a drop shadow follow the detailed outline of the subject of your picture so that it comes forward as a cutout, like Figure 14.36. This is more time-consuming. The entire circumference must first be shaped out using a marquee or lasso tool. It is

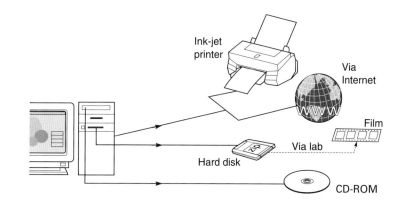

Figure 14.37 You can output finished work as ink-jet prints in colour or monochrome, or transmit to other computer terminals via the Internet, page 301. Files can be output on hard disk for custom labs to convert into film negatives or slides. CD-ROMs are a low-cost way to send out digital portfolios of your work for potential clients to keep

next pasted on a white background before applying drop shadow. Bear in mind when you are setting your shadow's direction that it should relate to the direction of lighting shown in the picture itself.

'Saving' your digital file

When you scan-in or download a picture file into the computer you will need to give it a name (short of this it comes up 'untitled'). The dialogue box 'Save As' appears or can be accessed via *File* on the command bar. Three actions are required of you: (1) using the keyboard type in a short, one or two word image name, such as 'Flowers'; (2) click onto one of a list of folders ('photos' for example) where you want the picture to be stored on the computer hard disk; (3) click on which file format you want it stored in.

Current software makes available about ten different file formats, but the most important and universally used two are TIFF and JPEG. In essence pictures saved as TIFF files retain maximum resolution and are accepted everywhere – by labs, publishing houses and printers. The only trouble is that TIFF files take up many megabytes of space on your hard disk for each picture and are also slow to download through the Internet, etc.

JPEG on the other hand utilizes what is aptly known as a 'lossy' compression technique, to slim down the digital information held for each picture. The result is a certain loss of resolution and colour fidelity. Far more JPEG files can be held on your hard disk, which is helpful if the computer is underpowered. They also download quickly to Web sites, etc., where lower resolution pictures still look good read off monitor screens.

Wherever practical it is best to file your work as TIFFs, knowing that a JPEG version can always be generated from it, but not the reverse since information is missing. Photoshop supports its own (PSD) file system similar in characteristics and universal acceptance as TIFF but not interchangeable with it.

When you have finished on an image and click the *Close File* command or icon, a fly-out queries whether you wish to save the changes you have made. Clicking 'Yes' updates the file, which still keeps its same name. Alternatively you can store your manipulated image in a second, new file by clicking File>Save As and then, say, typing in Flowers 2. This way you retain access to both the original picture (File>Open>Flowers 1) and the manipulated version (File>Open>Flowers 2).

Figure 14.38 Photoshop's unsharp mask (Filter>Sharpen>Unsharp mask) is the most effective way to improve visual resolution in an image before printing. Typical settings are shown on this fly-out, but explore the effect of each slider while you watch appearances on the sample panel, switching the preview off and on.

Figure 14.39 'The Gilly-flower' by Victorian photographer H.P. Robinson. A combination print from two negatives – the figures in the garden, and the seascape behind the fence. This manipulated image was made in 1880

To avoid filling up your computer's limited hard disk space you can transfer or duplicate files onto removable compact discs. This way you can send out finished images to publishers, custom labs, etc. Storage on disk is also a way to back up your work stock – disks can be stored away from the computer itself which could get stolen or damaged. Since each full 35 mm film frame scanned at 2700 dpi creates a TIFF file of around 30 MB, disks themselves must have plenty of storage capacity – at least 100 MB, preferably 250 MB or more. They should also be a widely used system, such as Zip or some form of CD acceptable to almost everyone working with a computer.

Digital ethics

Now that we have programs and equipment to convincingly manipulate photographs, where do we stand on how they should be used? The appearance of digital tools in the mid-1990s at first sparked off great rows. Some photographers believed that work produced digitally should be banned from exhibitions, and carry a special disclaimer when reproduced in print. They argued that photography's key characteristics

Figure 14.40 'Loves Sonnet'. Ian Coates made extensive use of digital manipulation to weave appropriate elements into his romantic contemporary illustration.

Figure 14.41 'Storm in a teacup' by Paul Wenham-Clarke. A strong example of how a phrase can be translated into a visual image with the help of digital techniques. Imagination and good planning results in the kind of picture much used in poster and press advertising

depend on recording what is seen and captured in the real world, by someone with visual sensitivity. Manipulate and combine images in a computer and you reveal the weakness of photography as an honest medium.

Others heartily disagreed, pointing out that manipulation is almost as old as photography itself. After all, pictorialists were combination printing from different negatives (Figure 14.39) or making paste-up montages well over 100 years ago. Think too of all those touched-up glamorous Hollywood portraits of the past – and high street studios employing armies of retouchers to 'stipple over' every square inch of their clients' faces in portraits. In any case all photographs on the printed page today have been scanned-in and often modified in some way to improve reproduction. Photographers should explore every conceivable new technology to see what it offers as an image-making tool.

In advertising work digital manipulation is extensively used for eye-catching sales images (within legal limits of product deception). People accept most of this obvious trickery in the spirit of entertainment. Computers allow new, often romanticized, approaches to portraiture.

Also commercial mail-order catalogue illustration work is now almost entirely digital. Products shot in the studio are easily montaged into outdoor location backgrounds, fabrics shown in a whole range of colours working from one garment, etc. Fine art photographers too see computers as tools to help them express visual ideas and develop new kinds of imagery.

The main difficulties concern press and documentary photography, and photo-journalism. Here undetectable picture alterations undermine what has traditionally been regarded as the camera's 'photographic truth'. Admittedly, photographers working in war zones have been known to physically rearrange the possessions of battlefield casualties for stronger effect . . . or simply change lens and viewpoint to exaggerate perspective. Editors too regularly crop off 'unnecessary' parts of photographs. (The right hand edge of the Vietnam picture, Figure 1.7, originally included a soldier, apparently indifferent, reloading his Nikon.)

Computers now make it a simple step to excesses such as intensifying bruises on the face of a victim of a mugging, showing a teetotal politician holding a glass of champagne in place of a tumbler of water, and so on. Working today that great surrealist documentary photographer Henri Cartier-Bresson could in theory have put the figure in his street scene (page 8) into just the right position by digital means, long after his picture was taken.

The reality of the decisive moment in great photo-journalistic shots is what has always given them substance in the past. Now that digital manipulation can hoodwink readers, they have to rely on the integrity of photographers and editors. It has been mooted that any doctored picture in a newspaper should have the fact admitted in its caption. The idea has not been taken up, although since the late 1990s several newspapers have quietly adjusted the attribution alongside the photographs they publish from '*Photo:* A N Other' to '*Picture:* A N Other'.

Summary. Digital image manipulation

- Working with a computer you can change image depth of field, create movement blur, clone other bits of a picture to change its contents or cover defects; plus most of the regular darkroom techniques including colour printing.
- You need patience and ample time at first to master the chains of command, understand new technical terms. It all becomes easier as you grow more experienced.
- In specifying your computer hardware make sure that its hard disk, processor and RAM memory all offer sufficient capacity and speed to handle the large digital files photographs create. Have drives for CD and removable hard disks built-in. You can always start with a minimum specification computer and upgrade its various components later.
- Essential peripherals include a high resolution monitor of sufficient size, mouse, keyboard and printer. For a full kit include flat-bed and film scanners, digital camera card reader, graphics palette and modem.
- Photo-manipulation software ranges from entry-level programs up to highly comprehensive packages such as Photoshop. If you are a beginner work your way up gradually. Make notes.

- Typically programs display your picture surrounded by a command bar, tool bar, scrolling controls. Clicking symbols on the bar in turn releases fly-outs such as dialogue boxes for you to make settings.
- Image changes made by computer which parallel what you are used to achieving in the darkroom are often the easiest to learn first. The 'Help' command brings up explanations and advice on screen, more accessible than an elaborate manual.
- Key manipulation controls – Brightness/Contrast; Colour balance; Rotate/Crop; Clone; Undo.
- Using tools you can change colours; shade and print-in; move elements in your picture to new positions; montage parts of different pictures together; and many more. It's also possible to reduce depth of field and introduce movement blur, either overall or just over selected areas. Ease off the 'special effects'.
- Before montaging several images together make sure they match in lighting, perspective and (preferably) colour balance. If you are scanning-in from film remember that *negatives* are inherently less contrasty than slides and so often give better quality digital images.
- Levels (Histograms) and Curves offer a sophisticated way of altering the distribution of image tone values and colours.
- Experiment working in monochrome, and check out the use of duo-tone and tri-tone. With a flatbed scanner explore photograms; consider combining them with camera-shot images.
- By applying distortion a 'flat-on' shot can be reshaped into an image with pseudo-perspective. Converging verticals can also be corrected this way. Edge-lining and a drop shadow suit some pictures as a finishing touch.
- Be sure to save all your finished work onto the computer's hard disk, and if possible, duplicate files on a removable disk as back-up. Saving as a TIFF or PSD file will retain maximum resolution, but is demanding on disk space. JPEG compresses information, saves disk space and suits electronic transmission where work will only be viewed small size on a computer screen.
- Although image manipulation has long played a role in photography, modern digital techniques allow speedy, far more convincing results. This casts grave doubt on the integrity of some forms of photography (e.g. documentary) which people still trust as factual evidence.

Projects

1 Find examples of manipulated silver halide photography. Check out: H.P. Robinson, Le Gray, Oscar Rejlander, Hannah Hoch, E.L. Lissitzky, John Heartfield, Angus McBean, Peter Kennard. What do you think was the *purpose* behind the work of each of your chosen photographers?

2 Using an entry-level photo-manipulation program it is possible to practise digital work with a basic computer having as little as 40 MB RAM, 8 GB hard disk, and a 15 inch monitor. Your high street lab can inexpensively put a selection of your negatives and slides onto a Photo-CD. The equipment will be slow in opening files, making changes, but you can get started and learn a lot.

3 Pick just one or two tools at first and thoroughly learn what each can do. Try Brightness/Contrast, Clone, and Colour Balance. Make notes. (You don't necessarily have to print anything out.)

15

Finishing and presenting work

This final chapter is about completing your work and presenting it to other people in the most effective way. Finishing off means mounting, spotting if necessary, and deciding how pictures might be brought to the attention of potential clients. Probably you will have to trudge around showing your portfolio . . . or you may be lucky enough to get work published or have an exhibition . . . or you could decide to display your talent via the Internet. In all these forms of presentation communication skills are important. You not only have to pick what images to show, but how to back them up with verbal or written information.

The permanence of prints

Image stability is a vital element in professional photography. Clients have a right to expect the work they have purchased to last a reasonable time – either as many years as possible, or at least sufficient for its intended purpose. Over time a great deal has been learnt about the permanence of prints on silver halide papers. The recent use of ink-jet prints however has created some concern over how long they will last without fading.

Conventional silver halide prints

In chemical processing you can either aim to get prints of average stability for normal commercial use and storage conditions, or you can work to the highest possible archival permanence. The latter should certainly be the aim when selling a print as an expensive piece of fine art, or producing records which will be filed away in archives and so must survive unchanged for the longest possible period. An archival print is one that is as free as possible of residual thiosulphate (fixer) and silver by-products, and has extra protection from chemical reactions with air pollutants. One form of protecting the silver image is to coat it or convert it to a more stable material by toning. Present thinking suggests the following as the best archival printing routine. Choose a fibre-based printing paper, preferably a silver-enriched premium weight type. Make sure you develop fully. Follow this by effective stop-bath

treatment but don't use the solution at greater than the recommended concentration. Fix in rapid fixer with hardener, using a two-bath system and remembering to agitate regularly. Then there are two choices. Either rinse and treat in hypo clearing agent, or tone the image using selenium toner made up in working-strength hypo clearing agent. In both cases agitate continuously. Finally wash prints for 60 minutes in an effective print-wash system, then squeegee and air dry them.

Ink-jet prints

Early (pre 1997) digital ink-jet prints had a bad reputation for fading. Manufacturers prioritized other needs, such as smooth-toned images and quick drying, so the paper used was very porous in order to have excellent ink absorption. As a result prints readily absorbed atmospheric gases which in conjunction with strong light caused image fading after about three months. Since then intensive research by ink and paper manufacturers has greatly improved permanence. Lifetimes before noticeable fading occurs have since been quoted as around five years for ink-jet prints, six for dye-sublimation prints and ten years for laser prints. As with all relatively new materials the way tests are made have taken time to establish, and improvements are made all the time. Lyson fine art inks for example have since been given an (indoor) life expectancy of over eight years when used with the recommended coated paper. This is as good as an average neg/pos silver halide colour print, tested under the same conditions.

However, just how long your finished print will last depends on many factors outside your control – adverse temperature or humidity, display under excessive UV rich radiation, effects of atmospheric pollution, or contact with non-archival packing, mounting or framing materials.

Mounting methods

Mounting is an important stage in presenting professional-looking work. In addition it can help to protect the photographic image from chemical deterioration and handling damage.

Figure 15.1 Dry mounting. A: attach the centre of the mounting tissue to the back of the print, using a heated tacking iron. B: trim off borders plus excess tissue. C: tack corners to your mount. D: cover the print with silicon release paper and place it in the heated mounting press

Dry mounting

Provided you have access to a heated, thermostatically controlled press, *dry mounting* is the best means of attaching a print to a board with a professional looking finish. As Figure 15.1 shows, you first attach a thin sheet of heat-sensitive material to the back of your (untrimmed)

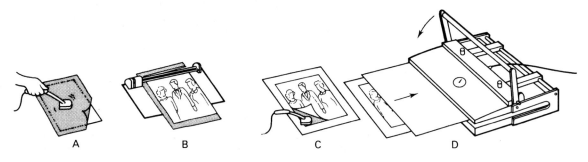

A B C D

Figure 15.2 Window mat mount construction, using thin linen tape to tack the untrimmed print in place and hinge the top board over it. The cut-out area looks best given bevelled edges

print. Then you trim the print plus heat-sensitive material together, and position them accurately on a suitable acid-free board, preferably museum board.

You next protect the print surface with a sheet of silicon non-stick release paper. Board, print and silicon cover sheet must all be absolutely dry. The whole sandwich then goes face-up into the top-heated press, which melts the adhesive layer into both print and mount within a few seconds. Press temperature is especially critical with RC prints, and above 99°C (210°F) blisters may occur. If your print was made by ink-jet printer or some other digital output, check the paper maker's recommendations. Most dry-mounting materials are designed for temperatures between 66° and 95°C, according to type.

The most common dry-mounting faults are (1) tiny pits or protrusions in the print surface due to grit caught between print and press, or print and mount, respectively; (2) unmounted patches due to uneven heat or pressure; (3) adhesive sheet firmly mounted to the print but not to the mount, owing to insufficient heat; (4) adhesive stuck to the mount but the print detached (and blistered if RC) because of excessive heat.

Adhesive tape

Double-sided adhesive tape (or sheet) is a quick way of mounting small prints, especially RC materials, but it is less permanent than dry mounting. Alternatively, if the paper is of reasonable weight, use single-sided linen tape to tack one side of the untrimmed print to mounting board. (One-sided attachment allows for differences in expansion.) Then the print is held down flat with a window mat cut from similar or thicker high-quality board; see Figure 15.2. The mat also protects the print surface from sticking against glass if the work is framed, and allows air circulation.

Liquid adhesives

Most general-purpose household adhesives are unsuitable for photographic mounting, as chemicals eventually attack the image. Heavy-duty wallpaper adhesive is the most practical way to mount very large bromide prints. Handle them the same way as wallpaper, and if you are

Figure 15.3 Spotting-in white specks and a hair mark by hand on the surface of a mounted bromide print. Use an almost dry 0 size watercolour brush with a good point. Far right: the patient stippling-in of tone is half completed. A hair line like this is best broken in two or more parts first, then each section matched into surrounding tone

Figure 15.4 Removal of defects from a digital image, using the computer's clone tool (page 275) before printing-out. Near right: 'Red eye' corrected by cloning in from a dark shadow area elsewhere in the picture. Far right: this cracked area of an old print is filled in by cloning from adjacent picture detail. As you drag the large cross horizontally over this image tones from just above the tear (see small cross) are copied and fill in the defect

mounting on to flexible board, remember to paste several strips of paper across the *back* of the board too, to prevent it curling as your print dries and contracts. Resin-coated bromide prints can only be mounted this way if your board is porous enough to allow solvent from the adhesive to evaporate.

Impact adhesive is another way of mounting oversize prints: coat both the print back and mount, allow them to dry, then bring them firmly into contact with a roller squeegee. Aerosol spray-on adhesive is recommended only for temporary 'paste-ups' such as montages or panoramas which will eventually be re-photographed. Dry-mount your base print. Then cut out and chamfer the edges of the print you want to mount on top, by sandpapering the back until wafer thin. Spraying then allows you to apply a very thin layer of adhesive to this surface before pressing the cut-out print into place. (Note: often impact adhesives are highly flammable – use them only in a well-ventilated place.)

Spotting

Silver halide materials. Often prints have a few white spots which you must 'spot in'. Use diluted dye or water colour – either black or the appropriate tint – and apply it with an almost dry, fine-tipped brush. By patiently adding tiny specks (not a *wash*) of matching tone, pale defects can be merged with adjacent image grain; see Figure 15.3. As an alternative to a conventional brush, 'brush tip' pens which each contain their own shade of dye are sold in sets of ten. A set for monochrome spotting for example provides a grey scale ranging from a very pale grey pen to one giving deep black.

Spotting is easiest with a grainy image on matt or semi-matt paper. Glazed glossy prints are almost impossible to spot without leaving some evidence of retouching on their mirror-like surface. However, gum arabic (e.g. from the glue flap of an envelope) mixed in with the water-colour helps it to dry with some form of matching glaze.

Dark spots are best tackled earlier – turned into white by spotting the negative, or by touching the print with a brush tip loaded with iodine

Figure 15.5 A 24 × 20 inch weatherproof, zip-up portfolio. Having individual prints in plastic sleeves protects the work, and allows you to change prints or alter their order

bleach (page 319). Then they are spotted like any other white defects. However, on matt prints you can also try direct print spotting with white pigment.

Digital materials. It should not be necessary to spot the actual hard copy print-outs from digital files. Image defects are very easily eliminated using your manipulation software before the picture goes to your printer. The cloning tool is invaluable here, see Figure 15.4.

Getting your work noticed

The world of photography is very competitive, so at the earliest opportunity it is important to start to get yourself known. For example, enter as many photographic competitions as possible – even if you don't win they can provide you with good sources of project themes, get you used to working to deadlines. Try to have some pictures published, together with a credit line. Look up the *Writers and Artists Yearbook.* Even something in a local newspaper or a trade magazine will mean you can put a photo-copy in the back of your portfolio, helping to prove that other people have confidence in you. Seek out cafes, bars, etc., willing for you to put up a display. And check out how to create a web site to show your work; see page 301.

Portfolios. Taking around a battered parcel of prints of all sizes to show people makes you seem amateurish, immature . . . or just arrogant. At least have work mounted on thin boards matching in size, which are shown in a box (Figure 15.6) or a ring-binder type book. These make it simple to change your selection and the order of pictures to suit the occasion. (20–25 pictures is about the right number.) Better still invest in a zip-up professional 20 × 16 or 24 × 20 inch portfolio with acetate leaves to contain each print in complete protection, Figure 15.5. Just remember that if people only view your work through the acetate the tone qualities appear degraded. Darkest tones especially look weak and lost.

Figure 15.6 Some basic forms of presentation. Left: album for prints up to 10 × 8 in, back to back in acetate sleeves. Centre: framed behind glass. Right: fold-open box for loose mounted prints – pictures are transferred to the other half of the box as viewed

As much as possible take your portfolio around to art directors, gallery curators and other potential clients. Their comments are always worth hearing, even though you may not always agree. Think ahead too in terms of how to give intelligent answers to the sort of questions you could be asked as someone in the art world examines your work. 'Why did you take this photograph?' 'What were you trying to convey – what led you to this place and moment in time?' 'Which is your favourite picture in this collection you are showing me. Why?' Be prepared to

Figure 15.7 Exhibition display. When hanging pictures of mixed proportions work to a common top line using tensioned horizontal cord set by spirit level as a hanging guide. For variety, use end facing walls for large bold 'points of emphasis', and enclosed areas to show smaller prints in a contrasting environment

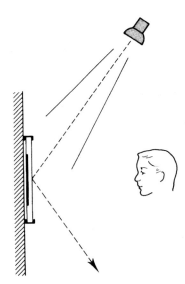

Figure 15.8 For prints exhibited behind glass, position lighting from a high, oblique angle. Flare reflection will then be directed downwards on to the floor, not towards the viewer However, have the light source as distant as possible, to minimize unevenness between top and bottom

openly express your thought process – it will help to prove that the work has direction and cohesion. Can you discuss the work of other photographers, seen in books or the Net, or in exhibitions?

Displays and exhibitions. If you are lucky enough to be offered some form of exhibition the standard of presentation becomes even more important. (After all, you will not be there all the time to speak for your pictures). Take care over the lighting. The same tone range degradation effect caused by viewing prints through portfolio acetate applies to photographs framed behind glass. You may be able to control this by careful positioning of spotlighting, Figure 15.8. In locations with many surrounding reflective surfaces, or having only flat frontal lighting, it may even be best to remove glass from the frames.

The form of presentation which least influences a picture's content is flush mounting – attachment to a board or block, trimmed to the picture edge. This is often a good direct way to show journalistic and social documentary photography. Flush mounted prints, displayed proud from a wall and spotlit, also suit commercial and industrial exhibitions, etc.

At the other end of the scale, framed portraits, decorative landscapes, etc., for hanging in a domestic or office location are effectively picked out if plenty of space is left between picture edge and frame. This might be a wide border left on the print or mounting board, or a window mat, Figure 15.2. (Bear in mind that a mat also gives you a final opportunity to adjust composition.) Make sure that the *tone* and *width* of any surround suits the picture content. For example, a strongly coloured window mat is likely to overwhelm a black and white picture. Unless you aim for a special effect, use only a mount or mat which has a very muted hue, and harmonizes with any dominant colour in the print.

A dark-toned surround (mat, or wall area) tends to emphasize your picture's lighter contents, and any shapes formed where pale objects are cut by picture edges stand out. A white surround has the opposite effect. Bear in mind too that wide areas surrounding a relatively small print tend to make it look smaller (and more intimate) still.

With any exhibition or display area, the size and tone density of your pictures, and the form of presentation, should be related to the physical conditions in which they will be seen. The intensity and evenness of the lighting is one factor; the height and layout of display walls is another.

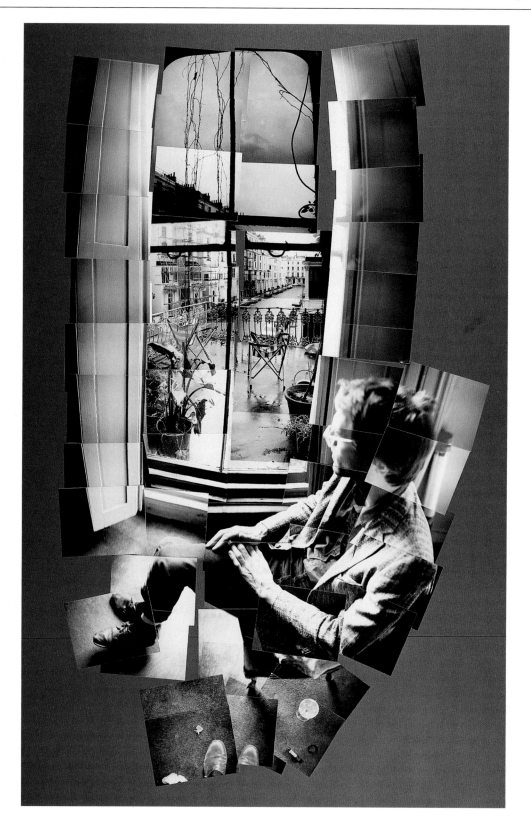

Figure 15.9 Opposite: 'David Graves Looking at Bayswater, London, November 1982', a collage, using paste-up instant picture prints. David Hockney's 'joiners' are not meant to be accurate mosaics but a selective build-up of a scene from its detailed elements

Corners offer natural breaks in a picture sequence and alcoves provide intimate enclaves, whereas a long unbroken surface and tall ceiling suit a run of large prints. Think too of likely spectator viewing distance relative to the perspective of your major pictures (page 82).

An exhibition should contain variety – carefully considered 'high-points' created through juxtaposition of picture content, size and proportions. You need a thread of continuity, too, without lapsing into dull uniformity. Much can be done here by maintaining consistent image colour, mat tint and style of frame, and ensuring that they also relate well to the tone and texture of the exhibition display surfaces.

Pictures on the World Wide Web

The World Wide Web is a widely used special service. Like e-mail it runs on the Internet, the world-wide network of computers linked by telephone line and providing an interactive information resource. The WWW is made up of billions of web 'sites', gathered through servers and channelled into the Internet. Each site itself is made up of web pages which contain images, text, etc., called up and displayed on your computer monitor with the aid of a piece of software (usually given away) called a browser.

The web makes it possible to show your photography all over the world, to any web user who chooses to 'visit' your site. Typically a portfolio is displayed in the form of up to a dozen thumbnail size images per page, Figures 15.10 and 15.11. Images this size are just big enough to give a reasonable impression of image content. Anyone browsing may click onto a chosen shot to double or quadruple it in size on screen, but since you keep the displayed image file down to quite a small number of pixels image quality is not good enough for people to download and illegally re-use.

Showcasing your work on a web site means that it can be seen in over 100 countries and is accessible 24 hours a day. Anyone who wants to publish one of your portfolio pictures or buy a copy can contact you

Figure 15.10 The web site of Digital Press Office. This is an image distribution system representing a number of British photographers. Visitors to the site can order images either for downloading direct to computer or in various other media, digital or conventional photographic

Figure 15.11 A page from a web site designed to appear as an array of medium format colour transparencies viewed on a light box. Selection of one of the 'thumbnail' images may open a link to a larger, more detailed image or related information. The images can be updated as necessary

by e-mail to have a high resolution version downloaded to their computer, or be sent the work as a disk or in photographic print form. Often too potential clients – design studios, art editors, publishers – visit web-located portfolios, looking at the style and quality of different photographers' work before deciding who to commission for a job.

On the other hand, with such a vast number of web pages now in use around the globe it is important for people to know how to log onto your site. As the WWW expands, users get increasingly frustrated attempting to locate what they need from upwards of 20,000 sites now specifically related to photography. This is where web 'search engine' software is helpful. Of course, if people know your name they can find you by simply typing this into the search engine. But more often they enter the required category of photography and the program retrieves a list of web sites (with brief written descriptions of content) relevant to their query. Using the mouse they can then click on any one of hundreds of sites to make its home page appear. If your site has several pages your first home page can display an index of your own picture categories.

How to get connected

Apart from a computer, which can be quite basic for WWW purposes you will need:

1 A modem to link the computer to your phone line. Modern computers often have a modem built-in. A 56 kb/s modem downloads data at 56 kilobits per second, which has become a standard specification for speed.
2 An account with an Internet service provider (ISP). This is a very competitive industry – ISPs offer unlimited access to the Internet, charging a monthly rent. Their start-up package includes all software needed for connection, plus your user name and password.

3 Additional software such as a web browser. Simple software like this often comes free, attached to magazines and similar publications. Netscape Navigator and Microsoft Internet Explorer are popular browsers in the UK.

You can easily do the designing of your web site appearance yourself, using WYSIWYG (what you see is what you get) authoring tools. Most photo manipulation software includes these as a feature, or you can buy them as software plug-ins. You can get then on with pasting in your choice of images plus text, without having to worry about technical complexities to ensure it will all work on the web.

Although you may not have a web site of your own, being on the web gives you access to an enormous volume of photographic reference material, visual and technical. Galleries, museums, photographic manufacturers, publishers, even auction houses selling antique photographs and equipment are all worth a web visit. Remember too that you are sourcing worldwide – one minute you can be viewing a leading photographer's work in Australia, then drop by the Royal Photographic Society's historical collection in England before visiting the massive Eastman Kodak site in America . . .

Summary. Finishing and presenting work

- Image permanence in prints is very important for all photography sold professionally – especially fine art prints. An 'archival' silver halide print should be on fibre-base paper, as free as possible of fixer and silver by-products, and given some protection from air pollutants through selenium toning. The jury is still out on the long-term permanence of digital ink-jet prints. Intensive research on inks suggests that life span for this new medium will soon match traditional silver-halide processes.
- However carefully a print is made, image fading and other changes are just as often due to the way it is later displayed and stored. Excessive UV rich lighting, damp, chemical pollution from packaging or atmospheric conditions all take their toll.
- Mount your silver-halide prints by dry-mounting; sandwiching behind a window mat; use of self-adhesive sheet or tape; or (giant prints) a wallpaper liquid adhesive. Prints mounted on board can be trimmed flush without borders, or left with print or mount borders which are either white or some tone harmonizing with your image. Underplay coloured mount or mats.
- Retouch white spots on silver-halide prints using dye or watercolour on a fine brush, gradually blending in with surrounding tone. Alternatively apply spotting dye from a range of brush tip pens.
- Get your work noticed. Enter competitions; get some pictures published; find good places where you can put work on show. Perhaps you can set up or share somebody's web site?
- Good work doesn't deserve to be presented in a scruffy portfolio or box. Take care picking your pictures (20–25) and deciding their order, bearing in mind the individual who will be looking at them.
- Get out to see art directors, gallery curators and others with your portfolio. Think how you will present it. Be ready to answer questions articulately on your approach and the intended meanings

in your pictures. Have a view on the work of some leading photographers, present and past.

● When planning a display or exhibition sequence your prints with due regard to continuity and variety. Fully exploit the physical environment where your show is taking place – use its features to create natural breaks, give points of emphasis.

● Lighting the work effectively is very important. Prevent reflections, which dilute the richness of image tones and colours.

● The World Wide Web provides an important, fast-growing showcase for photographers. You can display thumbnail versions of prints viewable 24 hours a day from almost every country in the world. People browsing the web on their computers can visit your work, buy pictures, decide to commission you for jobs.

● Connection to the web calls for a modem; browser software; and the services of an Internet service provider. You can design your own web site using tools within most modern image manipulation software programs.

● Browsing the web yourself gives you an enormous source of visual information on what other photographers are currently doing, especially in other countries.

Projects

1 Examining a series of small, hand-size prints in a set order is an intimate one-person experience, very different to looking at a wall of big pictures in a public exhibition. Make yourself a 6 × 4 in book of 12–15 pages containing one small print per double page. The theme might be a poem, or a nostalgic memory of childhood, a diary of a simple event, or visual recollections of a place. Think carefully about your approach to shooting, print qualities and the order in which each picture is to be separately viewed.

2 Mock up a World Wide Web site which displays up to 10 of your pictures, plus brief text material to explain how you can be contacted. Scan in the work so that it fills your monitor screen, or prepare it as small bromide prints mounted on card the size and shape of a 17 inch screen.

3 Shoot a panorama, or a 'joiner'. For the panorama shoot from one position with a normal or long focal length lens, panning the camera between shots. The subject content of each frame should overlap that of the next by at least 30 per cent. A joiner (Figure 15.9) can be more loosely structured, varying viewpoint slightly to give more an impression than a record. Make a series of prints matched in tone and size, and mount to give one composite picture.

Appendices

A: Optical calculations

Pinholes
The best size pinhole for forming images has to be a compromise. It must be small enough to form quite tiny circles of confusion, so that as much subject detail as possible can be resolved. But the smaller the hole the more diffraction (page 326) increases, so that eventually detail no longer improves and rapidly becomes worse.

$$\text{Optimum pinhole diameter} = \frac{\sqrt{\text{distance from film}}}{25}$$

So for a pinhole placed 50 mm from the film, best diameter is the square root of 50 divided by 25 = 0.3 mm. To make the pinhole, flatten a piece of thin metallic kitchen foil on a pad of paper. Pierce the foil gently with the tip of a dressmaker's pin. Check with a magnifying glass that the hole is a true circle and free of ragged edges. By placing the millimetre scale of a ruler next to the hole and examining both through the magnifier it is just possible to measure diameters down to about 0.2 mm.

In the example above the relative aperture is $f/150$. However, a modern SLR camera set to aperture priority (Av) mode should be sufficiently sensitive to measure exposure from the image itself. You may need to adjust your film's ISO setting to compensate for long exposure reciprocity failure; see page 314.

Image size, object and image distances from lens
Codings:

F = focal length
M = magnification
I = image height
O = object height (neg height when enlarging)
V = lens to image distance*
U = lens to object distance* (to neg or slide when enlarging or projecting)

*See warning note on page 306.

Magnification formulae:

M = I divided by O
M = V divided by U
M = V divided by F, minus one
I = O multiplied by M
O = I divided by M

Object/image distance formulae:

V = M plus one, multiplied by F
U = one divided by M, plus one, multiplied by F
V = F multiplied by U, divided by U minus F

Close-up exposure increase when not using TTL metering
This is important when you are using a camera which does not measure light through the camera lens. Extra exposure (by means of aperture or time) has to be given when you are working close up. The increase becomes significant when the subject is closer than about 4.5 times the focal length of your lens, or to put it another way, when the image size is greater than one-sixth of the size of the subject. Under these conditions and assuming that you would be measuring exposure with a separate hand meter, the exposure that the meter reads out has to be multiplied by either:

(i) M plus one, squared
(ii) V squared, divided by F squared; or
(iii) U divided by U minus F, squared

For example, you might be using a rollfilm camera with an 80 mm lens to photograph a small 10 cm high product 5 cm high on film. The hand-held meter reads $\frac{1}{2}$ sec at f/16. Following formula (i) above, magnification is 0.5, so exposure needs multiplying by $2\frac{1}{4}$ times. In practice, this means changing to 1 sec at f/16.

***Warning note on telephoto and inverted-telephoto lens designs.** The above formulae are sufficiently accurate for most large-format camera lenses, enlarging lenses, and normal focal length lenses for rollfilm and 35 mm cameras. However, expect some discrepancy if using any formula containing V or U for lenses of either telephoto or inverted-telephoto construction. This is because it is difficult to know from where to make simple measurements with a ruler alongside such a lens. In these circumstances you can still calculate close-up exposure increase accurately using the formula based on M rather than V or U.

Figure B.1 The range of ways in which large-, medium- and some small-format cameras allow you to shift or tilt the lens or back to provide 'camera movements'. A: baseboard view camera. B: 35 mm shift lens, racked upwards to give rising front. (Lens mount rotates, allowing you to also turn this into a crossfront movement.) C: bellows unit replacing Hasselblad body. Accepts regular lens and rollfilm magazine but uses a direct focusing screen. D: A 'shift camera' with rollfilm back set to give rising front. The linked direct viewfinder pivots to adjust framing

B: Camera movements

The term 'camera movements' refers to the group of features offered on some cameras by which the lens and/or film plane shifts sideways or pivots. The advantage of a camera with movements is that it can get you out of all kinds of difficulties, particularly in architectural or still-life studio photography. Using movements you can create depth of field, adjust the apparent shape of subjects, even photograph square-on views of reflective surfaces without your reflection showing.

The most comprehensive range of movements is to be found on large-format cameras, but some are offered by medium-format professional cameras too. Special lenses allowing movements are made for 35 mm SLRs. See Figure B.1 and Figure 4.14 on page 63.

Normally in any camera the surface of the lens is parallel to the film, the lens centre is aligned with the dead centre of the picture format, and a line between the two (the lens axis) is parallel to the camera base. In a camera offering movements this arrangement is said to be 'neutral'. From here there are *shift* movements (known as rising, drop and cross front or back) and *pivoting* movements (swing front or back), see Figure B.2.

Shift movements

Rising front means upward shift of the lens, remaining parallel to the film surface.

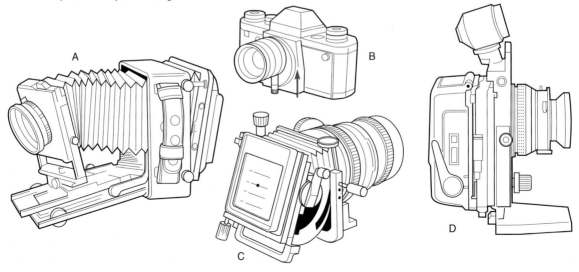

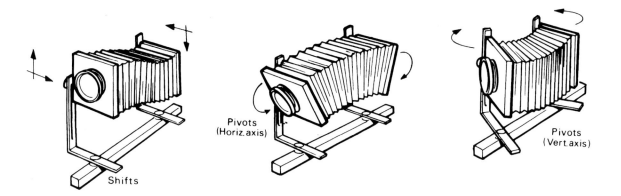

Shifts Pivots (Horiz.axis) Pivots (Vert.axis)

Figure B.2 A monorail camera offers the greatest variety and range of shift and pivot movements, which can be used simultaneously

Drop front means shifting the lens downwards, again parallel to the film, placing the lens axis below the centre of the picture format.

Cross front involves shifting left or right, parallel to the film, placing the lens axis to one side of the picture centre.

These three shift movements are achieved on a view camera by undoing locks on the front (lens) standard and sliding it a few centimetres up, down or sideways. On a monorail view camera front and back standards are identically engineered, so you can double the effect by moving them in opposite directions – for example shifting the back of the camera downwards when you use rising front. Standard-length bellows may not be flexible enough to allow much shift movement. With a view camera you can work more easily by changing to bag bellows instead (Figure 5.9). One or two rollfilm cameras (wide-angle shift cameras) offer shift movements by not having bellows at all. Instead (Figure B.1) two sliding plates are used and the lens has its own focusing mount.

On small- or medium-format SLR cameras the body as such may not offer movements. Instead you fit a 'shift' or 'perspective control' (PC) lens. This has a special mount allowing the whole lens to slide a centimetre or so off-centre in one direction. The mount itself rotates, to allow you to make this off-setting give either upward, downward or sideways shifts.

Note on lens coverage

Shift movements (or lens pivoting) tend to move the lens axis *away from the centre of the picture format*. You should only do this if your lens has sufficient covering power (Figure B.4) to continue to illuminate the entire picture area. Otherwise the corners and edges of the format farthest from the lens axis will show blur and darkening. Most good lenses for view cameras are designed with these movements in mind and have generous covering power.

The usual range of lenses for medium- and small-format cameras cover little more than the picture area for which they are designed. Shift lenses are exceptional. Optically they must cover a much larger image patch. Mechanically too the back of the lens must be far enough forward to allow off-setting and pivoting without fouling the sides of the mount. Most shift lenses are wide-angle, typically 75 mm for 6 × 4.5 cm or 35 mm or 28 mm for 35 mm format.

Using rising front

Effect. As you raise the lens the image shifts vertically too. The lowest parts of the subject no longer appear but you gain an equivalent extra strip at the top of the picture. Raising the lens, say, 1 cm raises the image 1 cm. But in most situations the image is much smaller than the subject, so this small shift alters the subject matter contained in your picture by several metres – far greater than if you raised the whole camera by 1 cm.

Practical purpose. Rising front allows you to include more of the tops of subjects (losing an equivalent strip at the bottom) *without tilting the*

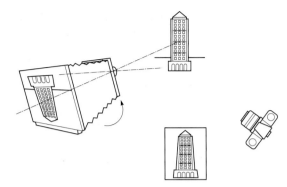

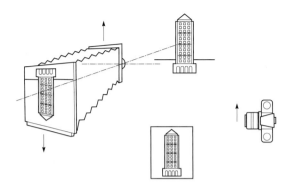

Figure B.3 Shooting a subject well above camera height, when you cannot move back or change to a wider angle lens. Below left: tilting the camera results in converging vertical lines. But (below right) camera movements allow you to keep the camera back vertical and raise the lens to include the top of the subject without convergence. See also Figure 14.34

camera upwards. The objection to tilting the whole camera is that vertical lines seem to converge. Tall buildings shot from street level or cylindrical containers photographed from low level in the studio begin to look triangular. You can argue that this is exactly how they appear when you look up at a tall subject. However, the stereoscopic effect of seeing with two eyes plus the physical act of looking up helps you to accept converging uprights as a perspective effect – the top of the subject is experienced as more distant than the base. On a two-dimensional photograph though results can be interpreted as something with non-parallel sides, particularly when they are just slightly out of true. (The same problem occurs when you must record a painting fixed too high to allow a centred camera viewpoint, or have to shoot an interior showing more ceiling detail than floor, without walls appearing to converge, Figure B.5.)

To use rising front for, say, the tall building assignment, choose the best viewpoint for perspective and subject inclusion, and position the camera *with its back absolutely vertical.* See Figure B.3. This is vital if vertical lines in the structure are to reproduce parallel. The top of the building will now be out of the picture and too much is included at the bottom. Focus the image, then raise the camera front or shift lens until the image of the top of the building moves on to the focusing screen. If in doing this you lose too much at the bottom of the scene, either

move back (and accept slightly flatter perspective) or change to a wider-angle lens.

Overdone, any shift movement can produce two ill effects. These are 'cut-off' (image darkening) and shape elongation. Both are likely to show in that part of the picture you have just moved onto the screen. Watch out for darkening towards the two corners here, and remember that cut-off has a much more obvious edge when the lens is stopped down. This kind of trouble occurs most often with the extensive shift movement offered by a view camera.

Secondly beware of subject shapes within the area shifted into your picture looking stretched and elongated. This is because they are well off the lens axis, so that light strikes the film more obliquely here. Disguise distortion by keeping such areas plain or free of recognizable elements, especially in the corners.

Figure B.4 Covering power. The patch of image light given by this lens is insufficient to cover film format A. Format B is sufficiently covered provided it remains centrally aligned with the lens. Only film format C is suitable if you intend to use this lens off-centre (essential for most camera movements)

Using drop front

Effect. Shifting the lens downwards, making the lens axis lower than the centre of your picture, includes more at the bottom of your subject and less at the top.

Practical purpose. You can use a camera viewpoint looking slightly down, yet avoid vertical parallel lines in the subject appearing to converge downwards. In architectural photography, for example, your only camera position may be high up, perhaps to avoid traffic obstructions. In the studio you may want to show something of the top surfaces of upright objects such as boxes and packs. In all cases keep your camera back parallel to the vertical surface you do not want to taper, then shift the lens downwards to get the lower subject parts into your picture. There are the same risks of cut-off and image elongation as described with rising front, but this time they will appear in the *lowest* parts of the scene.

Using cross front

Effect. Shifting the lens left or right of centre means that more is included on one side of the picture, and less on the other.

Practical purpose. Cross front allows you to shoot an apparently 'square on' image of a subject from a slightly oblique viewpoint. For example, you may need a flat-on record photograph of a shop window, or an interior shot directly facing a mirror. Instead of setting up the camera opposite the centre of the glass where its reflection will be seen, you can position it farther to the left, keeping its back parallel to the subject. Then you cross the front to your right so that the whole image of the window or mirror shifts sideways until it is centre frame.

Similarly, when a pillar or other obstruction prevents a square-on view of some wall feature you can set up the camera right next to the obstruction, Figure B.6, its back parallel to the subject. Then cross the front to move the feature into frame. (This often gives less distortion than the alternative – fitting the camera in between obstruction and subject and changing to a wider-angle lens.) If cross front is overdone, your image may show signs of cut-off and elongation along the side and corners of the frame farthest from the shifted lens axis.

Figure B.5 Extreme rising front used with a good wide-angle lens may not give 'cut-off', but stretches recognizable shapes and details near the top part of the picture (furthest from the lens centre). Results in this area are like an extreme wide-angle; see Figure 5.14. However, in cramped locations this may be unavoidable

Pivoting movements

Swing front means pivoting the lens so that it tilts upwards or downwards about a horizontal axis, or sideways about a vertical axis, both at right-angles to the lens axis itself (Figure B.2). Front swings on view cameras are achieved by releasing a lock on the side of, or below, the lens standard, pivoting it several degrees and then re-locking. Some medium-format SLR cameras, such as Hasselblad, allow you to replace the reflex body with a very flexible bellows system. This provides a full range of swings, but you must then compose and focus on a rear screen, like a view camera. One or two shift lenses for 35 mm SLRs also contain a pivoting mechanism. Using this in conjunction with its rotating mount, you can make the lens swing about a vertical or horizontal axis, or anywhere in between.

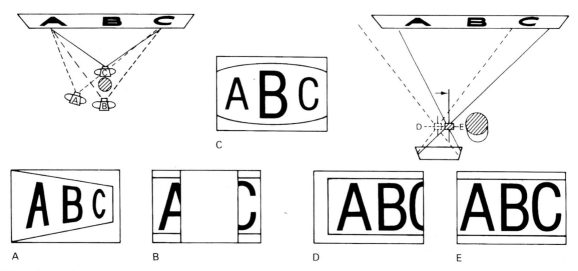

Figure B.6 Using cross front for a square-on image, despite obstruction. Without movements viewpoint A gives convergence, B is blocked and C, because you are forced to use an extreme wide-angle lens, gives distortion. In D the camera is next to the obstruction, back parallel to poster and movements neutral. E is the same camera position as D but with the cross front shifted to the right. (For easier comparison all lens images are shown right way up)

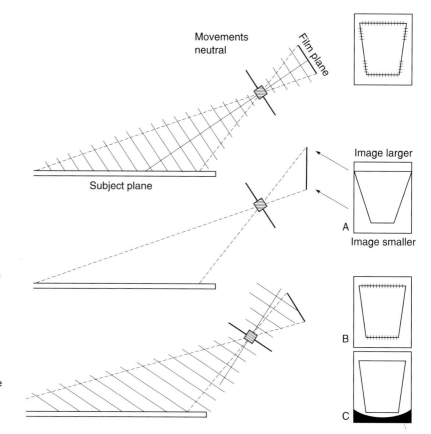

Figure B.7 Top: Even with the lens fully stopped down this oblique subject is not sharp overall. A shows the result of using swing back alone. Since near parts of the subject come to focus farther from the lens, pivoting the film into the (more upright) plane of sharp focus increases depth of field but exaggerates shape. B is the result of using swing front alone. This slight horizontal pivoting of the lens gives a better compromise between subject and film planes. Depth of field improves without shape distortion. However a lens with poor covering power will give 'cut-off' (result C)

Practical purposes. Pivoting the lens (a) alters effective coverage because it moves the point where the lens axis meets the film format, and (b) tilts the plane over which the subject is sharply imaged. The latter effect is explained as follows. A subject at right-angles to the lens axis is normally sharply focused as an image on film also at right-angles to the axis. This is typical, say, of copying a flat surface – subject plane, lens surfaces and film are all parallel. But when you swing the lens it views the subject obliquely (Figure B.7). One part of the subject, now effectively closer, is brought to focus slightly farther from the lens. In fact the whole plane on which the subject is sharply focused is pivoted to become much *less parallel* to the subject.

You can swing front to achieve effect (a) above, in which case (b) usually forms the drawback. Or you can use it for (b) but find yourself limited by (a). Here are examples of each kind of situation.

Photographing a tall structure, you use rising front to avoid tilting the camera and making vertical lines appear to converge. However, there is darkening and other tell-tale signs of image 'cut-off' in corners around the top of the subject. By unlocking the horizontal axis swing movement, you can pivot the lens to point upwards very slightly. This makes the lens axis less off-centre on the film; effective coverage is improved and cut-off miraculously disappears.

However, your lens, in viewing the subject obliquely, sharply images it on a plane at an angle to the back of the camera. It is probably impossible now to render the top and bottom of your subject sharp at the same time; the best thing to do is focus for the centre and stop down.

As another example, you have to photograph an expanse of mosaic floor extending into the distance. The camera views the floor obliquely, and even at smallest aperture there is insufficient depth of field. By pivoting the lens slightly downwards about a horizontal axis it views the floor less obliquely, giving a better compromise between planes of floor and film. This adjustment of swing front is critical, but you will find depth of field greatly improves across the floor surface.

This time the drawback is that your lens axis is now much higher than the centre of the film. A lens with only adequate covering power may produce signs of cut-off around corners of the picture where the farthest parts of the floor are imaged.

Although these examples feature swings about a horizontal axis, the same principles apply to vertical-axis swings. Their use in equivalent circumstances would be to improve coverage with extreme *cross* front, or increase depth of field over an obliquely photographed *vertical* surface, such as a long wall.

Using swing back

Swing back means pivoting the back of the camera about a horizontal or vertical axis across the film surface, usually at right-angles to the lens axis (Figure B.2). On a monorail view camera you achieve this movement by mechanically adjusting the back standard in the same way as you would alter the front standard for swing front. Baseboard view cameras offer much less swing back because of their box-like structure. Notice how swing back does not itself move the lens axis off the centre of the picture format. Therefore the lens you use needs not have exceptional covering power, unlike lenses used with shift or swing front movements.

Practical purpose. Pivoting the camera back (a) swings the film into (or out of) the plane of sharp focus for a subject, and (b) alters image shape. Once again you can use this movement primarily for (a) and suffer (b), or the reverse.

For example, you have to photograph, from one end, a long table laid out with cutlery and mats. The table must taper away into the distance, its oblique top surface sharp from front to back. Unfortunately there is insufficient depth of field for you to do this, even at smallest aperture. When you think about the problem (see Figure B.7), light from the closest part of the table actually comes to focus some way behind the lens, while the farthest part comes to focus nearer the lens. So by swinging the back of the camera until that part of the film recording near subjects becomes farther from the lens and the part recording far subjects becomes closer, you have angled the film into the plane of sharp focus. Depth of field is greatly extended – and may even be sufficient to shoot at a wider aperture.

The drawback is that the part of your image now recorded farther back from the lens is considerably larger than the image recorded near the lens. Front parts of the table will reproduce larger than they appear to the eye, and distant parts appear narrower. Perspective appears

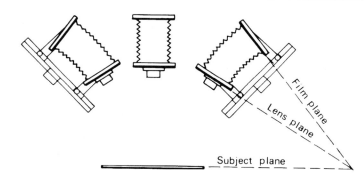

Figure B.8 The Scheimpflug correction, to maximize depth of field over a subject plane imaged obliquely. This uses some swing of both front and back, minimizing the side effects of each movement. See Figure B.9

steeper, although *only along the plane of the table*, which may give it a noticeably elongated shape. (Sometimes of course you can choose just this kind of distortion for dynamic effect.)

As another example, the new wing of a building must be shown obliquely, to taper away at one side to a feature at the far end. But it is surrounded by other buildings, and the only available viewpoint is opposite the centre of the wing. From this square-on position it appears rectangular. However, you can set up the camera to include the whole wing, then swing the back about a vertical axis to bring the right-hand side of the film closer to the lens, and the left-hand side farther away. In this way, the image at the left end is made bigger and at the right end becomes smaller – the building appears tapered.

The drawback is that the camera back no longer corresponds with the plane of sharp focus for the building (which, because it is square on, is at right-angles to the lens axis). Both ends will look unsharp; you must stop down fully and if

necessary reduce the amount of swing to get the whole image in focus.

Combined use of movements

Combinations of movements are useful either to gain extra collective effect or to create a movement the camera itself does not directly offer. Most importantly, you can often produce the result you want and minimize problems by combining a *little* of each of two movements which have a common effect but different drawbacks.

Figure B.9 Camera movements used to improve depth of field. Below, left: no movements, fully stopped-down lens. Centre: swinging the back more vertical gives the depth of field needed, but distorts shape unacceptably. Right: combined use of some front and back swings (Scheimpflug) achieves the overall sharpness needed, with minimum side-effects

For instance, in tackling the mosaic floor you could create your extra depth of field by using a little of each of front *and* back swings. The back is swung (horizontal axis) just enough to start to improve depth of field, without noticeable shape distortion. Then the front is swung (horizontal axis) just enough to extend depth of field to the whole floor at your chosen aperture, without noticeable cut-off due to poor coverage. You will notice that in doing this the subject plane (the floor), the film plane (camera back) and the lens plane (glass surfaces) all point towards one imaginary position below the camera. The less front swing you set, the more back swing is needed, and vice versa. This meeting of planes, giving best compromise position of front and back to maximize depth of field over an oblique subject plane, is known as the Scheimpflug principle, as shown in Figure B.8. Remember it as a guide.

The great thing about camera movements is to understand and control them, but use them with restraint. Decide whether it is necessary to show the verticals in a building or studio still-life as truly vertical, or whether tapering will give a stronger impression of height, more striking composition, etc. Bear in mind too that several of the perspective changes previously achieved by camera movements can now be carried out later using the computer, page 287.

C: Expressing film response

Film response to light is often presented in manufacturer's technical data in graph and in table form. Both allow you to make comparisons between different products, show a film's performance under differing conditions, etc. It is therefore worth making yourself familiar with how certain technical information is expressed, and what this means in practical terms.

Response to colour

A graph such as Figure C.1 (top) shows how a particular monochrome film responds to the colours of the visual spectrum, on the final print. This film records deep blue and purple, and to a lesser extent red, as lighter in tone than they appear to the eye. On the other hand it responds to greens as if darker than the eye's impression. Where such differences are important a green or yellow filter over the lens will bring them more into line.

The same pan film colour response curve can be compared against film (or paper) which is only blue sensitive or orthochromatic (Figure C.1, centre). The graph shows how shooting on a blue sensitive emulsion would result in a print in which green, yellow and red objects reproduce black or very dark and unnatural in tone. Ortho film responds better by encompassing green, but makes reds black; see Figure 9.14. This film can be handled safely under red lighting.

Figure C.1 Top and centre: Tonal reproduction of colours (final print) by panchromatic, ortho, and blue-sensitive black and white materials, relative to eye response. All emulsions respond to ultraviolet down to about 250 nm – still shorter wavelengths are absorbed by gelatin. Bottom: Relative response curves for the blue, green and red colour-sensitive emulsions used in typical daylight-balanced slide film. Only response *above* the broken line is significant. Y, M and C stand for yellow, magenta or cyan dye finally formed in each emulsion to give a full coloured image

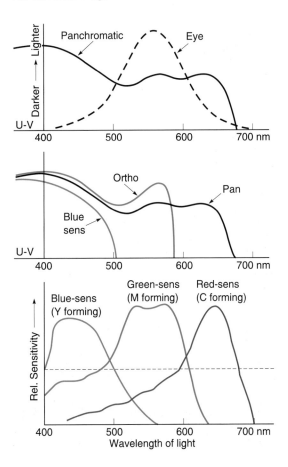

Indicated exposure time (s) ▶	$\frac{1}{10,000}$	$\frac{1}{1,000}$	$\frac{1}{100}$	$\frac{1}{10}$	1	10	100
B & W negative	+ $\frac{1}{2}$ stop	none	none	none	+ 1 stop	+ 2 stops[†]	+ 3$\frac{1}{2}$ stops[†]
Colour negative	none	none	none	none	+ $\frac{1}{2}$ stop	+ 1 stop	+ 2 stops
Colour slide* (daylight)	+ $\frac{1}{2}$ stop	none	none	none	+ 1 stop 15B	+ 1$\frac{1}{2}$ stop 20B	Not fully correctable
Colour slide* (tungsten)	none	none	none	none	+ 1$\frac{1}{2}$ stop 10R	+ 1 stop 15R	Not fully correctable

* Colour correction filters vary with brand.
† Reduce development time by 20–30 per cent.

Figure C.2 Reciprocity failure; typical exposure/filter compensation required

The three emulsions present together in the colour film (Figure C.1, bottom) collectively respond to the whole spectrum. Where individual response 'dips' in the greeny-blue and orange bands, this receives some correction by the fact that *two* emulsions overlap their sensitivity here. This slide film is a daylight balanced type – had it been exposed/tested to an image lit by red-rich tungsten illumination instead the blue-sensitive and green-sensitive curve would be lower than the red curve. After processing the final picture would have a shortage of cyan dye. The dominant yellow and magenta combine to give the slide a reddish cast.

Response to length of exposure ('reciprocity failure')

Giving a film or printing paper a long exposure time to a dim image should always have the same effect as short exposure to a bright image.

Figure C.3 Characteristic curves of various monochrome films

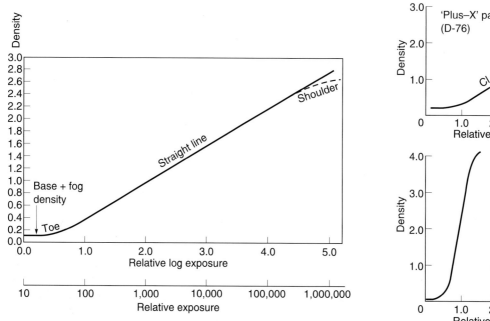

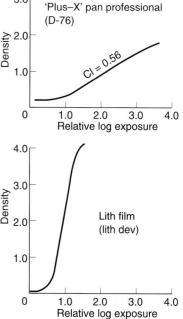

After all, this *reciprocal* relationship forms the whole basis of controlling exposure using aperture and shutter settings. In practice though films behave as if they are less light sensitive when exposures of 1 second or longer (or 1/10,000 second or less) are given. This *reciprocity failure* is mainly an issue in long exposures such as when shooting at night or in other dim lighting conditions. Since RF can also affect the various emulsion layers in colour films by different amounts a correction filter is sometimes needed for slide films. As Figure C.2 shows, it is best to allow for reciprocity failure by widening the lens aperture (intensity) rather than further extending time. Films launched in recent years suffer no reciprocity failure for the most used shutter speeds. However, if you are bracketing exposures around what the TTL or hand meter reads as 1 second or over then always give a series of *more* rather than *less* exposures, preferably via aperture adjustment.

Characteristic curves

A so-called characteristic curve is a performance graph showing how a particular film or paper responds to both exposure and processing. To produce the characteristic curve of a black and white film (Figure C.3) the material is first given a series of tightly controlled 'light dosages'. This is done in an instrument called a sensitometer, which exposes the emulsion to a series of light intensities a small patch at a time, giving the same short exposure for each. This is rather like exposing an image in the camera, except that (a) it gives a much wider range of intensities than you are likely to find in any one actual scene. Also (b) the amount each separate patch or step differs in exposure from the preceding one is an exact regular factor, normally 2.

The exposed sample film is next developed under strictly controlled conditions. The processed result is a series of tone patches, from clear film to something quite dark. The exact darkness of these results is measured with a densitometer instrument, which reads out the values as density figures. (Density is the \log_{10} of opacity, which is incident light divided by light transmitted by the film. When half the incident light passes through the sample opacity is 2.0 and the density reading is 0.3.)

'Input' (exposure to light) can now be plotted against 'output' (the resulting series of density readings). To prepare a characteristic curve graph, the vertical axis is scaled in density values and the horizontal axis is scaled in log exposure (or relative log exposure) values. The use of a \log_{10} scale here is to avoid an otherwise unmanageably long range of figures; the axis also becomes compatible with the \log_{10} sequence used for density. An increase of 0.3 on the log E axis means doubling of exposure.

When a densitometer linked to a computer plots density figures against each exposure given to the test film, it reads out a graph which is not a straight line, but escalator-shaped.

Significance of curve shape. Most characteristic curves can be divided into three distinct regions: the toe; the straight-line portion; and the shoulder. Remember that both density and exposure axes cover a very wide range of conditions for maximum information. In practice most actual images you expose on film are unlikely to have a brightness range much beyond 100:1, which spans just 2.0 on the log E axis. This means that, like selecting a group of notes from a long piano keyboard, you have options. You might underexpose your image so that it wholly falls on the lowest part of the curve, where there are least resulting densities. Or by giving it greater exposure, the image can correspond to values wholly within the straight-line portion. Again, by overexposing, you might make use of the curve shoulder, which produces the heavier densities.

In this way the characteristic curve shows the total performance of a film under given processing. And the part that relates to a particular shot depends on your image brightness range (a low-contrast scene spans a much shorter length of the log E axis than one that is very contrasty), as well as whether you under-, over- or correctly expose it.

The toe. The very bottom of the characteristic curve becomes a horizontal straight line. Here the film has received too little light to respond at all. The very slight density value present is due to the film base itself, plus normal fog density. As log E values increase, the graph begins to rise gently, meaning that density values are increasing too. However, the image tones are very compressed – shadow parts of the subject are still difficult to pick out (any density less than about 0.1 above fog usually prints indistinguishably from black). Look at Figure 10.2 on page 180.

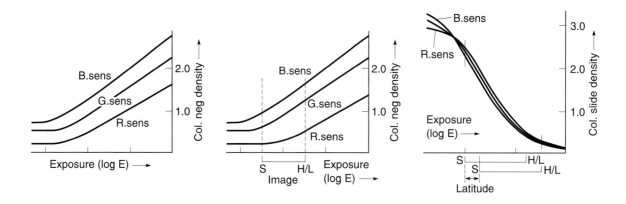

Figure C.4 Colour film characteristic curves. Left: A colour negative film exposed to an image in light for which it is colour balanced. (Emulsion responses to R, G and B are plotted individually.) Centre: If this film is used with light of reduced red content (colour temperature too high) the red sensitive layer reacts as if relatively slow. Its curve has shifted right which shows that the red density and contrast now differ between the image highlights and shadows. This may not be correctable in printing. Right: A colour slide film, exposed to light of the correct colour balance. Compared against lower contrast materials, such films allow much less exposure latitude

Gradually, with more exposure, the upper region of the toe merges into the straight line. The actual length of the toe varies with different films – for example it is longer with Tri-X than Plus-X.

The straight line. In the straight-line part of the graph image tones are still compressed as the material translates them into negative densities, but now the log exposure/density relationship is more constant: tones are compressed evenly. You might assume from this that getting your image to fall entirely on the straight-line portion would be the most 'correct' exposure. But, to maximize film speed, and to avoid image highlights becoming so dense that sharpness suffers and graininess is increased, 'correct exposure' is regarded as using the upper part of the toe plus only as much as is necessary of the lower part of the straight line; see Figure 10.3. Printing paper characteristics are designed to suit negatives exposed in this way, and reproduce mid-tones to shadows with contrast slightly greater than mid-tones to highlights.

The steepness of the film's straight-line portion also shows you what contrast to expect.

The extremely steep line shown for lith film (Figure C.3) indicates that the particular combination of emulsion and development gives a much more contrasty negative (for the same brightness-range image) than material with a lower pitched slope, such as Plus-X.

The shoulder. At the top of the characteristic curve the graph begins to flatten out again. Increasing exposure now gives less and less increase in density. The material is approaching its maximum black under these development conditions.

With most films the shoulder is never reached in practical picture making because of the poor image quality produced, as mentioned above. In fact the shoulder of the curve is often not included in data published for general-purpose films because of its unimportance.

Theory into practice. Exposure meters are so calibrated that a single overall (or centre-weighted) reading, which is assumed equivalent to a mid-grey in the scene, is 'placed' on the average film's characteristic curve at about the lowest part of the straight-line portion. Given an 'average' 100:1 range camera image this means that shadows will fall on the toe, but not beyond the lowest useful part. Highlights fall further up the straight-line portion, but nowhere near the definition-destroying upper part or shoulder. You can see from this that a lot of assumptions have to be made.

For tighter control it is better to use a spot or local reading, provided you know what you are doing. This way you can choose your own mid-tone in the scene to place on the curve.

By taking two spot readings – darkest important shadow, brightest important highlight – you

measure your image contrast range. If this greatly exceeds the 'average' it will also remind you that for better results you might well slightly overexpose and underdevelop. The development change will reduce the slope of the whole characteristic curve and so avoid an excessively contrasty negative. The reverse is true if your two camera readings show the image is much flatter than average; see Figure 11.20. Of course, this kind of adjustment is more difficult if you have a whole mixture of subjects exposed on one film. A magazine-type camera back is then especially useful for critical work; you can expose all your most contrasty subjects on the same film, earmarking this for reduced development.

D: Chemical formulae

Most proprietary forms of developer (Acuspeed, Rodinal, etc.) do not have published formulae.

They are only sold as ready-mixed concentrated solutions or occasionally as powders. However, the table at the foot of this page gives some well-established developers you can prepare yourself at relatively low cost from their constituent chemicals.

Other formulae in this appendix have a long history but are still listed because they remain of practical value, although some are difficult to track down in a ready-prepared form. The component chemicals you need are stocked by a few suppliers (in London for example by Silverprint or Creative Monochrome). Chemicals marked ★ should be handled with special care. Be sure to read over the appropriate advice in Appendix E before you begin.

Preparing solutions from bulk chemicals. First weigh out all the dry chemicals listed in your formula, using clean paper on the scales for each one. The quantities shown in formulae below are in metric units (for conversion, see page 319)

Developers (all weights of solids in grams)

Chemical	Gen-purpose fine-grain		Soft-working D23	Contrasty D19	Line D11	Prints D72	Vari-contrast (Beers)		Function*
	D76/ID 11	DK50					A	B	
Metol ('Elon') cryst	2	2.5	7.5	2	1	3	8		Dev agent, soft-working
Sod sulphite anhyd	100	30	100	90	75	45	23	23	Preservative
Hydroquinone cryst	5	2.5		8	9	12		8	Dev agent, contrasty
★ Pot/sod hydroxide		1.5							Extreme alkali
Sod carbonate anhyd				45	25.5	67.5			Alkali or accelerator
Pot carbonate anhyd							20	27	Alkali or accelerator
Borax cryst	2	7							Alkali or accelerator
Pot bromide cryst		0.5		5	5	2	1.1	2.2	Restrainer
Make up to	1 litre	1 litre	1 litre	1 litre	1 litre	1 litre	1 litre	1 litre	
Working sol, if different from above (stock + water)	1 + 1	1 + 1				1 + 2	See chart, page 318		
†Typical dev time (min) at 20°C (68°F)	7–12	4–7	5–9	5–14	4	$\frac{3}{4}$–2	2–$2\frac{1}{2}$		

*For terms see Glossary †Times apply to formulae here but may differ from pre-packed versions.

Substitutions

Chemical:	When formula quotes weight for:	And the only available form is:	Multiply weight by:
Sodium carbonate	Anhydrous or desiccated	Monohydrate or H_2O	1.2
Sodium carbonate	Anhydrous or desiccated	Crystalline or decahydrate ($10H_2O$)	2.7
Sodium sulphite	Anhydrous or desiccated	Crystalline/heptahydrate($7H_2O$)	2
Sodium thiosulphate	Crystalline/pentahydrate	Anhydrous/desiccated	0.6
Sodium thiosulphate	Anhydrous/desiccated ($5H_2O$)	Crystalline/pentahydrate	1.7
Borax	Crystalline/decahydrate ($10H_2O$)	$5H_2O$	0.8

Beers print developer: proportions and contrast

	Lowest						Highest
Sol A	8	7	6	5	4	3	2
Sol B	0	1	2	3	4	5	14
+ Water	8	8	8	8	8	8	0

Stop baths

	SB-5 (for films)	SB-1 (for paper)
Water	500 ml	750 ml
★ Acetic acid (80%)	11 ml	17 ml
★ or Acetic acid (glacial)	9 ml	13.5 ml
Sod sulphite anhyd	45 g	
Water up to	1 litre	1 litre
Treat for	30 seconds	5–10 seconds

Some bromocresol purple can be added to SB-1 to form an indicator stop bath. The solution then appears yellow when fresh, turns orange in use, and becomes purple when the stop bath is exhausted and must be replaced.

Fixers

	F-24 Non-hardening*	F-5 Hardening acid fix	F-7 Rapid hardening acid fix[†]
Water (at about 50°C)	600 ml	600 ml	600 ml
Sod thiosulphate (hypo) cryst	240 g	240 g	360 g
Ammonium chloride			50 g
Sod sulphite anhyd	10 g	15 g	15 g
Sod metabisulphite	25 g		
★ Acetic acid (80% sol)		17 ml	17 ml
Boric acid cryst		7.5 g	7.5 g
Pot alum			15 g
Water up to	1 litre	1 litre	1 litre

*As required when selenium toning, etc.
†Prolonged fixing time may bleach image

Residual fixer test HT-2

Water	350 ml
★ Acetic acid (80% sol)	22 ml
★ Silver nitrate cryst	3.75 g
Water to	500 ml

Store solution away from light, in a labelled brown screw-top bottle. To test a washed print or film, cut off a small strip of rebate and wipe off surface water. Place a drop of HT-2 on the emulsion surface and allow it to stand for 2–3 minutes. Rinse off. There should be little or no staining. Prints can be compared with a Kodak hypo estimator colour chart.

Negative intensifier: chromium IN-4

Bleacher stock solution:

Water	500 ml
★ Potassium dichromate	90 g
★ Hydrochloric acid (conc)	64 ml
Water to	1 litre

Use 1 + 10 parts water

Film, which should be hardened, is bleached until yellow-buff right through, washed 5 minutes, then darkened in a regular print developer. Rinse, fix and finally wash 5 minutes. Can be repeated for greater effect.

Sulphide toner T-7a (sepia)

Bleacher working solution (reusable):

Water	700 ml
Potassium ferricyanide	30 g
Potassium bromide	10 g
Sodium carbonate	16 g
Water to	1 litre

Toner stock solution:

Water	300 ml
Sodium sulphide anhyd	50 g
Water to	500 ml

Dilute stock 1 + 9 parts water for use

Fully bleach the black image to pale straw colour (about 5 minutes). Then rinse 1 minute, and tone for 4–5 minutes. Finally wash thoroughly, separately from other prints.

Blue toner IT-6

Sol A	Water	700 ml
	★ Sulphuric acid (conc)	4 ml
	Potassium ferricyanide cryst	2 g
	Water up to	1 litre
Sol B	Water	700 ml
	★ Sulphuric acid (conc)	4 ml
	Ferric ammonium citrate	2 g
	Water up to	1 litre

Use one part A plus one part B. This toner has an intensifying action, so start with a *pale* black and white print. Immerse prints until the required tone is reached, then wash gently until the whites no longer have a yellow stain. Over-washing begins to bleach the blue – this is reduced by adding salt to the wash water.

Gold toner GP-I (blue-black or red) For red tones, sepia tone the print first.

Water	700 ml
Gold chloride, 1% stock solution*	10 ml
Sodium thiocyanate	10 g
Water up to	1 litre

Make up just before use. Treat for 10 minutes, then wash 10 minutes.
*1 g of sodium chloro-aurate in 100 ml water.

Bleachers
Farmer's reducer R-4a

Sol A	Water	250 ml
	Potassium ferricyanide	37.5 g
	Water up to	500 ml
Sol B	Warm water	1 litre
	Sodium thiosulphate cryst	480 g
	Water up to	2 litres

Mix one part A, plus 8 parts B, and 50 parts water, just before use.
For faster reduction of density, double the quantity of solution A.

Iodine IR-4
Recommended for locally bleaching out the print image completely, leaving white paper.

Warm water	750 ml
Potassium iodide	16 g
★ Iodine	4 g
Water up to	1 litre

Keeps well. For bleach-out, apply neat with brush or cottonwool to the damp (blotted) print. Finally rinse and treat in a small quantity of regular print fixing bath (5–10 minutes) to completely remove deep brown stain. Discard this fixer. Wash fully.

Conversions: metric, UK and US units

Use the information below in conjunction with a pocket calculator.

To convert length and area

Millimetres to inches	Multiply mm by 0.039
Metres to feet	Multiply metres by 3.28
Inches to millimetres	Multiply inches by 25.4
Feet to metres	Multiply feet by 0.305
Sq centimetres to sq inches	Multiply by 0.155
Sq inches to sq centimetres	Multiply by 6.45

To convert volume and weight

Millilitres to UK fl oz	Multiply by 0.035
Millilitres to US fl oz	Multiply by 0.034
UK fl oz to millilitres	Multiply by 28.4
US fl oz to millilitres	Multiply by 29.6
US fl oz to UK fl oz	Multiply by 1.04
Litres to UK fl oz	Multiply by 35
Litres to UK gallons	Multiply by 0.22
Litres to US gallons	Multiply by 0.264
UK gallons to litres	Multiply by 4.55
US gallons to litres	Multiply by 3.79
US gallons to UK gallons	Multiply by 0.833
Grams to ounces	Multiply by 0.035
Ounces to grams	Multiply by 28.35
Kilograms to pounds	Multiply by 2.20
Pounds to kilograms	Multiply by 0.454

To convert temperature:

°Celsius into °Fahrenheit:	Multiply by 1.8 then add 32
°Fahrenheit into °Celsius:	Subtract 32 then multiply by 0.56

and relate to dry chemical in anhydrous or crystalline form.

Start with about three-quarters of the final volume of water, and fairly hot (typically 50°C). Tap water is satisfactory unless distilled water is specified. Always dissolve chemicals one at a time, in the order given. Tip powder gradually into the water, stirring continuously. Wait until as much as possible has been dissolved into solution before starting to add the next chemical. Measure and pour in liquid chemicals in the same way, taking special care over strong acids; see notes on safety. Finally add cold water to make up the full amount and if possible leave the solution some hours to further dissolve and cool to room temperature. If your formula contains metol and sodium sulphite it is best to dissolve a pinch of weighed-out sulphite first – to help prevent the metol oxidizing (turning yellowish brown) during mixing. Then dissolve the remaining sodium sulphite after the metol, as listed in the formula.

Alternative forms of chemical. Many photographic chemicals come in anhydrous form (also known as 'desiccated'). Weight for weight this is much more concentrated than the same chemical in crystalline form. A few chemicals are marketed in 'monohydrate' (H_2O) form, which in terms of concentration falls between the other two. When a formula quotes the weight for one form of the chemical and you can only obtain it in another, make adjustments by the amounts shown in the substitutions table on page 317.

E: Health and safety concerns

Preparation and use of chemicals. Most common chemicals used in photography are no more dangerous to handle than chemicals – cleaners, insect repellents, adhesives – used every day around the home. However, several of the more special-purpose photographic solutions such as bleachers, toners and intensifiers do contain acids or irritant chemicals which must be handled with care. (These are listed in Figure 11.4 and also picked out in the formulae given in Appendix D.)

Your response to direct contact with chemicals may vary from finger staining to direct irritation such as inflammation and itching of hand or eyes, or a skin burning or general allergic reaction which may not appear until several days later. A small minority of photographers are particularly sensitive to chemicals present in developers. Metol, also known as Rhodol or Elon, can be troublesome to such people. Changing to a developer of different make-up such as those containing Phenidone instead of Metol (i.e. PQ developers) may solve the problem.

The following guidelines apply to all photographic chemical processes:

- *Avoid direct skin contact with all chemicals,* especially liquid concentrates or dry powders. Do this by wearing thin plastic (disposable) gloves, and using print tongs when lifting or manipulating prints during processes in trays, page 239.
- *Avoid breathing-in chemical dust or fumes.* When weighing or dissolving dry powders work in a well-ventilated (but not draughty) area. Don't lean over what you are doing, and if possible wear a simple respiratory mask (the fabric types as used by cyclists are inexpensive).
- *Be careful about your eyes.* When mixing up chemicals wear eyeshields, preferably the kind you can wear over existing spectacles. (Remember not to rub an eye with a chemically contaminated gloved hand during processing.) If you do splash or rub an irritant into your eye wash it with plenty of warm water immediately – it is always good practice to have a bottle of eye-wash somewhere close to where you are working.
- *Keep things clean.* Liquid chemical splashes left to dry out turn into powder which you can breathe in or get on your hands or clothes, as well as damaging films and equipment. Similarly don't leave rejected test prints, saturated in chemical, to dry out in an open waste bin close to where you are working. To prevent chemicals getting onto your clothes wear a PVC or disposable polythene-type apron.
- *Labels are important.* Carefully read the warnings and procedure the chemical manufacturer has printed on the label or packaging, especially if you have not previously used this product. Clearly label the storage containers for chemicals and stock solutions you have made up yourself. Never, ever, leave photographic chemicals in a bottle or container still carrying a food or drink label. Conversely don't put food in empty chemical containers.

- *Keep chemicals and food and drink well separated.* Even when properly labelled keep all your chemicals well out of the reach of children – and never store them in or near the larder. Avoid eating in the darkroom or processing in the kitchen where food is prepared.
- *Chemical procedure.* Where a formula contains an acid which you must dilute from a concentrated stock solution, always slowly add the acid to the water (adding water to acid may cause splattering). Don't tip one tray of chemical solution into another of a different kind, as when clearing up – cross-reaction can produce toxic fumes.

 Spray adhesives. Take special care to ensure ample ventilation when working with aerosol sprays of this kind. Their contents could cause nerve damage if you subject yourself to prolonged exposure in a confined space when mounting or montaging prints this way.

Electrical hazards

Many of the safety precautions you need to take are also common to domestic and simple workshop situations. For example:

- *Circuit protection.* Make sure that all your equipment – enlarger, lamps, heaters – are effectively earthed ('grounded') via three-core cable. Plugs should contain fuses which are appropriate to the equipment they serve. This is more than a question of not drawing more power than the fuse will handle, page 120. A 13 amp fuse for instance is quite suitable for equipment drawing 10 amps, but used with something taking only 4 amps means that you are underprotected – before this fuse burns out the cabling could heat up considerably. A circuit-breaker at the mains fuse box is a good protective measure for the whole system. When lighting subjects at locations you have not used before check that the circuit is sufficiently powerful and in good condition to supply your gear. (To light a large area it may be best to hire a generator.)
- *Cables.* Check all your equipment cables regularly for signs of cracked or worn installation, or loose connections. Don't roll lighting stands over cables on the floor. Never pull out a plug by means of tugging on its cable. Don't power a lighting unit through a long cable still coiled on a drum – electricity can heat the coiled-up cable until it starts smouldering. Make sure your main cable is of a suitable gauge to carry all the power you need and will not heat up due to overloading, especially when it feeds several pieces of equipment through adaptors or splitter boxes. Avoid cable runs which come into contact with moisture (condensation as well as water) unless fully protected in a waterproof sheath. Damp grass, wet bench areas of darkrooms, bathrooms and saunas are all hazardous.
- *Flash.* Studio equipment and even small handflash units should not be opened to make your own repairs – residual charge held in internal power-storage components may give you an electric shock.

F: Digital notebook

When you are first learning to use a digital manipulation software program it is helpful to compile your own notes. These can be simple reminders of the sequence of steps you have found you have to take to achieve a particular image change. After all, if you are forgetful and make one wrong selection this often breaks the whole chain and brings you to a frustrating halt. On the other hand an image manipulation may often be achieved by more than one command route, and as you progress you can discover which seems the fastest or easiest to remember.

The listings below are practical notes on command sequences for ten different image changes, in a choice of two photo-manipulation programs. Bear in mind too that programs are re-issued in revised editions at frequent intervals, so some of these sequences may now differ in current software. They appear here to simply show how you might set out your own quick-check notebook. Figure 14.11 on page 271 shows the typical positions of command bar, fly-outs, etc., displayed by Photoshop on the computer monitor screen.

Image adjustment	PhotoSuite II	Photoshop 5.0
Zoom image magnification on screen	Select Edit Photo. Click on magnifying glass icon. Position cursor centre screen, then keeping the mouse button pressed move cursor gently up the screen (to zoom in) or down screen (to zoom out). Alternatively, keep keyboard Ctrl key pressed and use + or − keys	Select Window on the command bar, and click 'Show Navigator' on fly-out. Use cursor to drag the slider within the navigator dialogue box or keep keyboard Ctrl key pressed and use + or − keys
Overall brightness, and contrast	Click on Touch-Up and Transform>Touch-Up>Brightness and Contrast. Use cursor to drag one or both the sliders located below the picture window. Click on Apply tab	On the command bar click Image>Adjust>Brightness/ Contrast. Then drag sliders within fly-out. Click OK. Or Image>Adjust>Curves. Use cursor to drag and reshape graph (page 281). Click OK
Shading or burning-in small areas	Click on Touch-Up and Transform>Remove Red Eye. Select either lighten or darken. Drag Opacity slider to a low setting. Select Paint (brush) size. Apply by wiping the cursor across the area to be changed, keeping the button pressed	Select either Burn or Shade tool from tool bar or fly-out. On command bar select Window>Show Options. On fly-out set Exposure (say 30%) and tones (e.g. midtones). Then Window>Show brushes. Set large soft-edged brush size. Apply by repeatedly dragging the cursor with button pressed
Cloning	Select Edit Photo. Click on clone icon. Under your picture set a suitable brush size, also Opacity (say 100%). Position cursor on the image where you want to 'pick up'. Click mouse. Move cursor to where the pick up detail is to be put down. Press mouse and keep it pressed as you brush over the put-down area. To change to a different part of the image locate the pick-up (larger) cursor in the new position, hold down the Ctrl key and click mouse. Then release key again and as before move cursor to where the new pick-up is to be put down	Click on Marquee (rectangular) selection tool and mark out entire picture area. Select Rubber Stamp (unshaded) tool. In Rubber Stamp options dialogue box, set 'Normal' and Opacity of say 100%. On command bar select Window>Show brushes. Choose size and softness of edge. Position cursor on the image where you want to 'pick up'. Depress Alt key and click mouse. Move cursor to where 'pick up' detail is to be put down. Press mouse button alone and keep it pressed as you brush over the put-down area. To change to a different pick-up hold down Alt key, move cursor to the new position, click mouse and release Alt key again
Erase parts of one picture overlaying another	File>Open the first picture. Then via File>Add photo, open your second picture on top. Use accompanying pull bars to size and position the second picture. Click outside picture area to remove pull bars. Click on Eraser tool icon. Set Intensity on the slider under the Picture area (100% or less if a degree of transparency is needed). Set brush size. Drag cursor over the area to be erased, with button depressed. Top picture will melt away, revealing the details of the picture underneath	File>Open. Picture 1 on screen. Click on marquee (rectangular) selection tool. Mark out entire picture area. Edit>Cut. Then File>Open. Picture 2 on screen. Then Edit>Paste. Click on Eraser tool icon. Command Window>Show brushes and set brush size. Also Window>Show Options. In dialogue box set Pressure (normally 100%) and 'Airbrush'. Drag cursor over area to be erased, with button depressed
Overall colour balance correction	Click on Touch Up & Transform>Touch Up>Fix Colors. Then drag Hue, Saturation, & Value sliders (i.e. increase blue hue to compensate a picture shot on daylight film in tungsten lighting). Apply	Command Image>Adjust>Variations. Then visually judge and pick the correction needed from 'ring-around'. Click OK. Alternatively command Image>Adjust>Color balance and drag individual sliders on fly-out. Click OK
Unsharpen chosen areas	Click on Touch Up & Transform>Remove Red-Eye>Soften. Set level ('intensity') high. Set a suitably large diameter brush size and apply repeatedly by swabbing over the chosen area with the cursor button pressed. Don't overdo	File>Open to put chosen picture on screen. Then command Layer>Dupe layer. Click OK. Next, Filter>Blur>Gaussian blur. In dialogue box set required level of unsharpness. Click on OK to affect whole picture. Then localize unsharpness by clicking on History Brush icon in tool box. Use cursor with mouse button pressed to swab over parts of the picture to be returned to sharpness
Sharpen overall	Not recommended	Click on command bar Filter>Sharpen>Unsharp Mask. On fly-out set radius (say 1.5), Amount (150%) and Threshold (20). Adjust each to Maximize effect. Click on OK
Soften or motion blur over chosen areas	Select Edit Photo. Then with freehand selection tool mark out the area to become blurred. Soften the marked out image by selecting Touch Up & Transform>Touch Up>Soften. Set the intensity on the slider below the picture. Apply	Click on Lasso tool and draw around the area to be blurred. Either command Filter>Blur>Radial, and on fly-out set the centre of rotation and click OK. Or Filter>Blur>Motion. Then on fly-out set the direction and amount of straight streaky blur. Click OK
Changing from colour to monochrome	Click on Touch Up & Transform>Touch Up>Fix Colors. Drag Hue and Saturation sliders to full minuses. Apply. Select Brightness/Contrast and adjust sliders to give best tonal quality. Apply	Click on command bar Image>Mode>Greyscale. On dialogue fly-out click OK for Discard color information. Then Image>Adjust>Brightness/ Contrast. Adjust sliders. Click OK

In some programs 'Help' information refers to the key marked Ctrl on many keyboards as 'Command'; also Alt is referred to as the 'Option' key.

Glossary

Accelerator Chemical ingredient of developer to speed up the otherwise slow activity of developing agents. Normally an alkali such as sodium carbonate, borax, or (high-contrast developers) sodium hydroxide. Also known as 'activator' or 'alkali' component.

Acid Chemical substances with pH below 7. Because acid neutralizes an alkali, acidic solutions are often used to halt development – as in stop bath or fixer.

Adaptor ring Narrow threaded ring which fits the front rim of a lens to allow use of accessories of a different ('step-up' or 'step-down') diameter.

AE Automatic exposure metering.

AE lock (AE-L) Camera control which locks the exposure settings made by an auto exposure programme.

Aerial perspective Sense of depth conveyed by changes of tone with distance. Typically seen in a rolling landscape when atmospheric haze is present.

AF Autofocus.

AF lock (AF-L) Camera control which locks the focus setting made by an auto-focusing lens.

Aliasing A rough edge effect ('jaggies') seen most clearly on diagonal or curved lines in an electronic image. Created by low pixel resolution. This staircase appearance is due to the large square pixels present.

Alkali Chemical substances with pH above 7. Solution feels slippery to the touch, can neutralize acid. See also Accelerator.

Ambient light General term covering existing subject lighting, i.e. not specially provided by the photographer.

Analogue Continuously variable. A monochrome photograph is one example of analogue data – having a continuous range of grey tones from black to white.

Angle of view Angle, formed at the lens, between lines from the extreme limits of a (distant) scene just imaged within the diagonal of the picture format. Varies with focal length and format size.

Anhydrous (anhyd) Dehydrated form of a chemical. More concentrated than the same substance in crystalline form.

ANSI American National Standards Institute. Present title of organization once called American Standards Association. See ASA.

Anti-halation Light-absorbing dye present in film to prevent reflection or spread of light giving 'halos' around bright highlights. Disappears during processing.

Aperture Circular opening within the lens. Usually variable in diameter and controlled by a diaphragm calibrated in f-numbers.

Aperture preview SLR camera control to close the lens diaphragm to the actual setting used when exposing. For previewing depth of field.

APS Advanced Photographic System. System of easy-load cameras and film cartridges about 30 per cent smaller than 35 mm, planned and introduced (1996) by a consortium of manufacturers – Canon, Fuji, Kodak, Minolta and Nikon.

Archival processing Procedures during processing aiming for the most stable image possible.

Array A single row of charge coupled devices (CCDs), as used in flatbed scanners, etc., to respond to light and convert it to digital information.

Artificial light General term for any man-made light source. Artificial-light film, however, normally refers to tungsten illumination of 3200K.

ASA American Standards Association, responsible for ASA system of speed rating. Doubling the ASA number denotes twice the light sensitivity. Now replaced by ISO.

Aspect ratio The ratio of the width to the height of an image. 35 mm format has an aspect ratio of 3:2, computer monitor and TV screens 4:3.

Autofocus System by which the lens automatically focuses the image (for a chosen area of subject).

Av Aperture value. Auto-exposure camera metering mode. You choose the aperture, the meter sets the shutter speed. (Also known as aperture priority system.)

B setting See Bulb.

Bag bellows Short, baggy form of bellows used on view cameras when working with a wide-angle lens. Allows camera movements otherwise restricted by standard lens bellows.

Ball and socket Swivelling ball joint between camera and tripod, monopod, etc. Camera may be angled and clamped.

Barndoors Set of folding metal flaps fitted around the front of a spotlight. Controls light spill, or limits beam.

Baryta papers See Fibre-based paper.

Baseboard camera View camera with fold-open baseboard, which supports lens and bellows.

Bellows Concertina light-tight sleeve used on some cameras and enlargers between lens and film to allow extensive focus adjustment.

Between-lens shutter Bladed (or 'leaf') shutter positioned between elements of a lens, close to the aperture.

Bit (b) A binary digit. Basic digital quantity representing either 1 or 0. The smallest unit of computer information.

Bit depth The number of bits per pixel. Can vary from 1 bit per pixel within a black and white line image, to 32 or 36 bit depth for a colour image (composed of cyan, magenta, yellow and black, each 8 bits per pixel). The greater the bit depth, the better the tonal gradation and colour quality of the digital image.

Bitmap An image made up of pixels, or dots.

Bleacher Chemical able to erase or reduce image density.

Blooming In digital photography refers to halos or streaks recorded around images of bright light sources or other intense highlights.

Blue-sensitive Emulsion sensitive to the blue and UV regions only of the visible spectrum.

Bracket In exposure, to take several versions of a shot giving different levels of exposure.

Brightness range See Subject brightness range.

Bromide paper Printing paper with predominantly silver-bromide emulsion.

Browser Software which permits your computer to transfer information and display multimedia sites on the World Wide Web, e.g. Microsoft Internet Explorer.

Buffer Chemical substance(s) used to help maintain the pH (acidity or alkalinity), and therefore the activity, of a solution such as developer or fixer.

Bulb Also 'brief'. The B setting on a shutter – keeps the shutter open for as long as the release remains pressed.

Bulk film Film sold in long lengths, usually in cans.

Burning-in See Printing-in.

Byte (B) A (small) measurement of the memory or storage space in a computer. One byte equals 8 bits.

One kilobyte represents 1024 bytes. See also Gigabyte and Megabyte.

C-41 process Processing procedure used for the vast majority of colour (and monochrome chromogenic) negative films.

Cable release Flexible cable which screws into a camera shutter release. Allows the shutter to be fired (or held open on 'B') without camera-shake.

Capacitor Unit for storing and subsequently releasing a pulse of electricity.

Cassette Light-proof metal or plastic film container with light-tight entry slot. Permits camera loading in normal lighting.

Cast Overall bias towards one colour.

CCD Charge-coupled device. Electronic light-sensitive surface, e.g. modern substitute for film in digital cameras. In simpler form used in AF systems to detect image sharpness.

CD-R Compact disc, recordable. A CD to which digital data can be written once only, but read many times. Cannot be erased.

CD-ROM Compact disc with read-only memory. Non-re-writable disc used to provide software programs, etc.

CD-RW Compact disc, read/write. A CD to which data can be read and written many times. (Old data is erased by laser beam.)

CdS Cadmium disulphide. Battery-powered light sensor cell, widely used in exposure hand meters.

Characteristic curve Graph relating exposure to resulting image density, under given development conditions. See page 212. Also known as an H and D curve.

Chlorobromide paper Warm-tone printing paper. Uses emulsion containing silver chloride and silver bromide.

Chromogenic film Films which form a final dye image rather than one of silver, when given appropriate dye-coupled processing (C-41 for example). Includes monochrome film designed to be processed with standard colour film chemistry.

CI See Contrast index.

CIE Commission Internationale de l'Eclairage. Originator of a standard system for precise description of colours.

Circles of confusion Discs of light making up the image formed by a lens, from each point of light in the subject. The smaller these discs the sharper the optical image appears.

Clearing time The time taken in a fixing bath for a film emulsion to lose its milky appearance.

Click stops Aperture settings which you can set by physical 'feel' as well as by following a printed scale.

Close-up lens Additional element added to the main lens, to focus close objects.

CMYK Cyan, magenta, yellow and key (black). The colour printing model used by most ink-jet and dye sublimation printers. Photo quality printers mostly

add pale cyan and pale yellow inks for improved pastel tones, making six inks in all.

Coating Transparent material deposited on lens glass to suppress surface reflections, improve image contrast.

Cold-light enlarger Enlarger using a fluorescent tube grid. Gives extremely diffused illumination.

Colour balance (of film) Relates to the lighting under which a colour film is designed to record subject colours accurately. Typically expressed as daylight balance (5500K) or tungsten light balance (3200K).

Colour head An enlarger lamp head with a colour printing filter system built-in.

Colour temperature Way of defining the colour of a (continuous spectrum) light source, in Kelvin. Equals the temperature, absolute scale, to which a metal black body radiator would have to be heated to match the colour of the source.

Colour wheel Diagram in which the colours of the visual spectrum are shown 'bent' into a circle, with each colour facing its complementary; see Figure 9.25.

Complementary colours Resulting colour (cyan, magenta or yellow) when one of the three primary colours (red, green or blue) is subtracted from white light. Also called 'subtractive primaries', 'secondary colours'.

CompactFlash Type of digital camera removable card.

Compression Electronic 'squashing' to reduce file size and therefore its storage needs, and minimize the time taken to transmit it via networks. Greatest compression can be achieved by means of 'lossy' methods such as JPEG, but at the cost of poorer image resolution.

Condenser Simple lens system to concentrate and direct light from a source, e.g. in a spotlight or enlarger.

Contact print Print exposed in direct contact with negative, therefore matching it in size.

Contrast The difference between extremes – of lighting, of negative or print tone values, of subject reflectance range, etc. The greater the difference between extremes present together, the higher the contrast.

Contrast index A numerical index relating image brightness range to resulting processed density range when 'correctly exposed' on the film's characteristic curve. Therefore relates to development, and contrast. (Most general-purpose negatives to be printed on diffuser enlargers are developed to a CI of 0.56.)

Conversion filter Colour filter used to compensate for differences between the colour temperature of the light source and the colour balance of the film, where the two differ.

Converter lens Multi-element lens unit specially designed to (typically) double the focal length of each of a given range of long focal length camera lenses. Fits between prime lens and camera body.

Covering power The area of image of useful quality that a lens will produce. Must exceed camera picture format, generously so if movements are to be used.

CPU Central processing unit. Solid-state electronic chip housed within a computer or camera. In the camera used to compute exposure, focusing, etc., from data input by other electronic components. In a computer it translates, intercepts and executes instructions received as digital data, communicating with and transfering data between itself and all other internal circuits.

Cropping To trim one or more edges of an image, usually to improve composition.

Cropping tool A tool in image editing software. Allows you to trim an image as you would mask the borders of an enlargement being made in the darkroom.

Cross front Camera movement. Sideways shift of lens, parallel to film plane.

Cut-off Term describing the blocking-off of image light ('vignetting') usually at one or more corners of the picture format. May be caused by using the wrong size lens hood, or excessive use of certain camera movements.

Darkslide Removable plastic or metal sheet fronting a sheet-film holder or film magazine.

Daylight film Colour film balanced for subject lighting of 5500K.

DCS Digital camera system. Prefix used for a number of Kodak camera models.

Dedicated flash Flash unit which fully integrates with camera electronics. Ensures that the shutter speed is correctly set for flash; detects film speed, aperture, light reading, subject distance, etc.

Dense Dark or 'thick', e.g. a negative or slide which transmits little light. Opposite to 'thin'.

Densitometer Electro-optical instrument for reading the densities of a film or paper image.

Density Numerical value for the darkness of a tone on a processed film or paper.

Depth of field Distance between nearest and furthest parts of a subject which can be imaged in acceptably sharp focus at one setting of the lens.

Depth of focus Distance the film (or printing paper) can be positioned either side of true focus whilst maintaining an acceptably sharp image, without refocusing the lens.

Developing agent Chemical ingredient(s) of a developer with the primary function of reducing light-struck silver halides to black metallic silver.

Dialogue box On a computer a special window (often in fly-out form) which may appear on screen as part of a photo-manipulation program. It asks the user for information and/or commands before a task is completed.

Diaphragm Aperture formed by an overlapping series of blades. Allows continuous adjustment of diameter.

Diffraction Minute change in the path of light rays when they pass close to an opaque edge. The cause of poorer image quality if a lens is used with an extremely small size aperture.

Digital camera A camera or camera back in which a CCD chip and supporting electronics replace film.

Digital image An image defined by a stream of digitalized electronic data, typically made visible by display on a computer monitor screen.

Digitalize Process of converting *analogue* data, which is continuously variable, into digital data represented by a code made up of combinations of only two (binary) digits, 0 and 1. In this binary form pictures can be processed by computer.

DIN Deutsche Industrie Normen. German-based system of film speed rating, much used in Europe. An increase of 3 DIN denotes twice the light sensitivity. Now replaced by ISO.

Dodging See Shading.

dpi Dots per inch. A measurement of the resolution of a computer scanner, monitor (72 dpi) or a printer (typically 600 dpi).

Dragging Holding down the computer mouse button while moving it, to reposition items on the monitor screen, etc.

Dry mounting Bonding a photograph to a mount by placing dry, heat-sensitive tissue between the two and applying pressure and heat.

Drying mark Uneven patch(es) of density on film emulsion, due to uneven drying. Cannot be rubbed off.

DX coding Direct electronic detection of film characteristics (speed, number of exposures, etc.) Read from the chequer board pattern on the film cassette by sensors in the camera's film-loading compartment.

Dye-image film See Chromogenic film.

E-6 process Colour reversal processing procedure in widespread international use for most forms of colour slide/transparency film.

Easel See Masking frame.

Edge numbers Frame number, film type information, etc., printed by light along film edges and so visible after processing.

Effective diameter (of lens aperture) Diameter of the light beam entering the lens which fills the diaphragm opening.

Electronic flash General term for common flash units which create light by electronic discharge through a gas-filled tube.

E-mail Electronic mail.

Emulsion Mix of light-sensitive silver halides, plus additives, and gelatin.

EV Exposure value. Each value expresses a series of shutter/aperture combinations all giving the same exposure effect, e.g. an EV of 12 means 1/250 @ *f*/4, or 1/125 @ *f*/5.6, or 1/60 @ *f*/8; EV 13 means 1/500 @ *f*/4, etc.

Existing light See Ambient light.

Expiration date The 'use by' date found stamped on the packaging of most light-sensitive materials.

Exposure-compensation dial Camera control effectively overriding film-speed setting (by + or − exposure units). Used when reading difficult subjects, or if film is later to be 'pushed' or 'held back' in processing to modify contrast.

Exposure latitude Variation in exposure level (over or under) which still produces acceptable results.

Extension tube Tube, fitted between lens and camera body, to extend lens-to-film distance and so allow focusing on very close subjects.

F-numbers International sequence of numbers, expressing relative aperture, i.e. lens focal length divided by effective aperture diameter. Each change of *f*-number halves or doubles image brightness.

Fast Relative term – comparatively very light sensitive.

Feathered edge In digital manipulation a command giving a soft (vignetted) edge to the whole image, or the area selected for cutting-out, darkening, etc. Helps avoid an obvious hard edge when printing-in or shading. Allows seamless montaging effects.

Ferrotype sheet Polished metal plate used for glazing glossy fibre-based prints.

Fibre-based paper Printing paper with an all-paper base.

File The term for a single document (e.g. a camera image) of digital data, as held on a storage device such as the computer's hard disk or some form of removable disk.

File format Digital images need to be saved in a format that can be read by your software program(s). Typical file formats are TIFF, JPEG and bitmap.

File size The volume of image information forming the contents of a digital file. Becomes larger as the data from a digital image becomes more complex. Measured in kilobytes or megabytes.

Fill-in Illumination that lightens shadows, so reducing contrast.

Film holder Double-sided holder for two sheet films, used with view cameras.

Film pack Stack of sheet films in a special holder. A tab or lever moves each in turn into the focal plane, e.g. Polaroid peel-apart material.

Film plane The plane, in the back of the camera, in which the film lies during exposure.

Film scanner Device for converting the (analogue) data of images on film into the digital data of image files. Incorporates a CCD array which scans the original.

Film speed Figure expressing relative light sensitivity. See ISO.

Film writer/film recorder Device to convert digital files into images on silver halide photographic film, negative or transparency.

Filter Optical device to remove (absorb) selected wavelengths, or a proportion of all wavelengths.

Filter factor Factor by which exposure should be increased when a filter is used. (Does not apply if exposure was read through lens plus filter.)

Fisheye Extreme wide-angle lens, uncorrected for curvilinear distortion.

Fixed focus camera Camera (typically very simple type) with a non focus-adjustable lens. Usually set for its hyperfocal distance.

Fixer Chemical solution which converts silver halides into soluble salts. Used after development and before washing, it removes remaining light-sensitive halides, so 'fixing' the developed black silver image.

Flare Unwanted light, scattered or reflected within a lens or camera/enlarger body. Causes flare patches, degrades shadow detail.

Flashing Giving a small extra exposure (to an even source of illumination) before or after image exposure. Lowers the contrast of the photographic material.

Flat A subject or image lacking contrast, having minimal tonal range.

Flatbed scanner Light box with an internal CCD array able to digitally scan-in photographic prints, etc. placed face down on its flat glass upper surface.

Floodlight Artificial light source giving broad, generally diffused illumination.

Floppy disk Flexible, removable disk for digital data. Typically 3.5 in diameter and permanently housed in a hard plastic case. Used to store data such as text and low resolution digital images (owing to its limited file size capacity relative to hard disks).

Focal length Distance between the sharp image and lens when the lens is focused for an infinity subject. More precisely, between this image and the lens's rear nodal point.

Focal plane Plane on which a sharp-focus image is formed. Usually at right-angles to lens axis.

Fog Unwanted veil of density (or bleached appearance, in reversal materials). Caused by accidental exposure to light or chemical reaction.

Format or 'frame' General term for the picture area given by a camera. See also Aspect ratio, and page 62.

Gamma Tangent of the angle made between the base and straight-line portion of a film's characteristic curve. Once used as a measure of contrast.

Gelatin Natural protein used to suspend silver halides evenly in an emulsion form. Swells to permit entry and removal of chemical solutions.

Gigabyte (GB) Unit of computer memory equivalent to 1024 megabytes.

Glossy Smooth, shiny print-surface finish.

Gradation Variation in tone. Tonal range or scale.

Graded papers Printing papers of fixed contrast. You purchase the grade you need as indicated by a number on the packaging. The lower the number, the lower the contrast.

Gradient Digital manipulation term for filling an area with a colour or grey tone which gradually changes in density across the filled zone.

Graduate Calibrated container for measuring liquids.

Grain Clumps of processed silver halides forming the image. Coarse grain reduces fine detail, gives a mealy appearance to even areas of tone.

Greyscale A digital image containing only shades of grey, black or white.

Guide number Number for simple flash exposure calculations, being flashgun distance from subject times the f-number required (when using ISO 100/21° film). Normally relates to distances in metres.

Halftone Full tone-range photograph broken down into tiny dots of differing sizes, for ink reproduction on the printed page.

Halides Alkali salts such as potassium iodide or potassium bromide, which when combined with silver nitrate form light-sensitive silver halides.

Hard Contrasty – harsh tone values.

Hard disk High capacity magnetic disk, usually held internally in the computer, forming the main storage device for programs and image files.

Hardener Chemical which toughens the emulsion gelatin.

High-end Digital equipment capable of capturing, manipulating, or outputting high resolution image files.

High key Scene or picture consisting predominantly of pale, delicate tones and colours.

Highlights The brightest, lightest parts of the subject.

Histogram A bar chart graphically representing a digital image's distribution of grey or colour tones. See Figure 14.25.

Holding back Reducing development (often to lower contrast). Usually preceded by increased exposure. Also called 'pulling'. Term is sometimes used to mean shading when printing.

Home page The opening page of a web site. Introduces contents, and offers click-on links to other pages.

Hot shoe Flashgun accessory shoe built into the camera; it incorporates electrical contacts.

Hyperfocal distance The subject distance focusing setting for a lens which gives depth of field extending from half this distance to infinity.

Hypo Abbreviation for sodium hyposulphite, the fixing agent since renamed sodium thiosulphate. Also the common term for all fixing baths.

Icons Small graphic symbols displayed on the computer monitor. These provide 'click-on' positions for your cursor to command applications, open or close files, activate tools, etc.

Incandescent light Illumination produced from an electrically heated source, such as the tungsten-wire filament of a lamp.

Incident light Light reaching a subject, surface, etc.

Incident-light reading Using an exposure meter at the subject position, pointed towards the camera, with a diffuser over the light sensor.

Infinity A subject so distant that light from it effectively reaches the lens as parallel rays. (In practical terms the far horizon.)

Infra-red (IR) Wavelengths longer than about 720 nm.

Ink-jet printer Converts digital images into microscopic dots of ink on paper, so creating a final print in colour or monochrome.

Instant-picture material Photographic material with integral processing, e.g. Polaroid.

Interpolation Increasing the apparent resolution of a digital image by averaging out nearby pixel densities and generating a new pixel in-between. (Cannot therefore truly provide additional detail.)

Inverse square law With a point source of light, intensity at a surface is inversely proportional to the square of its distance from the source; e.g. half the distance, four times the intensity.

Inverted telephoto lens A lens with rear nodal point well behind its rear element. It therefore has a short-focal length but relatively long lens-to-image distance, allowing space for an SLR mirror system.

IR focus setting Red line sometimes located to one side of the lens focus-setting mark, used when taking pictures on IR film.

ISO International Standards Organisation. Responsible for ISO film speed system. Combines previous ASA and DIN figures, e.g. ISO 400/27°.

Joule See Watt-second.

JPEG Joint Photographic Experts Group. The name of a widely used image file format able to give a very high level of compression (e.g. to one-hundredth its original size). As a 'lossy' system it inevitably degrades some image quality.

Kelvin (K) Measurement unit of colour temperature. After the scientist Lord Kelvin.

Keylight Main light source, usually casting the predominant shadows.

Kilobyte (KB) A measurement of digital file size, computer storage or memory space. One KB is 1024 bytes of information.

Kilowatt One thousand watts.

Large format General term for cameras taking pictures larger than about 6×9 cm.

Latent image Exposed but still invisible image.

Latitude Permissible variation. Can apply to focusing, exposure, development, temperature, etc.

Leaf shutter See Between-lens shutter.

LED Light-emitting diode. Used for light signalling – camera viewfinder information, battery check, etc.

Lens hood, or shade Shield surrounding lens (just outside image field of view) to intercept side-light, prevent flare.

Light meter Device for measuring light and converting this into exposure settings.

Light trap Usually some form of baffle to stop entry of light yet allow passage of air, solution, objects, according to application.

Lighting contrast ratio The ratio between deepest shadow and brightest lit areas of a scene. Assumes that in both instances the tone of the actual subject remains the same (grey card in each area for example).

Line image High-contrast image, as needed for copies of line diagrams or drawings.

Linear perspective Impression of depth in a picture given by apparent convergence of parallel lines, and changes of scale between foreground and background elements.

Liquid crystal display (LCD) Electronically energized panel used in film cameras to display settings, and in digital cameras to show the picture before and after exposure.

Lith film Highest-contrast film. Similar to line but able to yield negatives with far more intense blacks.

Location photography Photography away from the studio.

Log Logarithm. In photography common logarithms, to the base 10; e.g. \log_{10} of $10 = 1$ and \log_{10} of $100 = 2$.

Long focus lens A lens of longer focal length than normal for the format.

Long-peaking flash Electronic flash utilizing a fast stroboscopic principle to give an effectively long and even peak of light. This 'long burn' allows a focal plane shutter slit to cross and evenly expose the full picture format, at fastest speeds.

Lossless compression A non-destructive method of reducing the size of digital files. Avoids loss of quality relative to the original file when decompressed. TIFF is one such example.

Lossy compression Method of greatly reducing digital file size by discarding data. Induces loss of image quality when decompressed. JPEG is one such example.

Low key Scene or picture consisting predominantly of dark tones, sombre colours.

Macro lens Lens specially corrected to give optimum definition at close subject distances.

Macro setting A special, close focusing setting offered on some lenses (typically zooms). Accessed by a 'Macro' position on the distance scale.

Macro zoom Macro lens which can also be varied in its focal length.

Macrophotography See Photomacrography.

Magnification In photography, means linear magnification (height of object divided into height of its image).

Manual mode Selectable option on a multi-mode camera whereby you choose and make all the exposure settings.

Marquee tool An image manipulation selection tool used to outline an area of the image with a broken line showing where changes are to be made.

Masking frame Adjustable frame which holds printing paper flat during exposure under the enlarger. Also covers edges of the paper to form white borders.

Mat, or overmat Cardboard rectangle with cut-out opening, placed over the print to isolate the finished picture.

Matt Non-shiny, untextured surface finish.

Maximum aperture The widest opening (lowest f-number) a lens offers.

Medium format camera Camera taking pictures larger than 35 mm but smaller than sheet film sizes. A rollfilm camera, for example.

Megabyte (MB) A measurement of digital file size, computer storage or memory space. One MB is 1024 kilobytes of information.

Microphotography Production of extremely small photographic images, e.g. in microfilming of documents.

Midtone A tone about mid-way between highlight and shadow values in a scene.

Mirror lens Also 'Catadioptric' lens. Lens using mirrors as well as glass elements. The design makes long focal length lenses more compact, less weighty, but more squat.

Mode The way in which a procedure (such as measuring or setting exposure) is to be carried out.

Modelling light Continuous light source, positioned close to a flash tube, used to preview exact lighting effects before shooting with the flash itself.

Modem Device to convert digital data from a computer into analogue form capable of being carried (as sound) over regular telephone lines. Also acts in reverse – converting incoming analogue data back into digital data.

Monochrome Single colour. Also general term for all forms of black and white photography.

Monorail camera Metal-framed camera, built on a rail.

Motor drive Motor which winds on film after each exposure.

Multigrade See Variable contrast paper.

ND Neutral density. Colourless, grey tone.

Negative Image in which tones are reversed relative to the original subject.

Neutral density filter Colourless grey filter which simply dims the image by a known amount.

Noise Defect by which shadows and other dark areas of a digital image contain pixels of the wrong colour, randomly distributed. Most often occurs in digital camera pictures which have been underexposed.

Normal (or 'standard') lens Lens most regularly supplied for the camera size; typically has a focal length equal to the diagonal of the picture format.

Notching code Notches in one edge of sheet film, shape-coded to show film type.

Object The thing photographed. Often used interchangeably with subject.

One-shot processing Processing in fresh solution, which is then discarded rather than used again.

Opacity Incident light divided by light transmitted (or reflected, if tone is on a non-transparent base).

Opaque Impervious to light.

Open flash Firing flash manually while the camera shutter remains open.

'Opening up' Changing to a wider lens aperture.

Optical resolution In digital cameras the true maximum resolution possible – product of CCD resolution and lens quality – without resort to interpolation.

Ortho Orthochromatic sensitivity to colours. Monochrome materials which respond to blue and green, are insensitive to red.

OTF Off the film. Light measurement of the image whilst on the film surface during exposure – essential for through-the-lens reading of flash exposures.

Pan and tilt head Tripod head allowing smooth horizontal and vertical pivoting of the camera.

Pan film Panchromatic sensitivity. Monochrome response to all colours of the visual spectrum.

Panning Pivoting the camera – typically about a vertical axis, to follow horizontal movement of the subject.

Panorama camera Camera giving long-narrow format proportions by using the centre strip of the image given by the (wide-angle) lens.

Panoramic camera Camera in which the film moves behind a slit whilst the lens pivots about a vertical axis during exposure. Gives a long-narrow picture with curved horizontal perspective.

Parallax Difference in viewpoint which occurs when a camera's viewfinding system is in a position separate from the taking lens, as in compact and TLR cameras.

PC lens Perspective control lens. A lens of wide covering power on a shift (and sometimes also pivoting) mount. See Shift lens.

PCMCIA card Personal Computer Memory Card International Association card. (Also known as a PC card). These removable cards include types I, II & III, and are used to store images or add extra functions to computers. In digital cameras they have been largely replaced by lesser capacity but smaller cards such as SmartMedia.

PE Continental code for resin-coated paper. See RC paper.

Pentaprism Multi-sided silvered prism. Converts the laterally reversed image on the focusing screen of a SLR camera to right-reading, as well as reflecting it to the eyepiece.

Perspective Device to give impression of three-dimensional depth and distance in an image.

pH Acid/alkalinity scale spanning 0–14, based on the hydrogen ion concentration in a solution. 7 is neutral, e.g. distilled water. Chemical solutions with higher pH ratings are increasingly alkaline, lower ones acid.

Photoflood Bright tungsten studio-lamp bulb. Usually 3400K colour temperature.

Photogram Image recorded by placing an object directly between sensitive film (or paper) and a light source. Similarly objects placed on the top glass surface of a digital scanner.

Photomacrography Preferred term for extreme close-up photography giving magnification of ×1 or larger, without use of a microscope.

Photomicrography Photography carried out through a microscope.

Pixel PICture ELement. The smallest element making up a visual digital image.

Polarized light Light waves restricted to vibrate in one plane at right-angles to their path of direction.

Polarizing filter Grey-looking filter, able to block polarized light when rotated to cross the plane of polarization.

Polaroid back Camera magazine or film holder accepting instant-picture material.

Positive Image with tone values similar to those of the original subject.

PQ Developer using Phenidone and hydroquinone as developing agents.

Preservative Chemical ingredient of a processing solution. Preserves its activity by reducing oxidation effects.

Press focus Lever on most large-format camera shutters. Locks open the shutter blades (to allow image focusing) irrespective of any speed set.

Primary colours Of light: red, green and blue.

Printing-in Giving additional exposure time to some chosen area, during printing.

Program, programme, or P Setting mode for fully automatic exposure control. The camera's choice of aperture and shutter settings under any one set of conditions will depend on its built-in program(s).

Pulling See Holding back.

Push-processing Increasing development, usually to improve speed or increase contrast.

Quartz iodine Compact tungsten filament lamp. Maintains colour temperature and intensity throughout its life.

RAM Random access memory. Temporary memory created within a computer when it is switched on. Large amounts of RAM are required by a manipulation program in order to run its many image changes.

Rangefinder Optical device for assessing subject distance, by comparison from two separate viewpoints.

Rapid fixer Fast-acting fixing bath using ammonium thiosulphate or thiocyanate as the fixing agent.

RC paper Resin (plastic) coated base printing paper.

Rebate Unexposed parts outside a film's picture areas.

Reciprocity law Exposure = intensity × time. This relationship breaks down at extremely long (and short) exposure times.

Reducer Chemical able to reduce the density of a processed image. (Paradoxically the term 'reducing agent' is also applied to developing agents.)

Reflected-light reading Measuring exposure (often from the camera position) with the light sensor pointing towards the subject.

Reflector Surface used to reflect light.

Reflex camera Camera using one or more mirrors in its viewfinder system.

Refraction Change in the direction of light as it passes obliquely from one transparent medium into another of different refractive index.

Relative aperture See *f*-numbers.

Removable hard disk Storage medium for digital data which you can physically transport and insert into the hard disk player of another computer to download its information.

Replenisher Solution of chemicals (mostly developing agents) designed to be added in controlled amounts to a particular developer, to maintain its activity and compensate for repeated use.

Resolution (digital) Digital image quality as measured by multiplying the number of horizontal and vertical pixels. Results in a figure for resolution in *pixels per inch.*

Restrainer Chemical component of developer which restrains it from acting on unexposed halides.

Reticulation A now rare 'wrinkly' overall pattern created in an emulsion during processing, due to extreme changes of temperature or pH.

Reversal system Combination of emulsion and processing which produces a direct image of similar tonal values to the picture exposed on to the material.

Ring flash Circular electronic flash tube, fitted around the camera lens.

Rising front Camera front which allows the lens to be raised, parallel to the film plane.

Rollfilm back Adaptor back allowing rollfilm to be used in a larger format camera.

ROM Read-only memory. A type of computer memory able to store data which can be read later but cannot be subsequently amended. Used to contain the basic code that allows the central processing unit to work.

Safelight A darkroom working light of the correct colour and intensity not to affect the light-sensitive material in use, e.g. orange for regular blue sensitive bromide paper.

Saturated colour A strong, pure hue – undiluted by white, grey or other colours.

Scanner Device for converting existing (analogue) images – photographic prints, negatives, slides, etc. – into digital form.

Scrim Metal mesh attachment to the front of a lighting unit which reduces intensity without altering lighting quality or colour.

Secondary colours See Complementary colours.

Selective focusing Precise focus setting and shallow depth of field, used to isolate a chosen part of a scene.

Self-timer Delayed-action shutter release.

Sepia A colour ranging from reddish brown to chocolate, as formed in sepia toning by different combinations of toner and silver halide emulsion.

Shading Blocking off light from part of the picture during some or all of the exposure.

Shadows In exposure or sensitometric terms, the darkest important tone in the subject.

Sharp In-focus and unblurred.

Sheet film Light-sensitive film in the form of single sheets.

Shift camera General term for a bellowless, wide-angle lens architectural camera with movements

limited to up/down/sideways shift of the lens panel. No pivots or swings.

Shift lens Wide-covering-power lens in a mount permitting it to be shifted off-centre relative to film format. Useful in cameras lacking movements.

Shutter-priority mode See Tv.

Silhouette An image showing the subject as a solid black shape against white background.

Silver halides Light-sensitive compounds of silver and alkali salts of halogen chemicals, such as bromine, chlorine and iodine.

Single-use camera Simple, ready-loaded camera, broken open and disposed of by the lab when processing your exposed film.

Slave unit Flash unit which reacts to light from another flash and fires simultaneously.

SLR Single-lens reflex.

SmartMedia A PC card which fits into a digital camera or (typically through an adaptor) into a computer to allow storage or transfer of data.

Snoot Conical black tube fitting over a spotlight or small flood. Restricts lighting to an even, circular patch.

Soft (1) Low contrast. (2) Slightly unsharp or blurred.

Spectrum Radiant energy arranged by wavelength. The visible spectrum, experienced as light, spans 400–700 nm.

Speed (of emulsion) A material's relative sensitivity to light.

Spot meter Hand meter, with aiming viewfinder able to pick out small areas of (often distant) subjects and so make spot exposure readings.

Spot mode A TTL metering mode option which allows a narrow-angle exposure reading of the subject. The small area measured is outlined on the camera's focusing screen.

Spotting Retouching-in small, mainly white specks or hairs – generally on prints – using water colour, dye or pencil. Can also be performed digitally, using the cloning tool.

Still-life General term for an inanimate object, set up and arranged in or out of the studio.

Stock solution Chemical stored in concentrated liquid form, diluted for use.

Stop Historical term still used in connection with lens aperture settings, and changes in exposure.

Stop bath Acidic solution which halts development, reduces fixer contamination by the alkaline developer.

Stopping down Changing to a smaller aperture (higher *f*-number).

Strobe Inaccurate general term for electronic flash. Strictly means a fast-repeating stroboscopic lamp or flash.

Subject The thing being photographed. Term used interchangeably with object, although more relevant to a person, scene or situation.

Subject brightness range The ratio between the most brightly lit reflective part, and the most dimly lit dark toned part of the subject appearing in your picture.

Supplementary lens See Close-up lens.

Sync lead Cable connecting flashgun to shutter, for synchronized flash firing.

Synchro-sun Flash from the camera used to 'fill-in' shadows cast by sunlight.

T Setting 'Time' setting available on some large-format camera shutters. The release is pressed once to lock the shutter open, then pressed again to close it.

Tele-convertor See Convertor lens.

Telephoto Long focal length lens with shorter back focus, allowing it to be relatively compact.

Tempering bath Large tank or deep tray, containing temperature-controlled air or water. Accepts drums, tanks, bottles or trays to maintain their solution temperature before and during processing.

'Thick' image Dense, dark result on film.

'Thin' image Pale, ghost-like film, lacking density.

TIFF Tagged Image Format File. Extensively used file format for high-resolution digital images.

Tinting Applying colour (oils, dye, water colours) to a print by hand.

TLR Twin-lens reflex.

Toning Converting a black silver image into a coloured compound or dye. The base remains unaffected.

Transparency Positive image on film. Includes both slides and larger formats.

TTL Through-the-lens camera reading, e.g. of exposure.

Tungsten-light film Colour film balanced to suit tungsten light sources of 3200K.

Tv Time value. Auto-exposure camera metering mode. You choose the shutter speed, the meter sets the aperture. (Also known as shutter priority system.)

Ultra-violet Wide band of wavelengths less than about 390 nm. Invisible to the human eye.

Undo A digital manipulation program command which reverses the last editing command you applied to an image. Programs offering multiple undo allow you to work backwards over a number of commands.

'Universal' developer A developer designed for both films and prints (at different dilutions).

Unsharp masking (digital) Selective sharpening of the image in areas of high contrast, with little effect on areas of solid tone or colour. An effective method of improving the visual appearance of sharpness and detail.

Uprating Increasing your film's speed setting (or selecting a minus setting on the exposure-compensation dial) to suit difficult shooting conditions. Followed up with extended development.

UV filter Filter absorbing UV only. Appears colourless.

Variable-contrast paper Monochrome printing paper which changes its contrast characteristics with the colour of the exposing light. Controlled by filters. Multigrade; Polygrade; Varigrade and Polymax are all trade names for variable-contrast papers.

VGA Video Graphics Array. The established standard term for digital resolution of 640 × 480 pixels. Found in low-end cameras used as computer peripherals.

View camera Camera (usually large-format) in which the image is viewed and focused on a screen in the film plane, later replaced by a film holder. View cameras are primarily used on a stand.

Viewpoint The position from which the camera views the subject.

Vignetting Fading off the sides of a picture into plain black or white, instead of having abrupt edges.

Warm tone A brownish black and white silver image. Often adds to tonal richness.

Watt-second Light output given by one watt burning for one second. Used to quantify and compare the power output of electronic flash (but ignores the influence of flash-head reflector or diffuser on exposure).

Wetting agent Detergent-type additive, used in minute quantity to lower the surface tension of water. Assists even action of most non-acid solutions, and of drying.

White balance Automatic adjustment to a digital camera's CCD colour response. Ensures correct colour balance in images shot under lighting of various colour temperatures.

White light Illumination containing a mixture of all wavelengths of the visible spectrum.

Wide-angle lens Short focal length lens of extreme covering power, used on a relatively large format camera to give a wide angle of view.

Wide-carriage printers Ink-jet printers capable of outputting poster-size colour prints, e.g. over a metre wide and of unlimited length.

Working solution Solution at the strength actually needed for use.

WWW World Wide Web. That part of the Internet which involves servers (special computers) able to communicate with other computers on global tele-communication networks. Provides an infinite web of links to information stored in hundreds of thousands of servers all over the world. Makes possible electronic publishing.

X Electronic flash. Any flash sync socket and/or shutter setting marked X is for electronic flash.

Zip disk A popular removable data storage hard disk. Available in 100 MB and 250 MB versions.

Zone system Method of controlling final print tone range, starting with your light readings of the original subject. Pictures are previsualized as having up to nine tone zones, adjusted by exposure and development. Propounded by photographers Ansel Adams and Minor White.

Zoom lens Lens continuously variable between two given focal lengths, whilst maintaining the same focus setting.

Zoom range The relationship of longest to shortest focal lengths offered by a zoom lens, e.g. ×2, ×3, etc. See Figure 5.16.

Zooming Altering the focal length of a zoom lens.

Index

Note: Page numbers shown in italic indicate the location of figures which are separated from related text.